KENYA

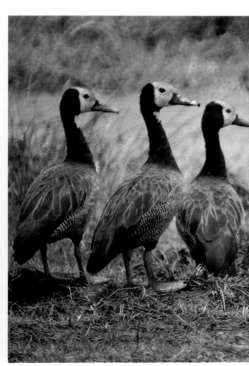

To the memory of our friend
William Holden

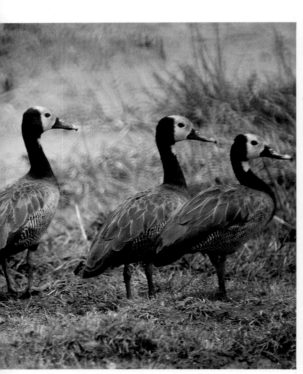

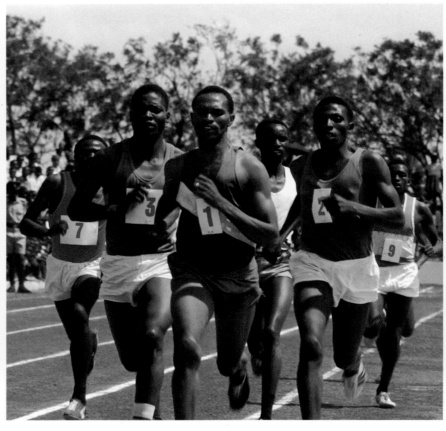

Journey through
KENYA

Mohamed Amin · Duncan Willetts · Brian Tetley

Introduction by William Holden

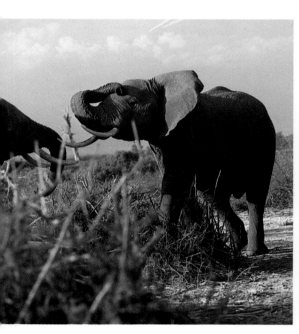
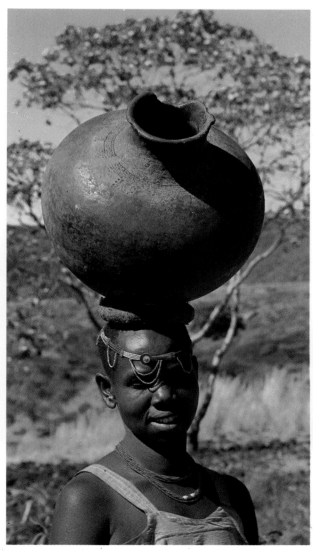

Camerapix Publishers International
NAIROBI

Acknowledgements

We would like to thank the many people throughout Kenya who gave us help and advice in the production of this book, particularly in verifying facts and stories recounted in the text and in the captions. We are especially grateful to the late William Holden and to Don Hunt of the Mount Kenya Game Ranch, who offered their invaluable encouragement and support. We would also like to thank S.F. Muka, former Director of the Kenya Literature Bureau, Dr Taitta Toweet, Chairman of the Kenya Literature Bureau, Peter Muiruri, Jake Grieves-Cook, John Eames, Alastair Matheson, Masud Quraishy, and Peter Moll. We would like to thank Graham Hancock for editing the text.

The spelling of place-names follows that laid down in the Kenya Gazetteer produced by the Survey of Kenya. The use of kilometres for distance and feet for height is the common usage in Kenya.

This edition first published 1987 by
Camerapix Publishers International,
P.O. Box 45048,
Nairobi, Kenya

First published 1982 by
The Bodley Head Ltd
Second impression 1983
Third impression 1984
Fourth impression 1985
Fifth impression 1987
Sixth impression 1989
Seventh impression 1993

© Camerapix 1982

ISBN 1-874041-01-6

This book was designed and produced by
Camerapix Publishers International,
P.O. Box 45048,
Nairobi, Kenya

Design: Craig Dodd

Filmset by Keyspools Ltd. England.
Printed in Hong Kong by South China Printing Co. (1988) Ltd.

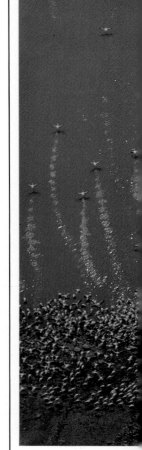

Half-title to Contents page: Kamba woman selling tomatoes. Kenya coffee plantation near Nyeri. Six geese on goose march. Kipchoge Keino, world-beating Kenyan athlete with rival Ben Jipcho. Elephant in Amboseli beneath Kilimanjaro's majestic peak. Kalenjin-speaking Bok tribe from slopes of Mount Elgon. Suba fisherfolk casting nets on Lake Victoria. Flamingos on Lake Bogoria. Cheetah cubs.

Contents

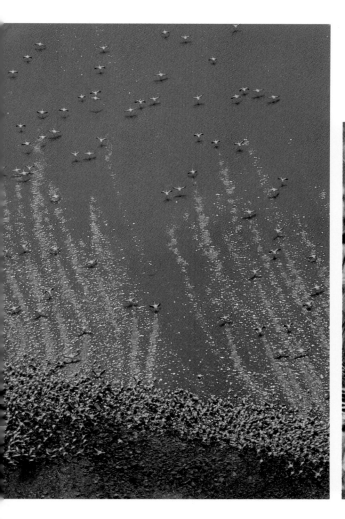

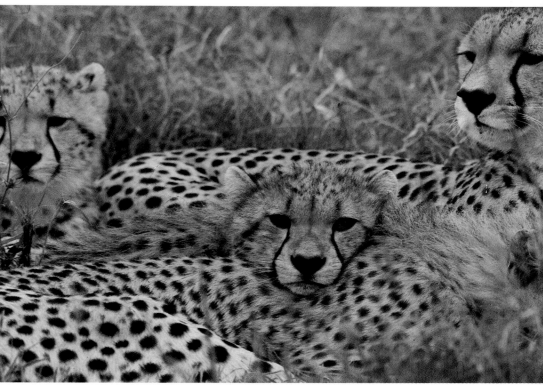

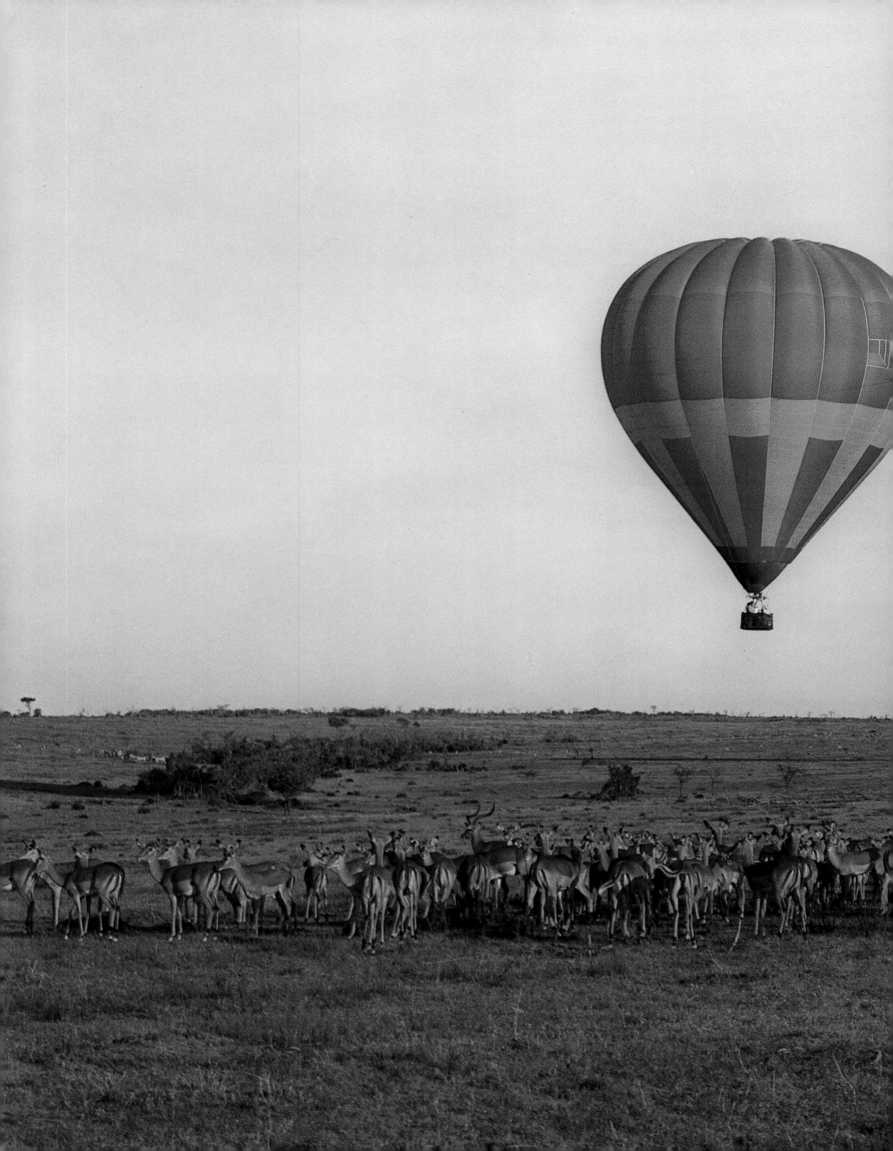

1 · *Journey Through Kenya*
by William Holden

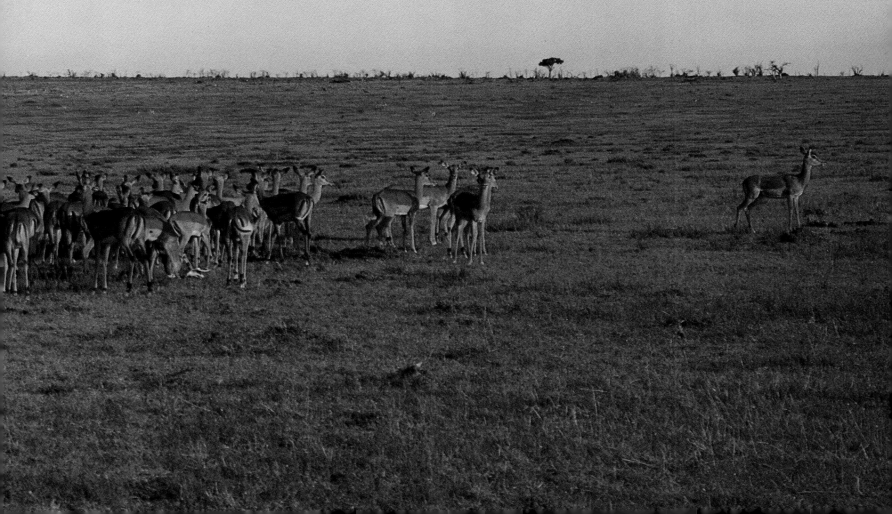

Wildlife has fascinated me for as long as I can remember. In the vast savannahs of Africa there is a dimension of space and time that is an echo of our own beginnings and which reminds us that we were not born initially to live in the concrete jungle.

For more than twenty-five years I have counted Kenya as a second home and high on the slopes of old Kirinyaga, the sacred mountain of the Kikuyu tribe, Mount Kenya, I can watch the sun slide over the Aberdare Mountains within sound of the call of the jackal and the leopard. Don Hunt and I have a game ranch on the mountain. We have taken a lovely piece of Africa and have built a private reserve as a home and safe haven for more than 1,000 animals of twenty-six species. We have a capture unit that captures and exports animals to zoos and safari parks throughout the world.

We also work closely with the Kenya Government to capture animals in areas where they are threatened by poaching or the crush of civilization, and translocate them to African national parks and reserves where they will be safe. Some of my most memorable safaris have been with Don Hunt and his dedicated team of Kenyans capturing game in the vast Northern Frontier areas and moving the animals to protected areas or back to our game ranch. It gives me great pleasure that some of the offspring of the animals we have rescued over the years can now be seen and enjoyed by all in such far away places as the Los Angeles Zoo or the International Wildlife Park in Dallas, Texas, where they provide a very true and living image of what lies in store for the visitor to Kenya.

Interest in Africa's wildlife has grown tremendously since the Second World War. Watching wild animals in their natural surroundings has become big business for the national economy of countries like Kenya.

To a first-time visitor there is magic at night when every tree becomes an elephant and every rock a rhino. In most National Parks there are lodges where these animals parade under the light of electric moons. These performances were staged long ago—before fledgling man took his first footsteps, perhaps at a place called Koobi Fora on the shores of Kenya's Lake Turkana, a jade sea set in the stony deserts of the north and known to many as the 'Cradle of Mankind'.

When Adam got up and walked on his hind legs as *Homo erectus*, more than a million years ago, elephants and many other beasts were much bigger than their descendants today. Man's initial footsteps were the first unconscious stage in cutting the Lord of the Jungle down to man-size; more's the pity perhaps. There is something infinitely wise about the elephant. But now it is in peril, for man's footsteps were to affect every living thing on earth no matter how big or small.

Consider the hyrax, for instance, a small furry overgrown kind of guinea pig, one of all things bright and beautiful in Africa. Yet it is the closest relative the elephant has got—12 inches long against his cousin's 150 kilogrammes of fodder and 140 litres of water a day which add up to a full grown weight of more than 5 tons. But the hyrax is not in danger. It is indeed proliferating.

Just now, a hyrax ran across my balcony as one of these giants—the largest land mammals in existence—strolled up to the water hole near where I am writing to cast an eye over the human herd. The clinking

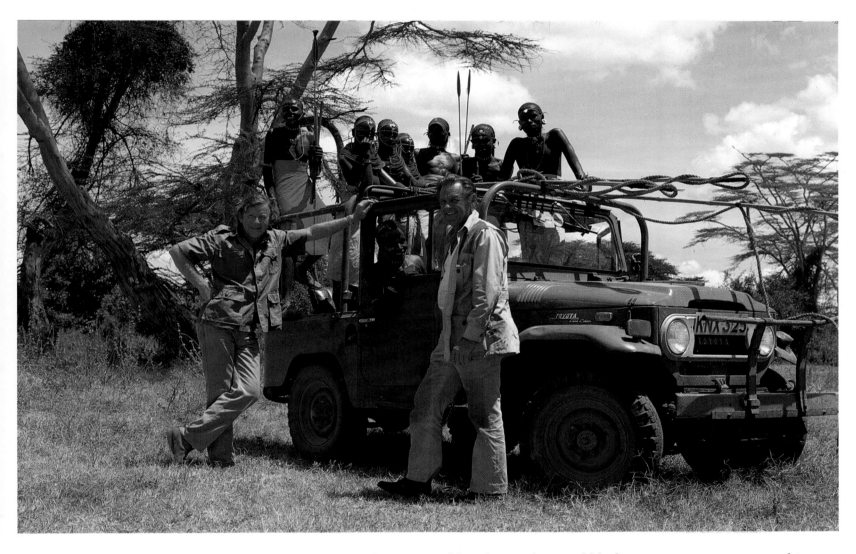

The late William Holden, right, with Samburu trackers and with game trapper and conservationist Don Hunt, his co-director in the Mount Kenya Game Ranch at Nanyuki.

glasses, twinkling binoculars and blinking cameras must cause him to wonder at the oddity of mankind. For the people who once paid to kill elephants now pay to watch them.

The Tarzan-style tree house of Eric Sherbrooke Walker was the progenitor of this, the most unusual spectator sport in the world. In the 1930s game watching was such an attraction that customers paid £10 a night, not much less than the cost of a licence to kill a rhino. The show was exclusive. It was limited to the times of the full moon and the accommodation—sufficient for four. The spectacle was so exciting it made Treetops, in the Kenya Highlands, the world's best-known hotel.

Now, every night, thousands enjoy Kenya's spotlit wildlife show at salt licks and water holes outside hotels in many of the nation's 39 national parks and reserves. These are spread around the thousands of kilometres which a young Scot, Joseph Thomson, crossed a century ago when he headed north from Mombasa with a team of porters.

Much of Thomson's trail became a permanent way not many years later. The Victorian establishment in Britain considered the concept of the Kenya-Uganda Railway madness enough to call it 'The Lunatic Express'. Fraught with peril in the building, it was overshadowed by

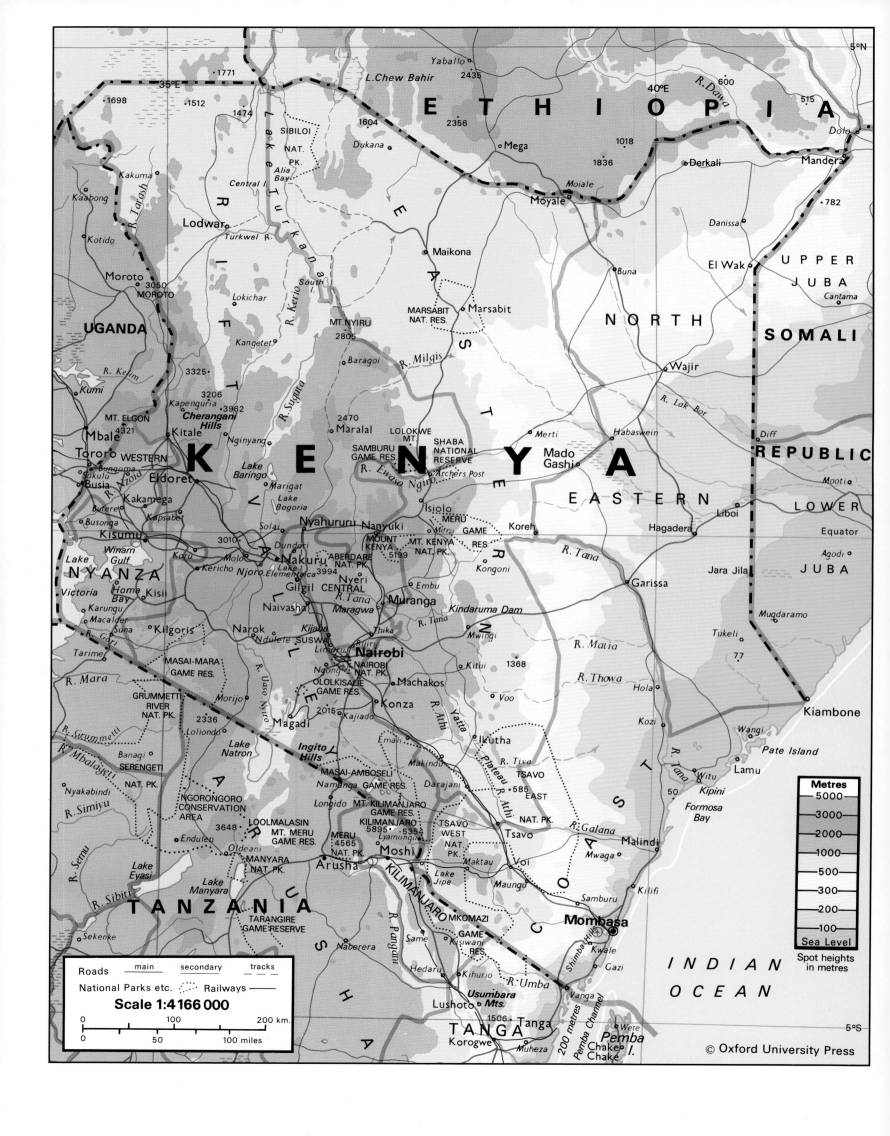

controversy and opposition in its planning and administration. Of 32,000 Indian labourers brought across to build the line, more than 2,000 died before it was completed years behind schedule. Yet it was nothing short of a magnificent success and remains one of the great railways of the world—climbing from sea-level through desert and grass plain, mountain and forest to cross the Equator at 9,136 feet before heading down again to the humid 3,760-foot altitude of Lake Victoria's shores. It is an unforgettable journey across almost 1,000 kilometres covering much of the geographic and climatic range of Africa.

The lines run to Kisumu on the shores of Lake Victoria, the Uganda border at Malaba, Kitale on the slopes of Mount Elgon, Taveta on the Tanzanian border, Butere in western Kenya, Solai in the Rift Valley, Nanyuki on the slopes of Mount Kenya and, of course, to Thomson's Falls, now Nyahururu, on the slopes of the Aberdare Mountains. Today called the Nyandarua Range, these mountains were originally named by Thomson after the President of the Royal Geographical Society which sponsored his journey.

However, Thomson was no game watcher. He killed to eat, taking his pick from plains more crowded with animals than with human beings; a spectacle that not many years later Theodore Roosevelt likened to the 'Pleistocene age of the mammals'.

The railway, dubbed 'Iron Snake' by the Maasai and the Kikuyu, changed all that. It brought the first tourists, a Victorian and Edwardian élite of dukes and earls, peers and princes, and high-born commoners, among them Roosevelt. These 'sport' hunters took a heavy toll of Eden's beasts. In 1908 Roosevelt, ostensibly in the name of science, was killing specimens for American natural history collections. Did the Smithsonian Institution really need thirteen stuffed rhinoceroses?

The wildlife had supported human populations for thousands of years but the early communities killed mainly for food. The arrival of the Europeans brought the creatures of the wild face to face with great danger. The youngest of these had roamed Kenya's plains for more than one million years while the crocodile had warmed its cold blood in the Equatorial heat for more than one hundred million years. Now all began to dwindle. The ships which carried out the trophies of hides, skins and ivory, carried in the ammunition needed to obtain them.

The wildlife massacres reached a peak during the last war when Kenya accommodated—and fed—thousands of prisoners from the world conflict. They were mainly Italians from neighbouring Ethiopia and Somalia. Kenya was also a supply point for ships *en route* through the Indian Ocean to other imperial possessions which required food. The herds of cattle and flocks of sheep and goats in the Highlands were supplemented with Thomson's gazelles, impala, zebra, eland and other antelopes.

War's end, however, brought a reaction to the slaughter of fifty years. When a National Parks system was proposed during the Second World War it was mocked. The idea of a network of animal kingdoms tied together by the threads of ages-old game trails, rivers and lakes, aroused scorn. But, against the opposition of farmer, sportsman and

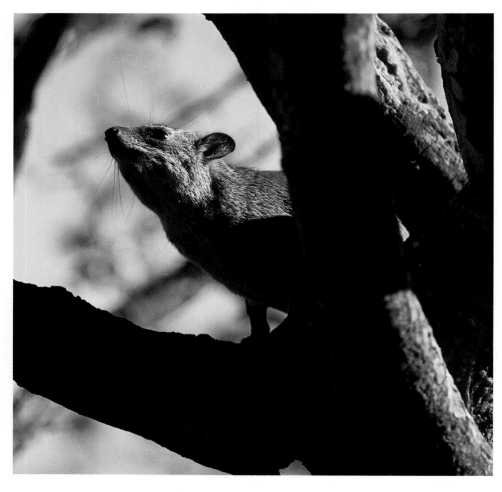

Left: The tiny tree hyrax, closest relative of the world's largest land mammal, the elephant, is inquisitive and often tame. The tree hyrax is greyish in colour and rather bigger than a guinea-pig. Its night cry is raucous.

hunter, Kenya's first National Park was inaugurated in 1946 under the administration of a wildlife zealot, Mervyn Cowie. Years later President Mzee Jomo Kenyatta, Kenya's first head of state, declared:

'The natural resources of this country—its wildlife which offers such an attraction to visitors from all over the world, the beautiful places in which these animals live, the mighty forests which guard the water catchment areas so vital to the survival of man and beast—are a priceless heritage for the future.'

Thus, after Independence in 1963, the network of twelve parks and reserves grew swiftly. In the first two decades of independence a further twenty-seven were put aside permanently for the conservation of animals. This meant that, with existing forest reserves, more than 10 per cent of Kenya's total land area would one day be lawfully exempt from the hunters, timber dealers and speculators.

The system was run at first by an independent board of trustees who appointed full-time professional conservationists as administrators. But because wildlife was such an integral part of Kenya's future development policy the National Parks merged with the Kenya Government's Game Department in 1976.

Running sixteen National Parks and twenty-three Game Reserves requires diligence against both poacher and natural disaster.

Below: Cheetah taking water in Nairobi National Park within 10 kilometres of Kenya's busy capital. Cheetah are reputedly the fastest land animals in the world and the most tractable of all feline predators. They make loving pets.

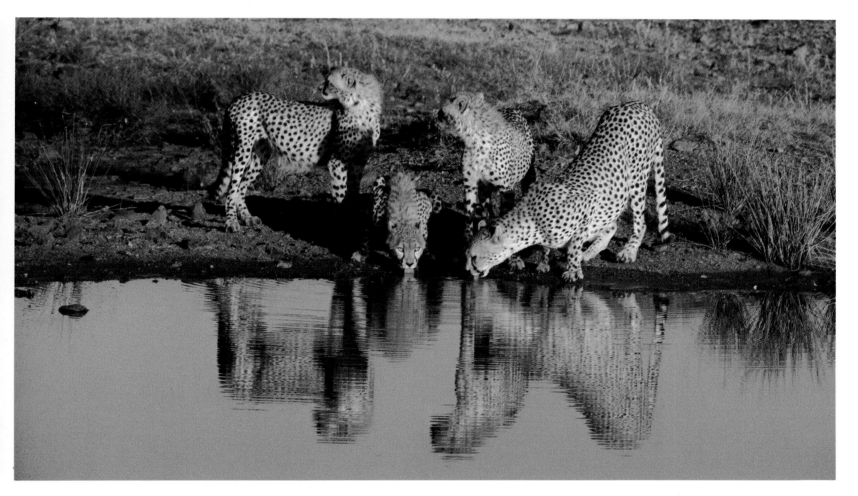

Throughout the nation, Kenya's Wildlife and Conservation Management Department deploys a staff of 4,000, most of them in the field as wardens, rangers and anti-poaching specialists.

Kenya's leaders long ago recognized the asset value of wildlife. If that wildlife could be preserved then the curiosity that first attracted the world's élite at the beginning of the century might attract millions of ordinary people in the future. They could come more quickly by jetliner and at a comparatively lower cost. And they would bring with them the lire, yen, pounds, dollars, Deutchsmarks, francs and kroner on the scale which Kenya needed to fund human development.

Thomson's journey was across a loosely defined land. Kenya was a kaleidoscope of people and cultures where local boundaries were delineated in accordance with the traditional balance of power. The Maasai had ascendancy over grazing grounds around Kilimanjaro, Naivasha and the Mara; the Kikuyu were content to rule and cultivate on the fertile, higher grounds of the escarpments and mountains.

Europe's political squabble for this land of stunning beauty astride the Equator had not yet begun. In 1883, Kenya's dynamics were tribal and its strengths the strengths of warriors whose battle honours adorned a thousand years or more. Their characteristics of courage were noted by the incoming Europeans.

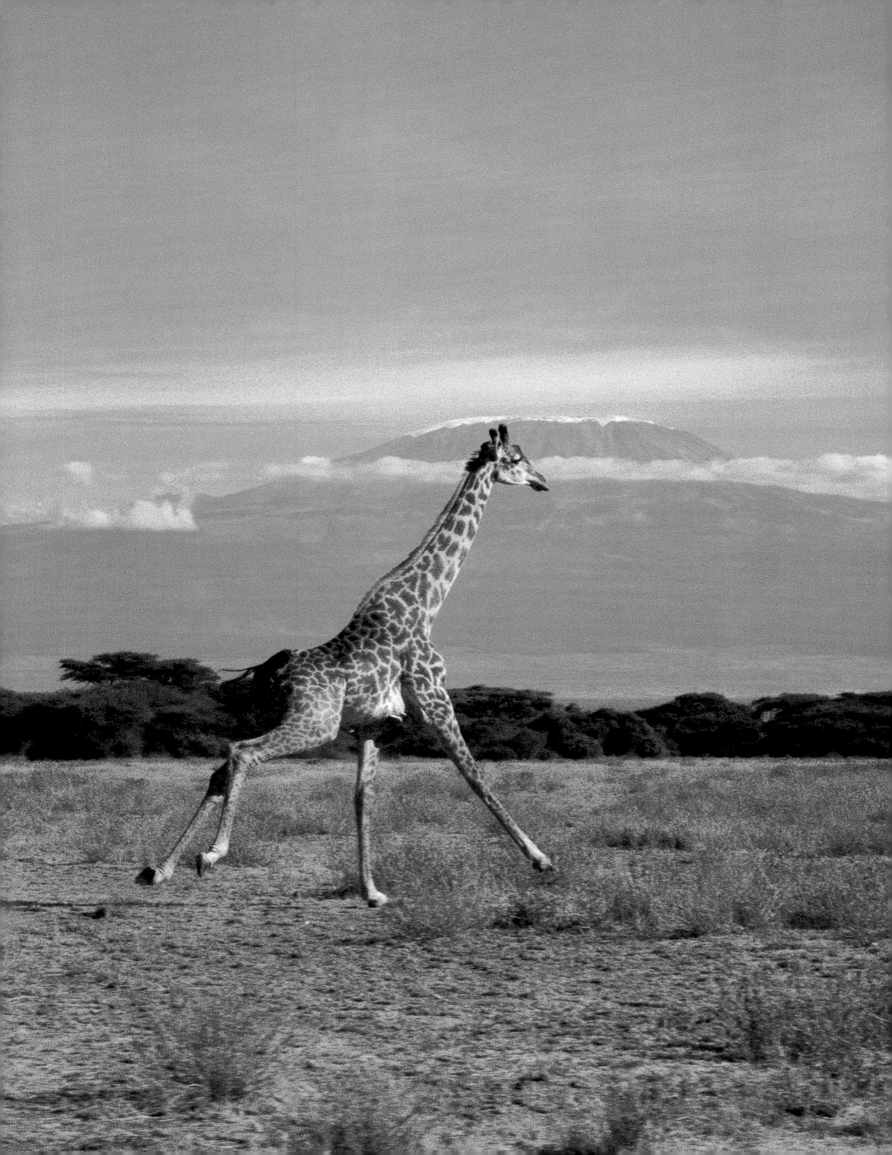

Left: Maasai giraffe galloping across the dusty Amboseli plains with Mount Kilimanjaro, 19,340 feet, in the background. These beasts are the world's tallest mammals and reach 18 to 19 feet in height.

Already there was a character about this yet-to-be defined nation and its peoples which set it apart from the rest of Africa. The white pioneers drawn by the rich farming potential in the land of eternal summer met their match among the Luo, Kamba, Giriama, Turkana, Samburu, Abaluhya, Borana, Taita, Kalenjin, Maasai, Kikuyu, Meru and Nandi. All these had laws of justice founded on compensation and not retribution, social systems built on a democracy of seniority and sharing of communal wealth.

Made up of four different ethnic units, Kenya's cultures are as old as man. This part of Africa has been a melting pot since our early ancestor, *Homo erectus*, first walked on the shores of Lake Turkana. All the ages of man and most of his ancient cultures are represented within Kenya. The remains of hand axes and cleavers are evidence of the Stone Age which thrived here long ago.

Between five to twelve thousand years ago, the bow and arrow developed along with new ways of making blades. In the Late Stone Age, three to five thousand years ago, evidence suggests that two different species of man co-existed, one squat and broad-faced, the other tall, lean and thin-faced, living peacefully together.

Three thousand years ago man in Kenya began to domesticate animals. Within the next two thousand years most of Kenya was settled: the earliest generations of Bantu people, the agriculturalists and iron-makers who form a majority of the population today, began to move down from Uganda and the west. Later, at the end of the nineteenth century, the Europeans and Asians made their way inland from Kenya's shores. Traditional tribal disputes over grazing and agricultural land paled in comparison with the massive territorial seizures inflicted by the Europeans. Inevitably there was bitterness—a bitterness expressed in the African struggle for *Uhuru*—Swahili for freedom. It is remarkable that despite the anger and conflict of the recent past, Kenya today is a homogeneous and tolerant society, one in which the European and Asian play a full rôle with more than forty different indigenous groups of great ethnic variety. This is the mosaic of modern Kenya.

Like its people, the land is characterized by diversity. Kenya is a world in miniature for within its boundaries exist almost every type of known landform from snow mountain and glacier to true desert.

This variety is reflected in the aureole of pink shrouded mist which swirls among Mount Kenya's loftiest, ice-clad spires and is distilled in the crystal cool of Naivasha's waters. Its vivacity bubbles on the waters of the 700-kilometre-long Tana River as it jumps, new born, down the shoulders of Mount Kenya on its long run to the Indian Ocean, and the coconut palms along the Kenya coast whisper it, too.

With twenty mountain peaks rising above 6,500 feet and five great massifs rising more than 10,000 feet, Kenya is studded with lakes which glimmer silver in the early morning sun. Its borders fall in the waters of Africa's largest lake, Victoria, and eight major rivers more than 200 kilometres long include impressive waterfalls of which one, high in the Aberdare Mountains, is almost 1,000 feet deep.

Below: When the East African Railway was built in the last decade of the nineteenth century, the largest obstacle facing the engineers was the sudden drop from the Limuru Escarpment to the floor of the Rift Valley. Ron Preston solved the problem with an ingenious ramp device. Later route changes, however, have made the gradient more gradual and it now follows the alignment along which this Kenya Railways diesel climbs to the escarpment summit. In the background is Mount Longonot.

There are two gateways into Kenya—one traditional, the other built within the last eighty years. In contrast to its most ancient city, more than a thousand years old, the national capital only came into being at the turn of the century.

As gateway to the interior, Mombasa's old port had no capacity to serve the influx of rail builders, soldiers of fortune, merchants of trade, Christian missionaries and the rest of the impedimenta introduced by the most commercially minded empire in history. A new port was needed. The growth of Kilindini docks had begun.

Moulded by the influence of Islam, which first spread to East Africa in the tenth century, Mombasa is the largest and most sophisticated centre on the East African coast—from the Horn of Africa to the far south of Mozambique. It lies on a large island roughly a quarter distance from Tanzania in the south and three-quarters distance from Somalia in the north. For many years this coast, and the sixteen kilometres of flat inland littoral, were part of the Sultanate of Zanzibar and, before that, part of a loose association of independent Islamic states no bigger than the towns in which the citizens lived—Gedi, Pate, Lamu, Manda and Zanzibar. Mombasa was the prize. On either side its sheltered creeks provided deep and safe anchorages; and its population the prospect of profitable trading.

The Portuguese navigator Vasco da Gama set his mark on the East African coast in the fifteenth century. His coming signalled the beginning of the end of these petty sultanates and fiefdoms. The carpet-baggers from Lisbon toyed with the coast but never gained total control. Nor did they seek it. They 'colonized' Mombasa, building Fort Jesus there after the fashion of a medieval European fortress.

The fort overlooks the entrance to the Island's harbours. Beyond the island lay what would become Kenya giving access to most of Africa south of the Sahara. In the evangelistic fervour which gripped Victorian Europe, Africa became the prime target of Christian missionaries bent on stopping slavery and, at the same time, capturing souls.

The appearance along the coast of Britain's anti-slavery squadrons around the 1840s and 1850s, and the arrival of Sir William Mackinnon's Imperial British East Africa Company (IBEA) in the last decade of the nineteenth century, marked the next stages in the colonization of Kenya. The railway was the key instrument of that colonization and its construction involved building a viaduct from Mombasa Island to the mainland—a thread of timber over which the first few lengths of line span out towards Lake Victoria almost 1,000 kilometres away. At about the same time, opposite that legacy of Portuguese sea-power Fort Jesus (now a 400-year-old museum) sprang up a symbol of British domination—the Mombasa Club. These two antiquities of different ages still survive, facing each other.

Today a modern bridge links the north mainland and the tourist resorts beyond. Along this coast lies the opportunity to take part in the excitement of Big Game fishing for giants like swordfish, tunny, bonito, falusi, sail fish, barracuda, shark, marlin, kingfish, wahoo and others. Aboard the power boats which cut a fast bow wave as they cream through the Island's old harbour to the open ocean, the solid blocks of Mombasa's new offices can be seen rising skyward, and on the

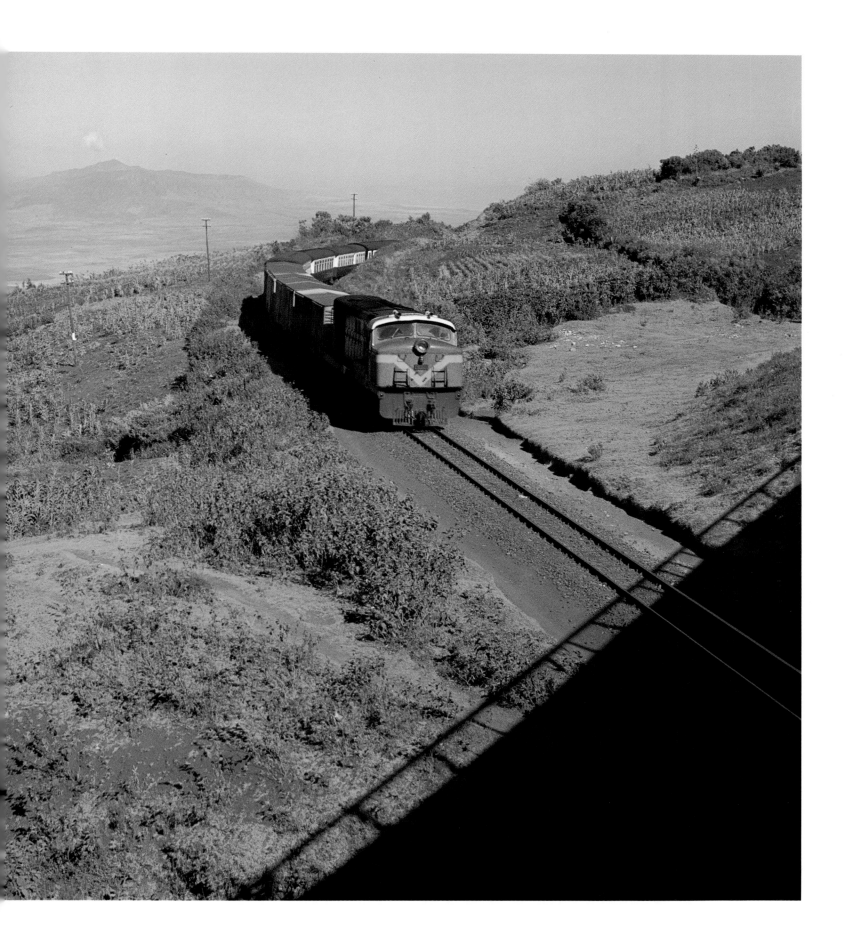

Overleaf: Early morning sunrise colours the skies above Mount Kenya in richly-toned sepias and oranges. The 17,058-foot-high peak is reflected in the still surface of a water hole in the neighbouring Aberdare Mountains.

mainland the Moi International Airport, named after the country's second President, Daniel arap Moi, awaits the wide-bodied jets bringing in more tourists from Europe.

Mombasa has night-clubs and cinemas and a teeming population of more than 340,000 people. Hindu temples, one with spires tipped with five kilogrammes of solid gold, glittering in the sun, above two massive doors of solid silver, have joined the Muslim mosques. Protestant churches have multiplied on the rock of the first Christian cathedral which is near to the law courts and the old colonial administration offices. State House commands a view overlooking the entrance to the island's deep-water harbours. Town has rapidly become city and the city's complex exciting atmosphere is added to by the jostling package tourists whose cultures overlay the local pastiche for a fortnight or three weeks at a time.

Down in the old town, Yusuf Amir now proclaims the virtues of his goods in German, and can quote his prices in Deutschmarks or dollars as easily as in Kenya shillings. But beneath this facade of change, Mombasa's traditional base has hardly altered.

Muggy in its average 28°C heat, softened only by the monsoon zephyr which sweeps across the domed roofs, Mombasa's ancient manners and cultures remain mostly hidden from the eye of the stranger—although some are picturesquely evident in the island's 13 square kilometres. Though fewer than ever, Arabian dhows still continue to call at Mombasa's old harbour and here, beneath the minarets of the mosques, within echo of the muezzin's calls, the pattern of life among the narrow streets of high-walled houses appears as unchanged as that of the great plains inland.

At the beginning of the century a journey by sea was the only way to travel the 8,000 kilometres from Europe to Kenya. It was a leisurely cruise taking three to five weeks either through the Atlantic and around the Cape of Good Hope, trading with the established ports of South Africa, or through the Suez Canal and around the Horn of Africa to discharge passengers and cargoes into the trains waiting alongside at Kilindini.

First views of Mombasa were limited, lacking the dawn radiance now reflected to a slowly circling jet: these views were more dark shadows and the belching of steam and the judder of wheels in the dark as the long train pulled out for the 500-kilometre climb through coastal jungle, escarpment desert and long African veld to the Nairobi railhead at 5,450 feet. Hauled by majestic steam engines fuelled from the stands of Kenya's high country forests, the journey often lasted three days.

The scar cut in Tsavo's red latosolic soil by railway workers was the only sign of man's intrusive presence. But in the wake of the line small settlements began to grow up, usually centred around an Asian-owned shop. The largest of these settlements developed on the swampy plain where the rail engineers had gathered to draw breath in 1899 and where Nairobi now stands. Up ahead, was the 3,000-foot climb in 50 kilometres to the edge of the Great Rift Valley escarpment and then the almost precipitous plunge down the Valley walls to the Rift floor below.

The railhead lay at the northernmost edge of the great Athi Plains.

Opposite: Water tumbles over the 894-foot drop of the Karura Falls high up in the Aberdare Mountains. In the distance is the country's deepest fall, Gura, tumbling 1,000 feet over the lips of an impenetrable ravine to join the largest river in Kenya, the Tana, a few kilometres downstream.

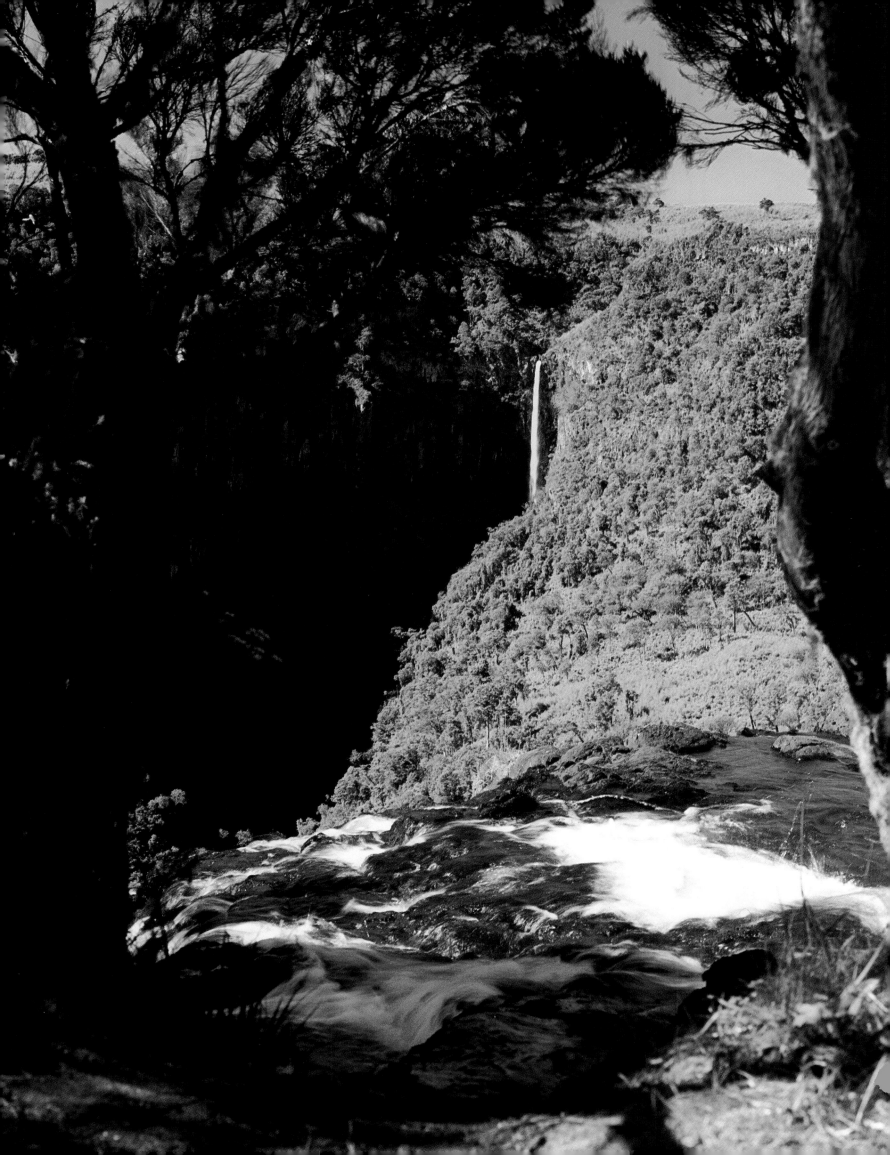

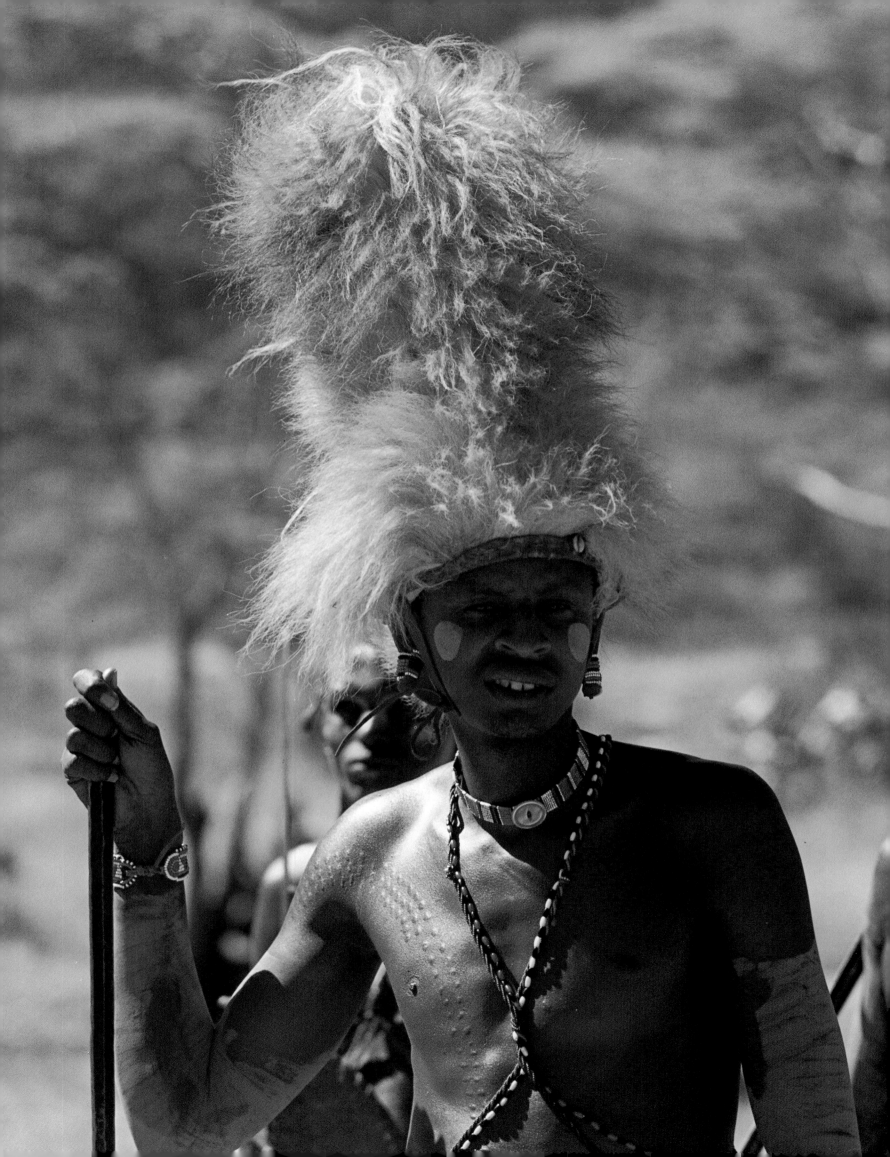

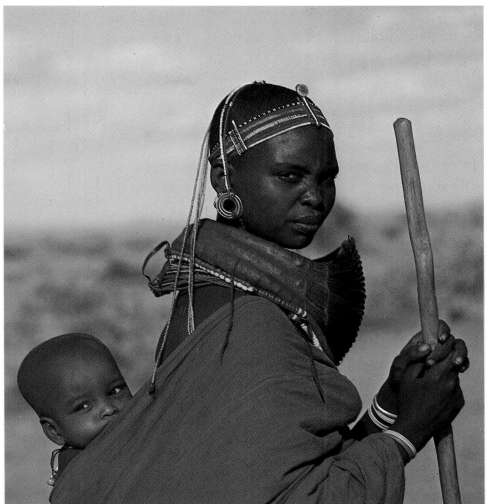

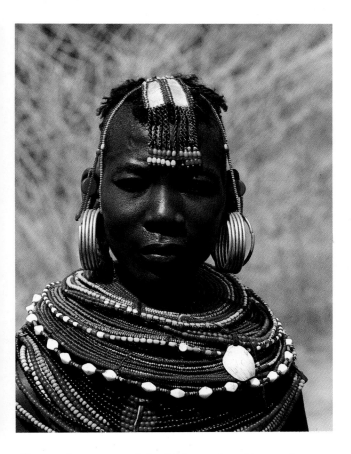

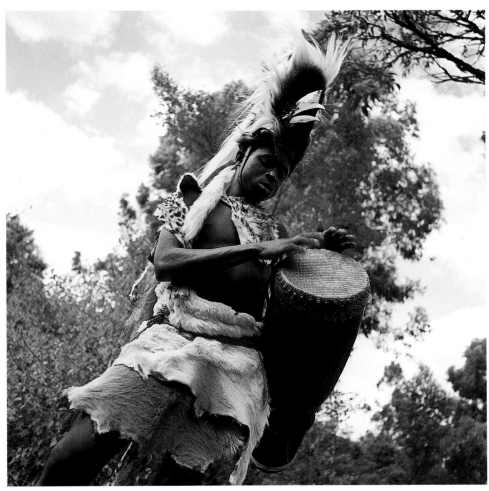

Above: A woman of the Pokot tribe. Close relatives of the Kalenjin, they live in the southern deserts of the Turkana region at the foot of the Cherangani Hills.

Top right: Rendille girl with infant relative in Kenya's Kaisut Desert, an arid, hot and stony wilderness. The 22,000-strong Rendille tribe are linked to the Samburu.

Right: The Abaluhya are one of Kenya's largest ethnic groups, made up of 17 tribes who live in the Kakamega region, between the Luo on one side and the Kalenjin on the other.

Opposite: The lion's mane head-dress signifies that this Maasai warrior has killed the king of the jungle in accordance with his tribe's time-honoured traditions.

Opposite: Flamingos cruise in a vee-formation over the surface of Lake Turkana, the Jade Sea, set in Kenya's far northern desert regions.

The swamp in which it stood had been named Nairobi by the Maasai who brought their cattle to drink at its cold streams. Before the railway the only permanent residents were mosquitoes, snakes, rodents, frogs and a handful of diseases.

Nairobi in its early days was unbelievably squalid. It was a shanty slum tied to the world by the single thread of the railway line. Yet within the next eighty years it grew into a graceful, flower-lined city of broad streets, open spaces and wooded hills. Today exhibitions in the Nairobi National Museum tell the story of first man. Paintings of Kenya people, flora and fauna, illustrate the nation's rich cultural heritage. There are musical instruments and other *objets d'art* and a photographic presentation which is a visual narrative of Kenya's fight for freedom. Close to the city centre, two or three hectares of shady forest have become the arboretum with more than 270 species of trees, each individually labelled.

Some things remain to evoke the colonial past: Queen Victoria's statue in Jeevanjee Gardens among them. But if the secluded Muthaiga and Nairobi clubs are reminiscent of a once privileged life, the Railway Museum breathes adventure for all. In its standing displays the *Maneaters of Tsavo* come to life again and the later melodrama of Police Inspector Charles Ryall's death in June 1900—when he was dragged by a lion from a railway carriage at Kima, also known as Mile 260— becomes more credible inside the actual wagon preserved in the museum and made in the English Midlands, according to a plate on its side.

A ribbon of green along Nairobi's central Uhuru Highway includes the city's first cemetery, the main Uhuru Park, Central Park, the University campus playing fields, and the Chiromo Forest. A tree-lined golf course is only a par-three distance from the nation's Parliament. Here 158 democratically elected and 12 nominated Members meet to debate the issues facing Kenya.

Nearby the 28-storey, 344-foot high Kenyatta Conference Centre, a dramatic superstructure in African rondavel style, dominates this city in the sun. In the centre's plaza, by a statue of the founder of modern Kenya, Mzee Jomo Kenyatta, the best of the world's rally drivers leave the ramp every two minutes each Good Friday eve at the start of The Safari Rally, one of the world's greatest motoring events. Divided into three legs, the route covers the length and breadth of Kenya. Most of the course is off tarmac, a unique challenge to the drivers and their cars as they climb to altitudes as high as 9,000 feet then plunge from wet, muddy mountain tracks to dusty, rutted desert trails at sea-level.

Nairobi's growth since Kenya's Independence has been phenomenal. The population now numbers more than 828,000 citizens with many more on the periphery. Garden estates lie to the west and north-west of its 689-square-kilometre environs; the more crowded areas to the east and south.

Night-clubs, casinos, restaurants, cinemas and theatres, flower-decked parks with forest walks, ten golf courses, sports grounds, squash courts and, ten minutes' drive from the city centre, the 'loveliest racecourse in the Commonwealth' all add zest to life in the capital's sunny streets.

Opposite: Coastal dhow in the Lamu archipelago loading a cargo of mangrove poles for export to the Arabian Gulf, where the wood is a valuable commodity.

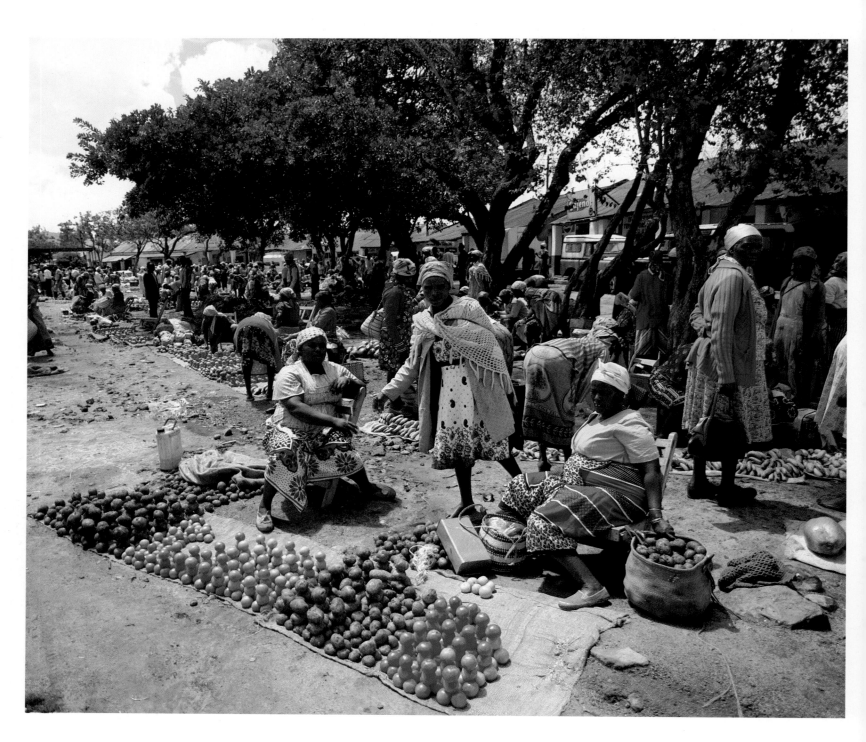

Above: Traditional Kenyan market which is held twice a week in the sleepy Kamba township of Tala.

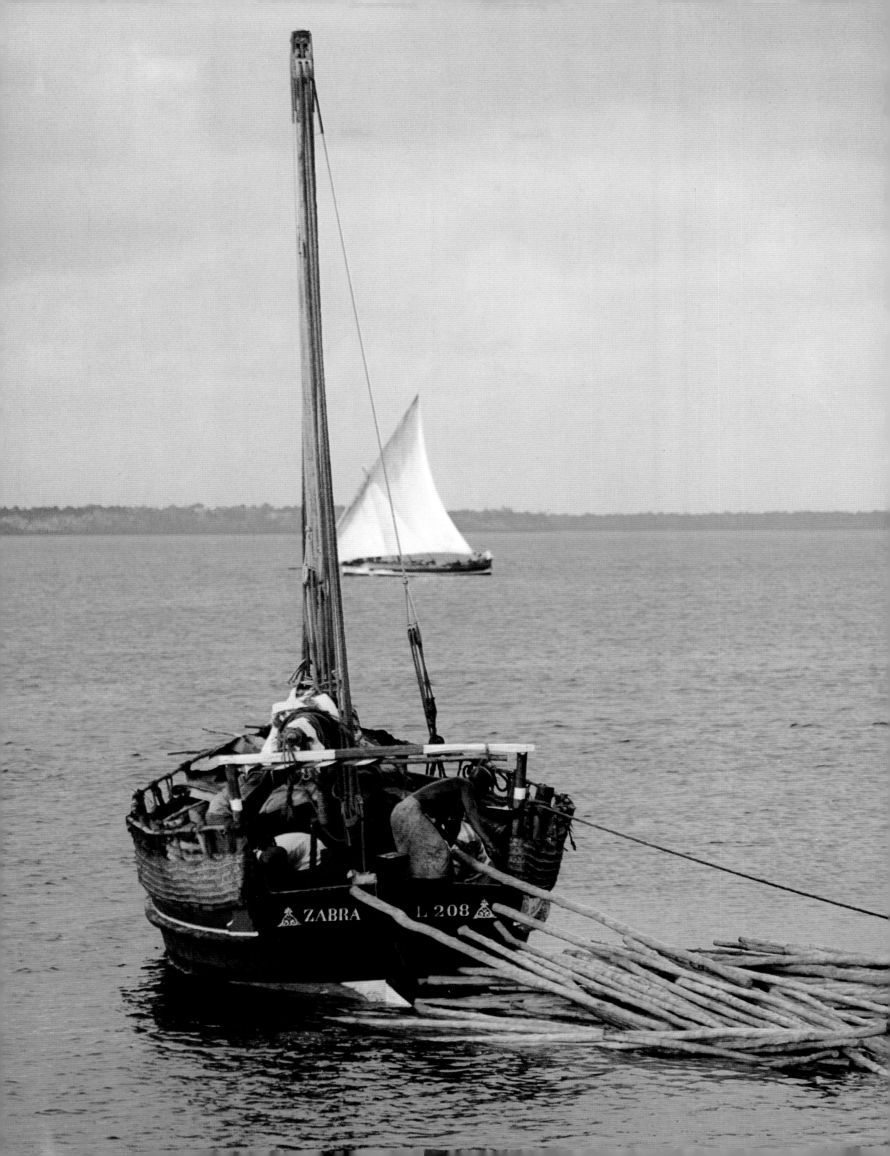

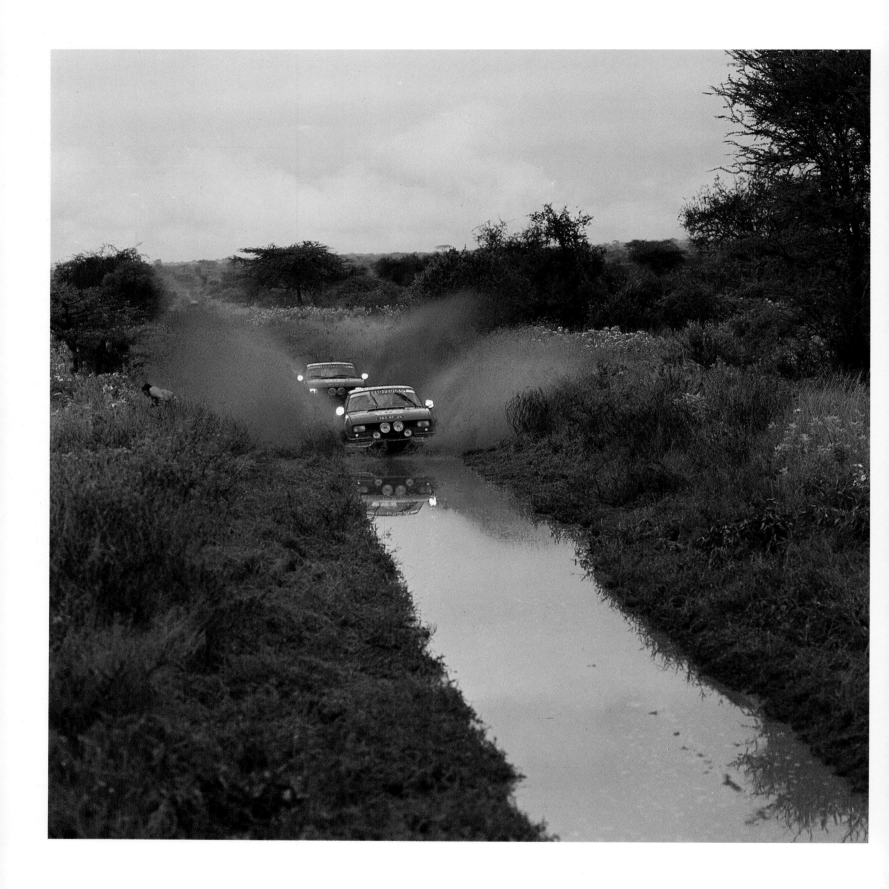

Right: Nairobi's Jomo Kenyatta International Airport, completed in the mid-1970s, is one of the world's most modern airports. It is also one of Africa's busiest with an average of more than twenty international departures a day.

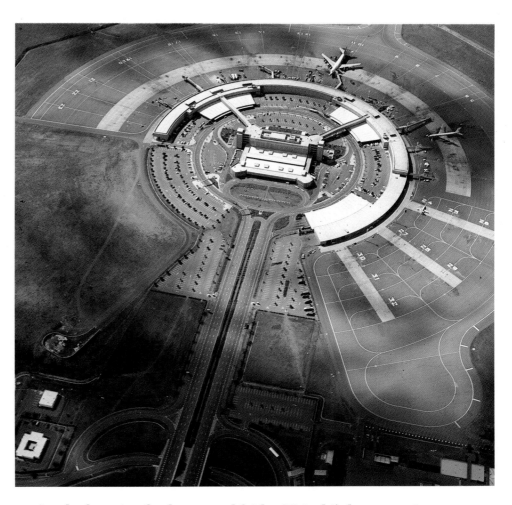

Overleaf: Skyline of the Kenya capital, Nairobi, with the 344-foot-high tower rotunda of the Kenyatta Conference Centre which dominates the downtown heart of the city. Foreground is the Intercontinental Hotel and left is the city's Catholic Holy Family Cathedral.

A polyglot mix of cultures and faiths, Nairobi's harmony increases with its prosperity. Italian, Chinese, French, Japanese, Indian and African restaurants jostle for attention. Sikh temples rise alongside the minarets of Islam which face the temple of a Hindu sect, all within sight of a Catholic cathedral and an Anglican church and only a walk away from the city synagogue.

The city's economy sits solidly on an expanding industrial area in the east which is already spreading north towards the industrial town of Thika. One day this expansion may mean that the two centres will merge, providing Kenya with an even larger light-to-medium industrial base encompassing car-assembly, brewing, paint-making, tyre production, food processing, the manufacture of domestic appliances, printing, packaging, pharmaceuticals and cosmetics.

Before Independence the railway was the only reliable direct connection between the capital and the coast. The road link was fragile, a dirt track often obliterated by rain. Now a fine highway through the heart of the nation's two Tsavo Parks, most of it parallel to the railroad, joins Nairobi to Mombasa. Overhead power lines have since been added and so has a network of microwave radio transmission stations for the

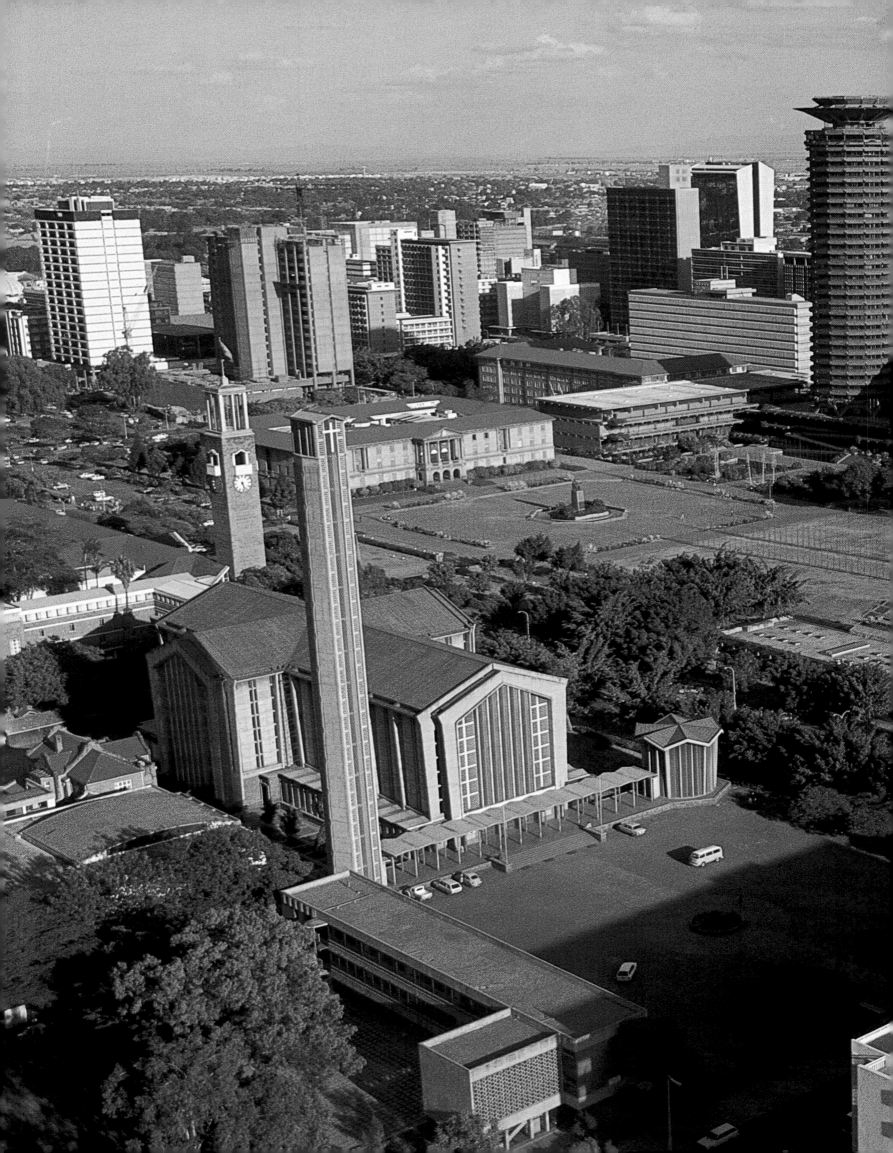

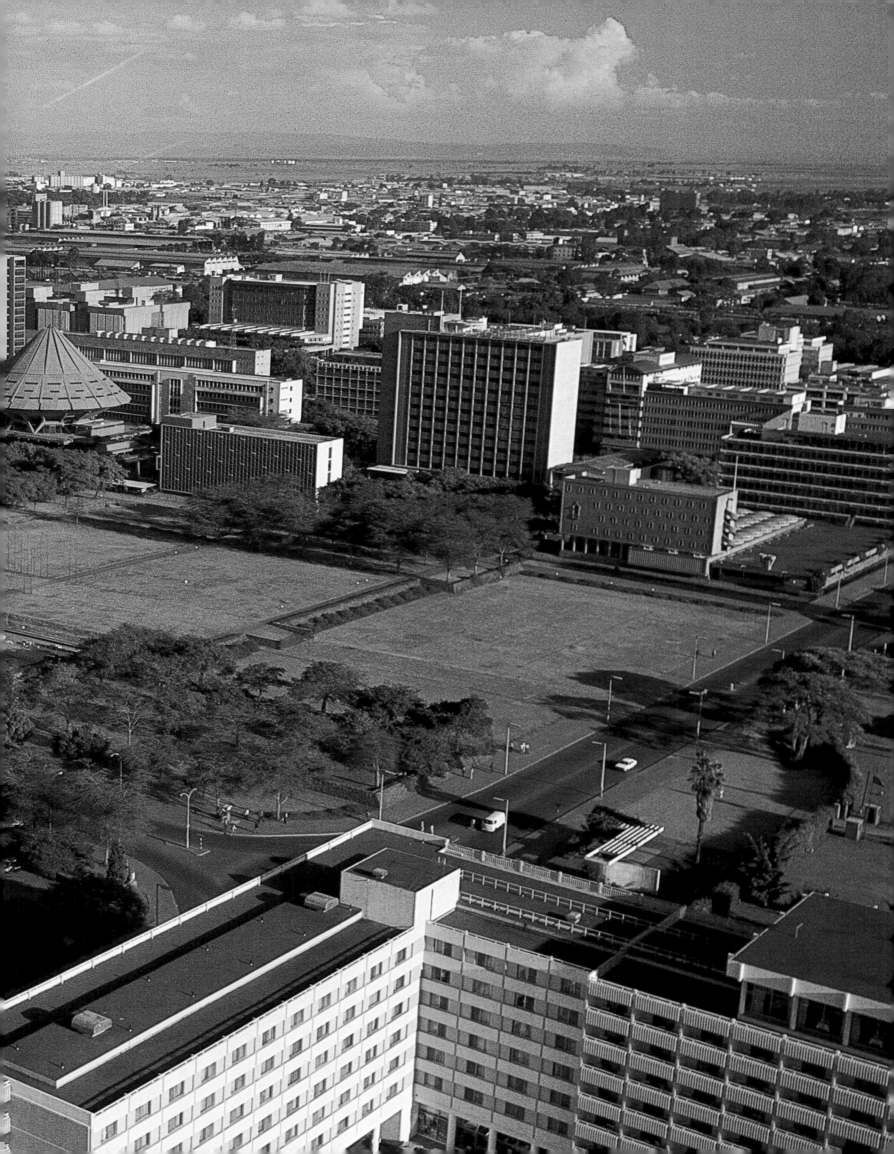

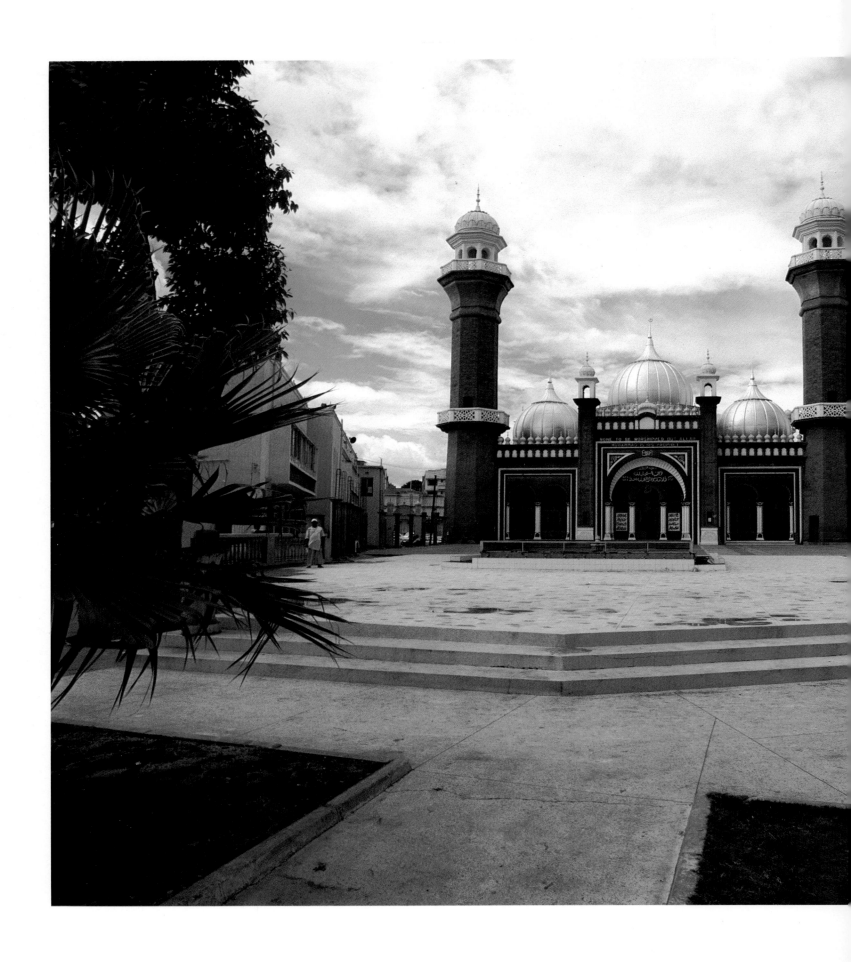

Below: The tall minarets of the Jamia Mosque symbolize the variety of faiths and the freedom of worship found in Kenya. The Mosque dominates the inner heart of Nairobi, Kenya's rapidly-growing capital.

country's telephone systems. Along the same route runs an underground pipeline pumping fuel from the oil refinery at the coast to Nairobi and upcountry. Some of this fuel is syphoned off to meet the considerable needs of Jomo Kenyatta International Airport, aerial crossroads of Africa, where twenty or more flights, for destinations as varied as Douala and Athens, Riyadh and New York, interconnect each day.

The Coast-Nairobi pipeline is a blessing for it has ended the dangerous convoys of lorries and tankers that used to transport fuel by road to the capital. The herds of game which used to graze and browse within sight of the road gradually slipped away into the depths of Tsavo East on one side and Tsavo West on the other during the years that the convoys rolled. Now the wildlife is returning and antelope and buffalo are frequently seen by motorists. The old faded signs are being renewed. They warn: BEWARE! ELEPHANTS HAVE RIGHT OF WAY.

I have been fortunate enough to count Kenya as my home for a great number of years and have come to love its untouched wilderness beauty, and to find in its wide open spaces something of the harmony and equilibrium reflected in the nomads who roam the north.

It is home also to Mohamed Amin and Duncan Willetts whose brilliant photographs never fail to do justice to the colour and magnificence of their subject. Even I—and I am not alone—have been astonished at the variety of cultures, landscapes and wildlife which are revealed in these pages of breath-taking illustrations.

Your guide through this wonderland of mountain and plain is Brian Tetley, who illuminates his story with a sure imagery interlaced with often amusing and unfailingly interesting anecdotes.

In the safe hands of these three veteran travellers of the wild I am confident every reader will have a memorable armchair safari through one of the last great natural paradises.

William Holden,
Mount Kenya Game Ranch,
Nanyuki,
Kenya.

June 1981

Overleaf: A link across untold millennia. On the one hand, the rhinoceros, which has been on this earth more than sixty million years; on the other, Nairobi City, not yet a century old. Nairobi National Park, in which these two rhino live, is less than 10 kilometres from the Kenyatta Conference Centre, the dramatic 344-foot-high superstructure in the background.

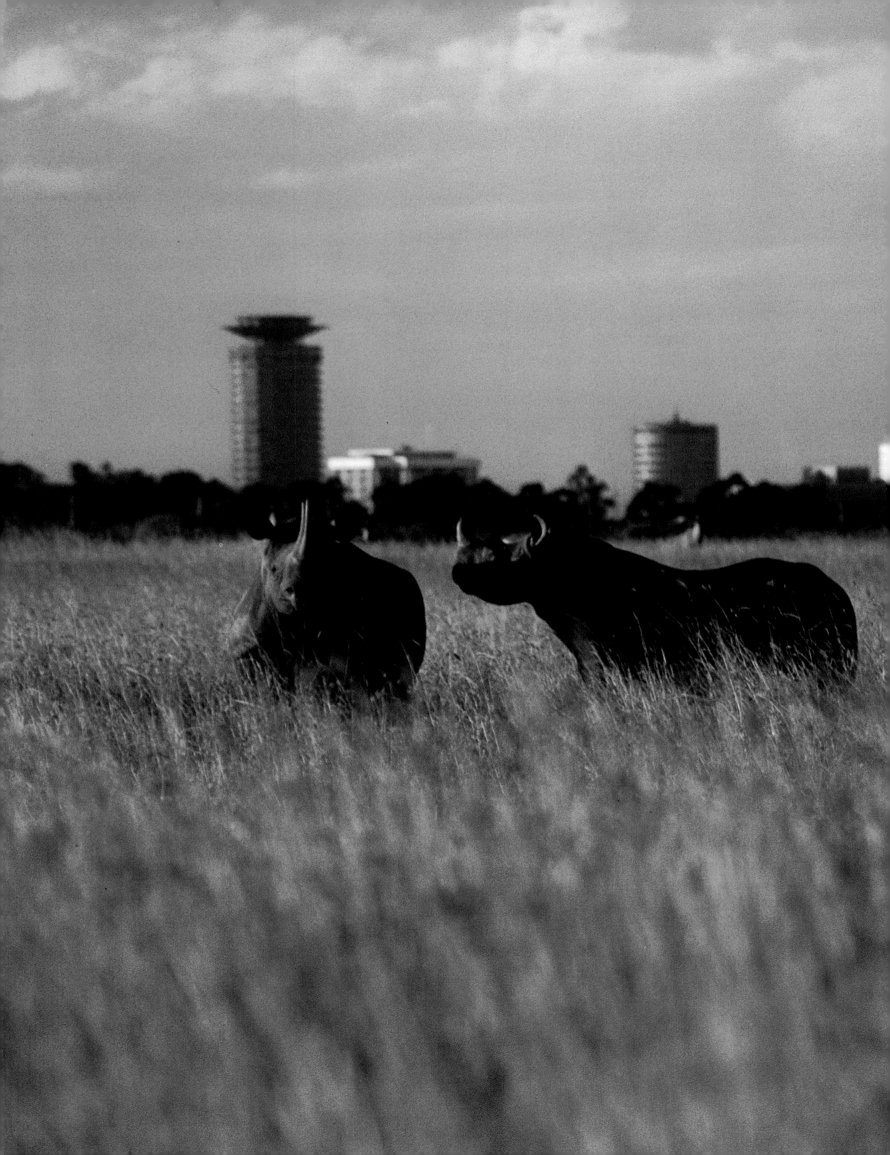

2 · Through The Great Rift Valley

It is that which lies on Nairobi's doorstep which makes the capital unique, and that which lies in the direction least taken which is the most fascinating.

For any who climb the knuckle-shaped ridges of the Ngong Hills, 30 kilometres south-west of the city, the view directly into the most dramatic portion of the Great Rift Valley is breath-taking. The Rift is a deeply indented scar in the earth's skin, clearly visible 150,000 kilometres out in space.

In Kenya and Tanzania the Rift is Leakey country. Seeking the origins of man, the family of fossil hunters has found profound clues to our beginning at sites excavated by the late Dr Louis Leakey and his widow, Dr Mary Leakey, and their son Richard.

The untidy, disordered landscape challenges most images so that whatever is painted or photographed or written about Kenya is never the whole. The writer Isak Dinesen's Kenya had 'no fat, and no luxuriance, distilled up through 6,000 feet . . . the strong and refined essence of a continent.' The feeling is captured on a ridge walk along the top of the Ngong Hills which have now been cleared of forest for smallholdings of five acres or less. In the middle of one of these stands a monument raised by Dinesen (whose real name was Karen Blixen) to her lover Dennis Fynch-Hatton. He died in an air crash near Voi in the 1930s. Untended and neglected, surrounded by maize, the obelisk is a sadness commemorating forgotten yesterdays.

Despite more recent cultivation by newly settled smallholders the Hills somehow remain much as they did when the authoress ran a coffee farm at the foot of them, the west slopes plunging sheer into the Rift.

It is down one of these walls, for those who choose to journey on, that the road makes a hairpin descent to Olorgasailie which lies 65 kilometres from Nairobi. With a small museum and exhibits *in situ*, it is well laid out for visitors to study the Stone Age cultures of 200,000 years ago. The site, excavated by Dr Leakey and his wife in the 1940s, was first discovered by the man who named the Great Rift Valley in 1893, the geologist John Walter Gregory.

Lake Magadi's trona deposits 45 kilometres beyond are the world's second largest source after Salton Sea in California. The deposits regenerate as fast as they are dredged out and pumped to the factory around which a neat little town, complete with golf course, has been built. The town presents an odd contrast to the wilderness and the lake, where water birds proliferate even close to the factory.

Right: On the marble-white surface of Lake Magadi a dredger digs out trona deposits which are pumped through the pipeline (seen on the surface) to a land-based factory. There the trona is processed into soda ash used in the manufacture of glass.

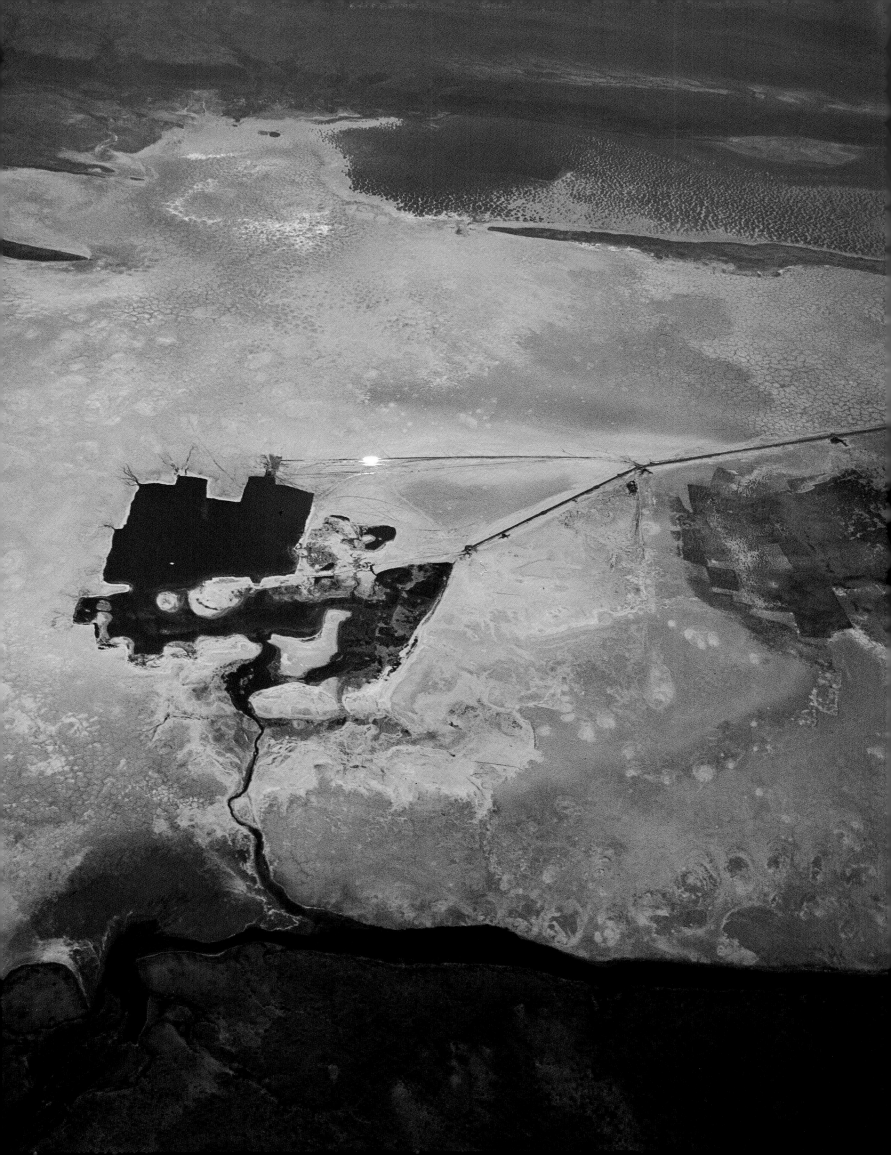

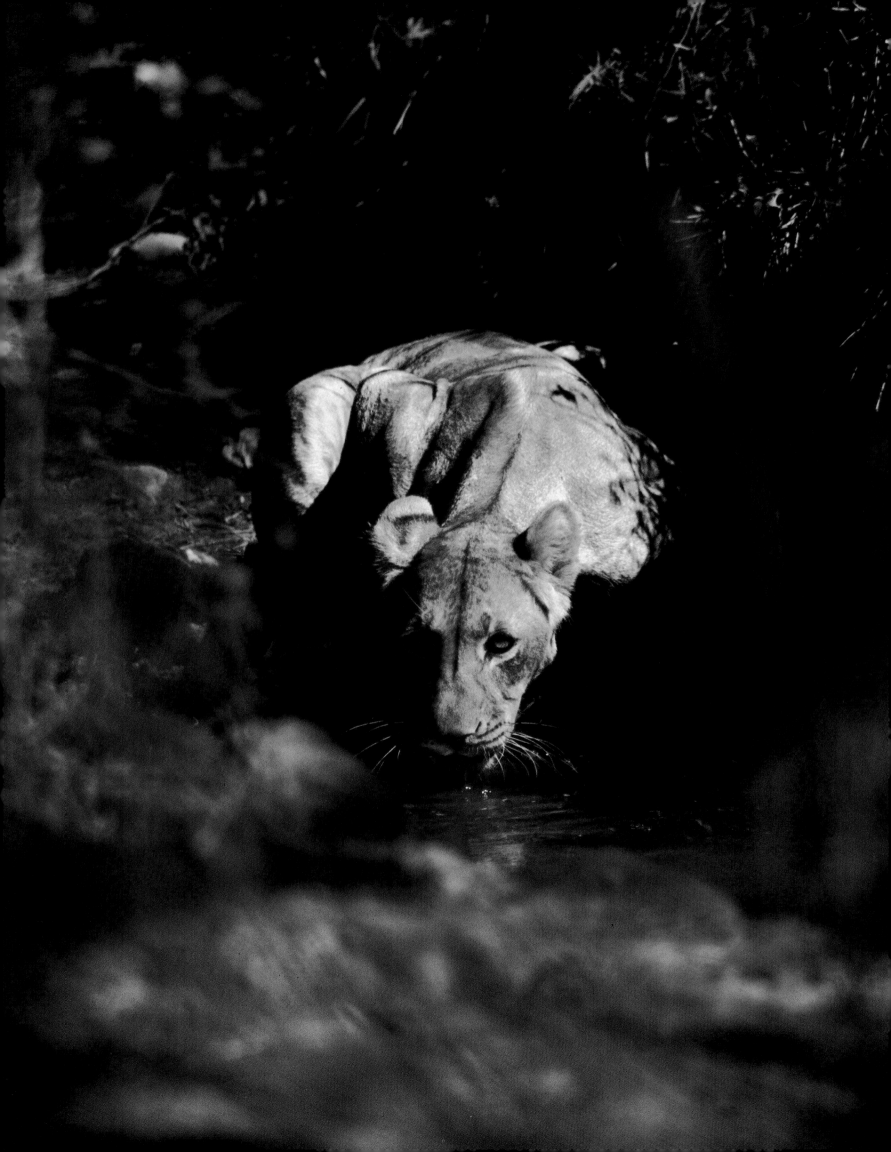

Opposite: Crouching on haunches in the dappled shade of a forest glade, a magnificent lioness takes water—her sleek body vibrant with alert watchfulness.

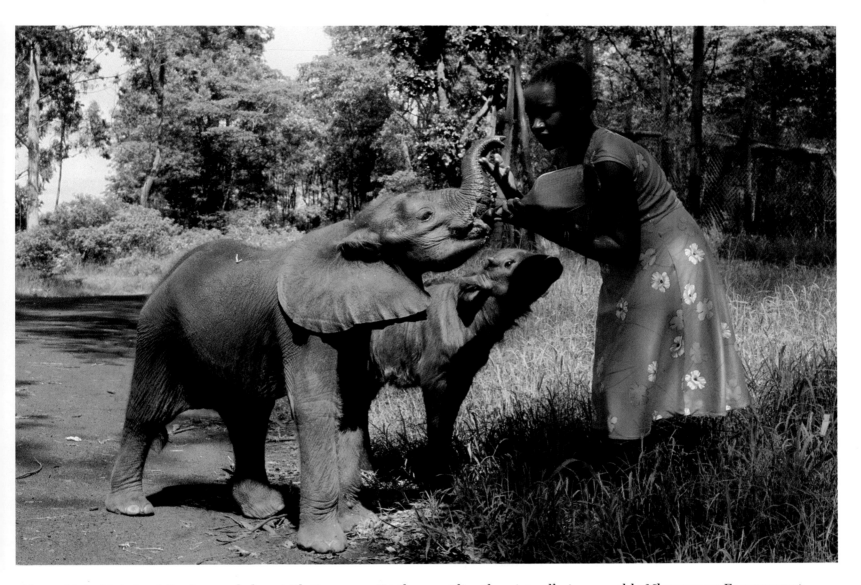

Above: Nairobi Animal Orphanage helper with tiny Juma, a young elephant separated from its mother on the Laikipia Plains during a game-moving exercise. Juma was raised by wildlife expert Daphne Sheldrick, authoress of Orphans of Tsavo. *The elephant was fed on a special baby's milk formula in the hope that he would be the first infant of his kind to survive under human care. Sadly he died during the critical days of weaning to a solid diet.*

To the west lies the virtually impassable Nkuruman Escarpment, only reached by a winding and difficult foot safari with pack animals, or by four-wheel drive vehicle. For most, however, the journey ends once again back in Nairobi, past the Ngong Hills.

The range, says Maasai legend, was formed when a giant tripped over Kilimanjaro 240 kilometres away and clawed up a handful of earth. These hills, more than 8,000 feet high, form a scenic backdrop to the first of Kenya's national parks, Nairobi, established in 1946. Intended as a recreational area, its use as a wildlife sanctuary 10 kilometres from the centre of the Kenya capital, well within the periphery of its multiplying suburbs, soon became mandatory.

The Park's most attractive feature is the Animal Orphanage, where lame and lost beasts are brought for rest and recovery from all over Kenya. A notice states that it is not a zoo though it does shelter gifts to Kenya's head of state—non-indigenous animals which would not be able to survive without protection.

The Orphanage's principle character is Sebastian, a chimpanzee noted for his addiction to chain-smoking, and his bad temper when refused tobacco. In his younger days he would break out in search of nicotine. Another inmate was a baby elephant, Juma. Raised on a special brand of baby's milk, Juma celebrated his first birthday in October 1980, becoming the first wild orphan elephant to survive a year when reared by human foster parents, but died soon after.

Many of the wild animals now in Nairobi Park and other Kenyan sanctuaries were restored to health or raised to maturity in the Orphanage. It is not to be confused with *Orphans of Tsavo*, a collection of infant animals raised under the care of Daphne Sheldrick, widow of the late warden of Tsavo East.

Inevitably Nairobi's continuing growth will make Nairobi Park an even greater asset by the turn of the century. No other city can claim such an Elysian ideal so close to the clatter of its industrial heart—the Park's northern fence is less than 200 metres from the Firestone factory and the Kenya assembly plant of General Motors.

At its eastern perimeter the Park abuts on the industrial town of Athi River. On one side only is the Park truly open. Here the Kitenkela Conservation Area is a corridor between the Park and the surrounding plain which allows the natural migration of its occupants. There has been encroachment by Maasai pastoralists, but as yet there has been no settlement and the species which inhabit the 113-square-kilometre park—one hundred buffalo, all imported strays from the Orphanage and other areas, rhino, similarly imported, lion, cheetah, leopard, hippo, crocodile and more than another ninety species—have freedom to come and go across the unfenced sections of the Athi Plains on the other side of the Mbagathi River which forms a natural boundary. This stream, born in the Ngong Hills, eventually decants itself as one of Kenya's major rivers, the Sabaki, at Malindi more than 500 kilometres to the east.

The stream winds away from Nairobi Park to encircle the little-known Ol Doinyo Sapuk National Park, a mountain peak which can be seen rising out of the haze 50 kilometres from the end of the runway of Nairobi's Jomo Kenyatta International Airport. The forested head of the 7,041-foot peak is alive with game, particularly bushbuck, impala and buffalo. Its Kamba name, Kilimambogo, means 'Mountain of the Buffalo'. Hidden in the thick forest the animals are often difficult to see.

One of the most attractive features of the tiny 18.4-square-kilometre Park lies outside the entrance on the approach road where the Mbagathi River, now the Athi River, tumbles over fourteen individual falls—an undeniable spectacle during the heavy rains. Four kilometres further on, the Park itself begins with no charge for admission.

Halfway up the solitary Park road, hidden in the bush, lies another reminder of forgotten yesterdays, the graves of Sir Northrup and Lady MacMillan and their servant Louise Decker. These American pioneers

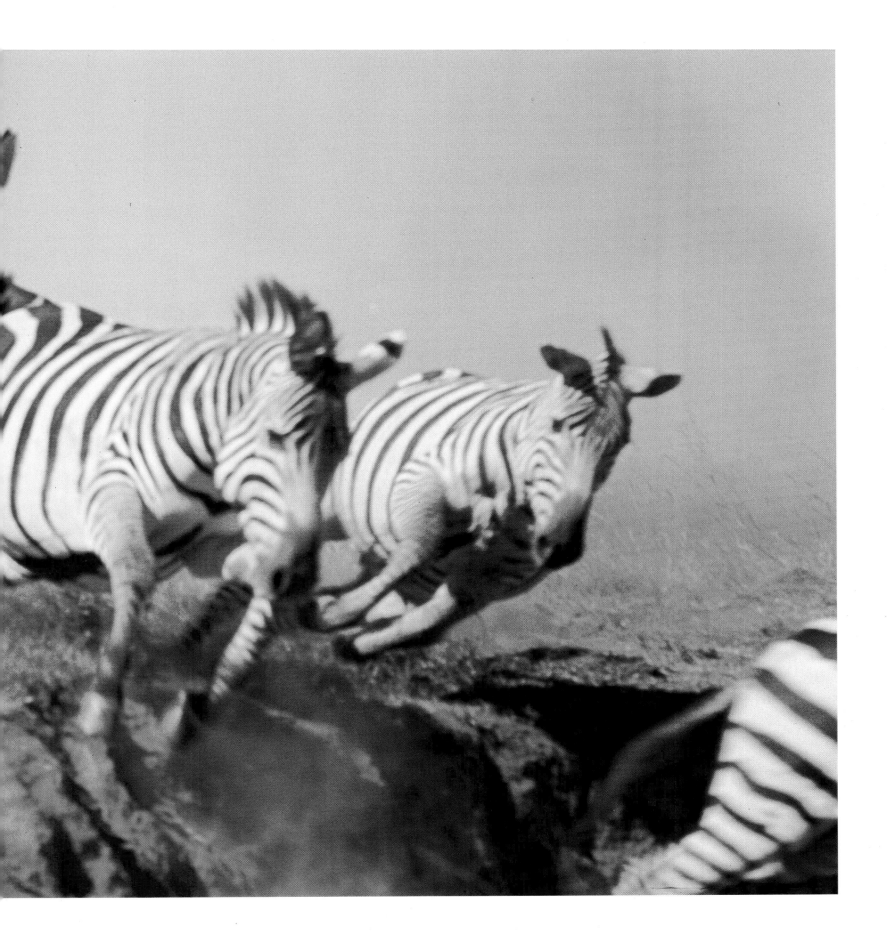

Below: Reedbuck are usually sighted singly or in pairs; herds are rare. These antelopes emit a sibilant whistle when alarmed.

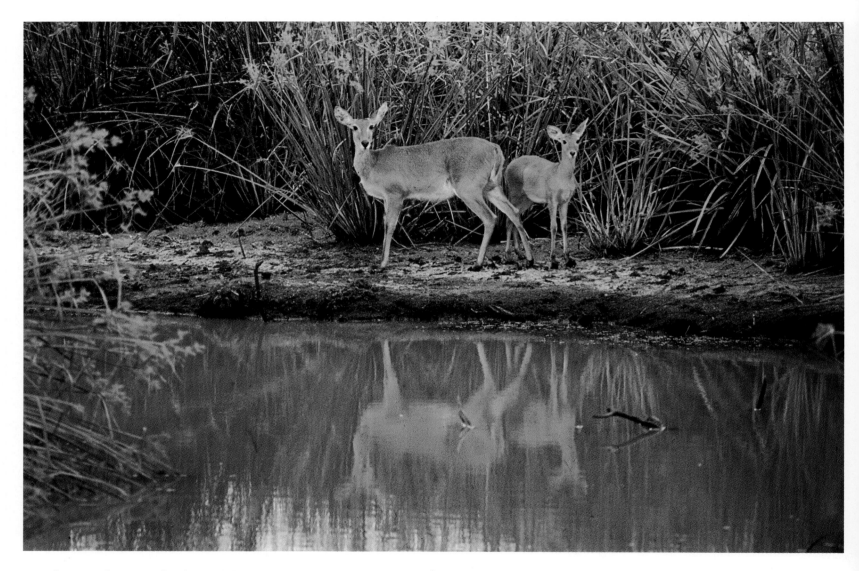

ran the Juja farm at the foot of the mountain. A better maintained monument to Sir Northrup stands in Nairobi—the MacMillan Library built by his widow.

Sir Northrup deserves to be remembered. An American, almost seven feet tall, he was so fat he had to walk sideways through most doors. He was knighted by the British. He was perhaps the first person in Africa to experiment with the domestication of wild game. He attempted to breed wildebeest on his Juja ranch, part of which is now a 25-hectare orange farm. Born in St. Louis, USA, Sir Northrup's sword belt from the First World War—he enlisted in the British ranks—gives some idea of his girth. It measured five feet four inches.

Below: Eland, the largest of all the Plains antelopes. Several attempts have been made to domesticate eland because their meat makes splendid venison. The descendants of one herd which was exported from Africa just before the turn of the century still graze on the steppes of the Ukraine. They are quite tame and some are milked regularly.

Overleaf: Spumes of water cascade over the picturesque Fourteen Falls on the Mbagathi River close to the foot of Ol Doinyo Sapuk National Park, a forested mountain some few kilometres down the road from the industrial town of Thika.

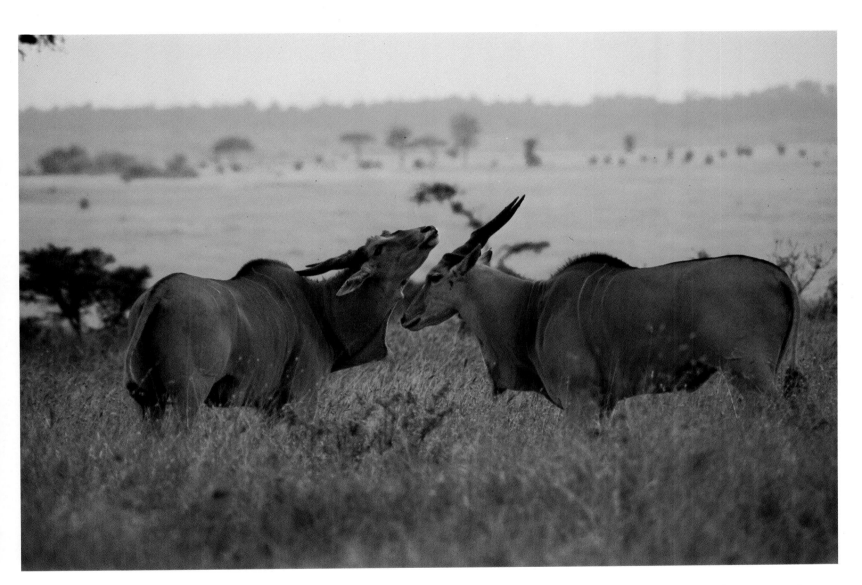

Sir Northrup made the Kilimambogo mountain-top his personal domain. While dispensing hospitality that became legendary, the 18 st. 5 lb. sportsman was toppling buffalo, with scant respect for conservation, from the back of a mule that, said the writer Elspeth Huxley, 'could barely be seen beneath him'.

The road back to Nairobi passes through the busy industrial centre of Thika where textile plants, canning factories and vehicle assembly plants operate twenty-four hours a day. Thika is also in the centre of Kenya's pineapple country. The world's third largest producer, most of Kenya's crop comes from the fertile volcanic soil of the large plantations to the north of the town. This land is better suited for these fruits than

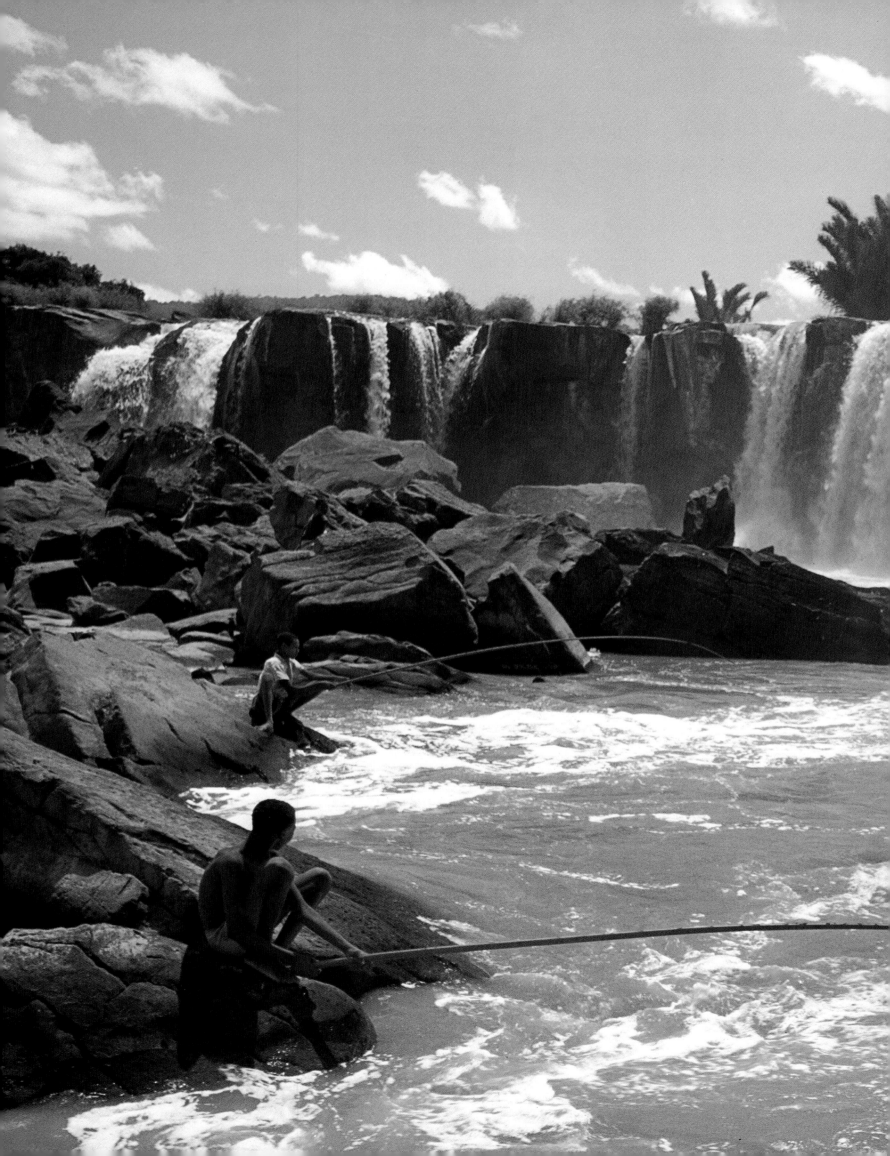

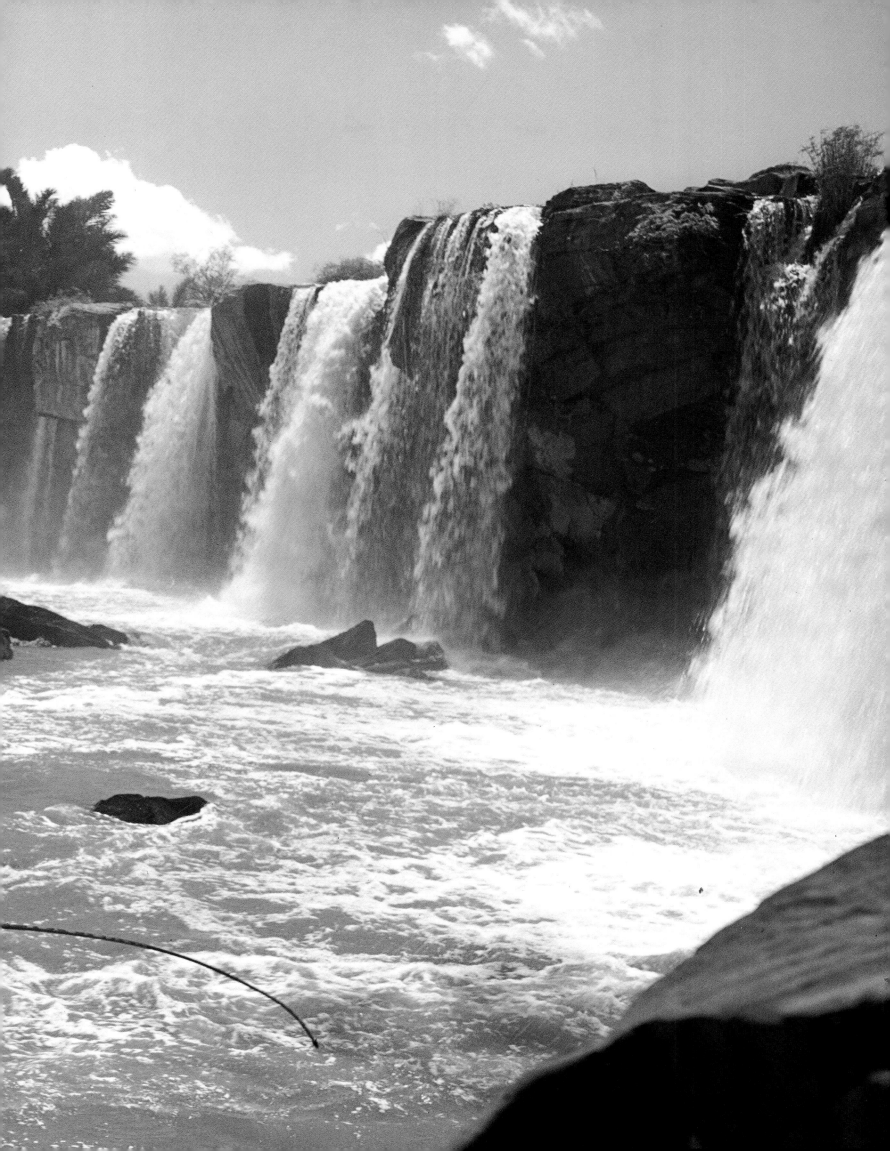

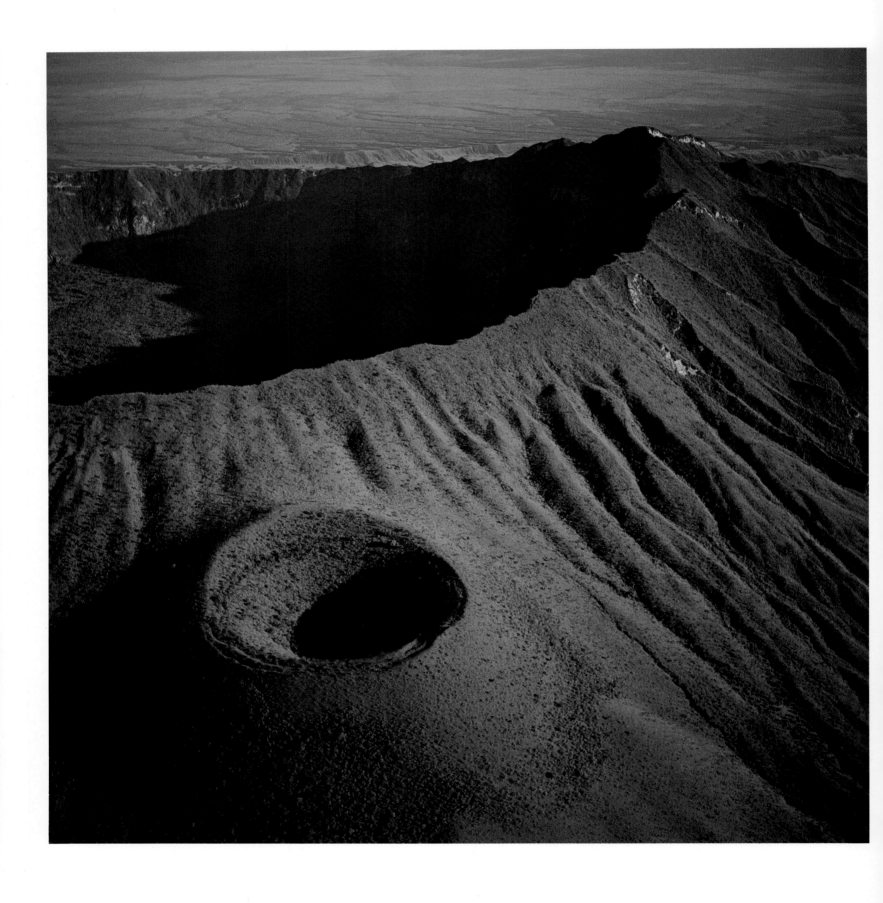

Opposite: Mount Longonot, 9,109 feet high, in Kenya's Great Rift Valley, is the dominant feature of the landscape between the Uplands Escarpment of the Rift Valley and Lake Naivasha. The volcano still gives evidence of life; none of the Rift volcanoes can be safely said to be extinct. Thermal springs at the base of Longonot are being harnessed to provide power for Kenya. A track winds around its precipitous, knife-edge rim and a parasitic crater is at left in the foreground.

for coffee. Not so many years ago Miss Huxley's father was tempted to buy what he was told was coffee-rich land at the inflationary price, for those times, of £4 an acre. Perhaps if he had planted pineapples he would not have lost his investment but that crop did not come into large-scale production until the 1940s.

It was at Thika, Miss Huxley reveals, that Winston Churchill shot a lion in 1908. This happened near a hotel called The Blue Posts, which still exists. At that time the hotel belonged to Harry Penton, steward during Nairobi's annual race week, who on one memorable occasion disappeared from the race track and was discovered naked on the roof of the Norfolk Hotel holding a tin bath over his head and shouting: 'I am a mushroom. I am a mushroom.' The Blue Posts still retains something of Penton's rustic and eccentric charm and remains a popular stopping place on the way home to Nairobi after a long upcountry safari.

Those who feel inclined, however, can turn towards the Limuru Uplands which lie 3,000 feet higher than Nairobi atop the great escarpment of the Rift. On the way the road passes through fertile coffee lands. Kenya coffee is regarded by connoisseurs as the world's finest arabica species; the main centre for its growth is Kiambu. Much higher up, the coffee gives way to the rich green of Kenya's original tea plantations and park-like pastures.

This is pleasant, high-altitude countryside, always cool. Much of Kenya's pyrethrum—the nation supplies 70 per cent of the world's total production of this non-toxic insecticide—is grown in this area because it flourishes at high altitudes. Until 1979, Limuru was the locality of a typical English eccentricity: the Limuru Hunt. Dressed in traditional shire regalia, the riders galloped off with the hounds in full cry, the shouts of 'Tally ho!' astonishing unsuspecting Kikuyu peasant farmers. But no fox darted through the trees and meadows—only two panting hunt servants dragging a lure of exotic aromas, selected guinea-pig droppings from mammals reared specially for just such occasions. When the hunt folded, the hounds were taken over by Ginger Bell, a former Mombasa butcher, and are now kennelled in Nakuru. Occasionally they return to their old Limuru hunting grounds as 'Ginger Bell's Hounds'.

In the past they often led the riders to the edge of the escarpment with its panoramic views across the Great Rift Valley, which extends 5,632 kilometres from the shores of the Red Sea in Ethiopia to Beira in Mozambique.

The Rift's perspectives are so large there are few scales by which to measure them, but the vertigo felt at the top of a city skyscraper is nothing compared with that felt at the edge of the 2,000-foot drop from the Uplands escarpment. The scarp falls sheer to the distant plains below which form the Valley floor and the 100-kilometre sweep of ranchland, volcano and wheatland to the far horizon where the matching escarpment wall, the blue-grey blur of the Mau Summit, rises up in the west.

Right: The central plateau of Susua Volcano rises 500 feet to 1,500 feet, like Conan Doyle's Lost World, *out of the centre of this Rift Valley crater. The deep moat between the volcano's outer wall and its inner plateau testifies to the tumult which created it and its sister volcano, Mount Longonot. In the background at left is the 12,816-foot massif of Kinangop in the Aberdare Mountains and, right, in the extreme distance, Mount Kenya's 17,058-foot-high Batian peak dominates the sky.*

From the Uplands a motorway follows the top of the escarpment to Naivasha with frequent picnic spots and parking bays. It is a route of incomparable beauty. At one viewing spot the clouds writhe and boil within the crater of the 9,109-foot Longonot volcano across the valley. If the viewing spot were another 450 feet higher the crater floor would be visible on clear days.

Longonot is one of the many volcanoes in the Kenya-Tanzania section of the Rift—a chain of sleeping fire which studs the valley floor all the way from distant Lake Turkana. In the 1920s an earthquake between Lake Baringo and Solai, at the foot of the Laikipia Escarpment beneath Nyahururu, split the earth's surface to a width of 6 feet, and there was a tumult of activity on the south shores of Turkana at the turn of the century. In 1966, at the other end of the system, the Maasai 'Mountain of God', Ol Doinyo Lengai, in Tanzania, erupted.

But volcanoes, even still smoking ones, have an appeal of their own and Longonot has well-trod paths to its rim, reached by turning off the old Rift Highway. Raddled with age, this tarmac was laid during the Second World War by Italian prisoners who built a little chapel at the foot of the Escarpment. Some kilometres beyond this, just before Longonot railway station, several footpaths lead up the volcano, a stiff 90-minute walk even for the fittest. But the spectacular views are worth the effort. The walk around the crater rim takes at least three hours.

Though ancient in years, Longonot is still active. Fumaroles are alive in the crater area and a few kilometres from its outer wall Kenya has harnessed underground steam wells to provide the nation's first geothermal electrical energy.

A sister volcano to Longonot is Susua, less than 50 kilometres from Nairobi in a direct line, and relatively unexplored until adventurers from Britain's Operation Drake expedition rigged a steel cable from its caldera to a central plateau above a 1,500-foot-deep 'moat'. The central plateau, with an extensive cave system, is a 'lost world' experience. Packs of baboons and other normally shy creatures display no fear at man's presence. Susua is in the Kedong Valley, some kilometres south of the tarmac road to Narok.

Between Longonot and the 15-kilometre diameter of Lake Naivasha lies Hell's Gate Gorge, with towering 600-foot cliffs frequented by birds of prey and popular with rock climbers, inhabited by an abundance of flora and fauna, rock hyrax and gazelles among them. Nearby are the hot springs and geysers which indicated the thermal energy potential now tapped with United Nations help.

Naivasha's clear waters provide irrigation for many vegetable and flower farms up above its shores on which more than four hundred species of birds—'a bewilderment of birds', one ornithologist called them—have been recorded. For some years, until the early 1950s, Naivasha was the Kenya stop on the London–South Africa flying boat air service.

The lake, a popular weekend resort for Nairobi residents, has several camp sites, hotels and marinas, all providing boating and fishing facilities despite frequent fluctuation in shoreline, depth and quantity. Naivasha continues to prosper as a holiday resort, fishing ground, bird

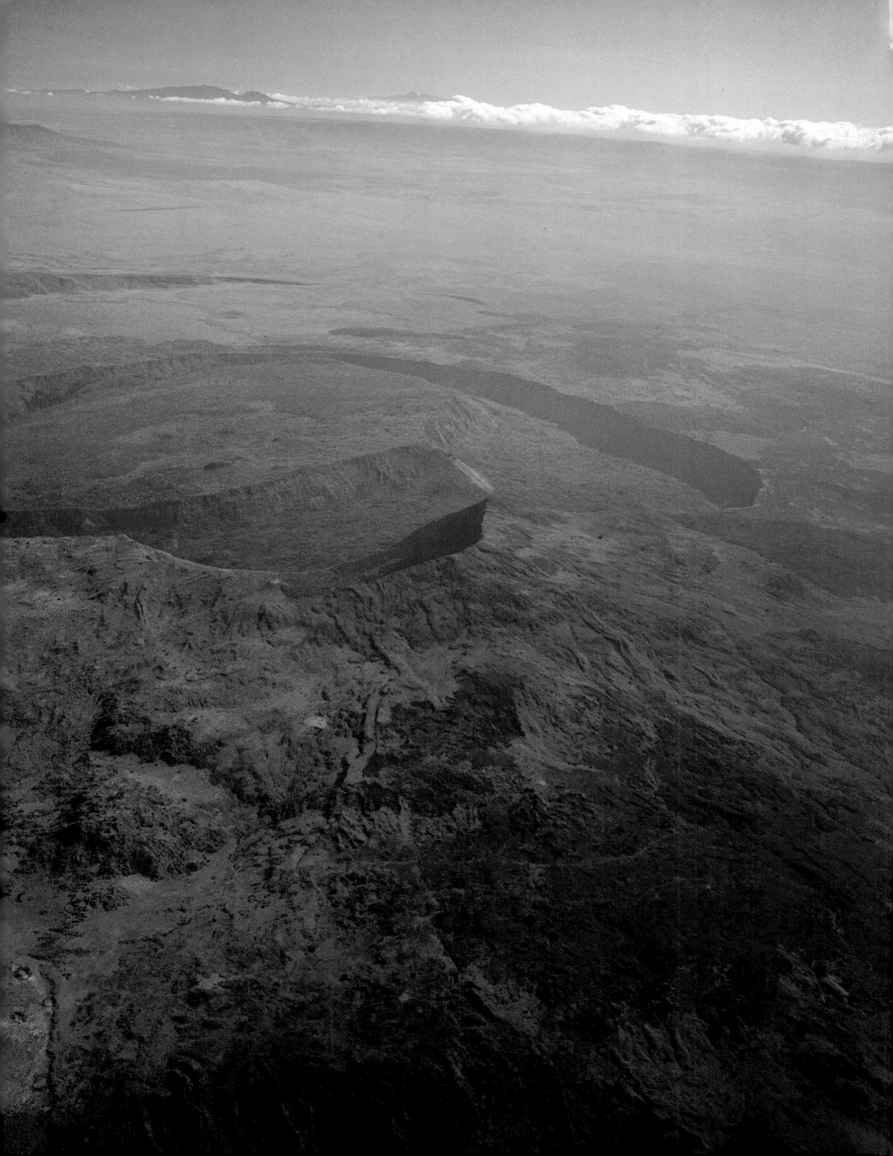

sanctuary, and as the Rift Valley's highest and purest fresh-water lake. A private game sanctuary, Crescent Island, is one feature of the lake which shelters in the shadow of 9,365-foot Ol Doinyo Opuru rising on its western shores.

The authoress of *Born Free*, and many other books, the late Joy Adamson, made her home amid acacia thorns, splendid lawns and colourful flower beds, enjoying the view of Opuru and also of the Kinangop, the southernmost shoulders of the Aberdare Mountains, to the east of Naivasha. The highest point of North and South Kinangop reaches to almost 13,000 feet. Below this, lies a stretch of fertile farmland which includes Sasumua Dam, one of the main sources of Nairobi's drinking water and an excellent spot for trout.

Naivasha has grown rapidly as an agro-industrial community with a multi-million dollar dried vegetable factory and the Sulmac flower farm as its main employers. Its existence began less than a century ago as a one-shed food-supply point for workers on the Uganda Railway.

Little proclaims the location as a central part of Maasailand. It was used by Joseph Thomson as a convalescence centre after he was gored by a buffalo. Five years later Count Samuel Teleki von Szek and his companion Lt. Ludwig von Hohnel also passed by the lake on their way to Lake Rudolf, now Lake Turkana.

On Naivasha's dusty plains, between Mount Margaret and Mount Longonot, the Maasai frequently attacked the early slave caravans. In fact, the large Maasai presence made the geologist John Walter Gregory fearful of dallying before these warlike people. In the 1890s he broke camp and went on for several days another 160 kilometres north to carve out the rock specimens by which he established that the Rift was one of the world's great wonders.

Arid ranchland divides Naivasha from Gilgil and another Rift soda lake, Elmentaita, episodically home to numbers of greater and lesser flamingos which vary their residence with stays in other Rift lakes, like Nakuru and Bogoria, which have alkaline qualities.

Near Elmentaita, on the edge of a small escarpment, is a diatomite mine and factory, producing filters from these ancient deposits, close to another prehistoric site excavated by the indefatigable Dr Leakey — Kariandus, with its relics of Stone Age hunters. There are other important sites of early man near the lake. Elmentaita has significance in modern history, too, as the estate of the first Lord Delamere to settle in Africa, the third Baron who was born Hugh Cholmondeley, who dedicated his foresight and his British fortune to develop Kenya's farm potential into one of the most efficient and prosperous in Africa.

H. Rider Haggard, the story-teller, fancied the path past the lake was the road to *King Solomon's Mines*, the title of that classic adventure which Kenya inspired him to write. In truth there was an old caravan trail from Naivasha to Gilgil used by Arab traders to haul out a wealth of ivory — close enough to the truth to justify the author's literary licence.

Another historic location is Mbaruk: a century ago the Maasai eliminated an entire slave caravan at this spot which is now the Elmentaita entrance to Nakuru National Park. Last of this close trio of Rift lakes is Nakuru. Nakuru is also the farming capital of Kenya

Opposite: Rock climbers on the 1,000-foot-high cliffs in Hell's Gate, a gorge near Lake Naivasha and Mount Longonot.

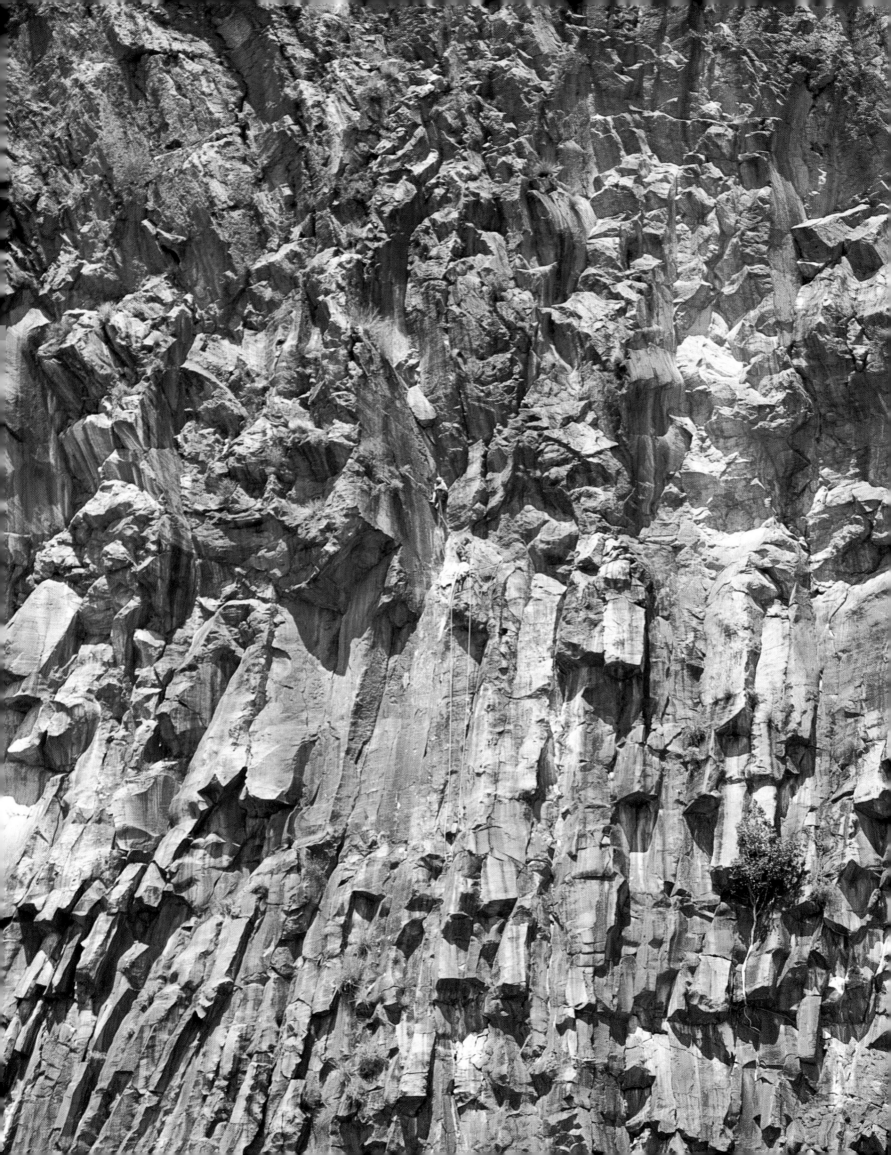

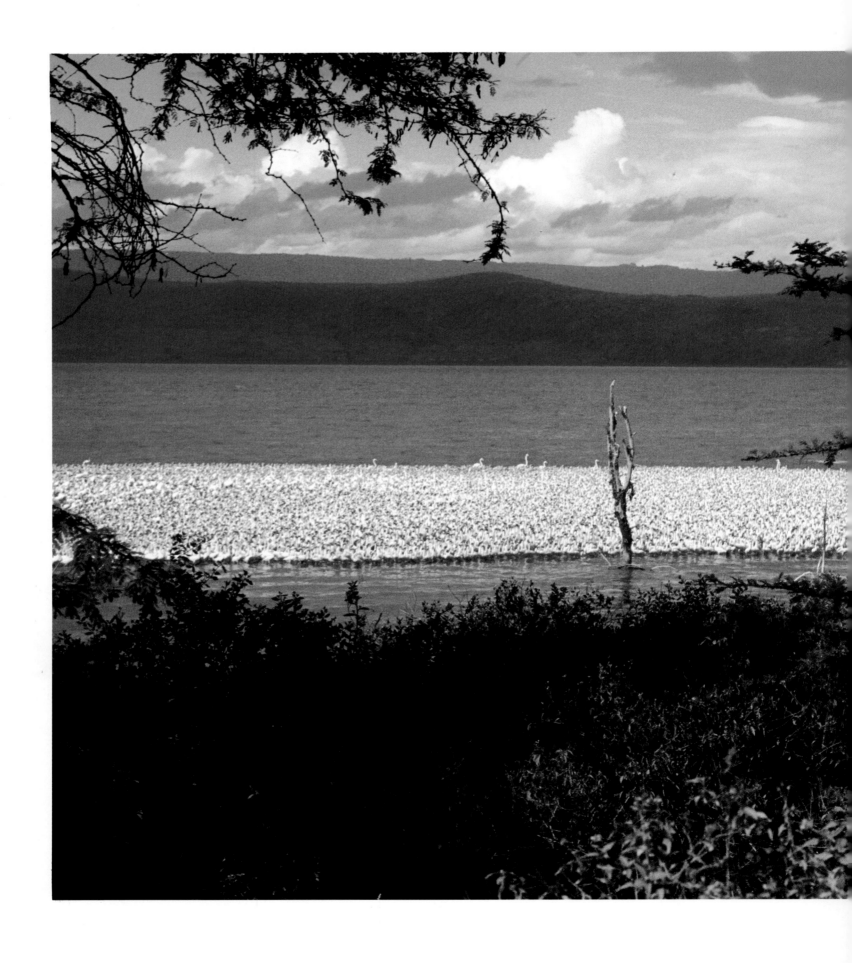

Below: Thousands of flamingos merge into a delicate pink mass against the green blue waters of Lake Nakuru. Famed for its flamingo spectacle, the lake almost dried up in the late 1940s and early 1950s. By the early 1980s the flamingos had once again deserted the lake in preference for its remote sister, Lake Bogoria, across the other side of Menengai Crater.

Below: Still waters radiate the reflections of a flock of great white pelicans as they wade near tall reeds in the waters of Lake Nakuru, which is famed as an ornithological paradise. More than 264 bird species have been identified here.

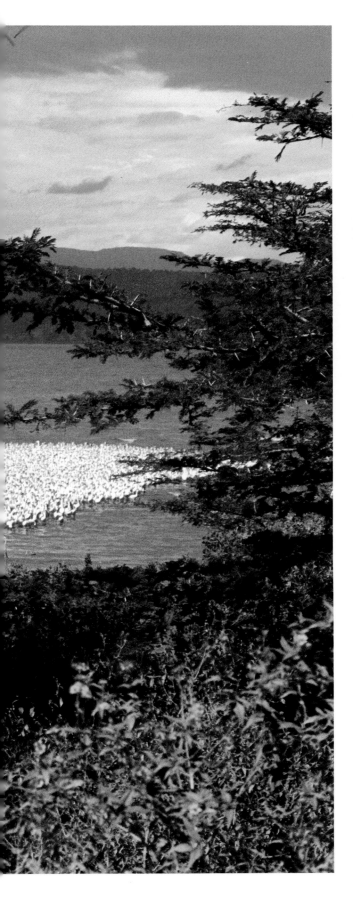

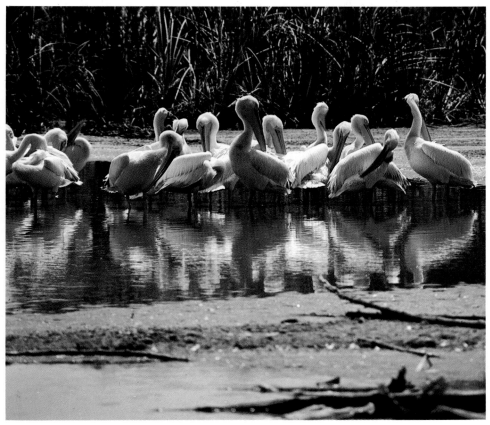

around which has developed a thriving town, the fourth largest in Kenya, with a population of more than 92,000.

Nakuru was once famed as the bird spectacle of the world. More than a million flamingo flaunted their delicate pink dance on its algae-rich waters during the 1960s and the early 1970s. However pollution, caused by farm fertilizers and chemicals introduced into the lake by rain and river runoff, has driven the colourful birds away. The birds earned Nakuru its right to be a National Park and though it still remains something of an avian spectacle it does so on a lesser scale. It is an animal spectacle too, though, with hippo, rhino, buffalo and fifty other species of mammals.

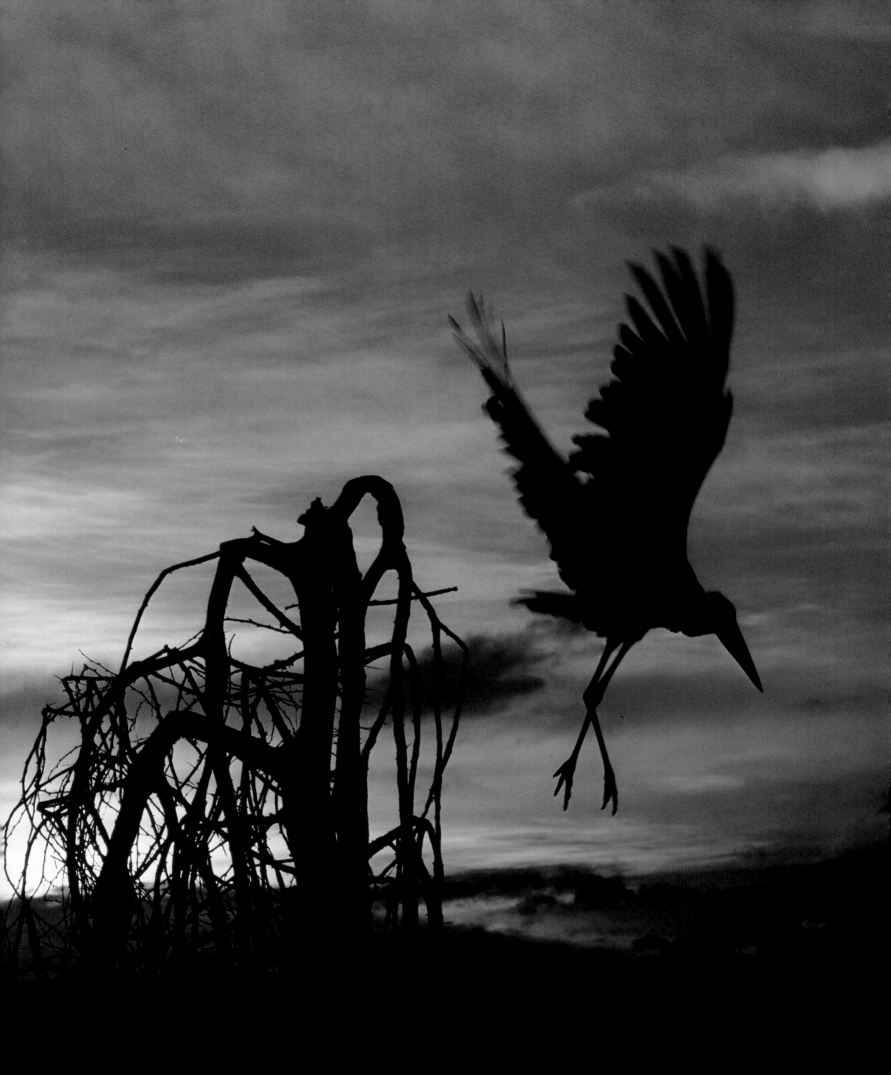

Opposite: Sundown at Lake Naivasha as the fading rays of the sun silhouette a marabou stork. Marabou are the most common, and ugliest, of the stork community in Kenya and are found in great numbers scavenging at rubbish tips in most towns and villages.

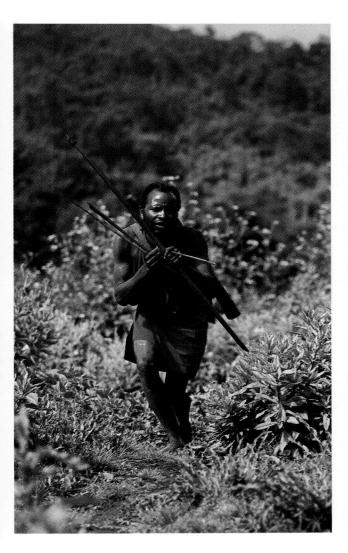

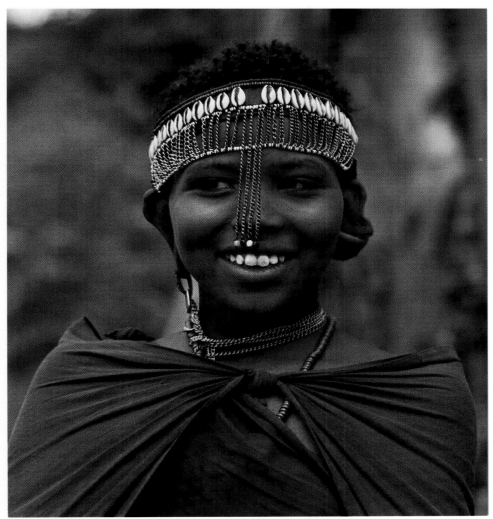

Above: Okiek hunter, on the high Mau Summit of Kenya's central highlands, stalks prey in clearing in lush forest as his ancestors did before him.

Right: A member of the Okiek group of hunter-gatherers, sometimes regarded as one of Kenya's Ndorobo tribes. The Okiek have at least 20 clans, each with different names, on the Mau Escarpment alone. The 21,000-strong people live by hunting and gathering honey in their forest homeland.

Overleaf: Bok women sip traditional beer through supple, hollow reeds during the tribe's circumcision ceremony. The potent drink—fermented from millet and other cereals—is brewed in containers set underground.

Above the lake rises the green wall of a large volcanic crater, the 89 square kilometres of Menengai. The view of the sudden plunge from the rim to the Rift floor is startling. By legend the rim is the site of an ancient battle between two Maasai clans. Locals still believe the soughing of the wind through the pipes and ravines of Menengai's caldera are the cries of the lost souls felled in the battle.

Hyrax Hill, another of the late Dr Leakey's prehistoric sites, stands on the east slopes. To the north, on the lower slopes of the crater wall, is a land rich with coffee and grain, a world of disciplined beauty before the ravaged disorder of the Rift.

Far away, the waters of Lake Bogoria, formerly named Hannington after a European bishop, gleam in the afternoon sun. Haven for the millions of flamingos which used to display themselves at Nakuru, this lake is at its best when the pale blush of early dawn colours the steam jets of spouting hot water which form thick mists on its west shores.

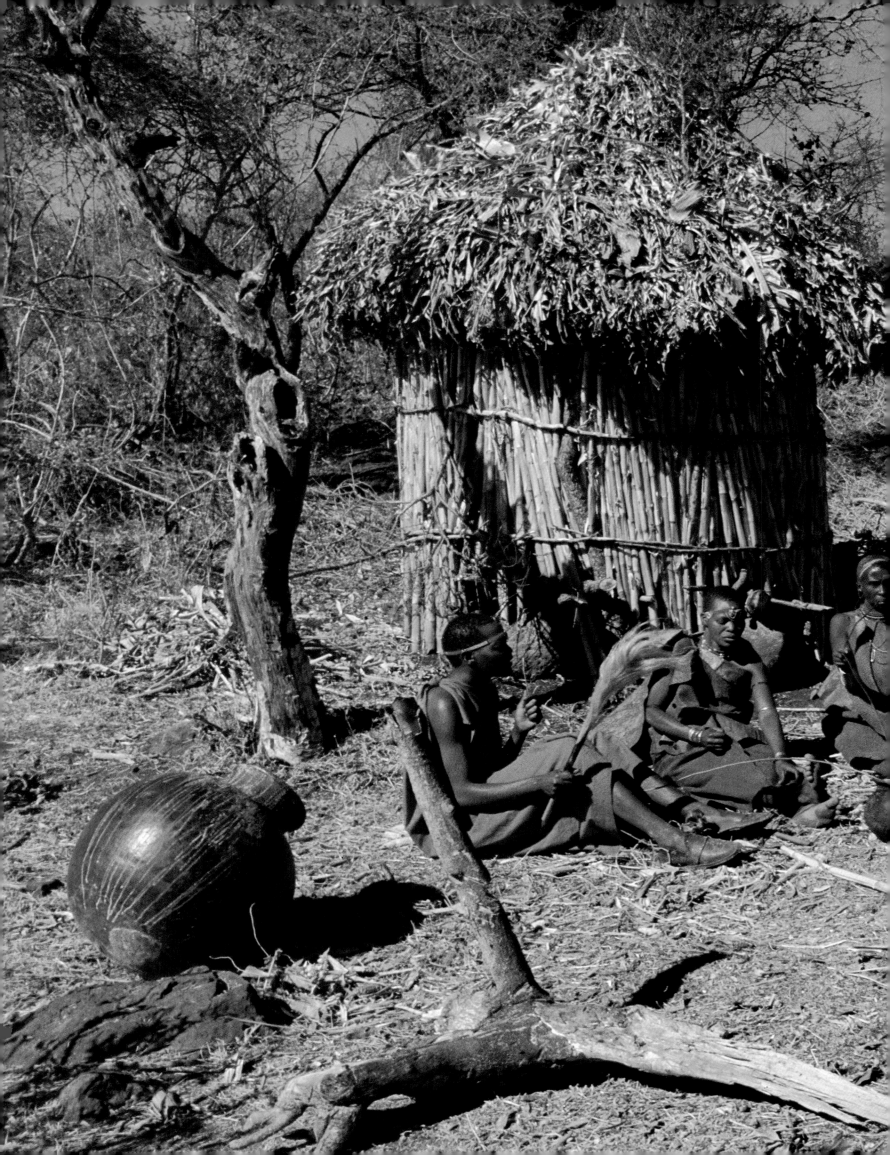

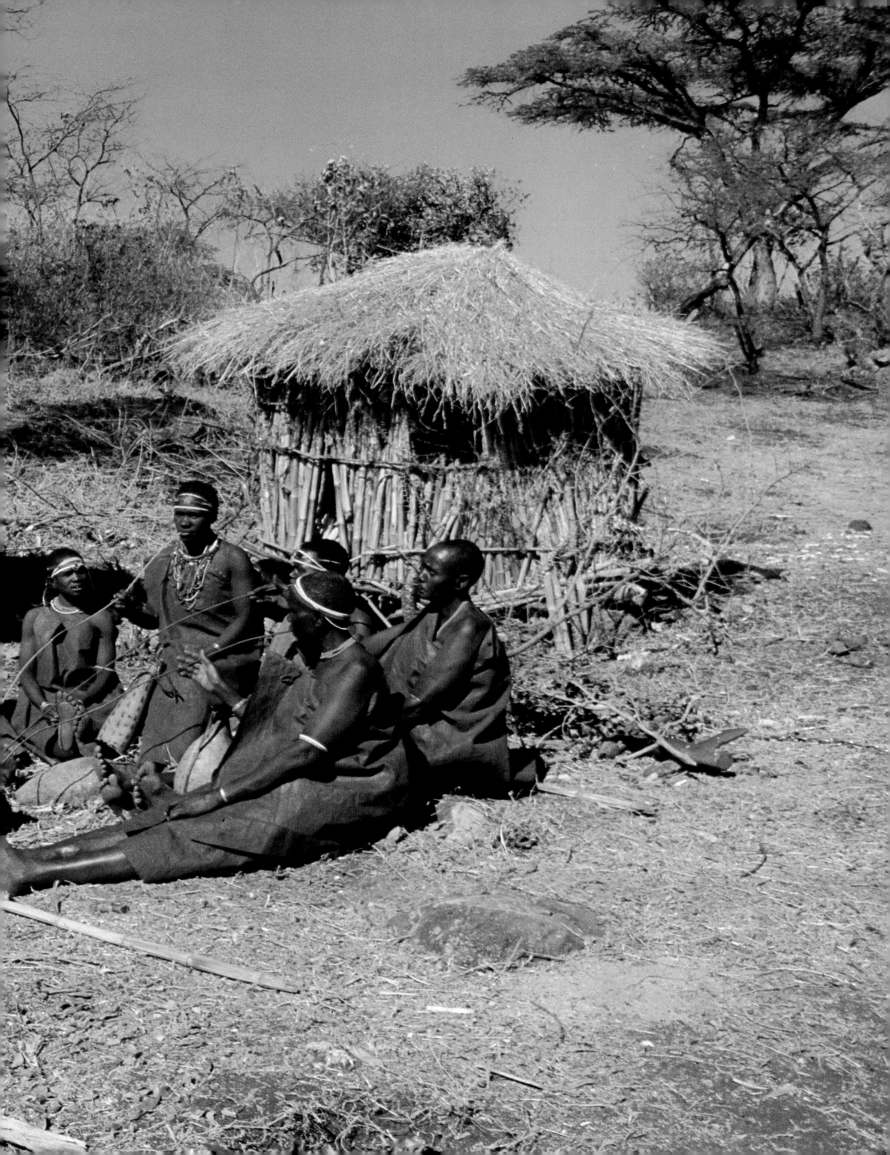

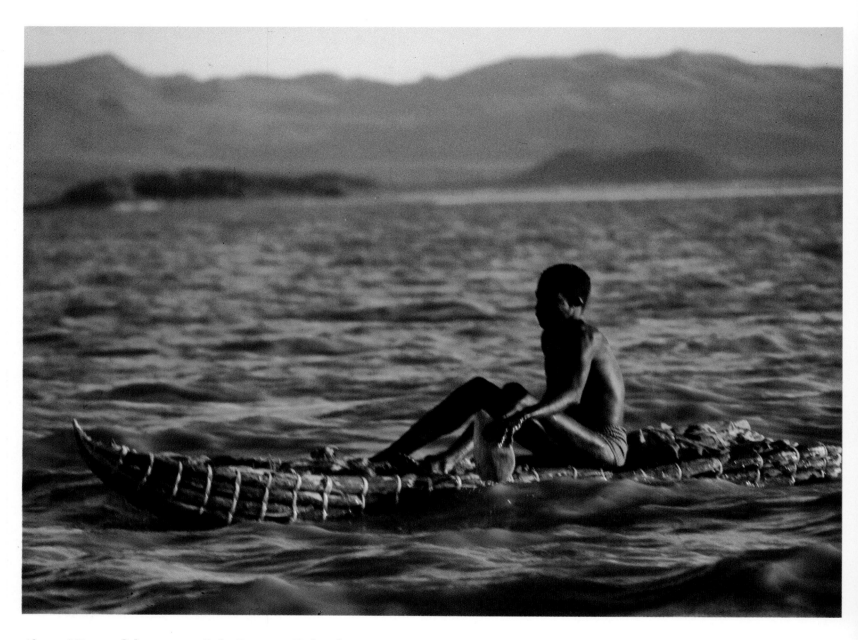

Above: Njemps fisherman on Lake Baringo. Related to the Maasai, the tribe have abandoned pastoralism for fishing, a strange contradiction of the nomadic life-style from which they spring. Their boats, similar in appearance to the coracles used by European fishermen thousands of years ago, are made from the wood of the ambatch tree, a lightweight timber similar in its properties to balsa wood. The craft is bound together with a natural fibre, sansevieria.

Overleaf: In silhouette, a jackal stalks a bird on a high shoulder of rock rising out of Kenya's savannah country. A scavenger, the jackal also kills for food. It is similar in appearance, and in cunning, to the European fox.

Bogoria's wildlife includes zebra, klipspringer, Grant's gazelle and Chandler's mountain reedbuck, and the rare greater kudu.

An area of some 100 square kilometres around the lake was proclaimed a National Reserve in 1973. The larger, cooler Lake Baringo, an hour's drive from Lake Bogoria, is one of Kenya's more remote and secluded retreats for jaded city-dwellers. A luxury tented camp on the large island in the middle of the lake is an excellent spot to watch a group of people called the Njemps, cousins of the Maasai, practise their ages-old way of fishing.

Swimming and water-skiing are popular despite the presence of crocodile which are said never to have attacked a human being because they feed on fish—a theory disproved in December 1981 when a maneater was shot. Two old forts on the lake shores, remnants of British military posts during the First World War, have become historic monuments. Another shore-based attraction is watching snakes being milked for venom at Jonathan Leakey's snake farm.

To the west lies the southern end of the magnificent Elgeyo Escarpment and a fascinating road climbing up its precipitous slopes through Marigat and Kabarnet to the fertile Uasin Gishu farmlands at the top. The capital of this region is Eldoret which has rapidly become a major industrial centre with a large wool-making industry and other factories. Historic Eldama Ravine, scene of an epic fight by the Nandi against imperialist forces near the turn of the century, is also near Baringo—and across the Equator, at Timboroa, is Kenya's highest main road at 9,500 feet.

The people who occupy this area, and the Highlands west of Lake Victoria and around Kericho and Eldoret, are among Kenya's proudest. Bravery is the most time-honoured cultural attribute of the Kalenjin; social courtesy is another. The warring spirit which made them formidable adversaries has more recently been applied with success in the sports field. Kenya's world-ranking athletes, in the main, derive from the Kalenjin and their high-altitude environments. Men with names that speak of their ancestry, Kipchoge Keino, Ben Jipcho, Julius Sang, Amos Biwott, and four-times world-record-holder Henry Rono, have written their names indelibly into track history. The Kalenjin have also provided Kenyans with their President, Daniel arap Moi, who is a member of the Tugen tribe.

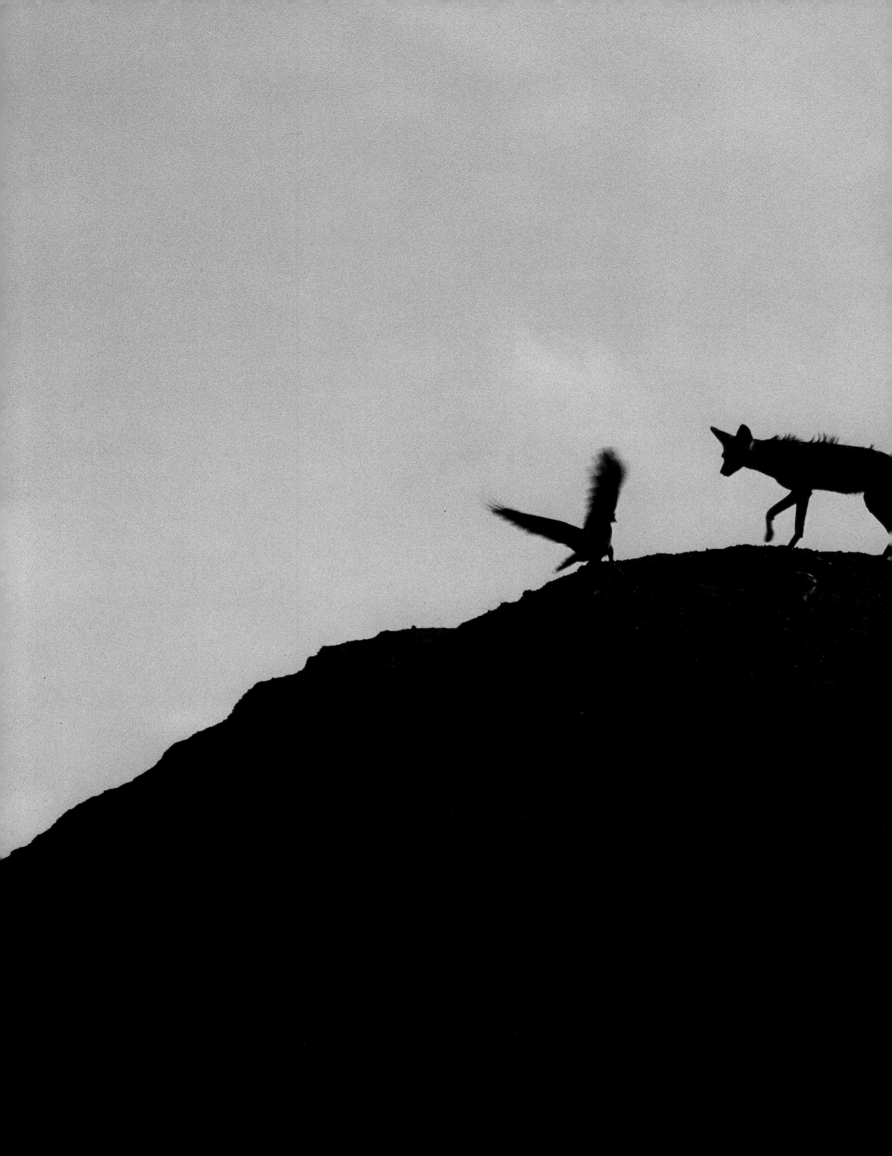

Amongst Kenya's game reserves, the Maasai Mara stands alone—and in more senses than one. In the far south-west of the country, well removed from any other game destination, it offers visitors the unique spectacle of nature's greatest, longest-running, continuous show—the annual migration of millions of wildebeest from Tanzania's Serengeti Plains to the Mara grasslands.

The 270-kilometre journey from Nairobi to Narok and across the south Ewaso Ngiro River leaves the high plateau of the Mau Escarpment on the north, shredding clouds against the deep blue of a late afternoon sky. This is Kenya's granary—the rich slopes of the 10,165-foot summit and the Loita Plains, which stretch beneath its southern slopes, have been converted into barley and wheatlands tended by Maasai pastoralists turned cash-crop farmers. The small town of Narok, at the foot of the Mau, is the grain capital of Kenya and developing fast. Beyond Narok, the grey, insidious dust of Maasailand enters every cranny, pervasive, yet acting only as a stimulant and not an irritant to adventure.

The sun's fading rays fall on plains teeming with herds of antelope and zebra. Thomson's gazelle twitch and stare and bound in desperate antics across the front of the car. Giraffe, stooping to drink from pools of water in the road, lope off in a display of slow kinetics.

Man's intrusive hand has wrought little change. The roads are no more than the game trails from which they have been carved. Out on the plains, the wildebeest wheel and turn in explosions of panic; a jitterbug of mindless fear. Yet each year some wisdom motivates them; an intuition as old as time tells them when to follow the rains.

In the first half of the year they graze in the far south of the Serengeti, hundreds of kilometres from Kenya. Then one day they raise their grotesque heads, sniff the air and pause. The time has arrived. Within days, millions will be on the march, cows calving on the way, predator and scavenger waiting to feed on the lame and the laggard and the strays which cannot keep pace. By August and September their millions darken the golden Mara and then, once again, as if activated by some flawless time-switch, they turn and head back seeking new pastures, a phalanx as mindless as the lemming.

Two lodges and several tented camps offer luxurious bases from which to see this spectacle—or simply to enjoy virtually all the species of Kenya's wildlife which flourish within the Mara's protective ambit. Both lodges offer early morning balloon game rides which end with a champagne breakfast on landing. The silent, stealthy passage of the balloon and its shadow fail to disturb the game below and a 90-minute flight across the Mara early in the morning is one of life's memorable experiences.

The Kenya shore of Lake Victoria lies north-west of the Mara and the mountains which loom over the dirt road signposted Homa Bay are the Gwasi and Gembe Hills. Rising to 7,450 feet, they cast a natural barrier around the Lambwe Valley Game Reserve and separate it from the lake. Lambwe Valley's 308 square kilometres are an idyllic reserve. But they make a perfect breeding ground for the tsetse fly—and tsetse fever is fatal to man and to man's herds. Because of this the roan antelope, Jackson's hartebeest, and the oribi, have found sanctuary rare in

Opposite: The leopard, most menacing and sinister of Kenya's feline predators, is rarely seen, being a nocturnal and solitary animal. One of its favourite tit-bits is the tortoise.

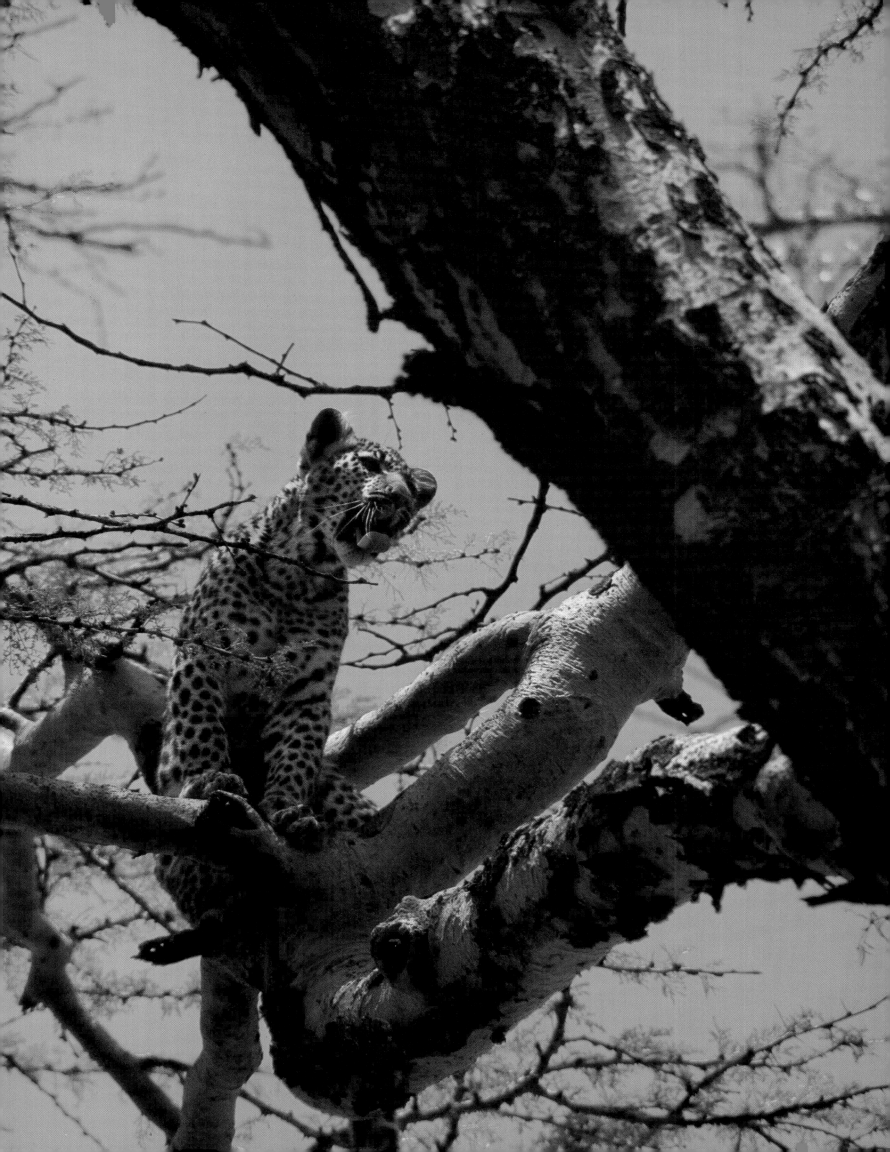

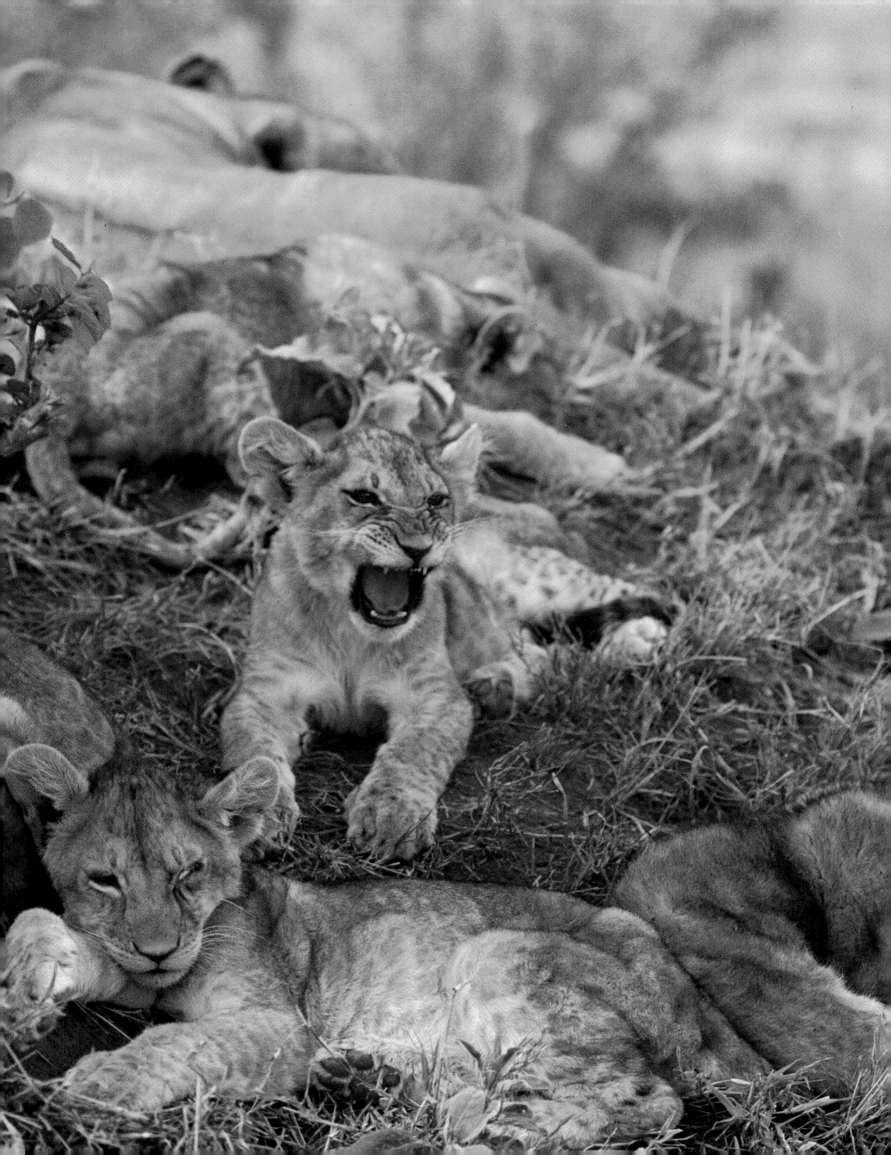

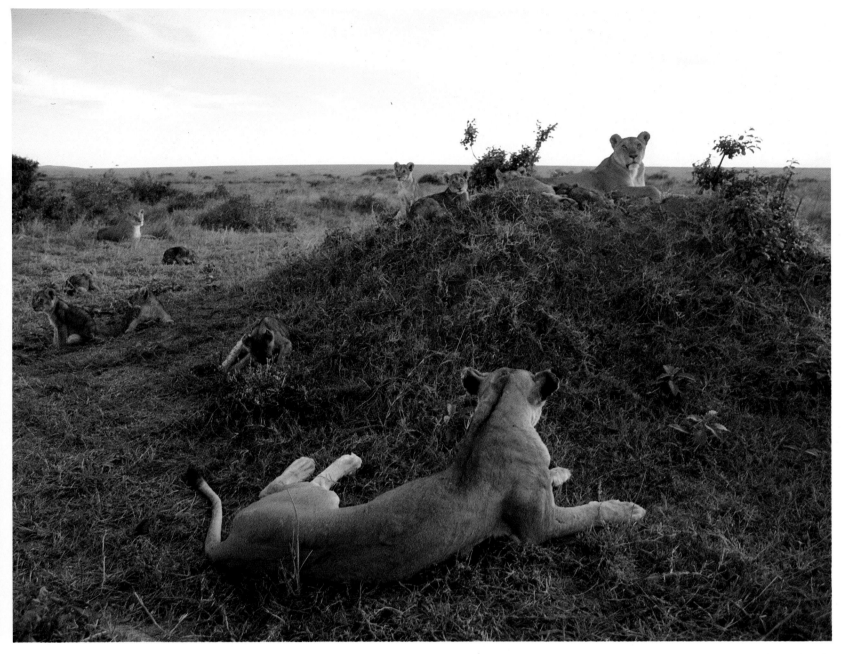

Opposite and above: Lion cubs on the rolling grasslands of the Maasai Mara in south-western Kenya. The Mara, an extension of the famous Serengeti National Park across the border in Tanzania, is one of Kenya's least spoilt animal sanctuaries.

Right: Zoologists point out that lions are remarkable lovers. Mating pairs will disappear from the rest of the pride for days and indulge in nothing but love play, often copulating as much as forty times in a single day. A zoo pair in Germany were recorded as mating 360 times in one week. The act itself can hardly be exhausting—it never lasts more than ten seconds.

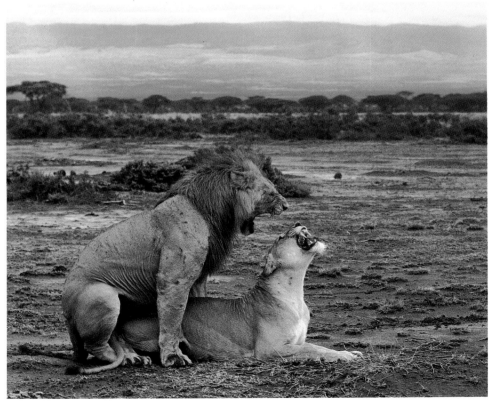

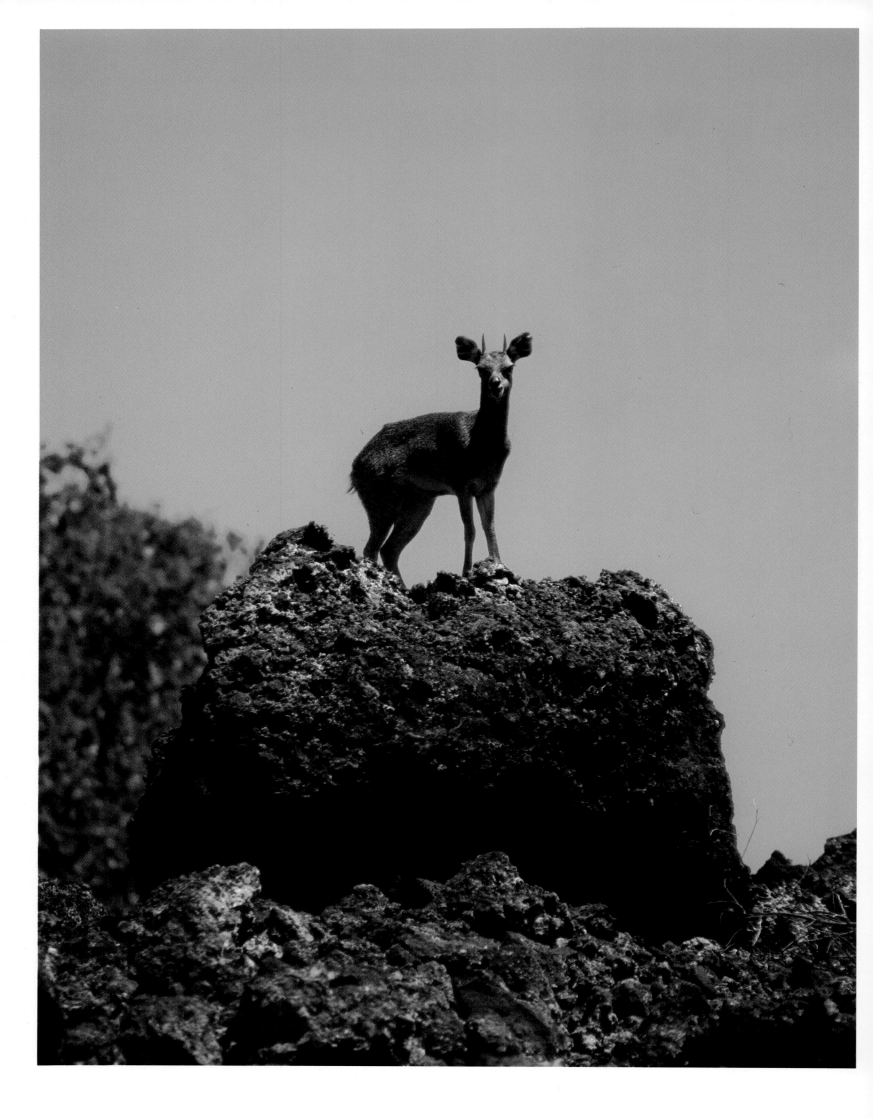

Opposite: Klipspringer are rarely seen and then only in a rocky gorge or valley. Extremely agile, this shy and nervous antelope is unique. Its feet are specially adapted to cope with the rocky habitat in which it prefers to live. Klipspringer are normally found in pairs. Both sexes carry horns, none more than five inches long.

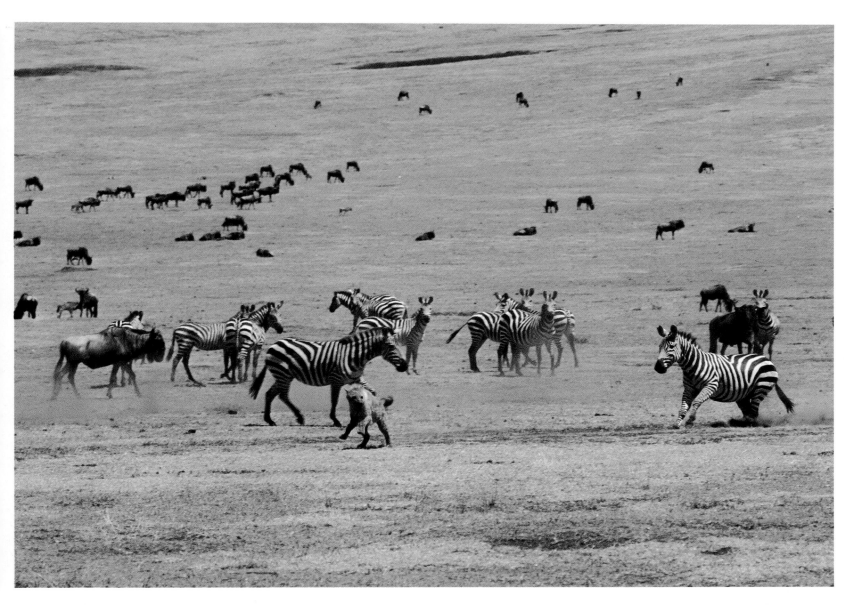

Above: Large herds of zebra join the annual migration of plains game—mainly wildebeest—from Serengeti into Kenya's Maasai Mara reserve. Predators and scavengers, including the hyena, follow—waiting for the sick, the lame and the young to fall out, ever-fearful of the retaliation of an angry, watchful mother.

Kenya, oppressed only by the leopard, but free from the dangers of human and other predators.

On the lakeside, a chain ferry links the mainland with Rusinga Island, birthplace and burial ground of Tom Mboya, one of Kenya's most outstanding politicians and statesmen. Rusinga has long been renowned for its 17-million-year-old fossil remains. To the south lies the tiny Ilemba Island where a profusion of bird life, including sun birds, finds easy living on the abundant growth of aloes.

Three national borders divide Lake Victoria. Its 63,000 square kilometres make it Africa's largest lake and the second largest body of fresh water in the world. Kenyan rivers provide two-thirds of Victoria's water, but Kenya has claim to only one tenth of its area; the rest is split between Uganda and Tanzania.

Interest centres not just on the lake's fish and marine life, including the few remaining crocodiles; Kenya's waterways within the lake are

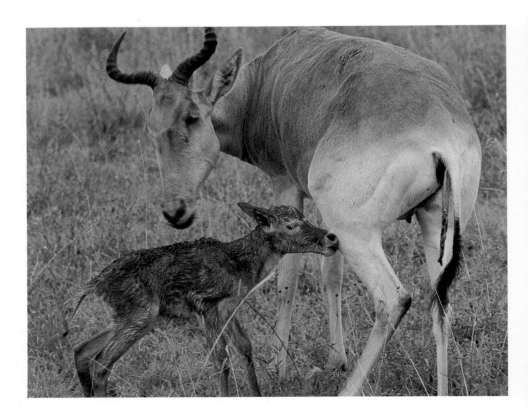

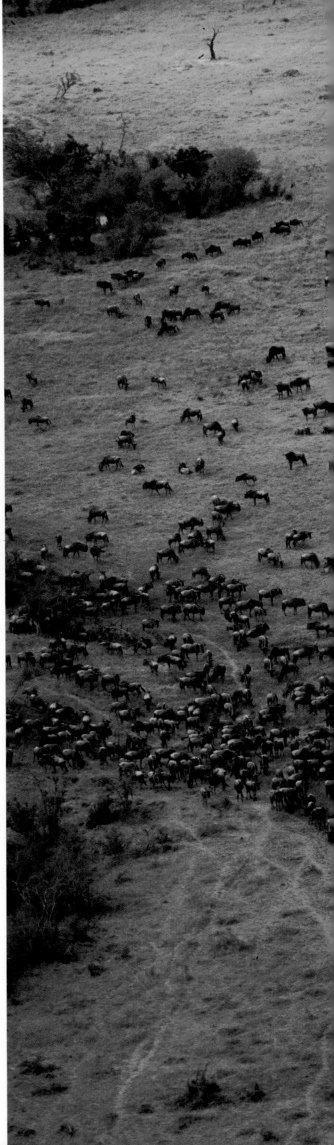

Above: The odd-looking kongoni, better known as the hartebeest. A mother licks her new-born calf in a Kenyan game park. The species has an extremely pliable neck enabling it to look back directly over its shoulders.

Right: Wildebeest swarm across the Maasai Mara grasslands during their annual migration from Serengeti. Their mindless travel is reminiscent of the lemming spectacle in Norway where the rodents hurl themselves from high cliffs. The wildebeest also drown in thousands by following their leaders into the swollen waters of the Mara River. For weeks the water is darkened by the bloated corpses.

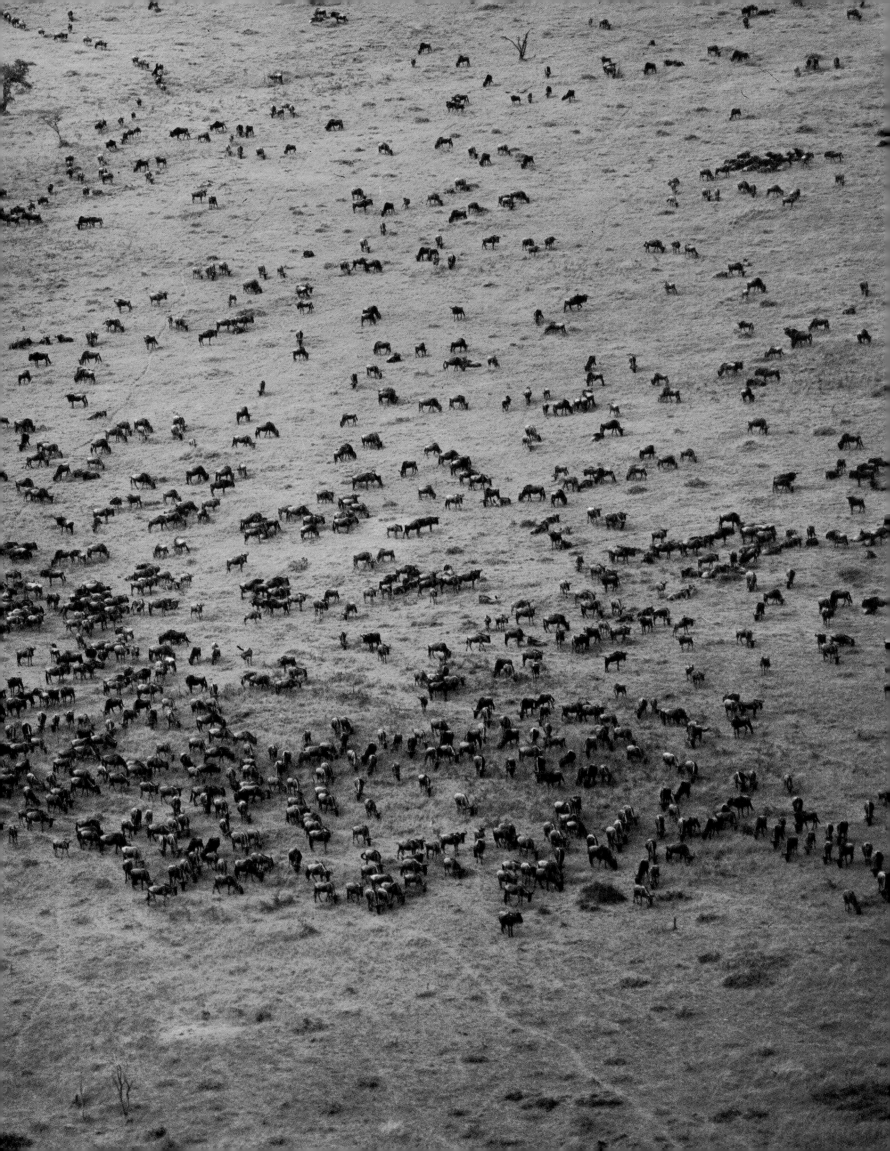

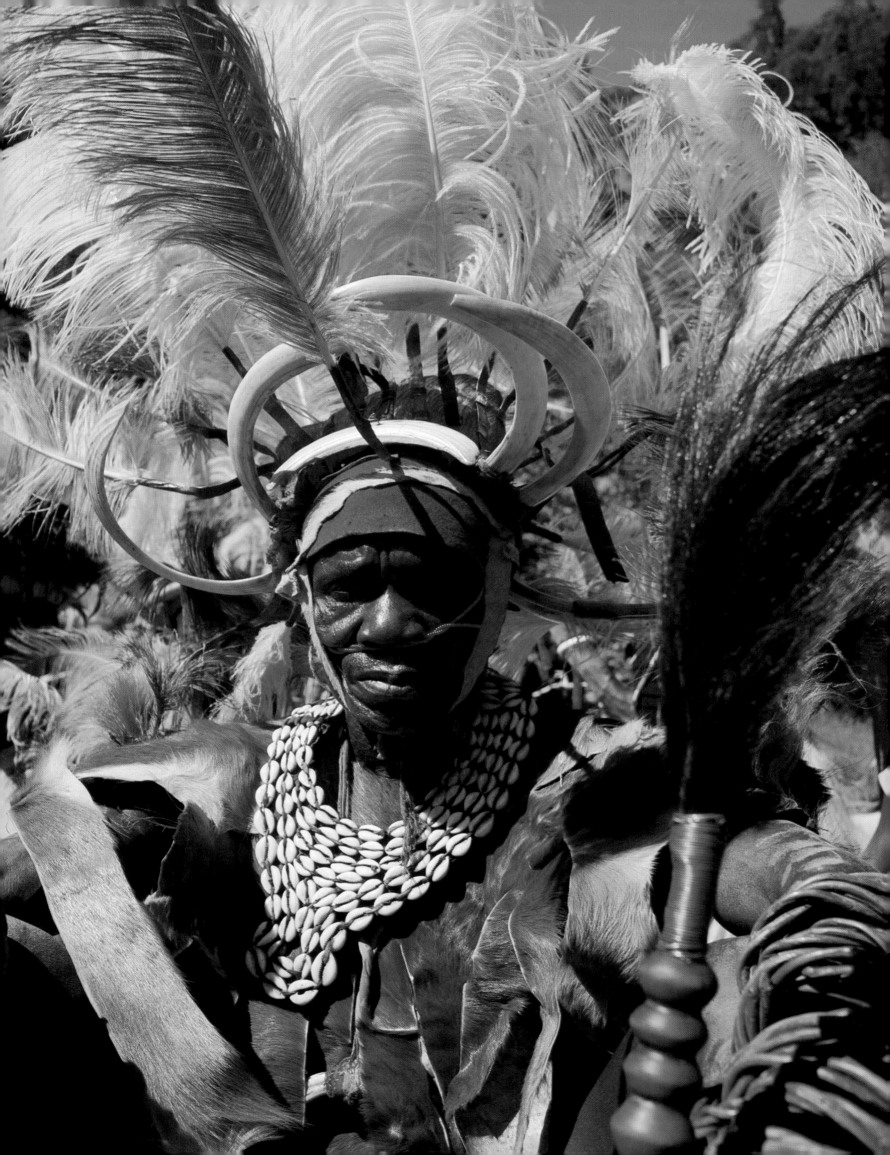

Opposite: A Luo warrior dressed up in extravagant tribal finery with hippo tusks adorning his head-dress and expensive white necklace.

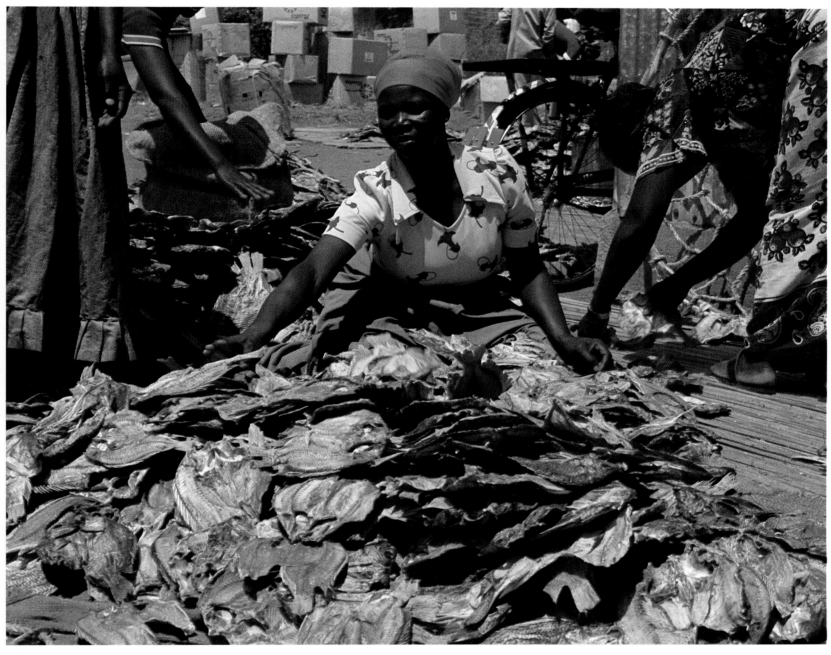

Above: A Luo market woman displays wares of sun-dried fish taken from Lake Victoria.

Overleaf: Sunset colours the still waters of Lake Victoria as Suba fishermen paddle their canoe home. The Suba, closely allied to the Kuria, live on a string of lake islands near Homa Bay on Kenya's south-east shores of Lake Victoria.

busy commercial routes with passenger and freight vessels plying all along the coast. At bustling Homa Bay a second class fare aboard MV *Alestes* costs nineteen shillings for a four-hour journey around the gaunt grandeur of 5,746-foot Mount Homa to the placid waters of Winam Gulf, formerly known as Kavirondo Gulf. The *Alestes* cuts between little fleets of dug-out canoes with lateen sails, used by Luo fishermen in search of Nile perch, tilapia and other species.

The Luo are Kenya's second largest tribal group. Numbering more than 1.9 million at the 1979 census, they do not practise circumcision; however they have another test of valour, the removal of six teeth from the lower jaw without anaesthetic. They must not show any sign of pain during the ordeal.

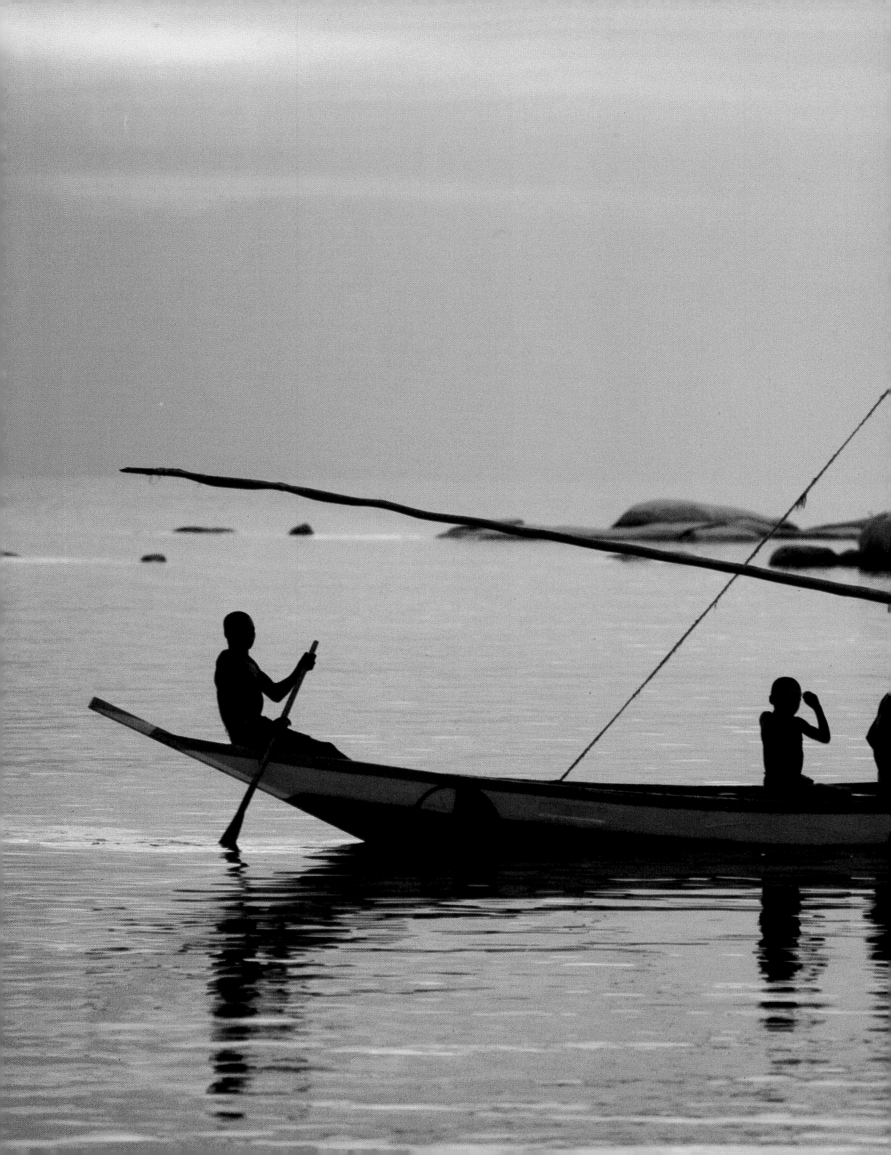

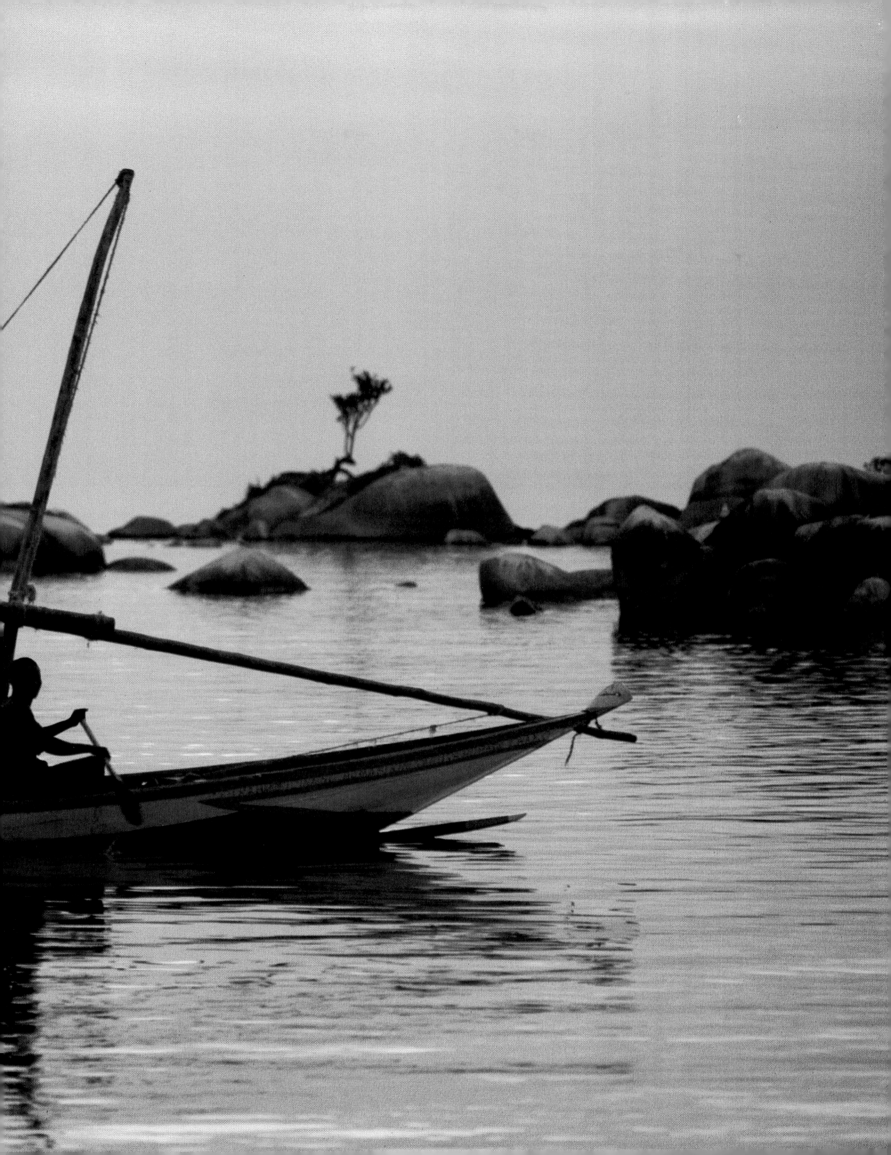

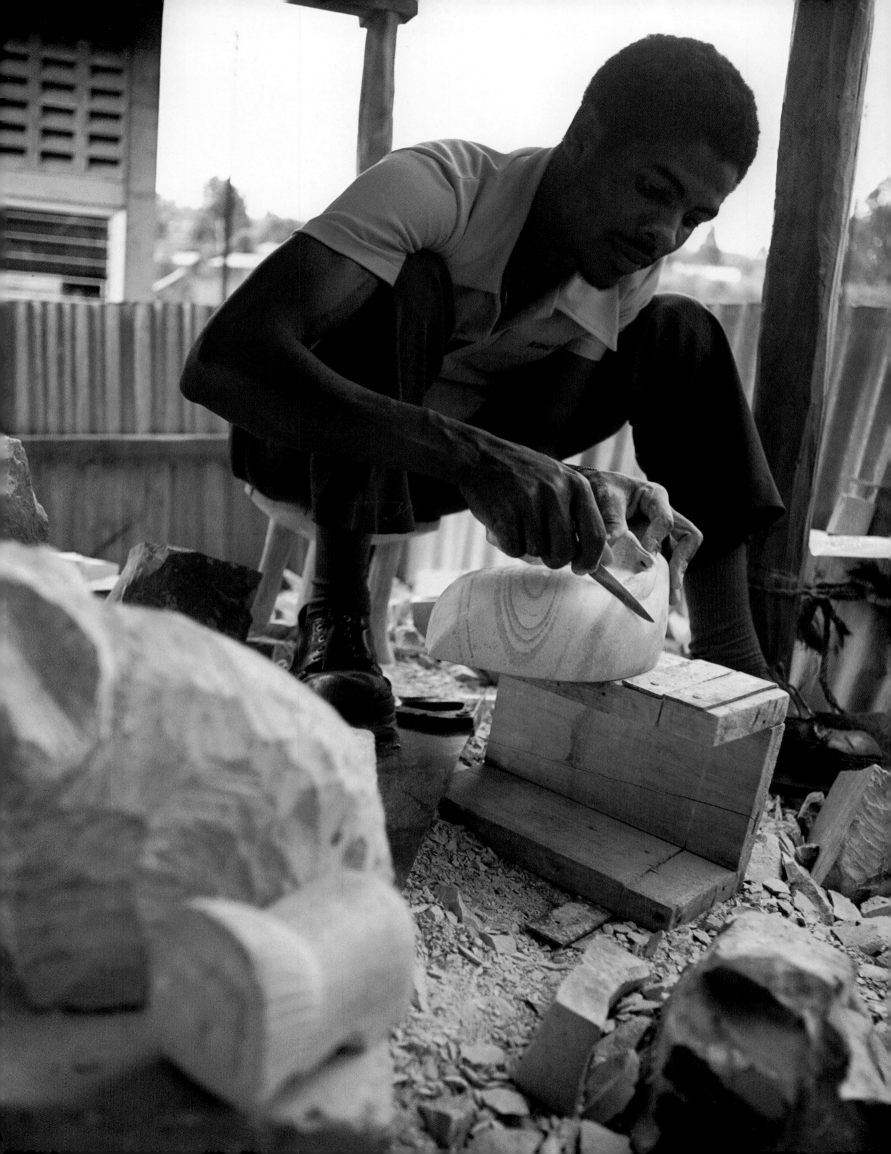

Opposite: A Kisii sculptor at work with the delicately coloured soapstone which is quarried in the region.

Right: A masterpiece in Kisii soapstone, sculpted by Elkana Ong'esa, the acknowledged master in this material. The soft, delicately-hued stone is found only in quarries in the Kisii district of western Kenya. Ong'esa's greatest work, a massive piece, now stands outside the Paris headquarters of UNESCO.

The Luo are cattle keepers and fishermen and the tribe dominates the Kenya shoreline of Victoria which is the country's largest and most developed freshwater source of fish.

As the *Alestes* approaches Kisumu waterfront, the office blocks rise white and gleaming against the background of the Nyando Escarpment. In one dock, steamers with shabby paint lie listing as the *Alestes* moors up in the oily waters alongside a quay once used by the boat trains. The days of week-long circular luxury cruises on Victoria's turgid waters, fanned only by the lightest of tropical breezes, are past.

Kisumu is a good centre from which to visit Kisii and Kericho, a pleasant day's circular excursion. Kisii, judged by the number of its schools, has claim to be the most studious community in Kenya. The town sprawls up and down the slopes of a hill in pleasant disorder, its gardens and smallholdings verdant and immaculate. The Kisii are renowned sculptors. Their work with the local Kisii soapstone first began as a tobacco pipe-making enterprise but has earned both the delicately coloured material, and the artists, an international reputation.

Elkana Ong'esa is the acknowledged master. His largest work, a two-ton masterpiece, was presented to UNESCO in Nairobi in 1976 and shipped across the world to stand in front of the Organization's Paris headquarters. Young Kisii are learning Ong'esa's skills for he passes them on as an art teacher in the town's teachers' college.

The Kisii's sensitive use of their fine-boned hands is not limited to art. For centuries Kisii traditional medicine men practised a remarkable form of brain surgery with primitive tools. They treated patients—without anaesthetics of course—by tapping a small hole in the skull with all the precision of a twentieth-century surgeon performing a delicate operation with his trepan.

North-east of Kisii, on the south-western shoulders of the Mau, is one of the great tea-growing regions of the world. The slopes which radiate around Kericho benefit from the convection of Lake Victoria's air currents and those of the Indian Ocean meeting the cold fronts from Europe high above the mass of the Mau. This creates the phenomenon of rain on at least 335 days a year. With the bright mornings characteristic of this region, the combination of sun and rain promote the right conditions for the growth of what has been described as the finest tea in the world. In the 1960s and 1970s Kenya attained pre-eminence as one of the top two tea-growing countries with a reputation not simply for quantity but also for quality.

Kenya tea, like its coffee, inevitably fetches top prices in the international market. It prospers best at between 6,000 and 8,000 feet where the neat avenues of the tree bushes march away in all directions chest high, forming a raised, immaculate carpet of green.

This region is the home of the Kipsigis, a Kalenjin tribe who were also renowned opponents of the first British forces, causing havoc during the building of the Uganda Railway. Their social festivities are highlighted by sipping millet beer through tubes two metres long made from local creepers.

The slopes of the Mau also provide excellent trout fishing and there is a lodge which caters specially for the angler casting in the reaches of the Kiptiget, Itare and Kipsonoi rivers. For other sportsmen Kericho boasts probably the loveliest golf course and cricket ground in the nation.

Kisumu, with a population of 152,000, is Kenya's third largest town. It was here that Florence Preston—Kisumu was briefly called Port Florence—drove in the last spike of the 962-kilometre-long Uganda Railway on 20 December 1901. Immediately before this the shores of the Nile watershed had inspired brave adventurers, romantics, missionaries and mystics in the search for this legendary fountainhead, the mystery of which dominated Victorian Britain as no other subject.

Overleaf: Tea-pickers on a large plantation at an altitude above 6,000 feet on the south-western slopes of the Mau summit, near Kericho, the capital of Kenya's tea-growing region. A unique combination of weather, sun and rain almost every day of the year, has made Kericho the most fertile tea area in the world.

All were frustrated except John Hanning Speke, an Englishman who came upon the cascade tumbling over the Ripon Falls at Jinja, Uganda. He deduced it was the start of the 6,670 kilometres of the Nile, the world's greatest river, and that Lake Victoria was its long-sought source.

His discovery brought no satisfaction. Such was the bitterness of the opposition aroused by his claims that he became a disillusioned man and died of shotgun wounds many believe he inflicted on himself. His one-time friend and later arch-rival, Sir Richard Burton, when told of Speke's death, said, 'There is a time to leave the Dark Continent. Madness springs from Africa.'

A thriving city, Kisumu's factories manufacture many commodities including textiles upon which Kenya's national economy depends, providing a healthy surplus for export. The country's sugar belt stretches across the plains on which the town lies, from Chemelil to Bungoma.

From Kisumu, the A1—a fine highway which in the south runs all the way to the Tanzania border—continues north as far as Webuye, passing through Kakamega on the way. The road climbs the steep Nyando Escarpment running through land liberally dotted with giant granite boulders, with goats and sheep grazing on the sparse grass in between.

In the 1920s Kakamega was known as 'the Klondike of Africa', the result of a short-lived gold rush. In fact there is gold in many parts of western and northern Kenya but few if any of these deposits are true veins. The precious metal is recovered from panning alluvial deposits in river beds.

The town, today, is the provincial administration headquarters. However, Kakamega has a more intangible but distinctive claim to fame—its forest which lies to the north-east. With a network of paths for safe walking, it is worth a visit for the unusual birds which make their home in its leafy glades. Watch out, too, for lethal snakes. Otherwise there are no dangerous species within the forest.

Kakamega is the centre of the Abaluhya group, a Bantu people made up of seventeen main tribes now totalling more than a million people. Renowned as fighters, today they celebrate life in music, dance, and as fanatical football enthusiasts.

Another pleasant diversion is to the nearby tea town of Nandi Hills and the Nandi Escarpment. The Nandi were fearsome opponents of British imperialism and fought them with skill and ferocity to earn a lasting place in the history books. One rock face testifies to their harsh philosophy. It was from this that wrongdoers were sentenced to jump 300 feet to their death. The Nandi Hills are also the forest home of the

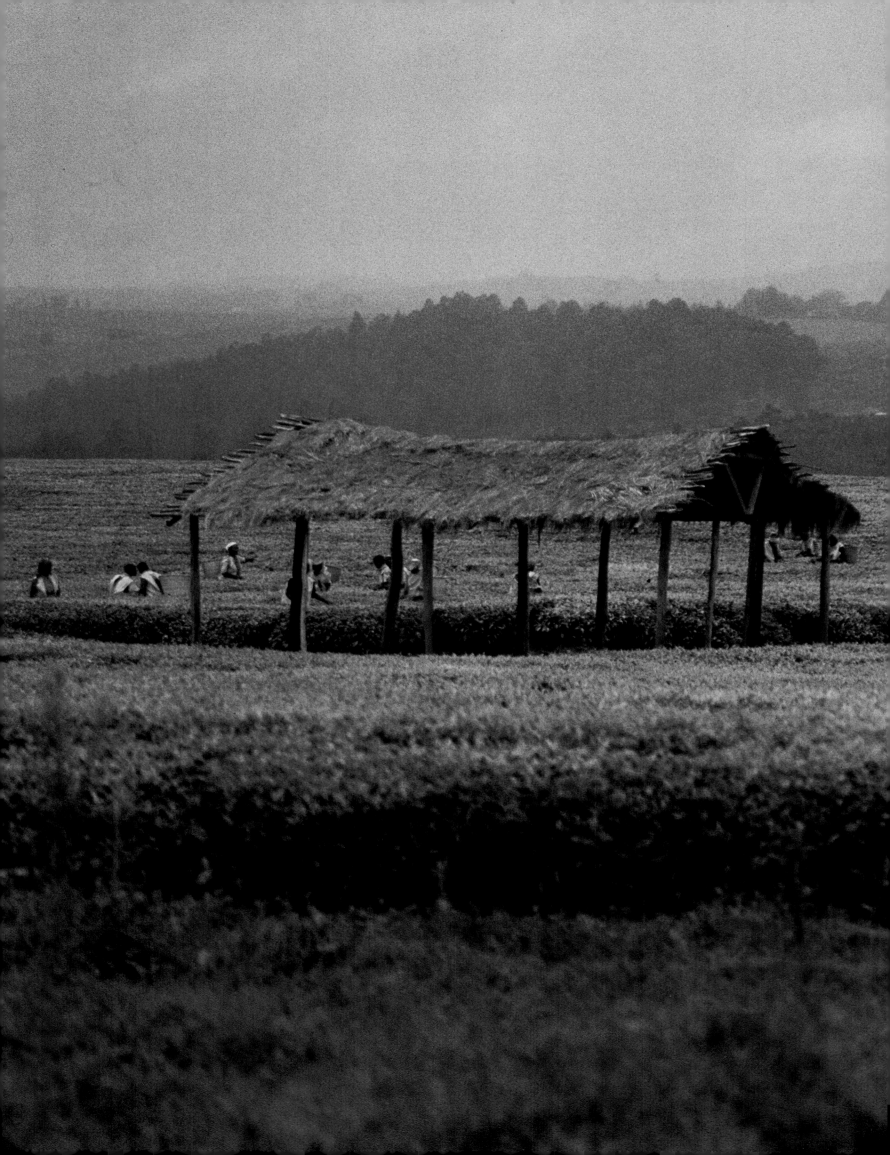

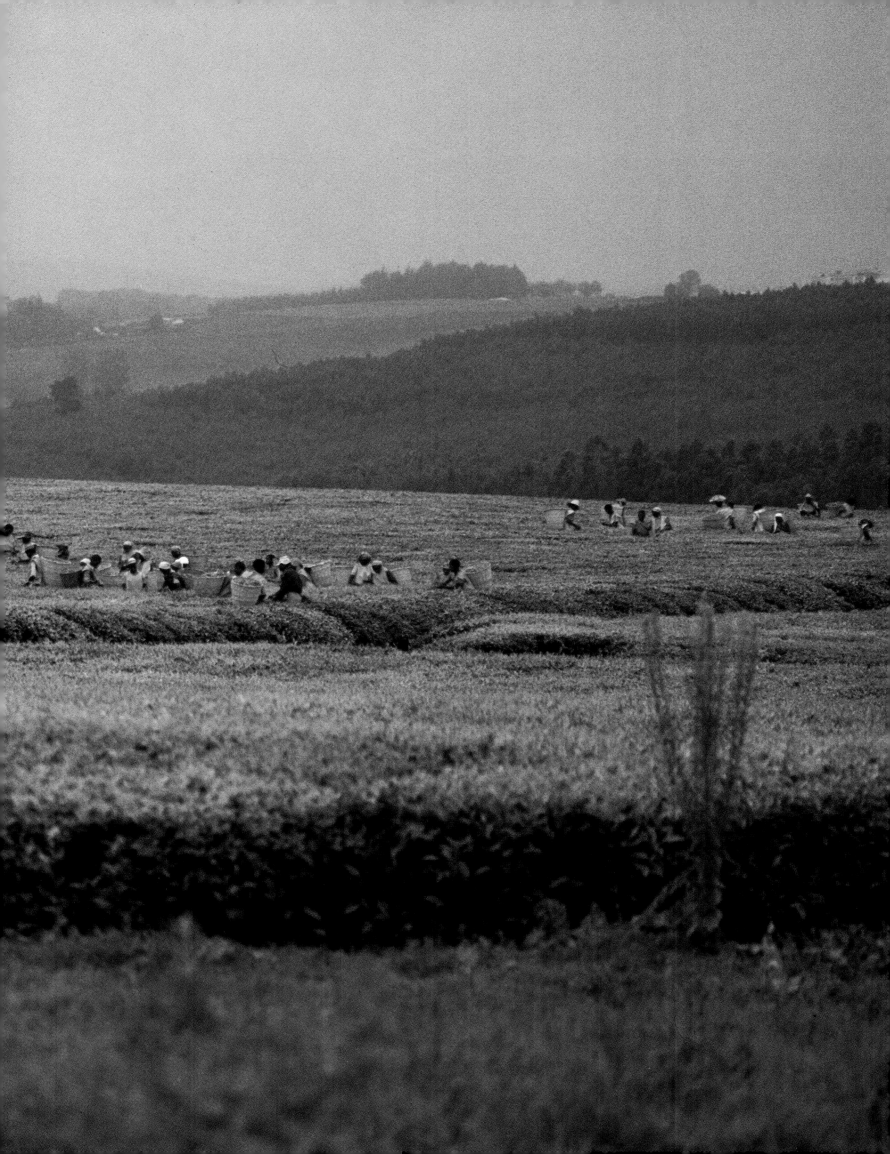

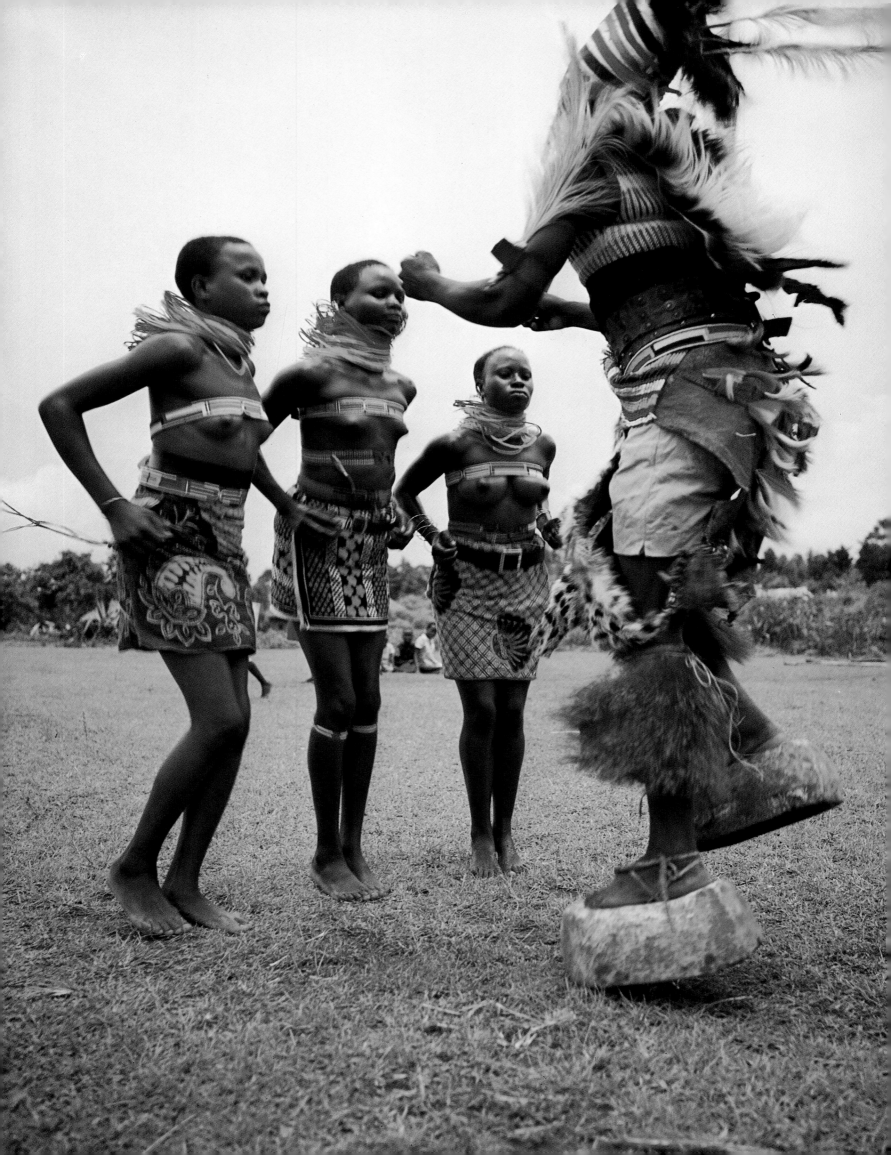

Opposite: The Kuria people live along the Kenya–Tanzania border, half-way between Lake Victoria and the Maasai Mara region. The centre of their population is found south of Migori. Jolly, colourful people, the Kuria enjoy dancing. They enlarge their ear lobes by piercing them and placing heavy wooden cylinders in the apertures. Some ear lobes stretch as much as four inches in diameter—the cylinders can weigh up to four kilogrammes. The Kuria have a unique circumcision ceremony—the boys and girls are circumcised almost simultaneously and then encouraged to roam the countryside together.

mythical Nandi Bear, a soft-footed creature which is Kenya's equivalent of the Abominable Snowman of the Himalayas—there are many legends about it, but as yet no evidence!

Webuye is the crossroads of the west. In one direction lies Bungoma, in the other Kitale and the magnificent Trans Nzoia farmlands. Webuye was once nothing more than an attractive, forest-shrouded 160-foot-deep waterfall named Broderick after an early European traveller. But the location of this water, and the stands of timber on the nearby hills, made it an ideal site for a paper mill. It began production in the 1970s and Webuye is now a major town thriving on the wise exploitation of Kenya's limited forest resources.

These resources cover under 3 per cent of the country and in the past have been badly depleted by senseless over-use—resulting in a Presidential ban on the unlicensed felling of trees whether within Government reserves or not. The national policy is to maintain and develop Kenya's forest resources which are a mixture of exotics, such as Australian eucalyptus, and attractive indigenous hard and softwoods including ebony, Meru oak, Elgon olive, mvuli, East African olive, camphor, muringa, mahogany, pencil cedar, juniper and podo.

Overleaf: Rock face high up on 14,178-foot Mount Elgon, in western Kenya. It was on this mountain that the author H. Rider Haggard visited giant elephant caves inhabited by bats and was inspired to write his epic adventure story, She.

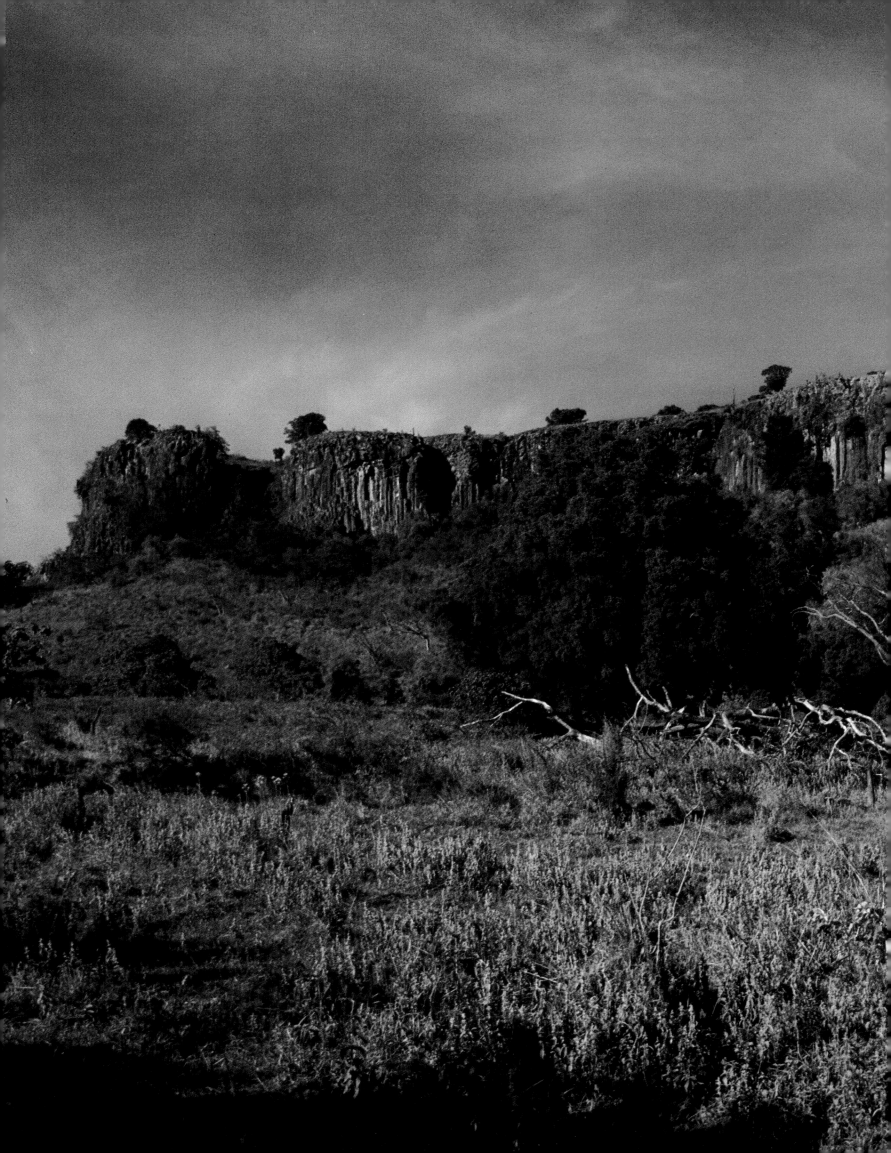

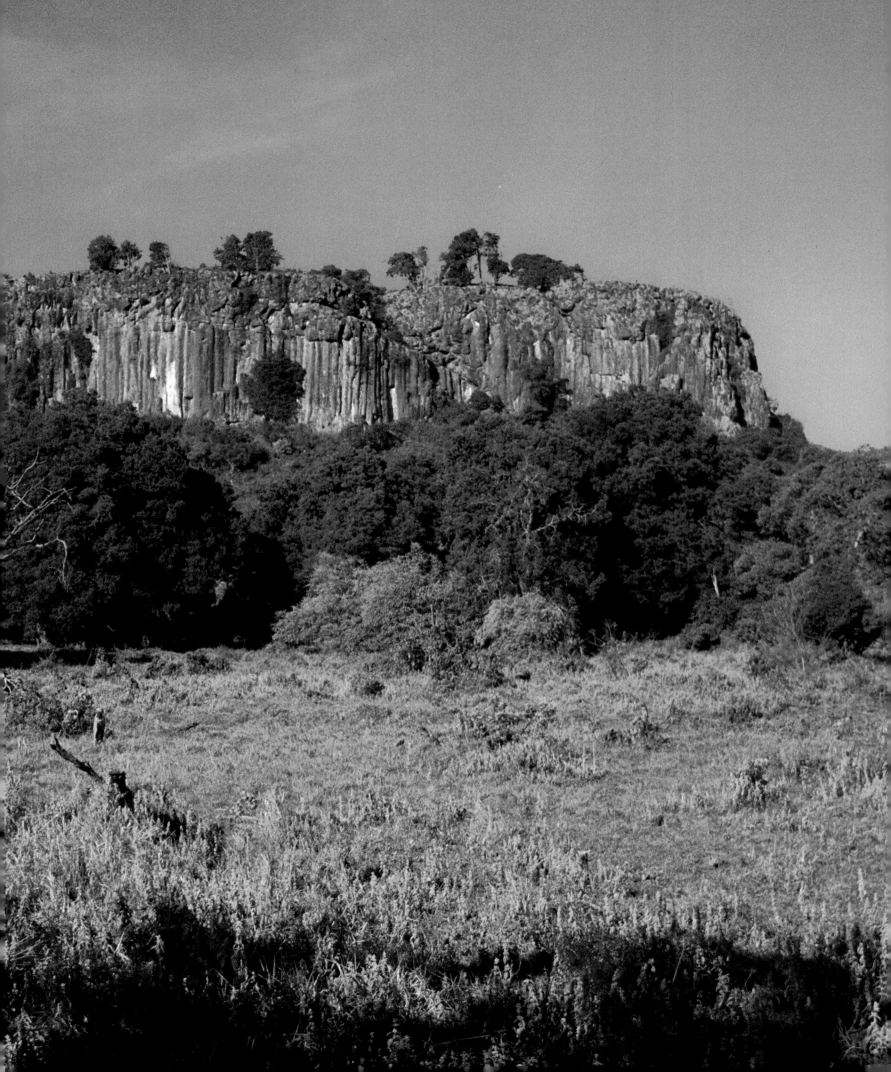

Time and distance seem infinite in Kenya. In four days a traveller can go so far across such contrasts of terrain that it is easy to imagine he is travelling in another time to another place. The earth satellite scanner in the shadow of ancient Longonot helps the illusion: 10 kilometres span the millenia between the Stone Age and the Space Age.

The forest slopes of Mount Elgon, one of the finest of Kenya's National Parks, add flesh to the feeling. These primal woods of olive and cedar and podo, of bamboo groves, and beyond them the Alpine moorlands, give effect to the impression of living in another dimension. Elgon is ancient beyond comprehension.

The mountain's 14,178-foot crown is sliced in half by the Uganda border. Its base is the largest of those of the three great mountains which Kenya shares—far greater than that of Kilimanjaro which has a seemingly identical, though higher, level summit. Elgon is ideal for mountain walking although the risks of high-altitude sickness above 13,000 feet are as real as on Mount Kenya.

There are some rock climbs but it is for its walks among its giant heathers, lobelias, helichrysums and groundsels—all unique to Africa's Equatorial mountains—and its hot springs, for which Elgon is best known. The Alpine plants are strange mutations which spawn into giants in the combination of high, rarefied air, unfiltered ultra-violet rays, and freezing nights. Elgon produces more and better specimens than can be found on Mount Kenya or Mount Kilimanjaro. Another attraction on Elgon is the trout fishing.

Part of the eastern slopes, 169 square kilometres in area, were declared a Kenya National Park in 1949. Animals indigenous to the area include the sykes, and the black and white colobus monkey. Elephants dig for salt in Kitum Cave on the lower slopes; the cave, home to thousands of bats, inspired Rider Haggard's novel, *She*. Different species of buck, duiker, buffalo, leopard and other animals are also present but the thick centuries-old forests with their 100-foot-high podo trees—clean, straight-stemmed, crowned with evergreen foliage—make the game difficult to spot, so that when an animal is sighted the experience is all the more rewarding.

Within the forests are well-laid trails. But on either side of them lies evidence of Elgon's impatient elephants—boles broken like weed in a duck pond, folded over or snapped and pushed aside by these animal foresters with no concern for their environment. Nature's trails are less elegant but more commodious than man's. The thick tangle of ancient trees and new-born saplings seems to bar the way. But the limbs torn down by the elephant hide the tracks over which the beasts tip-toe, up and down mountain ridges that rise and fall 1,000 feet in half a kilometre's distance.

In the dark, after the moon slips over the topmost peak, the barking of the baboons in the forest and the sawing cough of the leopard tell of an unseen drama. The morning search reveals the carcass of a young buffalo little more than 100 metres from camp.

The Park gate is the beginning of the normal route to the Koitobos Peak but there are several other ways up the mountain which do not fall within the Park's administration, including a car track that will take the visitor well into the giant heather area. The true summit, on

Opposite: Two reticulated giraffe. These tall beasts are formidable fighters despite their gentle appearance.

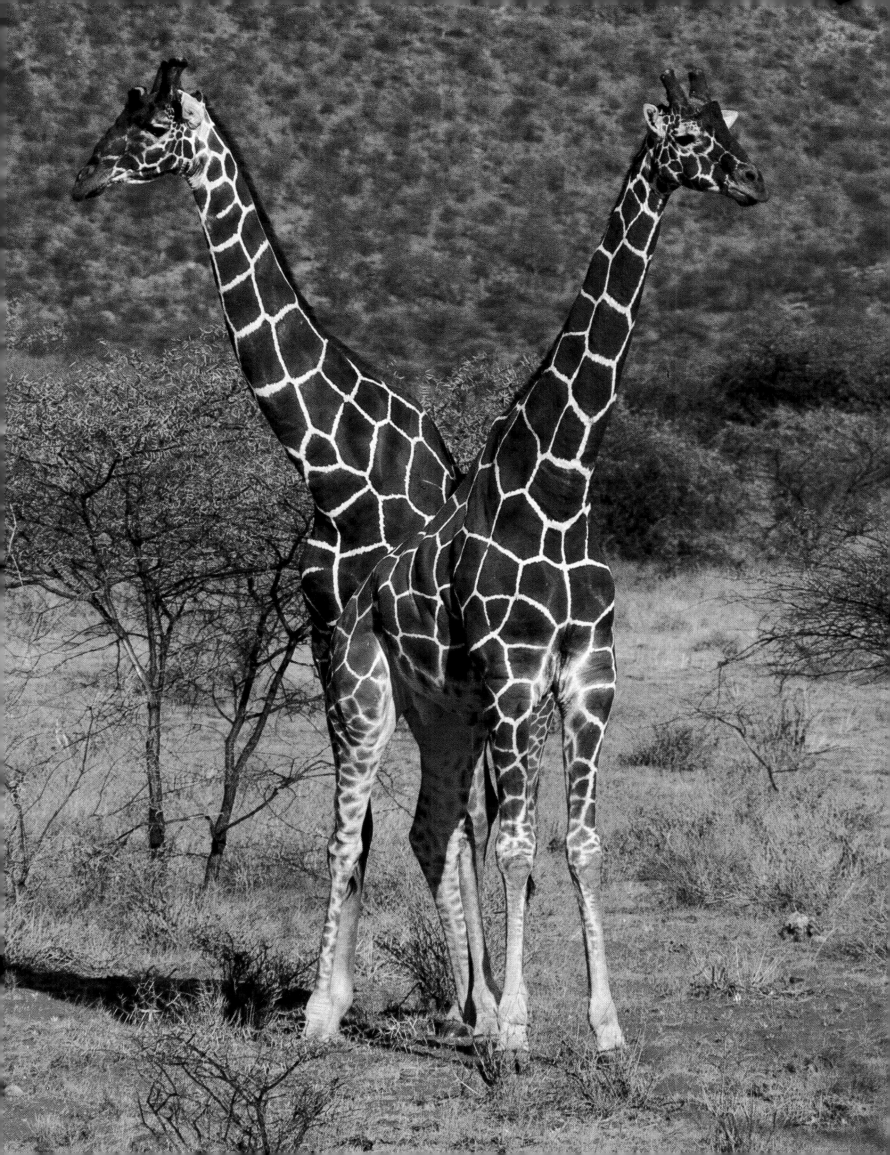

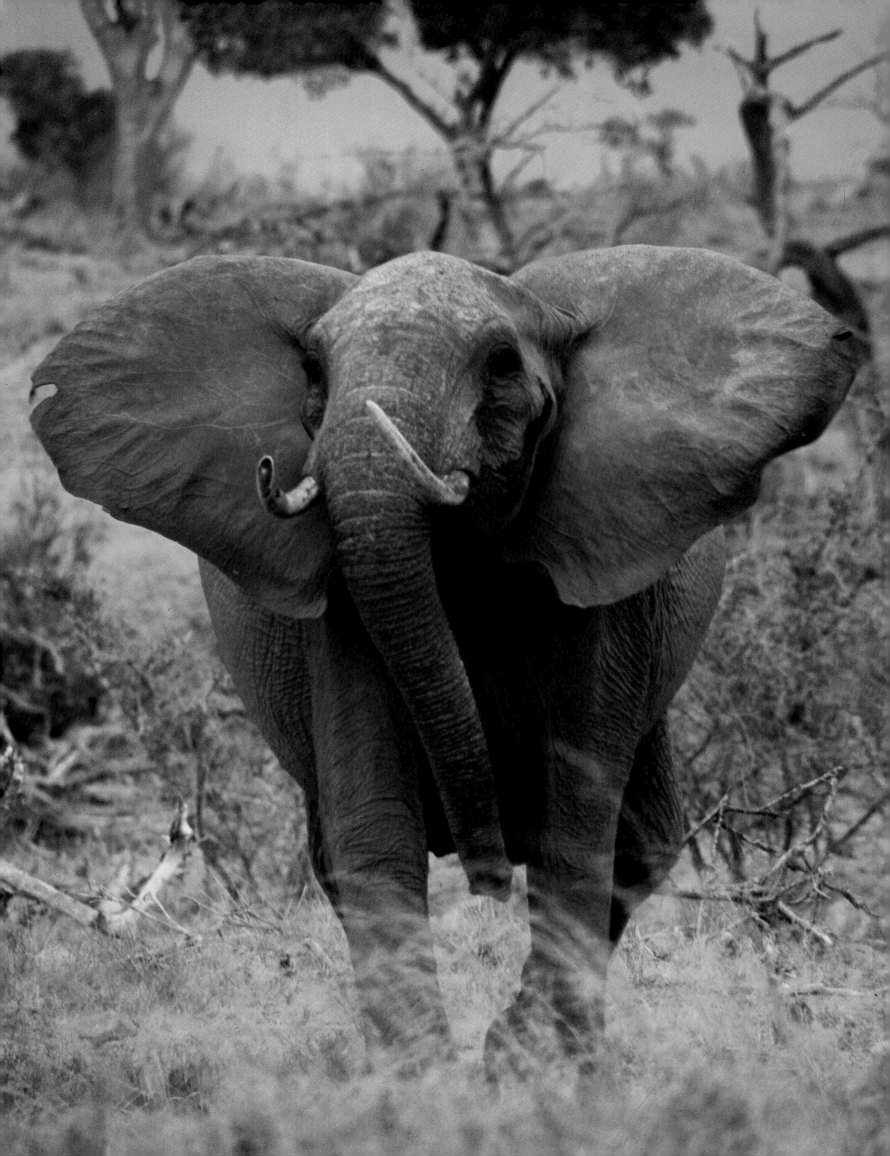

Opposite: Charging elephant; this particular stance, however, is more an expression of curiosity than menace. Dr Bernhard Grzimek, the German zoologist, says that when really hostile and intent on a serious charge the elephant lays its ears flat and 'looks smaller'.

the other side of the crag, is in Uganda and a good day's walk there and back from the Kenya side. But the Kenya summit is only a few feet lower and the views all around just as spectacular.

Elgon, however, is showing signs of the new pressures which are affecting Kenya's wildlife reserves—conflict with the expansionist needs of mankind. An electric fence called 'Elephence' has been built around the Park's lower regions. Its purpose is to keep the farmers out and the elephants in.

The town which lies at Elgon's eastern foot is Kitale, 380 kilometres from Nairobi. Its rustic charms include an expanding branch of the national museum, and the country's northernmost railhead. The station building is a fine example of early railway architecture. It is also the doorstep to Kenya's most remote wilderness, part of Kenya's Rift Valley Province and its vast northern desert regions. Almost 200,000 square kilometres, it represents a little over one-third of Kenya's total land area, bigger than Great Britain or Italy and three times the size of Portugal. Burnt out, it does not have much in the way of natural resources and is home for a number of hardy nomadic tribes. In the west it is bordered by the Cherangani Hills and the Elgeyo Escarpment.

Kapenguria, a little town with a unique place in Kenyan history, sits on the slopes of the Cherangani Hills. A show trial was stage-managed in the tiny schoolroom there in 1952, by the colonial government, when the father of the Kenya nation, Mzee Jomo Kenyatta, faced trumped-up charges which resulted in a *force majeure* conviction based on false evidence. As a result Mr Kenyatta was held incommunicado for nine years. The schoolhouse has become a national shrine to his memory.

Kapenguria is the point from which to visit the world's smallest nature reserve—1.9-square-kilometre Saiwa Swamp National Park, home of the rarest and shyest of African antelopes, the sitatunga. Its long-toed hoofs allow it to move at ease in its wet marshy habitat. Special viewing platforms have been built in the park from which to see this unusual beast. But should it be disturbed it often hides under the water with only its nose showing.

The 11,000-foot Cherangani Hills, Kenya's only range of fold mountains, form the western wall of one of the wonders of the world— the Elgeyo Escarpment, which drops 5,000 feet to the floor of the Kerio Valley. Trout flourish in the mountain streams. The Hills, clothed with bamboo forest and the 20-foot-high moorland plants also found on Mount Elgon, are another home, after the Aberdares and Mount Kenya, of that rare nocturnal antelope, the bongo. And at the base of the Cherangani Hills Kenya's north-western desert lands stretch into infinity.

The land at the foot of the range is the home of the Pokot people, an unusual mixture of pastoralist and cultivator, often in conflict with their truculent Turkana neighbours. They share certain cultural similarities with the Turkana but are, in fact, a Kalenjin tribe. They are unique for their practice of efficient irrigation developed over many centuries and perfected long before the coming of the Europeans. The Pokot protect their stock and their land fiercely against intruders from

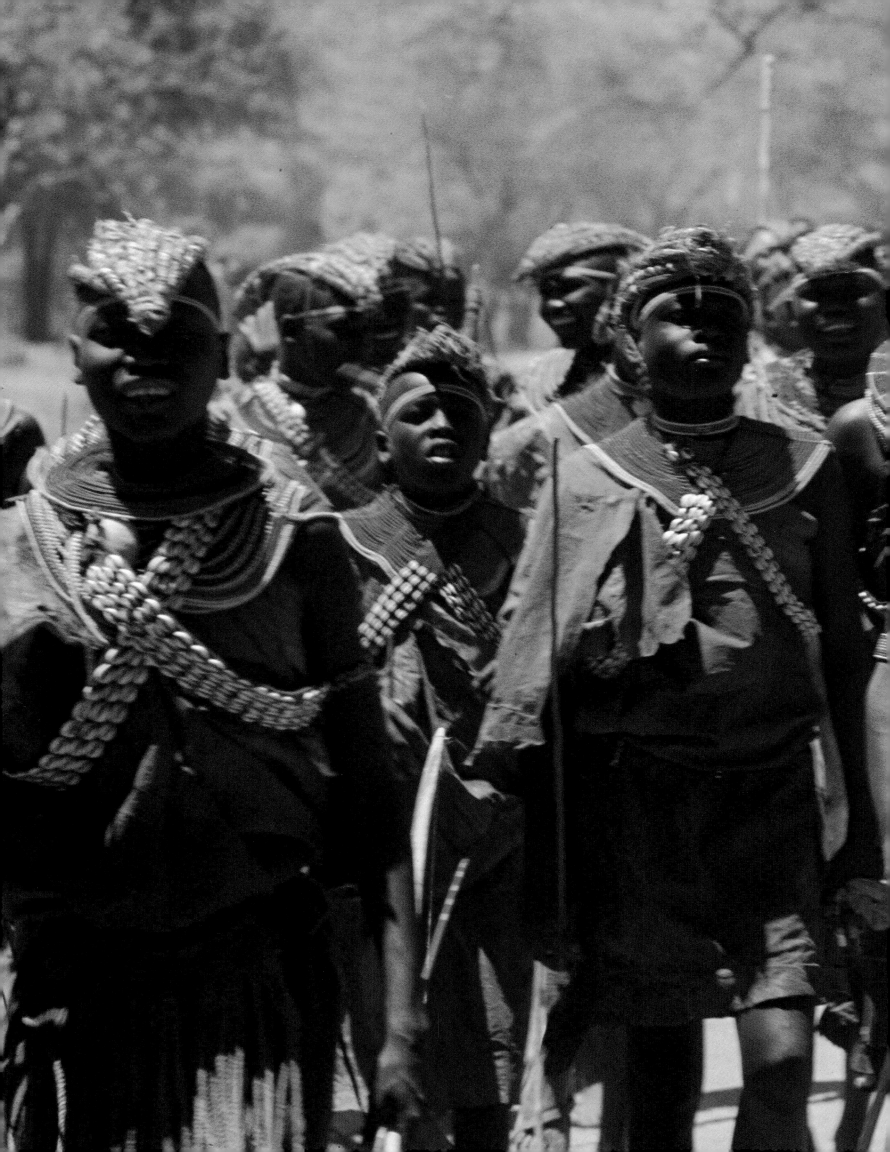

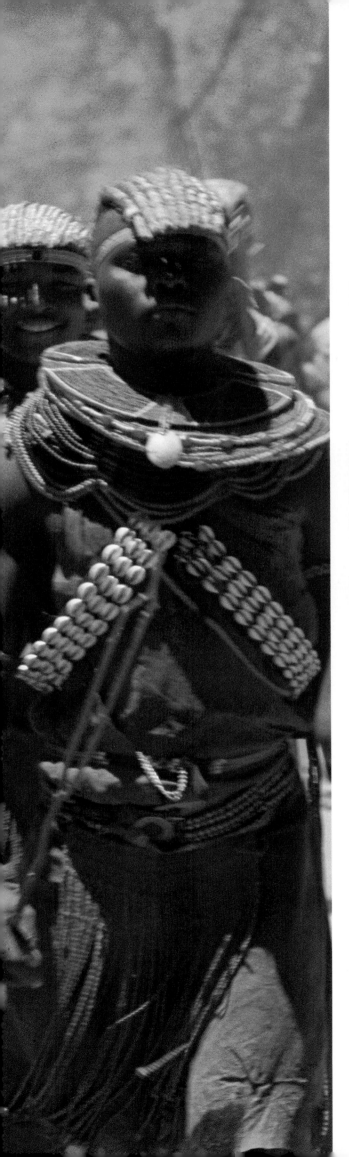

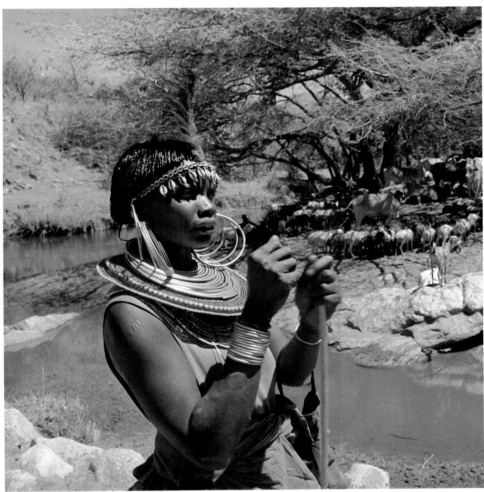

Above: Pokot woman: both agriculturalists and pastoralists, the Pokot—once known as the Suk— occupy the lower slopes of the Cherangani Hills, the Karapokot Escarpment and the withered wastes of the desert which lie between these highlands.

Left: Pokot youngsters in circumcision group. The ceremony is spaced at intervals ranging from between ten to fifteen years but not all Pokot practise circumcision.

Opposite: The klipspringer is one of Africa's smallest antelopes. Members of the species never measure much more than 14 inches high nor exceed a weight of about 4 kilogrammes. They are extremely shy and nervous and very difficult to observe.

Above: Oryx watering in Samburu Game Reserve. Two kinds of oryx, the beisa and the fringe-eared oryx, can be found in Kenya. These antelopes favour an arid or semi-arid environment. Their distinctive horns are a powerful defence against predators.

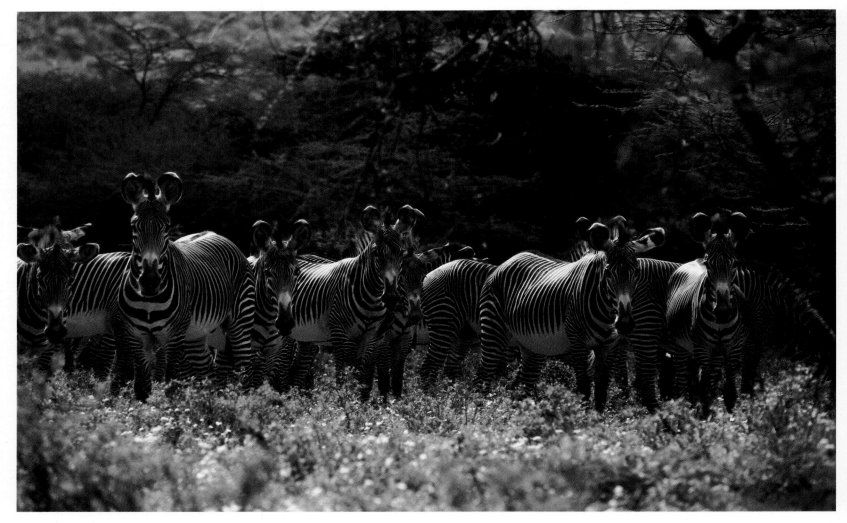

Uganda and from the Turkana. Those killed in these conflicts are buried facing the summit of the sacred 10,910-foot mountain of Sekerr, in accordance with Pokot custom. Sekerr lies to the east of the road to Turkanaland and the 10,067-foot bulk of Uganda's Mount Kadam rises in the west, adding a fresh perspective to an already dramatic landscape.

The remote regions north of these mountains were settled by the warlike Turkana about two to three hundred years ago, when the tribe migrated along the Nile Valley out of Sudan.

Lodwar is the administrative centre of the 48,000 square kilometres of Turkana country. And it was in Lodwar from 14 April 1959 that the British authorities held Mzee Jomo Kenyatta for two years following his release from prison in Lokitaung. Lodwar is the place from which a succession of early administrators attempted to impose modern ideals on the intractable but somehow admirable Turkana. The original male chauvinists, Turkana warriors seem to believe in little else beside war, the control of grazing lands, and the acquisition of wealth in the form of cattle and wives. They are a vivid anachronism in modern Kenya.

The men who attempted to impose colonial rule on them were almost

Above: Grevy's zebra in northern Kenya. Fears for the future of this species in Kenya were expressed after a census which established there were only 1,500 remaining members left. However another census, some time later, demonstrated that there had been a serious error. The species, in fact, numbers more than 15,000.

as colourful. One was Baron von Otter, a Swedish aristocrat who devoted his life to the Turkana. He adapted to this oven-like environment—average temperatures hover around 40°C—even better than these masters of desert warfare whom he proved he could outstrip on a day's march of 70 kilometres. He died of melanoma, a tropical illness affecting pigmentation. Still a Swedish national, his coffin was covered with the flag of the British whom he had served so well and faithfully. It was his last request. His body lies in Lodwar's graveyard.

Another administrator, Arthur Mortimer Champion, besides possessing an uncommon ability as a law-maker, was a gifted surveyor. He mapped the southern shore of Lake Turkana, one of the world's most remote stretches of water. It is dominated by a mass of volcanic craters, mountains and plateaux and by the glare of the Suguta Valley.

The temperature in this basin is a constant average all the year of above 40°C. The only growing things are a few doum palms, and thousands of flamingos on the soda crust surface of the valley's two lakes, Logipi and Alablab. The north wall is composed of a mountain barrier and recent volcanoes, some of which rise above 3,000 feet. Teleki's volcano, named after the Austrian Count who, with Lt. Ludwig von Hohnel, was the first white man to set eyes on the lake in March 1888, erupted seven years after the Austrians had left.

The Suguta is 400 feet below the level of Lake Turkana's surface which many thousands of years ago extended over the valley 160 kilometres southwards. It also used to flow into the Nile through the Lotikipi Plains on its north-west side. An alkaline, inland sea 289 kilometres long and 56 kilometres wide at its maximum, Turkana's shores are generally thought to be the place where modern man's ancestors took their first footsteps. Palaeontologists, in fact, have unearthed the impressions of seven human footsteps left in the soil one and a half million years ago. Yet, less than a century ago, the lake was unknown outside Kenya.

Teleki named it Rudolf after an Austrian Prince. None the less His Highness could not have been flattered: he committed suicide barely a year later. His name did not last long either in terms of posterity—the Kenya Government changed the lake's name to Turkana in 1975.

Turkana is fed by the River Omo which rises 1,000 kilometres away on Mount Amara in the Ethiopian highlands. The Omo enters the lake in a 30-kilometre-wide, almost impenetrable, delta.

The north-west shore is marked by the Murua Rithi Hills, by the Lapurr Range, and by a primal gorge through which the waters used to pour to help swell the Nile on its journey to the Mediterranean. Petrified forests, exposed and lying on the surface, indicate the age of Lokitaung Gorge. More recently, the little police post has attained historical significance because this is where the late Mzee Jomo Kenyatta was held by the British for seven years. No roads lead to the police post, even now, only a dirt track. The heat averages more than 35°C. The colonialists thought that, unable to reach him, the people he would lead to freedom would forget him and that the heat would achieve the rest.

Lokitaung is one of the most remote spots in all Kenya—150 kilometres by track from the thriving fishing community of Kalokol which lies on Lake Turkana's bulging midriff at Ferguson's Gulf. The

Gulf provides an anchorage and beach for more than 500 fishing canoes, dugouts and fibreglass, which 3,000 Luo and Turkana fishermen use to earn a living. Their catches are processed at the village's modern freezing and filleting plant.

Fishing is also sport on the tumbled waters of Turkana. Boats can be hired at any of the three fishing lodges on the lake—which is reputed to offer anglers the sport of 200-kilogramme Nile perch and one of the finest fighting fishes on the register, the savage tiger fish.

Other specimens among the forty species in Turkana offer rewards if not excitement. At Ferguson's Gulf the three-man crew of *Halcyon*, an 8-ton Scottish-built research trawler, tidy up the deck, haul up the anchor and feel the boat lift to the fury of an unpredictable Turkana gale. *Halcyon* draws only one fathom and rolls between 30 to 40 degrees. But it has revealed that forty tons of fish a day can be taken from the lake.

It is an hour's 8-knot run to the lee of Central Island, middle of the lake's three islands. Spider's web houses of grass and sticks indicate the presence of itinerant fishermen. Migrant birds from Europe depend on the bright green, salt-tolerant salvadora bushes for their food. The bushes, alas, are thinning out where the fishermen have destroyed them, and the beach is dotted white with fish, bird and crocodile bones.

In the night the water slaps the lava-black beach as a full moon rises above the island's still smoking main crater. In the 1960s nobody dared sleep on this beach. It was crowded with many of the lake's 12,000 Nile crocodile, the world's last remaining concentration in any great number. They may survive even longer than the cynics expect, despite the fishermen's depredations. Lake Turkana's alkalinity has provided them with an unexpected life preserver: the soda content has formed 'buttons' on their hides, making them less useful as leather.

When morning comes *Halcyon* sails for Alia Bay, on the east shore, three hours away. It steers to one side of a crescent island in the mouth of the bay and the water boils as thirty crocodiles, some almost five metres long, slide beneath the surface. The eyes of a hippo herd follow the wake of the boat: periscopes of another time. *Halcyon* anchors two kilometres offshore and a power boat works the ferry run. The landing beach is treacherous, ankle-sapping alluvial mud: footprints in the shore of Alia Bay echo those seven footsteps not far inland made by our ancestors, seven strides left indelibly in the soil of Koobi Fora—today a major site for research into the origins of humanity.

Alia Bay is headquarters of the least touched and most remote of all Kenya's national parks, Sibiloi, which boasts no more than two hundred visitors a year—hardly surprising when one of the entrances is signposted 294 kilometres away across the Chalbi Desert at Marsabit.

Most of Koobi Fora's sites lie within the park boundaries and the National Museum's field headquarters are not more than an hour's drive from the Warden's house. Concrete pillars with reference numbers mark the locations of the most important finds. The bones of many strange prehistoric creatures have been left *in situ*. The strata which have made this the richest single source of clues to mankind's beginnings cover an immense area: more than 1,600-square

Opposite: Turkana children at a water hole in a dry river bed. There are few permanent watering places in the Turkana's 48,000 square kilometres of desert badlands. Digging shallow wells in luggas— *dried-up river beds—is one of the main sources of supply.*

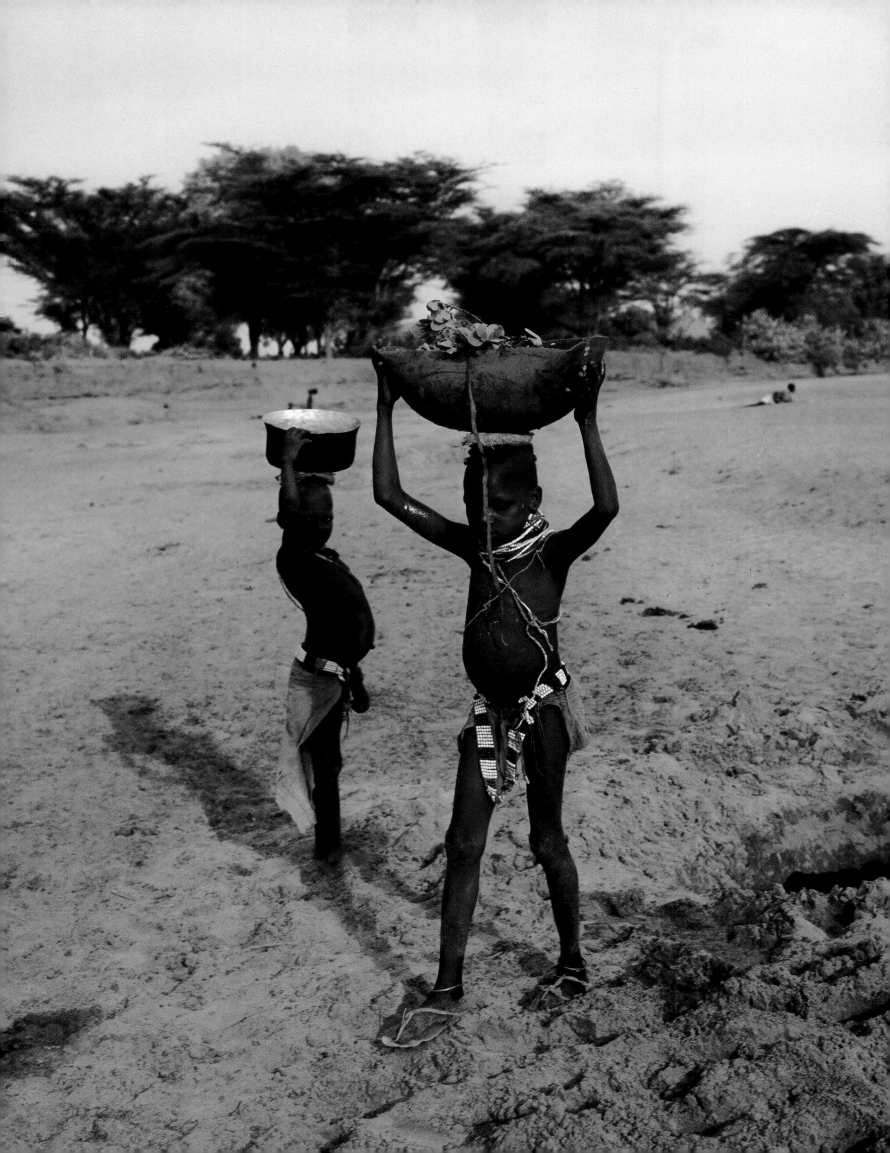

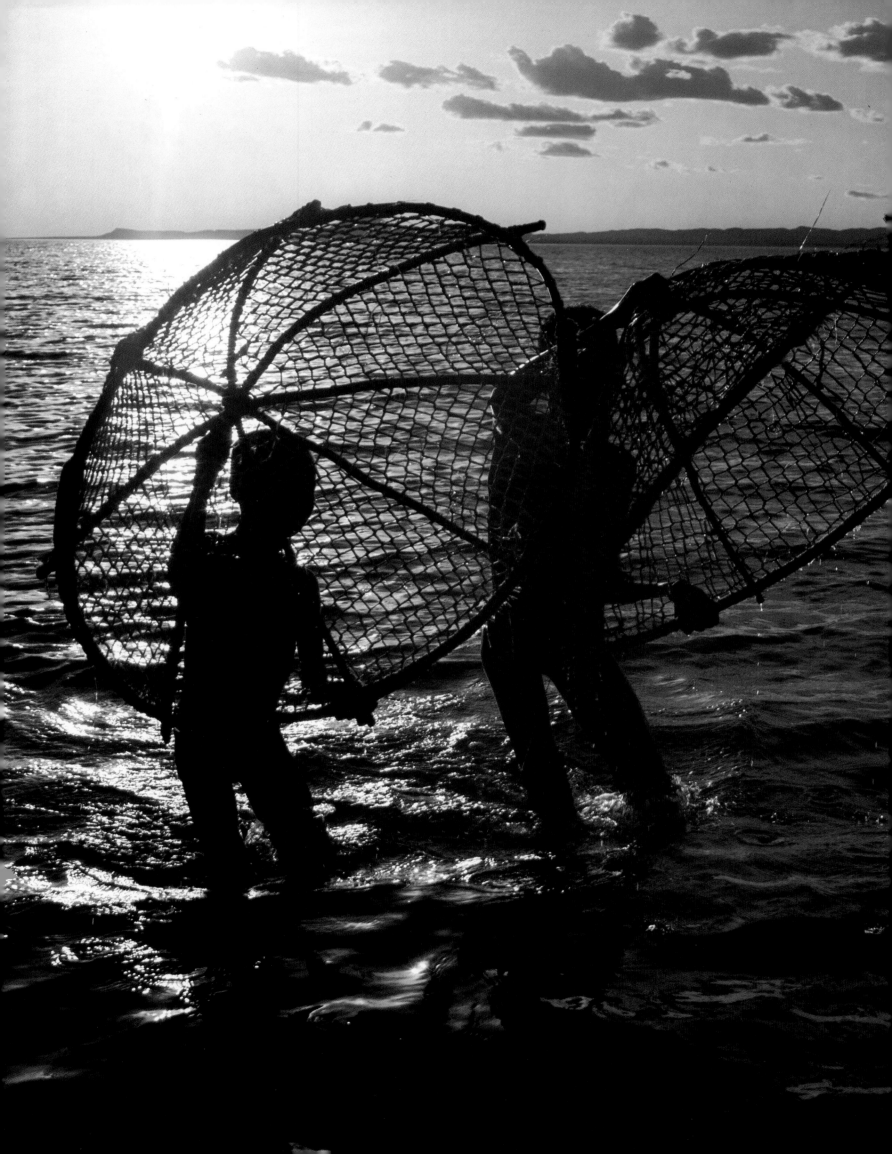

Left: Two el-Molo youngsters fishing with a basket trap on the eastern shores of Lake Turkana. The south-eastern shores of this 289-kilometre-long lake are the home of this group, once believed to be the smallest tribe in Africa.

kilometres. All this has earned the bleak eastern shores of Lake Turkana distinction as the 'Cradle of Mankind'.

It is an odd place to find a soccer pitch. But when the 'Gabbra Nomads', made up of research and Parks staff, challenged a team from Britain's Operation Drake, it was none the less an exciting affair. The pitch was pure alluvial volcanic sand. The two goal posts were a little crude but the game was played under FIFA rules before a large crowd. The result is not remembered but the injuries sustained from contact with the rock-hard pitch are still talked about.

Southwards, the shore is marked by impressive 500-foot cliffs rising out of the water and by the peaks of the Moiti and Porr Mountains. They provide a lee in which to sail in calmer waters; a necessary one. The convergence of the winds of two hemispheres above the mass of the 7,522-foot Mount Kulal transforms the lake's waters into a maelstrom. The effect is that of a wind tunnel with force 7 to force 12 winds a regular occurrence. Kulal is an intriguing mountain—split in two with a fascinating 3,500-foot gorge through its middle and an unclimbed knife-edge ridge between its two uppermost peaks, Arabel and Ladarabach.

Kulal stands out above the lake's second and only other major settlement—Loiyangalani, a missionary centre and small-scale tourist resort. Loiyangalani is also the main focus for the el-Molo people, once reputed to be the smallest tribe in the world, a group of Ndorobo hunter-gatherers who kill crocodile and hippo and gather fish. They live on the mainland in el-Molo Bay, and on two small offshore islands. For many years the tribe was thought to be on the verge of extinction. Their monotonous diet of alkaline fluoride water and too much fish gave them a number of diet-deficient diseases. Now they are improved in health and increasing in number, totalling almost 300 in 1982. No longer the people John Hillaby thought 'time had forgot', they are integrating happily into modern Kenya.

South Island, the largest of Lake Turkana's three main islands, lies some kilometres offshore; brooding and uninhabited. It is volcanic and, until recently, gave off a ghostly glow at night—probably still-burning fumaroles—which inspired many superstitious el-Molo stories of devils. Two Britons, members of an expedition led by the conqueror of Antarctica, Sir Vivian Fuchs, vanished on the island in 1934 and the mystery of their disappearance has never been satisfactorily explained.

To the south-east there are three mountain ranges: Nyiru, Ndoto and Ol Doinyo Lenkiyo. The one road from Lake Turkana cuts through a valley in Nyiru Mountain marked by the village of South Horr and on through Baragoi to Maralal, rich in Samburu culture.

The proud warriors of the Samburu, cousins of the Maasai, can be seen on every street in Maralal with their spears, standing heron-like, one foot raised behind a stiff leg. They inhabit the cool forests of Nyiru and spread into the Ndoto Mountains which they share with their close friends the Rendille, a nomadic pastoral tribe similar to the Samburu, but more monogamistic. The Samburu and Rendille circumcision ceremonies follow each other closely, roughly once every fourteen years.

The Samburu pastoralists find good grazing for their cattle on the

6,000-foot Lorogi Plateau, a game-rich forest land, and in the Ol Doinyo Lenkiyo Range.

The 8,200-foot Poro Mountain which rises above Maralal also abounds with zebra, buffalo, and eland, and with predators which include leopard. Several safari companies base their Turkana adventure tours at Maralal.

As in Maralal, the Samburu also crowd the streets of Wamba, a small administrative centre from which John Hillaby set out to walk to Lake Turkana, an adventure which resulted in the book *Journey to the Jade Sea*. Wamba is a lively trading post overlooked by the 8,820-foot Warges Mountain, the peak of which is a tiring five-hour trek over elephant trails. From the rocky crags martial eagles with wide wingspans circle on the thermals hunting for prey in the ravines below.

It is not far from the Ol Doinyo Lenkiyo Range where the highest peak, 7,792 feet, was named by Teleki after Sir Lloyd Matthews— commander-in-chief of the Sultan of Zanzibar's army—for his help in organizing the Austrian expedition. Beyond are the Ndoto Mountains and an almost untouched game paradise centred around Ngoronet, a virtually isolated mission station which can be reached in comfort only by plane.

Just 50 kilometres from Wamba the track joins the Great North Road by the rounded bluff of Lololokwe, a remarkable 6,400-foot slab of solid rock which rises sheer from the foot of the road and towers over the road junction.

The section of the Great North Road from Isiolo to Moyale took more than six years to build across a scorching wilderness infested by marauding *shifta* bandits at the end of the 1960s and early 1970s. The work was carried out by members of Kenya's National Youth Service and it was at this spot on the 640-kilometre-long road— 50 kilometres from Isiolo—that work ground to a halt. Every time they warmed up the bulldozers and graders the guerillas perched on Lololokwe opened fire and the unarmed youngsters had to dive for cover. The situation lasted for months and one of Kenya's Assistant Ministers for Works admonished MPs for criticizing the delay. He suggested that they should visit the spot where 'they would get a different impression'.

The road enters Ethiopia after the border town of Moyale. On the way it crosses many *luggas*, dried-up river beds in which the nomads of this area dig for water in the dry season. In the rare rainy season the *luggas* become raging torrents, sometimes 30 feet deep, capable of carrying away lorries, houses and even bridges in terrifying flash floods that rise in seconds and fall almost as quickly.

Halfway between Lololokwe and Marsabit is Laisamis, a missionary, police and game control post bordering Losai National Reserve's 1,807 square kilometres. The Reserve touches the Ndoto and Ol Doinyo Lenkiyo Ranges, visible to the west, and has a wide range of game including elephant. There are few facilities, however, for the visitor, though the missionaries are clearly making Laisamis something of a desert metropolis. Before the First World War an English aristocrat making a hunting trip in this region committed suicide after finding his wife in the arms of their handsome hunter-guide, Col. J. H. Patterson,

Opposite: Samburu warriors in the forests of the Lorogi Plateau near Maralal. Conceited dandies, the young men are fearless in their outlook on life. They have to remain warriors for at least ten years before attaining the status of junior elders, at which time they become eligible to marry.

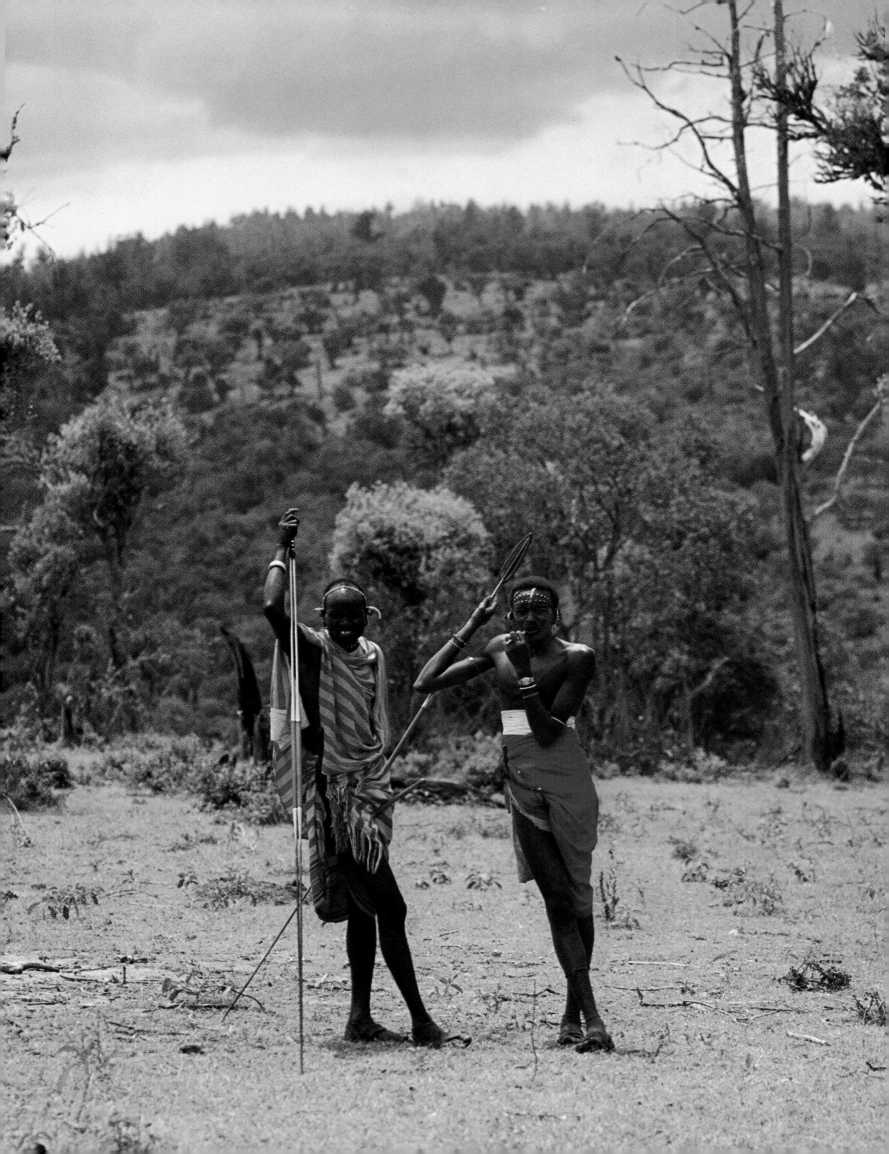

the hero ten years before of the drama on which *Maneaters of Tsavo* was based.

The air-strip in the missionary village of Logologo at the foot of Marsabit Mountain is evidence of the most efficient way to cross the desert. It is here that Milgis Lugga passes under one of the Youth Service bridges. Before the bridge was built flash floods would delay visitors for days.

The car lurches across giant corrugations in a sea of rocks. On either side is the Kaisut Desert: walls of raddled lava; rocks which look like disorderly dumps of rusted cannon ball and shot. The car bottoms, a heavy rock bangs the petrol tank and the fuel drains away. Silencer ripped off, shock absorbers broken, the vehicle belches up the last snaking pass and over the crest into Marsabit Town in four-wheel drive.

Was it worth it? Yes. The soccer stadium is an empty dust bowl adjacent to the brown stain of the main highway. A camel train plods across it in stately progress, the packs on the beasts' backs for all the world like the masts of sailing ships. These are the sticks and skins of the Gabbra and Rendille homes—simple nomadic forerunners of the tent which can be taken down or put up in minutes. With each step the wooden bells around the necks of the camels make a clapping sound.

Petrol stations in various stages of decay dot the town. Shell have pumps but they are not in use. The fuel is brought in on tanks lifted off lorries. The familiar sign flaps forlornly in the desert breeze. Workshops are busy welding what they can. The rusted ghosts of yesteryear's safaris form untidy piles of broken metal. Utilitarian bars offer refreshment and gregarious conversation. A new post office astonishes the eye: above it is the modern microwave relay link which makes it possible for someone in faraway Marsabit to call a friend in Massachusetts, USA.

The heat is as inexorable as in the desert below. The grass is brown and parched and patchy. Two kilometres away the dirt track halts at the gate of the 2,088-square-kilometre Marsabit National Reserve. Once through the gate and round the first bend the forest closes in and the car has passed into another world wherein marvellous secrets of fish and fowl, bird and beast are revealed in magic craters.

The Dida Galgalu (Plain of Darkness) in the north, the Chalbi, Koroli and the Kaisut Deserts, even Marsabit Town, seem far away in this sudden switch from hot desert to cool, primal forest.

The Reserve is sanctuary for lion, caracal, and leopard, for profligate baboon and buffalo, the rare greater kudu and aardwolf, and one of the most outstanding populations of bird raptors in East Africa. At least fifty-two species of eagle, hawk and falcon nest in the 650 to 700-foot cliffs amid stands of juniper and podo which give the Reserve's many craters a green fur lining, caused by the unusual early morning mists.

The trees, and the Reserve's elephants, make Marsabit a natural phenomenon. Born out of volcanic fire Marsabit Mountain is shaped by mist. Each night the heat drawn from the desert cools, takes form and an hour or two before dawn clamps its clammy fingers around the western peak. It rarely releases its grip before early afternoon. For

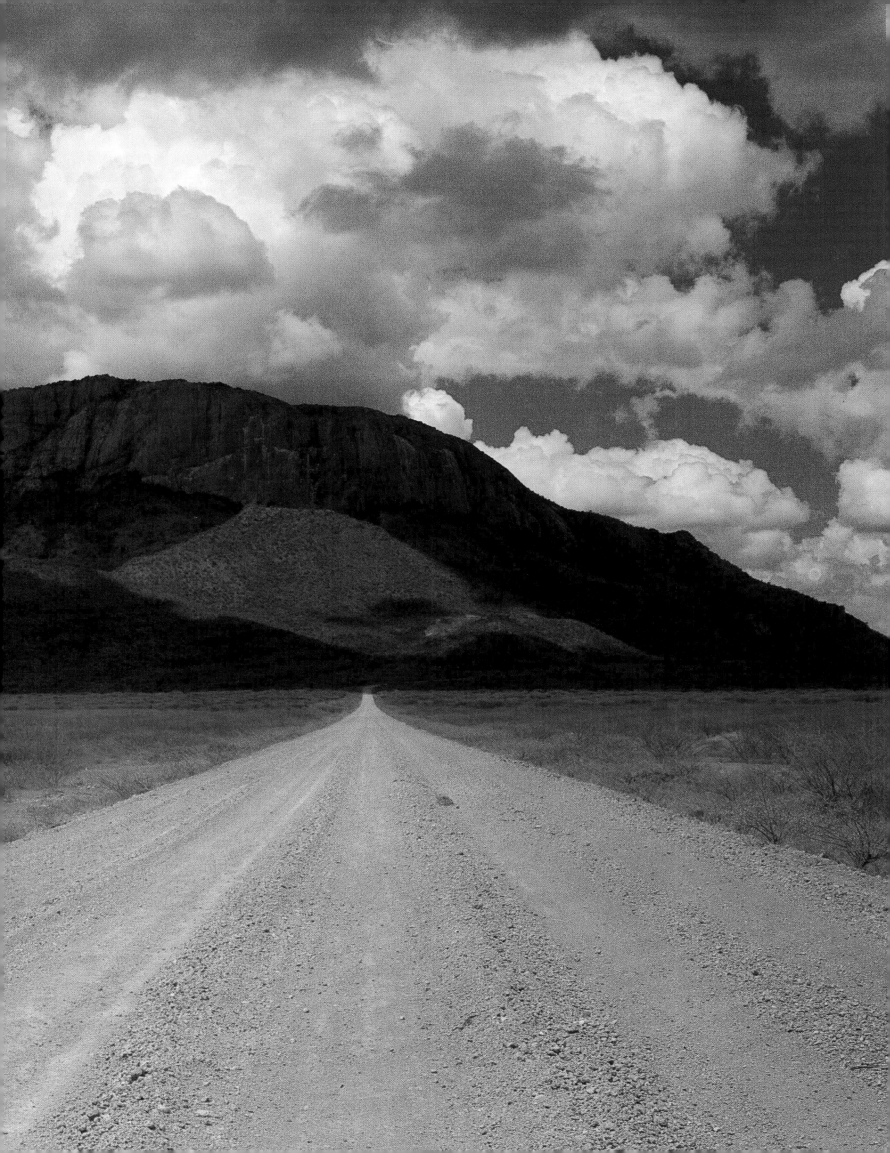

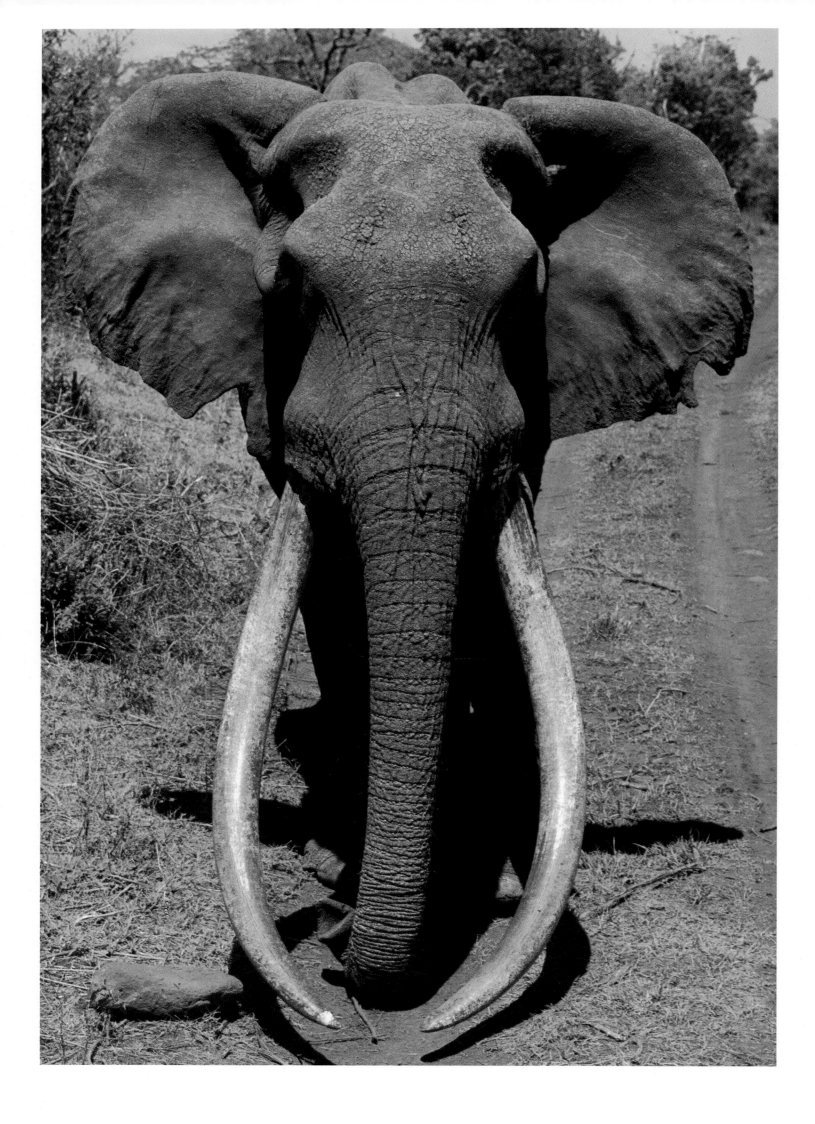

centuries its cold and wet touch has quenched the thirst of the olive and the cedar and laid tendrils of Spanish moss across the branches to keep them cool when the afternoon sun glows warm.

The bowls of the craters form natural amphitheatres. Mohamed, scion of Ahmed the Great who was a living legend and protected by Presidential decree, often leads his harem to the marsh grass at the rim of the Sokorte Guda bowl, perhaps one and a half kilometres in diameter. The simulated skin and tusks of Ahmed stand in realistic likeness at the National Museum headquarters in Nairobi. Marsabit's tuskers are the last survivors of the giants of old. Their tusks recall the days when Kenya was roamed by great bulls with ivory weighing more than 100 kilogrammes a pair.

Higher up misty Marsabit Mountain lies another amphitheatre called Lake Paradise. On the way to it there is a dappled glade with a rock pool filled with hyacinth. Above the pool there is a tree with two herons' nests. The water is filled with elephant dung. There is a concrete dam but no water spills over the slipway, and the pumping station and an attendant's house are both empty. The pump is silent. Karare is an ages-old water hole for elephants but then came man to say that this must be his water, too. The dam was built. The pump was installed and a sign put up which said: ADMISSION STRICTLY FORBIDDEN. The elephants could not read. They ignored this sign and now man has gone away from Karare and the water belongs once again to the beasts of the forest.

Lake Paradise lies below its old 500-foot caldera, rimmed with forest trees laced with Spanish moss, also known as Old Man's Beard. On one side, however, the caldera descends almost to lake level. From the air it looks like an eye—the pupil changing hue and tone, the iris sharp and clear and the lid curled, coy and seductive. For four years, in the 1920s, the American naturalists and film makers, Martin and Olsa Johnson, made their home at Lake Paradise.

Marsabit has other interests. The uncommon desert people meet here on common ground—the Gabbra, Rendille and Borana are attractive but uncompromising pastoralists with fascinating cultures. The Gabbra have a close-knit unity in which whole families of in-laws live together. The Rendille, close neighbours of the Samburu, who share many of their customs, believe it ill-fated to allow second-born or subsequent sons delivered on a moonless Wednesday to live, and so practise infanticide. The Rendille used to be close friends of the Gabbra but when the Gabbra attacked the Samburu many years ago this friendship ended and now neither trusts the other. All, however, have come to terms with their environment, bleak and arid and hot, to a degree of harmony which few peoples could hope to achieve. But it is a hardy existence. They have to dig deep permanent or temporary wells for water for themselves and their herds.

One set of wells, owned by the Borana, is known as the Singing Wells. They lie in a dusty valley. At the entrance cattle turds stain the red soil and brown boulders. The wells plunge vertically, 15 to 50 feet deep. The watering takes place each morning. The well masons work in

Opposite: Borana tribesmen raise water from a deep, permanent well in a valley situated on the lower slopes of Marsabit Mountain. The men scoop up the water in a series of rhythmic movements, using three buckets stitched out of giraffe hide and raised up and down with all the speed and dexterity of a circus juggling act. The wells form the only permanent water supply. In this century, the region has had heavy rains on only six occasions.

Below: A Borana woman in Kenya's far north. The tribe occupies the vast deserts around Marsabit mountain, migrating in seasonal patterns with the onset of the region's rare rains.

Right: Burji peasant farmer tossing grain to separate the chaff on his marginal farmholding in Kenya's far north-east, at Moyale on the border with Ethiopia.

Below: Elder of the Burji tribe at work with a traditional loom.

mud and water to fashion a quick-drying trough in the harsh forenoon sun.

Four men form a human ladder, the lowest one chest-deep in the water below, the second perched on a rocky ledge, the third balanced expertly on two slender poles and the fourth at the top. Three buckets of stitched giraffe hide are swung up and down in harmonic rhythm, the human ladder singing a song which sounds like a hymn. The trough is quickly filled. The Borana women, with glowing skins and aquiline features, garbed in full-length robes, hair crimped in old-fashioned style, hurry to take home the day's supplies. The beasts drink eagerly. The value the desert people place on these animals is clear. Rather than risk them dying in Marsabit's chill night air, they opt to walk as far as 70 kilometres to the heat of the desert floor before returning once again to water them.

The road continues from Marsabit to Moyale where it enters Ethiopia. To the far east is the town of Mandera where the three boundaries of Kenya, Ethiopia and Somalia merge.

Further inland is Wajir, an administrative centre in the middle of Kenya's vast northern desert with a relic of colonial eccentricity—the Royal Wajir Yacht Club. The nearest water is 600 kilometres away. The club was given the Royal prefix after entertaining a member of Britain's

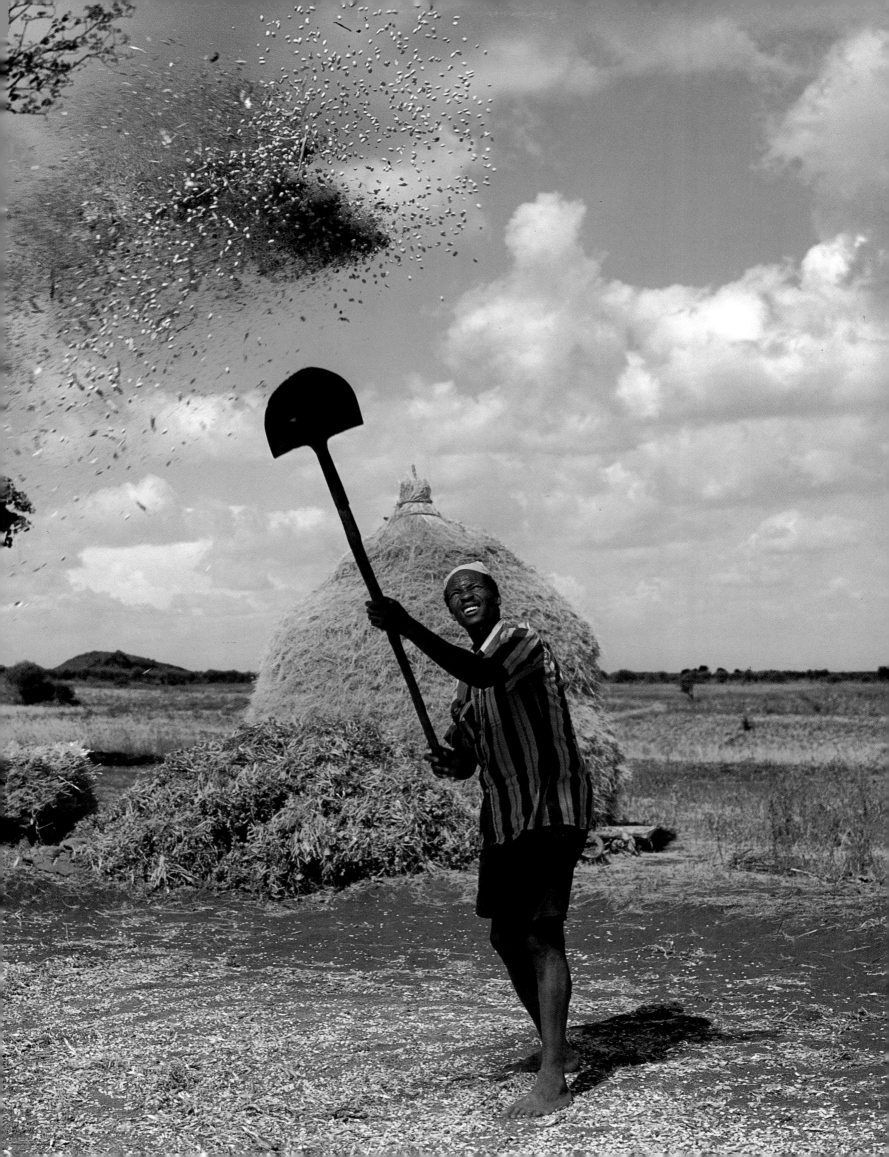

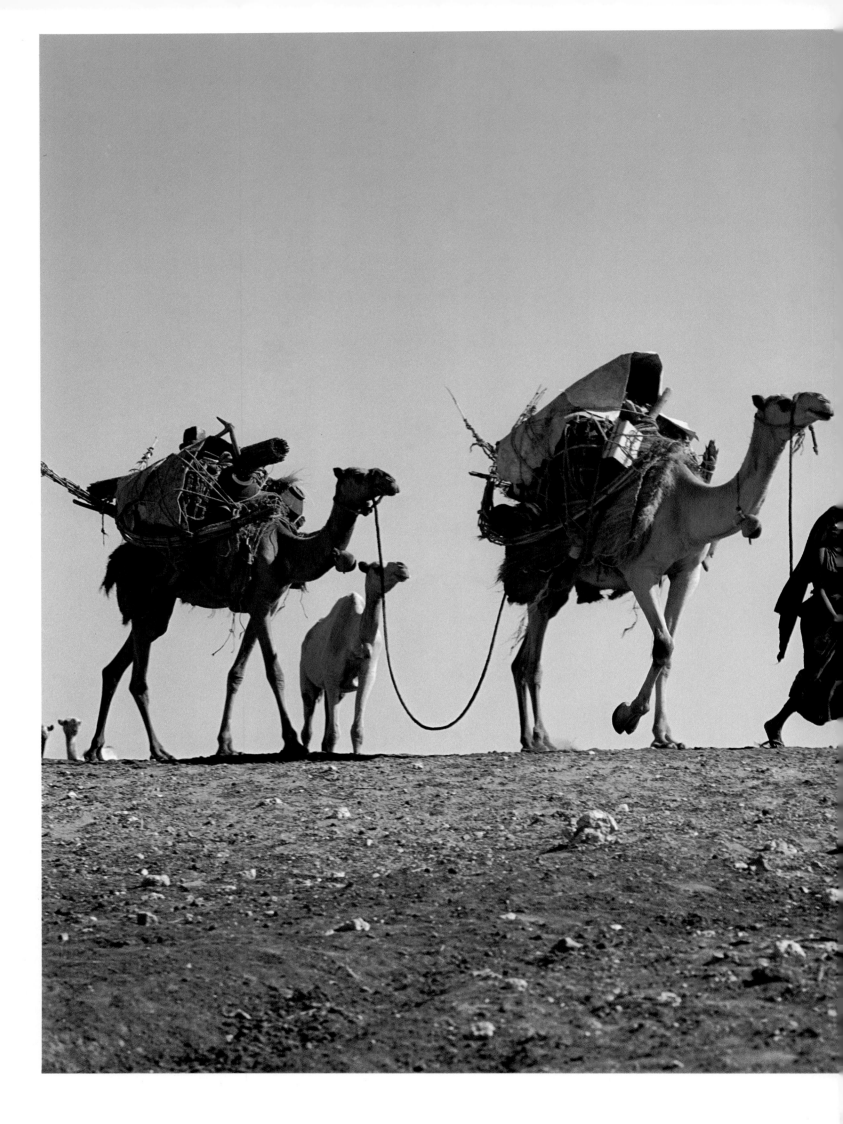

Left: Somali woman crosses Kenya's northern desert with her pack animals. Some Somali practise blood-letting and all supplement their milk-and-meat diet with grain whenever available.

Below: Young Somali herdboy at a water hole in Kenya's dusty northern deserts. Kenya's Somali groups number about a quarter of a million.

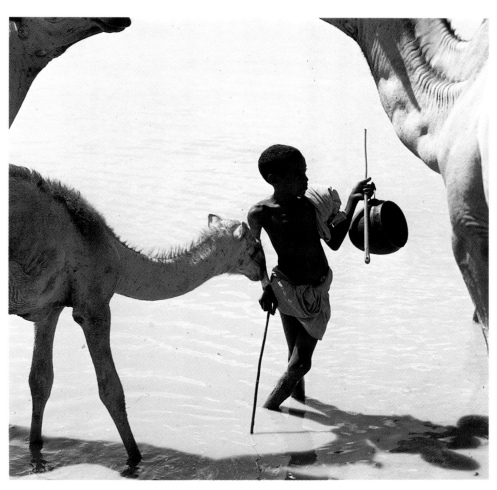

Royal Family in pre-Independence days. Now it is used as a hostel for civil servants.

Other intriguing desert outposts with names like el Wak, Mado Gashi, and Habaswein stand out above the flat countryside. Their castellated Beau Geste style forts are reminiscent of military outposts in a Hollywood version of the story of the French Foreign Legion. However, these battlements are not part of any celluloid make-believe but lines of defence against raiding Somalis who make this area of Kenya one where the military must be constantly vigilant in defence of land, cattle and property.

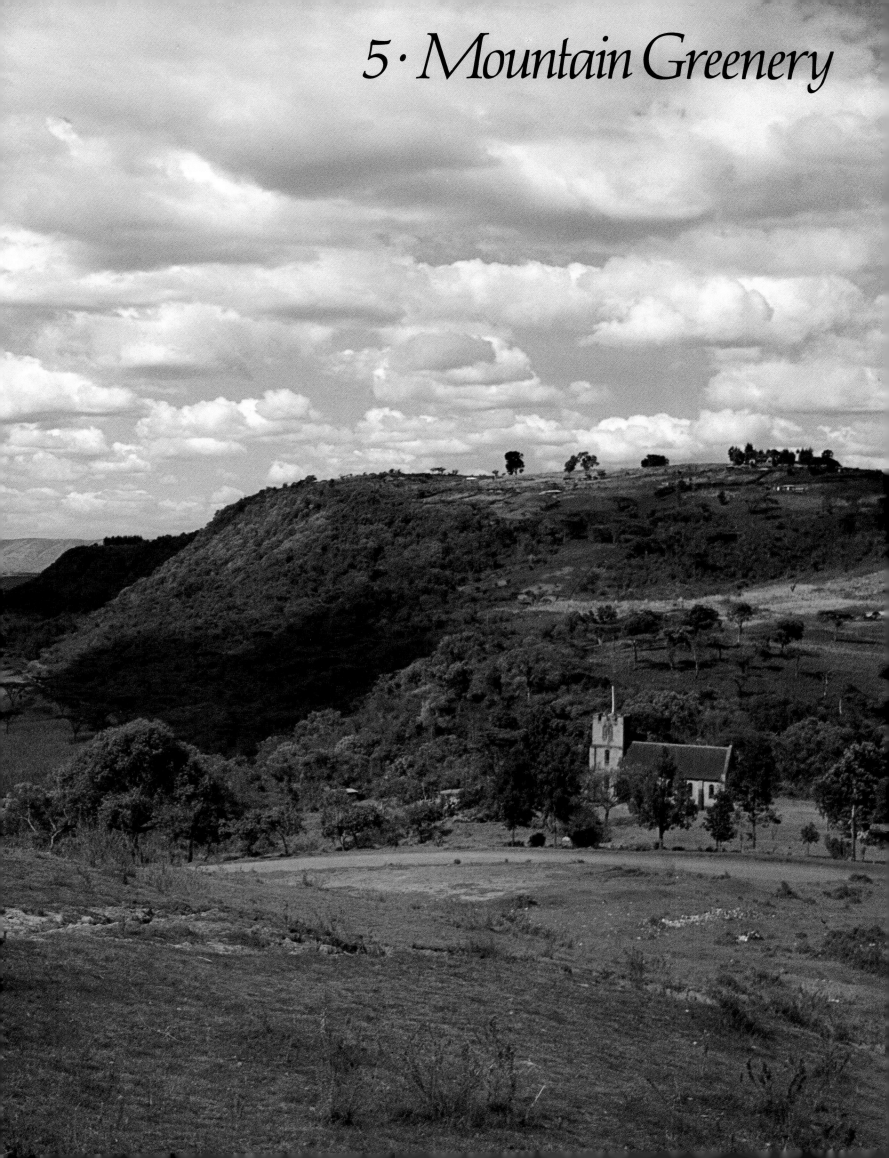

In the crystal dawn, the air so keen it seems almost pure oxygen, the hill beyond Nakuru's Menengai crater climbs through coffee country to a valley on the north shoulders of the Aberdare Range.

The moment is intoxicating. The Rift Valley lies 3,000 feet below the ridge of the escarpment. On the other side, cool and fresh, is Subukia, an undiscovered riot of dirt roads, green fields, tea and coffee plantations, and landscapes which might have been painted by Van Gogh. The eye cannot avoid the church by the side of the road. It is straight from a European scene and could well have sat among its garden of flowers for more than a thousand years. The spread of the Laikipia Escarpment and the tangled glory of the Rift as its backcloth, however, indicate that this is an illusion. A look at the date above the door of the Norman style church of St. Peter's of Subukia establishes the truth. It was built in 1951, a delightful piece of Christian religious nostalgia—and perhaps a shade on the snobbish side. But today its congregation are hardworking smallholders, no doubt similar to the farm workers who gave praise in such churches in feudal Europe.

After three more hills the road heads into the town of Nyahururu known the world over as Thomson's Falls. Nyahururu stands on the northern slopes of the Aberdares.

The Falls themselves are formed by the waters of the Ewaso Narok which plummet 237 feet at the rate of 900,000 litres a minute to leave the forest on top of the ravine bathed in perpetual mist. A small lodge commemorates Thomson's name and so does one of Kenya's most attractive plains game, Thomson's gazelle, a honey-brown and black species with a dash of white on its rump, and a permanent neurotic twitch. Its lifespan is about seven years, mostly spent in constant fear of being seized by a predator.

Perched at a lung-sapping 7,740 feet, Thomson's Falls' other claim to international fame was as the site of a high-altitude training camp for Kenyan and other athletes preparing for the Mexico Olympics of 1968. The camp has since fallen into disuse as Kenya, for political reasons, withdrew from the 1976 and the 1980 Olympics. The athletes ran among the green moorlands where cattle graze on lush grass and smallholders grow maize, beans and sweet potatoes.

West of the Aberdare moorlands lies the town of Ol Kalou and a salient below the forested head of 10,987-foot Kipipiri which, during the 1920s and 1930s, was nicknamed 'Happy Valley'. Outcasts from Europe's rich families and wealthy settlers built baroque homes all along the valley, raised cattle and played hell with morality. The repercussions of these 'keys-on-the-table' European high jinks dominated the 1941 headlines in Kenya, and even in war-riven Europe, over the mysterious murder in Nairobi of a Scottish earl, Lord Errol. Outrageous scandal said that the murder had something to do with the goings-on of the 'Happy Valley' set. Before his death the Earl, a notorious womanizer, was described by one divorce judge as an 'unmitigated blackguard'.

To the east of the Aberdares runs the highway linking Nyahururu with the capital of this region, Nyeri. In between is fascinating country. The Aberdares rise on one side and 80 kilometres away across the Laikipia Plains is Mount Kenya. The Plains hold some of Kenya's largest

Preceding pages: St. Peter's Church, Subukia, high on the northern-most slopes of the Aberdare Mountains. Built in 1951, this attractive Norman-style church stands at the edge of one of the Rift Valley's magnificent scarps with the neighbouring Laikipia Escarpment in the background.

Opposite: Queen's Cave waterfall high in the Aberdare National Park was named after the 1952 visit by Princess Elizabeth on holiday with her husband Prince Philip, the Duke of Edinburgh. It was during this holiday that she became Queen, on the death of her father, King George VI. At the top of the cliffs, overlooking the falls, is a wooden pavilion built so that she and her husband could eat lunch in cool shade. The giant flowers are groundsel.

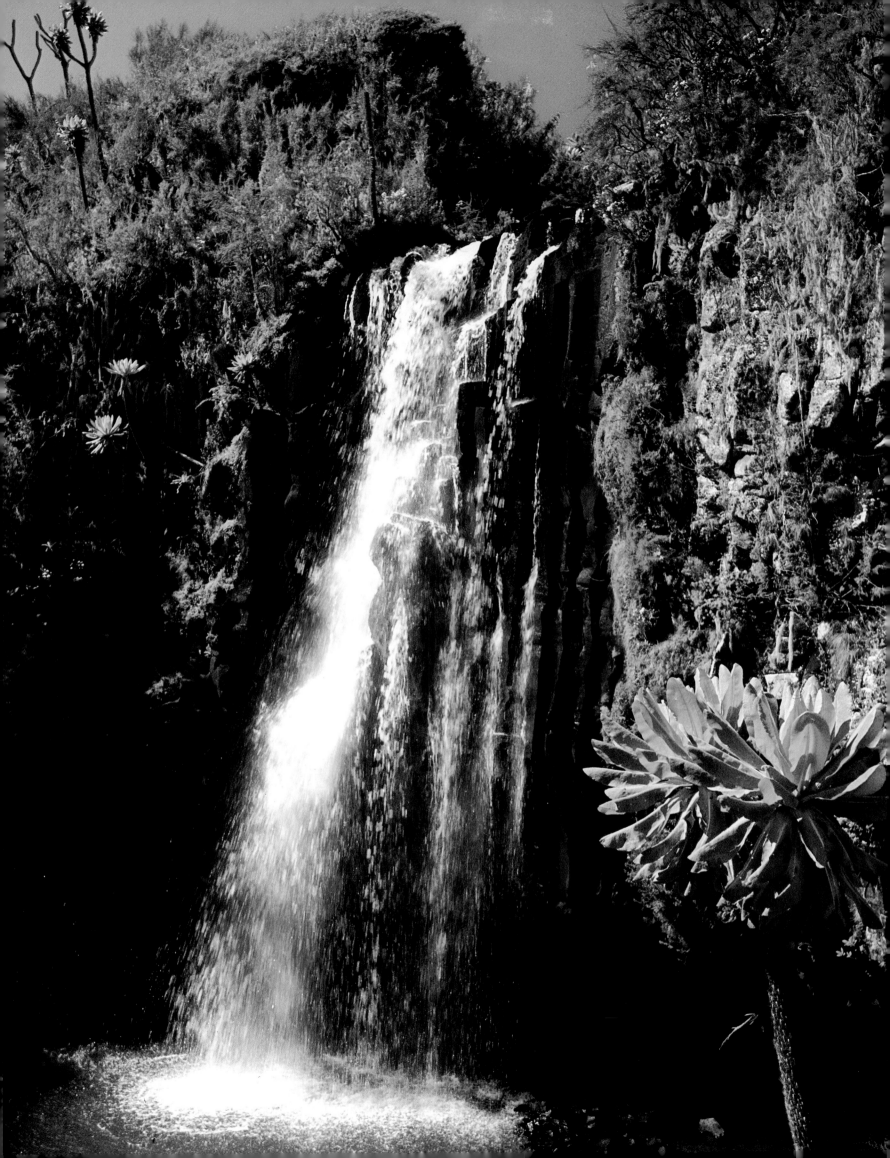

Below: Thomson's gazelle, named after the young Scotsman who walked across much of Kenya in 1883, having been sponsored by Britain's Royal Geographical Society. The size, beauty and gentle habits of the species have made it a favourite with all wildlife enthusiasts. Fully grown, a male reaches little higher than 2 feet, with a weight of about 25 kilogrammes.

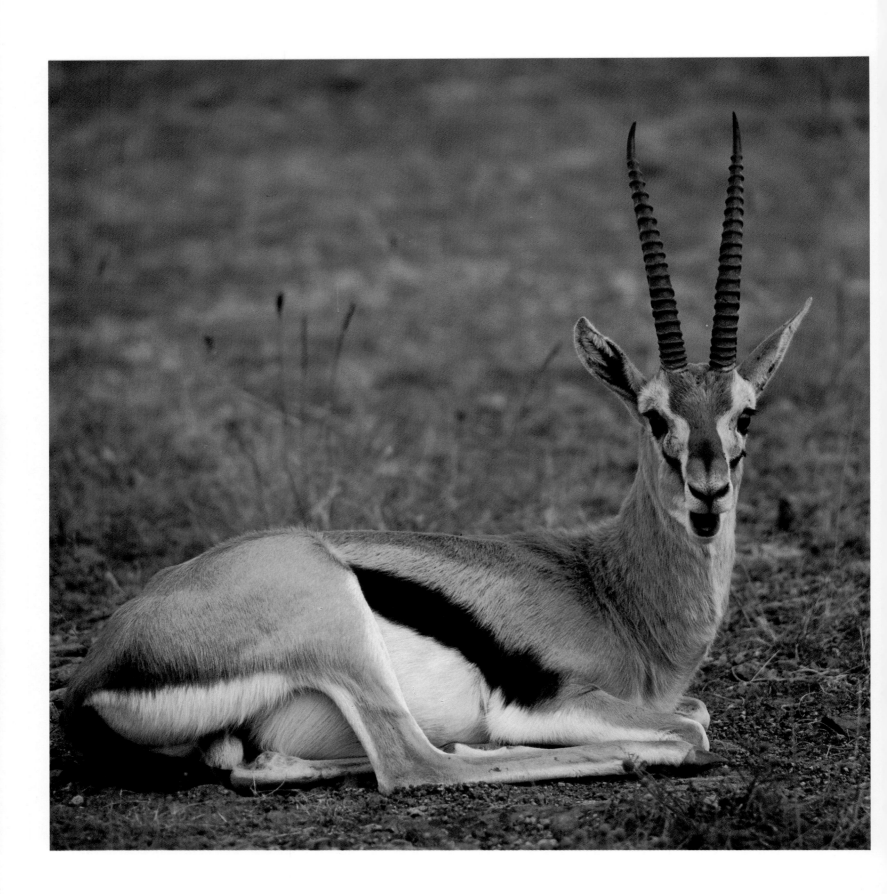

Overleaf: Giant groundsel in rare and vivid yellow bloom above 10,000 feet in the Aberdare Mountains. Flowering of these extraordinary mutations of what are normally tiny Alpine plants—at high altitudes they rise to heights of more than 20 feet—occurs roughly once every twenty years. Groundsel and other giant Alpines like lobelia are also found on the Cherangani Hills, Mount Elgon and Mount Kenya. The 13,120-foot peak of Ol Doinyo Lesatima is in the far distant background at left.

ranches and two have been maintained not only for cattle but also as magnificent private game reserves, heedless of the expense of costly fences trampled underfoot by browsing elephants. One of these ranch-reserves is Solio, close to Mweiga, and another is Ol Pejeta—a public company which runs more than 16,000 head of beef with wild elephant and other indigenous game species. The majority of shares in this ranch are held by the Saudi Arabian billionaire Adnan Kashoggi who is philosophical about the damage the wild animals do to the property, preferring to regard them as a trust charged to the ranch management.

The damage these beasts do to the smallholdings on the other large ranches which have been subdivided, on the other hand, is cause for worry. Expensive efforts to capture rhinoceroses through drugging them with darts and then translocating them to national parks and reserves had some success at the beginning of the 1980s. More than sixteen of these imperilled beasts were captured and released in places like Nairobi Park. Extremely territorial, they were confined to their cages near the Park entrance until they became accustomed to their new locality. However, one became so eager to regain his freedom he kicked his way through the cage and fled—luckily into the park and not out of it.

An American sculptor called Mihail attracted international attention when he persuaded game authorities to tranquilize a mature bull elephant on Ol Pejeta land in 1980. He spent three hours encasing the comatose, slumbering giant in bucketfuls of a quick-setting plastic dental material. One side was white and the other half was coloured pink—Kenya's first recorded instance of white and pink elephants. Mihail left behind a triumphant sign proclaiming his feat and returned to New York to cast ten life-size, bronze statues of the elephant to raise what he hoped would be a million dollars for conservation work.

Closer to the shadow of the Aberdares is Ngobit, a ranching town which also has a fishing lodge offering some of the best stretches of trout water in Kenya. These fish were introduced into the icy streams of the Aberdare and Mount Kenya Ranges early in the century by Captain Ewart Grogan, who walked from the Cape to Cairo to demonstrate his love for a woman. In 1906 the Captain imported 30,000 trout ova from Scotland and placed them under an experienced Scots ghillie called Arnott. Of these 10,000 failed to hatch. Of the 20,000 that swarmed to life, 2,000 fry were choked in silt raised by mountain floodwaters. But the remaining 18,000 flourished to form the nucleus of Kenya's stocks of rainbow trout. With brown trout, they continue to provide attractive sport for anglers.

Foul fishing is not allowed. Anglers have to play fair and the rules are strictly enforced by Fishery Wardens. Record weights have touched almost 7 kilogrammes for a rainbow and almost 6 kilogrammes for a brown trout. The best trout rivers run off the Aberdares and Mount Kenya, and names that bring nostalgic smiles to the faces of seasoned anglers are Naro Moru, Burguret, Sagana, Thego, Chania, and the

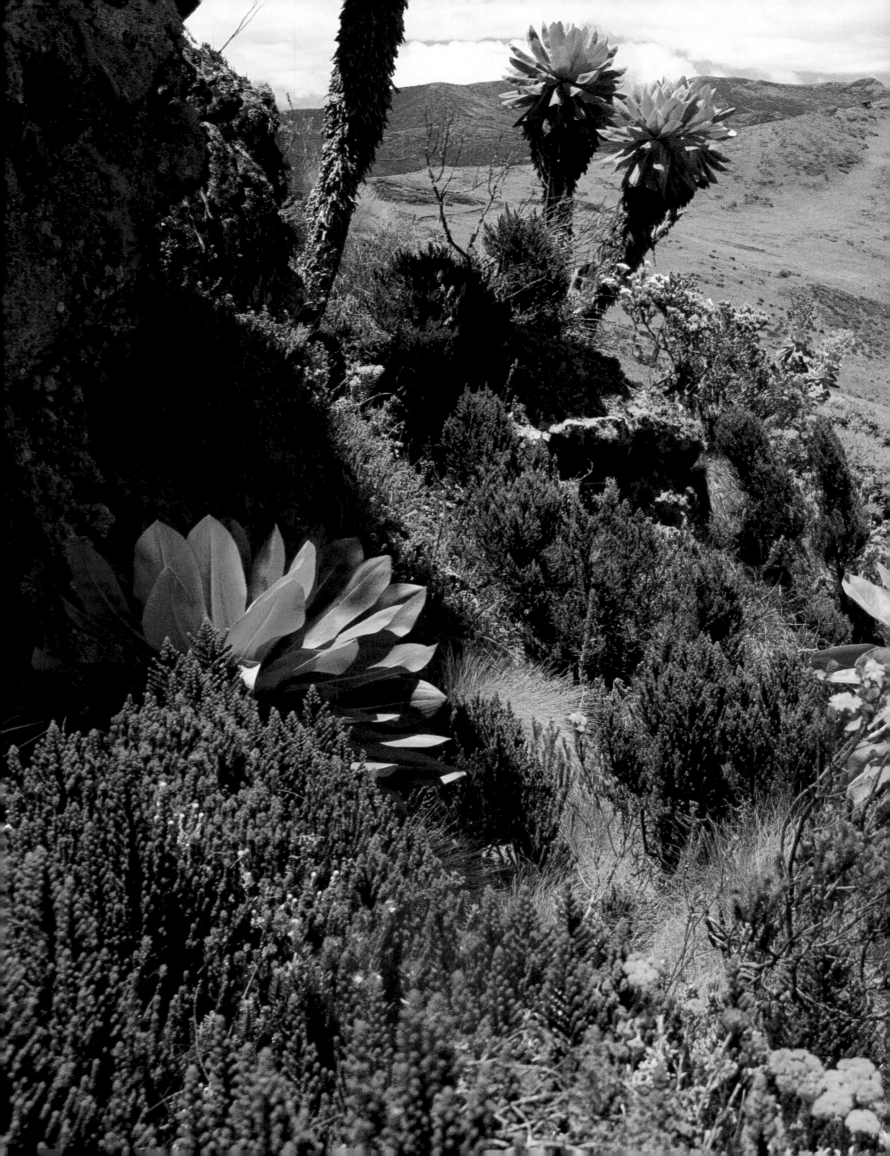

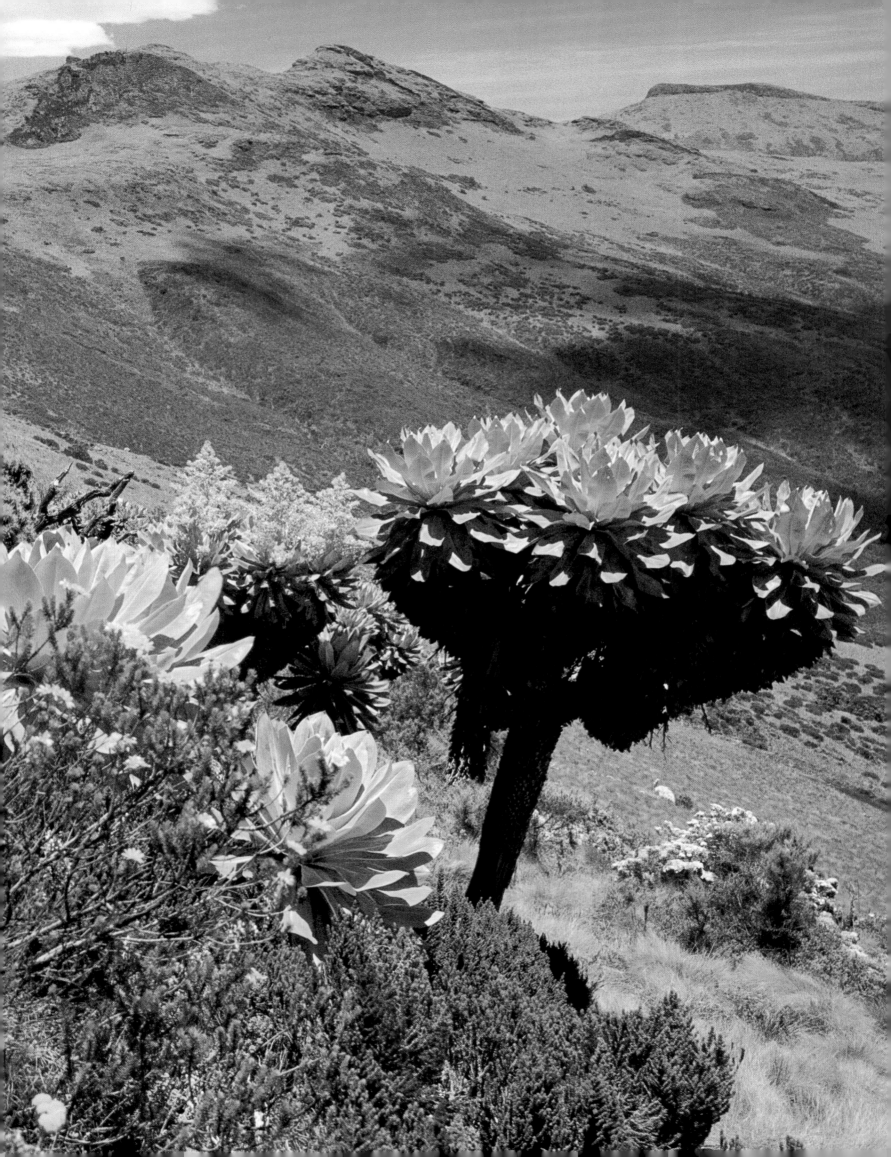

Gura—which has Kenya's highest falls, almost 1,000 feet. These and the Thika, Kiringa, Rupingazi, Nyamindi and others are Kenya's fish havens.

The Aberdares are remembered as the forest battleground in which many of Kenya's heroes such as Dedan Kimathi led the struggle for independence and earned themselves an enduring place in history. These highlands have a place, too, in British history. In February, 1952, Princess Elizabeth spent a holiday in Kenya with her husband, Prince Philip, the Duke of Edinburgh. On the evening of 5 February she climbed the steps of the world-famous Treetops Hotel to watch the wildlife below. When she stepped down in the morning it was to learn that she had become Queen of Great Britain.

Treetops was built in 1932 by Eric Sherbrooke Walker at the behest of his wife Lady Bettie Fielding, who wanted a tree house in the style of the one in J. M. Barrie's play *Peter Pan*. Walker was the owner of the

Opposite: Treetops, the famous house in a tree,
rebuilt in the 1950s after fire destroyed the
original. It was here that Princess Elizabeth slept
on the night her father died, when she stepped down
in the morning to learn she had become the Queen
of England.

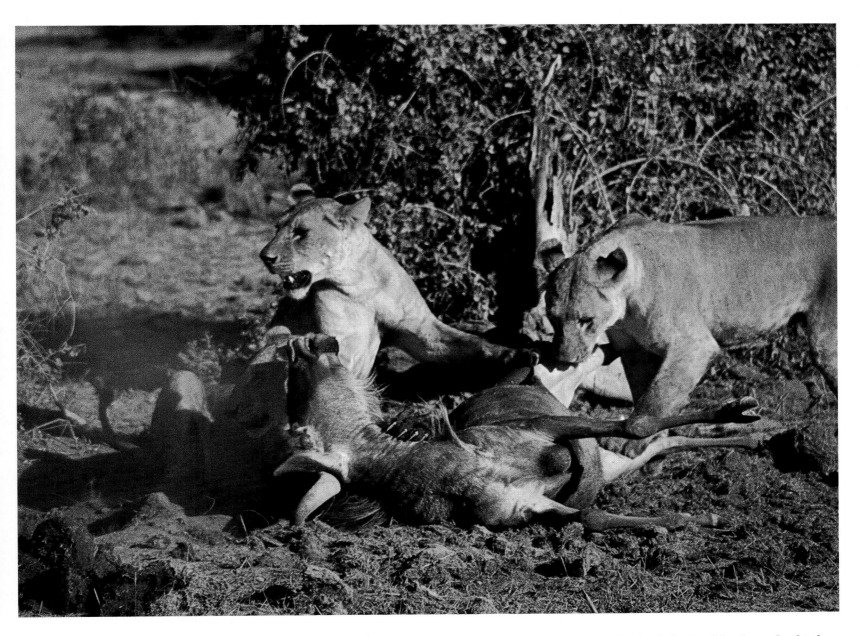

Above: Three lionesses gorging themselves on a
wildebeest kill. They hunt communally and kill
quickly, usually by springing or pouncing on the
prey from behind and jerking the head back.
Females hunt more frequently than males. The
species was once spread all over the world—they
did not become extinct in Greece until 200 BC—and
can survive at altitudes as high as 12,000 feet. The
king of the jungle lives a life essentially of idle love-
making but he can display prodigious energy when
needed. Some beasts have been known to jump
ditches as wide as 12 metres.

Outspan Hotel, the gracious Nyeri hotel which he had built and which
the Chief Scout, Lord Baden-Powell, chose as his retirement home.
Baden-Powell used to say, 'The nearer to Nyeri, the nearer to Heaven'
and spent his last years in a cottage in the Outspan grounds, called
Paxtu.

The cottage has been preserved as a Scout memorial but still
accommodates guests. Those who spend a night in it find it an evening
of rare peace. Something of the spirit of the Old Man, and of his quest for
peace, inherent in the cottage's name, still lingers as you browse over
the letters and memorabilia he left behind. It is a noble monument.

Lord Baden-Powell's remains lie in Nyeri churchyard along with
those of another famous name of the pre-war era, the Indian Big Game
hunter Jim Corbett.

Fire destroyed the original Treetops five years after Queen Elizabeth's
visit. It was rebuilt on a much larger scale and its roll of honoured

guests reads like a Who's Who of the World's Most Famous People.

The house in a tree predated the Aberdare National Park by almost twenty years. Established in May 1950, the 767-square-kilometre sanctuary is home for one of Kenya's largest herds of buffalo. It also has big families of bush pig and wart-hog. The Park, ravaged by fire in 1981, is composed of two high peaks, Lesatima, 13,120 feet, in the north, and Kinangop, 12,816 feet, in the south, with a moorlands plateau running between them. During the fire, which raged for more than a fortnight, billows of smoke plumed from the dry moorlands grass and could be seen 80 kilometres away. The flames destroyed ages-old stocks of 20-foot-high giant heather.

Blackened pastures testify to the fury of the moorland blaze which left only the giant, water-filled groundsels and lobelias untouched.

Wild animals fled the inferno, among them rare melanistic creatures which survive only in high-altitude areas—black servals and black leopards, rarely seen except in the most unusual circumstances.

The road to these moorland heights climbs through virgin forest filled with gnarled, ancient trees, their limbs rich with growths of an olive-green, parasitic moss. It makes the rheumy fingers of the forest branches look like gnomes from one of Tolkien's modern fables.

The 46 kilometres between Lesatima and Kinangop is an almost undisturbed high plateau much like Conan Doyle's *Lost World*, tramped by herds of wild and often unpredictable elephant, prides of lion and other carnivores. Their droppings provide a spoor but they are rarely seen. Their uncertain tempers stem from hereditary memories of bombing raids by British planes during Kenya's freedom struggle when these ancient hills provided a natural fortress from which Kenya's freedom fighters could strike out at their imperial oppressors.

The Range is an easy day excursion from Nairobi, entering the Park at one gate, perched 10,058 feet high, 27 kilometres from Naivasha. The rough road leads to a delight of waterfalls—from the shadowy depths of the Chania, to the groundsel-studded beauty of the Queen's Cave Falls and the dramatic, giddy leap of the Gura Falls down a sheer 1,500-foot face. The vista is captured on the precipitous brink of the sister Karura Falls, which themselves plunge 894 feet down the opposite wall of this one-kilometre-wide ravine.

The waters of the Gura sway plasmically in the strong afternoon thermals, curling and bending like a length of white twine, yet falling unerringly on the same spot 1,000 feet below its lips, before tumbling another 500 feet to the valley floor.

High on Lesatima, at 13,000 feet, lungs grasping at the thin but precious air, giant groundsels in a plume of vivid yellow are flowering after a lapse of twenty years. The Equatorial sun burns the skin as icy winds cool the blood. In the distance, 80 kilometres away, across the hazy Laikipia Plains, the snowy fingers of Mount Kenya beckon the breathless and the bemused.

The 5-foot-high tussock grass traps the feet on the descent to a long ridge and an exhilarating walk towards the Kinangop, the occasional droppings of a hyena or carnivore revealing that the walker is never alone even at these heights.

The appearances of these and other creatures outside Treetops and

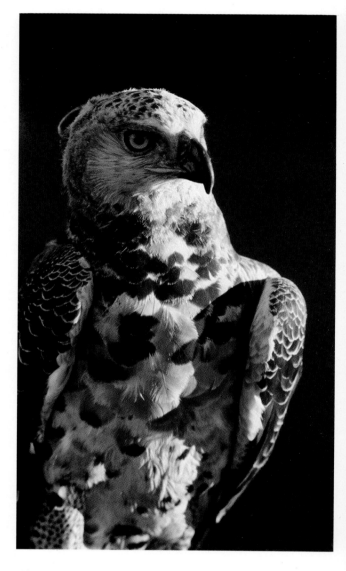

Above: Crowned hawk eagle, one of the many species of bird raptor found in Kenya.

Right: The secretary bird is rarely seen in flight, preferring to progress by strutting on its high legs in the exaggerated style from which it has won its common name. It is a bird of prey, none the less, despite its mincing walk.

similar night-time game viewing lodges makes a visit to them so worthwhile.

The mixture of *Boy's Own* adventure and five-star elegance is irresistible. A hunter meets the guests who assemble 200 metres from the lodge and he leads them, gun at the ready, to their accommodation. Barriers stand along the route to provide refuge in case of attack by any of Kenya's Big Five—elephant, rhino, buffalo, lion or leopard. The guests climb a wooden staircase which leads up inside the house in a tree. The rooms are comfortable and on the roof there is a viewing balcony.

Most of the animals appear at the water hole after sundown. For the watchers, it is a trip in time back to primordial Africa; this is where it all began. Once inside the lodge there is no release until the morning. Nor would anyone ask it. Warm coals provide glowing heat, a well-stocked bar conviviality, and a first-class kitchen a delightful dinner. Imagination in such catering is not necessary; a visit to Treetops is a once-in-a-lifetime experience for most. One lodge has served the same smoked tunny fish, turkey dinner and crêpes suzette every night for three years.

Treetops stands in the Park's eastern salient, which is the area closest to human habitation. Wide, deep moats surround the boundaries. These prevent the elephants and larger animals from leaving the Park

and destroying the smallholdings of the peasant farmers—an uneasy compromise, perhaps, but better than no compromise at all.

The Aberdare Park has many entrances and can be approached from any direction. Through Naivasha it is a pleasant one-day excursion from Nairobi, along a 10,000-foot-high moorland road which was formally opened by Britain's Queen Mother in 1959. There are now exits at Nyahururu or Nyeri. From Nyeri it is a short drive to Mount Kenya past the country's Police Training College at Kiganjo from which many of the nation's top athletes have graduated. A short detour on the shoulders of the mountain uses one of Kenya's most scenic roads passing Sagana State Lodge (which was built as a wedding present for Princess Elizabeth and is now the Presidential State Lodge) and a nearby trout farm where the experienced fly-fisher can catch his own lunch and watch it being broiled.

Mount Kenya, the most perfect model of an Equatorial mountain, is one of the highest national parks in the world. The Batian peak, at the apex of the Park's 704 square kilometres, thrusts 17,058 feet into the azure blue of an African sky. The phenomenon of snow on the Equator was dismissed as improbable by the closed minds of nineteenth-century European geographers. Reports in 1848 by the German missionary, Ludwig Krapf, of a mountain with snow were ridiculed. Even Thomson's eye-witness confirmation of the peak in 1883 was only grudgingly accepted by the more cynical among these learned men. Thomson's delight at his discovery was self-evident. 'Through a rugged and picturesque depression in the range (Aberdares) rose a gleaming snow-white peak with sparkling facets which scintillated with the superb beauty of a colossal diamond. It was in fact the very image of a great crystal or sugar loaf.' His eyes filled with tears.

According to Kikuyu legend the God Ngai, who sits on top of Batian, ordered Gikuyu and Mumbi, the father and mother of all Kikuyu, to make their home at Mukuruene wa Nya-Gathanga, which means 'the tree of the building site'. It lies outside Murang'a town and is filled with wild figs, the tribe's sacred tree. It is here, legend affirms, that Mumbi raised the nine daughters who were the progenitors of the Kikuyu's nine main clans. Mount Kenya is the tribe's sacred mountain.

The Kikuyu are Kenya's largest group, numbering more than 3.2 million in the 1979 census. They are Bantu by origin, and agriculturalists, but they keep domestic cattle and have entered into every aspect of Kenyan society as perhaps the most motivated ethnic group in the country. They call Mount Kenya Kirinyaga, or Kere Nyaga, 'White Mountain'. Subsequent contractions gave both the mountain and the nation their name.

But to really appreciate Mount Kenya's moods and its beauty it is necessary to climb through the damp cold of its bamboo and juniper forests, festooned with Spanish moss, to the moorlands above 11,000 feet. At this height the snows above appear pellucid, and 3,000 feet higher the ice-cliffs sparkle and twinkle like jewels. The sheer face of one 2,000-foot cliff is next to the aptly named 'Diamond Couloir'. The cliff's facets refract the light of the early morning sun. Shaped by nature's own gem-smith, the cutting edges of the jet stream have fashioned it into a unique African jewel. These are diamonds that

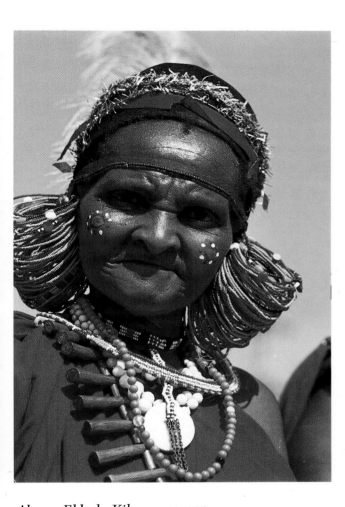

Above: Elderly Kikuyu woman.

Right: Kikuyu tribesman in traditional decoration. Kenya's largest tribe, the 3.2 million-strong Kikuyu are of Bantu origin. They settled many centuries ago in Kenya's central highlands around Mount Kenya and the Aberdares.

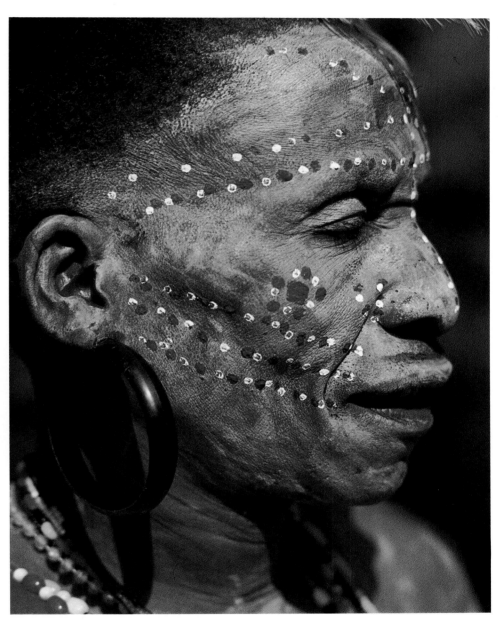

change their shape and beauty with the daily melting and freezing of the snows.

The sun in the southern hemisphere during one half of the year and in the northern hemisphere for the second half has created a phenomenon unique to Mount Kenya. The south face receives direct sunlight in the first six months and provides ideal rock climbs. The north face, excluded from direct sunlight, remains iced-up and offers ice climbs. Then in the second half of the year, within days, the situation is reversed as the solstice changes.

The peaks provide a challenge provocative enough to stimulate masters who have conquered major Himalayan routes. Indeed, experts rate Kenya as the world's toughest ice mountain. Warden Phil Snyder pioneered a great many new routes and, each year, thousands flock to the Park's main gate, 8,000 feet up the mountain, to test themselves

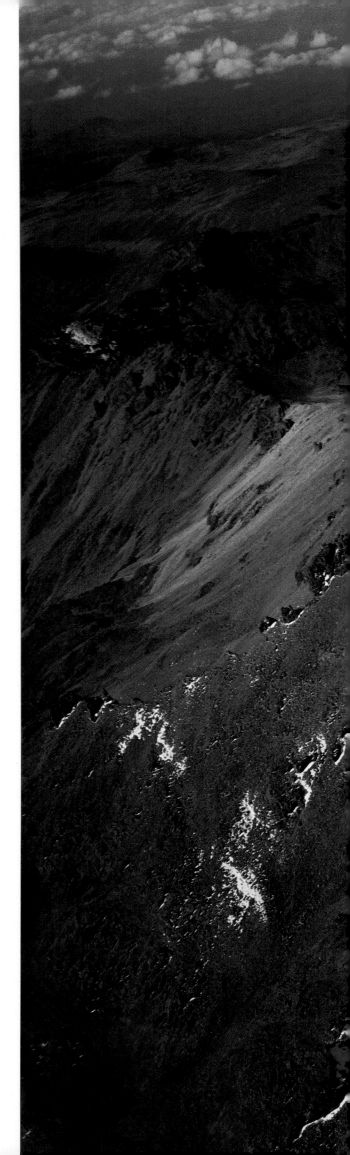

Right: Ice glaciers and cliffs on 17,058-foot-high Mount Kenya. Batian, the highest peak at right, is 36 feet higher than its twin, Nelion, from which it is separated by a narrow ridge known as 'Gate of Mists'. In the foreground, at left, is Harris Tarn at 15,100 feet. The mountain's third peak, Point Lenana, which can be reached by an inexperienced climber able to withstand the 16,300-foot altitude and the stiff walk, can be seen above the tarn on the other side of the Lewis Glacier.

against a vicarious combination of hurricane winds, shifting ice, and the risk of pulmonary oedema, a lethal high-altitude sickness endemic to Mount Kenya. It is possible for amateur climbers to ascend the Lenana Peak, 16,300 feet, but the rest offer stern challenges.

The excitement all begins at the 14,000-foot level around the base of the long dead volcano out of which the 'plug'—now the mountain's craggy, ice-capped topmost peaks—rises. The twin peaks, Batian and Nelion, are separated by a small ridge called 'Gate of Mists'. From the base an astonishing assortment of secondary peaks, walls, ice-cliffs and couloirs rise up in profusion running from 600 to 2,400 feet, all offering tests as severe as any found in the Alps or Himalayas. These climbs alter in quality all the time because of the unpredictable changes in weather. During sunny days a well-established ice pitch can turn into a wall of treacherous slush.

For this reason, all climbing is best done in Kenya's two dry seasons— January to early March and July to early October. Climbing has been carried out during the rains but only rarely have there been successful conquests of the topmost peaks at this time. Batian was first climbed in 1899 by Sir Halford MacKinder, and another thirty years passed before Eric Shipton made his way to the top.

There are several other gates into the Park beside the main one at Naro Moru—at Timau, Sirimon and Meru. The track from Meru, Carr's Road, actually climbs above 14,000 feet and was the highest motorable track in Africa at the time when a Model A Ford was driven up it in the 1920s.

The main climbs can all be approached from huts. Bivouac equipment is advisable, however, and essential on the toughest and longest routes. Count, too, on spending several days at increasing altitudes for acclimatization. Precisely because there is quick motor access to great heights the mountain has the highest incidence of pulmonary oedema in the world; it is advisable for even the fittest to take the climb slowly in the rarefied air.

Clustered on the road to the gates are the entrepreneurs who provide all the services needed for the climb—guides, porters, cooks, pack animals, tents, climbing and camping equipment, food, and transport to the topmost roadheads are all available at a reasonable price.

Kenya's eternal snows provide its real fascination but its moorland walks are as interesting and varied as those of the Aberdares and Mount Elgon. Indeed, with the thirty-two jewel-like tarns which stud the radial valleys below the axis of its peaks, Mount Kenya's high-altitude walks are unique. Magnificent predatory birds haunt the precipitous cliffs and lower peaks like Terere and Sendeo; here, too, there is more chance of seeing the melanistic black leopard.

Mount Kenya has a gothic air, ancient and mystical. Nobody can truly claim to know it. When the cloud wraiths twine around its gnarled fingers its mood is unpredictable, its dangers unalloyed. It claims at least one victim a year on average. The walls below its three peaks have the aspect of an organ vault; in the closing of the night the wind plays hymnals that speak of older faiths than mankind's. They tell of furies which only Mount Kenya can remember.

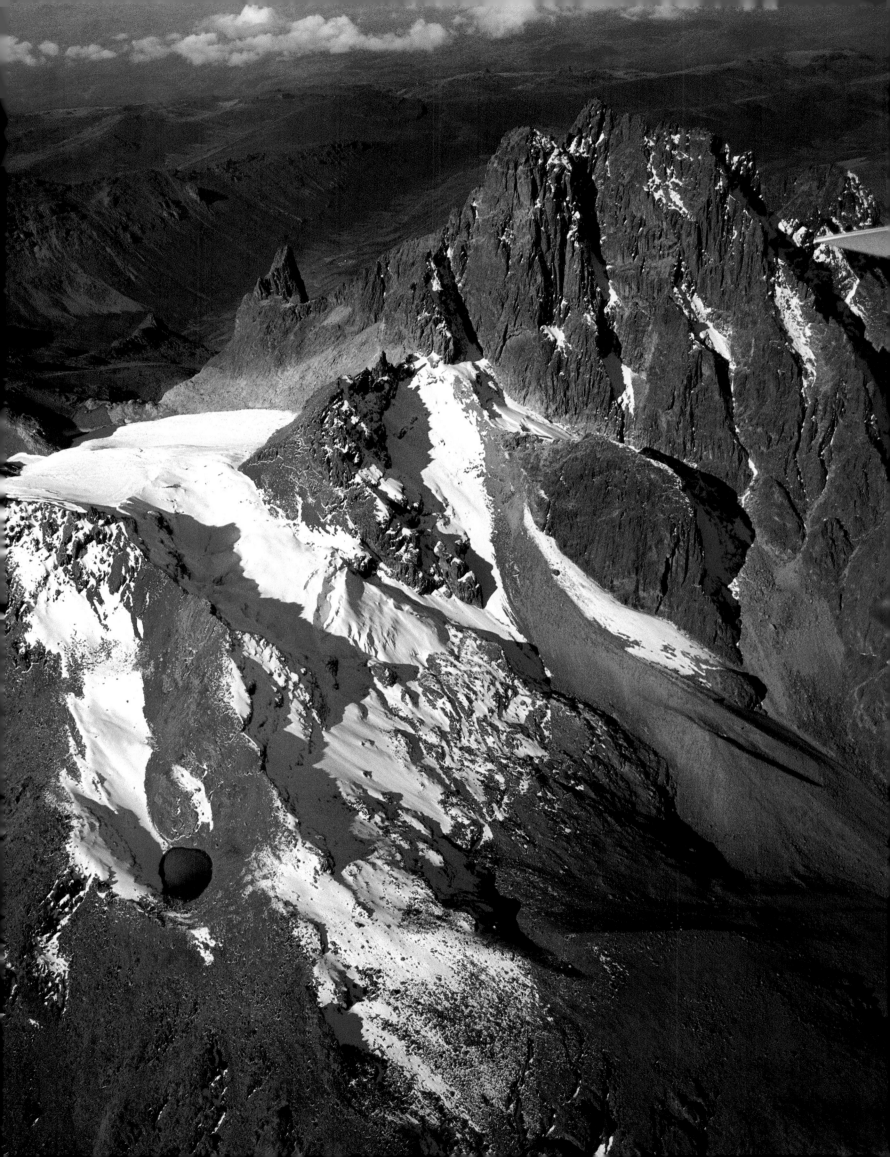

Left: Spanish moss glows rich and green in the late afternoon sun. For centuries mists have laid their wet, cold touch over the mountain slopes and built tendrils of this and other parasitic mosses over the forest's limbs.

The mountain can stand serene in a December sunset, salmon pink reflecting from its snows, and yet the hurricanes can lace tendrils of black-blue clouds around the gloomy spires within minutes. Only the best can climb Batian and Nelion and defy them. But poets with stout lungs can walk on Kilimanjaro's cotton cloud and sugar icing and who could fear Mount Elgon's moorland mutations?

These heights do not just lure professional mountain climbers. A barefoot mystic from a mountain village who was discovered at the summit by a three-man climbing team carried only a tattered Bible, a length of rope and a kettle. Warden Snyder saw him slumbering on Batian when he circled the peak in his plane.

The body of an elephant and those of several buffalo have also been found above 14,000 feet.

Proposals to use these upper slopes for hang-gliding—a sport at which Warden Snyder is an experienced veteran—are tempered by the altitude, the turbulent winds and the lack of adequate landing areas. Impenetrable forest hides precipice and crag and belligerent wildlife, too.

Mount Kenya's foothills harbour the pleasant town of Nanyuki with its broad main street. It is a bustling place with an expanding population. A few kilometres above the town stands the Mount Kenya Safari Club which started out as a coffee farm until crop failure forced

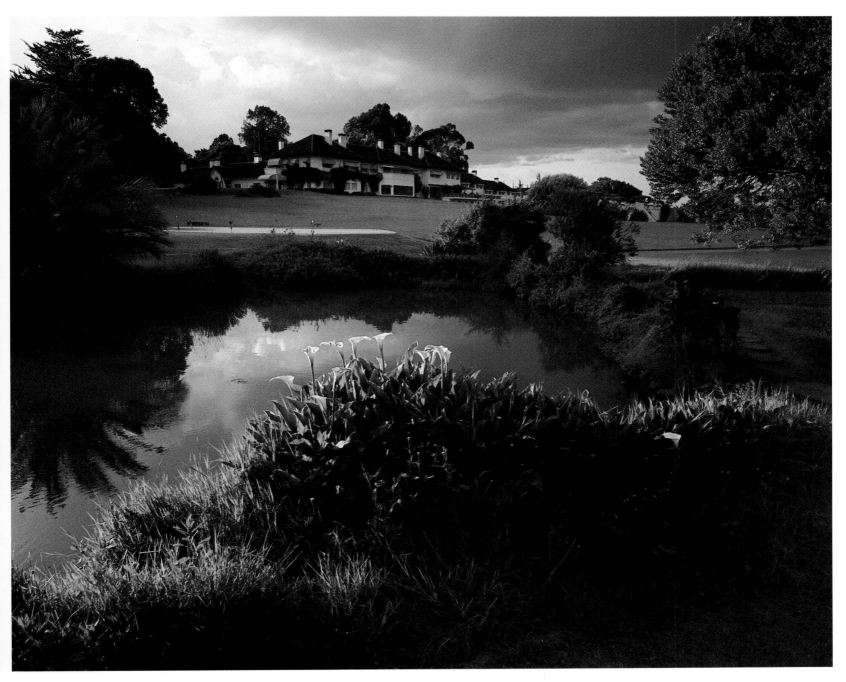

Above: Luxurious Mount Kenya Safari Club, once owned by the actor, the late William Holden. The club boasts a fully-equipped film studio and one of the most attractive golf courses in Africa. The lily pool in the foreground is one of the course hazards.

its owner to sell. Its grounds contain Kenya's only fully-equipped film studio, installed by film star William Holden for the making of the film *The Lion*, in the 1960s. Holden was one of the owners of the club and remained until his death a partner in the Mount Kenya Game Ranch which surrounds it and where wild species are reared or kept in holding after capture before transfer abroad to wildlife parks and zoos. It is run by Don Hunt.

Many of the more famous Kenya pioneers have spent their last days in Nanyuki at a colonial style pub called the Sportsman's Arms. One was Robert Foran, an octogenarian pensioner, living in a residential hotel on the outskirts of the town. One night in the 1960s he summoned the proprietor, the late Shamsu Din, founder of Secret Valley, and his wife to his room and commanded that they bring him some champagne. He was clearly near his end. The bottle opened, Foran instructed the proprietor to pour glasses for the three of them. He then sat up against his pillow, raised his glass to the couple 'in gratitude for caring for me' and again, 'to the life which I have so enjoyed', downed its contents, closed his eyes and died.

Foran was the original Commandant of Kenya's fledgling police force which at the time was composed of one Sikh sergeant. One night he was passing Nairobi's Norfolk Hotel when he heard the sound of gunfire from within. Lord Delamere and the Duke of Westminster were potting

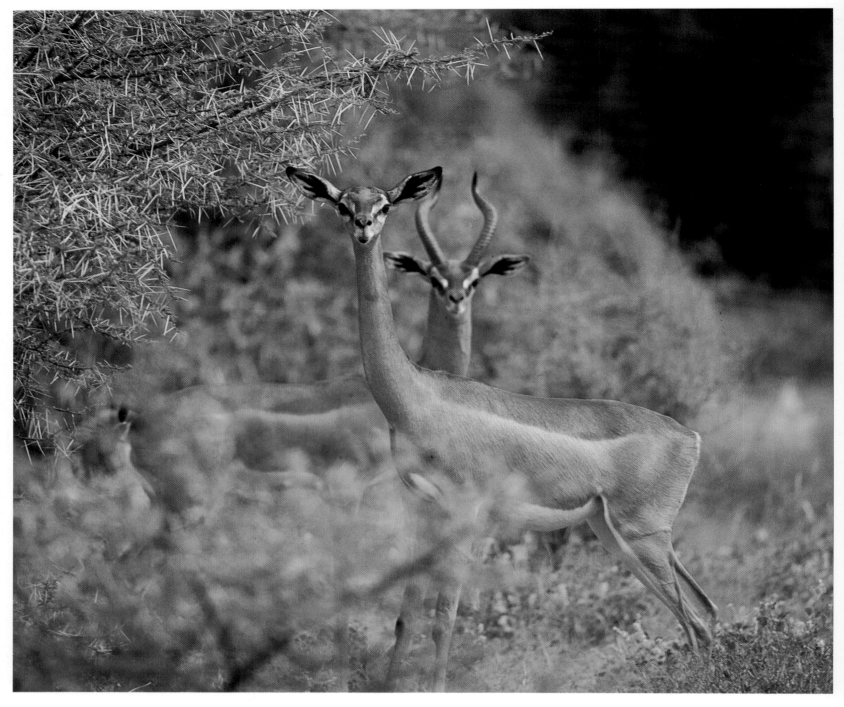

at bottles on the bar. Foran wagered which bottles they would miss and when they ran out of ammunition felt it safe enough to arrest them!

Northern Kenya has always been 'frontier country' and, even today, Nanyuki retains something of the frontier spirit. The first zebroids, a cross between an ass and a zebra, were raised in Nanyuki and used during the 1960s as pack animals on foot treks up the mountain. Amber May, their breeder, was the daughter of Raymond Hook, one of the first Britons to settle in Nanyuki. Her father went to Britain before the Second World War to race cheetah against greyhounds at London's White City dog track. Unfortunately the cheetah chased and ate the dogs instead of pursuing the electric hare. Another Nanyuki character built the Silverbeck Hotel. This was designed around its central feature—a bar where it was possible to drink with one foot on either side of the Equator. He argued that a man with a foot in both worlds could never fall down drunk. The bar, burnt down in 1974, is being rebuilt.

Beyond Nanyuki is the sudden drop from the 8,750-foot shoulder of Mount Kenya which carries the traveller down 5,500 feet in 30 kilometres, to Isiolo, an untidy tin-roofed sprawl. A border post on the town's northern edge is a legacy of the days when the Northern

Above: Two shy gerenuk, a mating pair in Samburu National Reserve. Their choice of arid and semi-arid habitats has been accompanied by the evolution of a bipedal stance to browse, upright on their hind legs and reaching for the greener shoots on thorn trees and other plants. They can survive without drinking water, drawing enough liquid from their food in a testimony to nature's remarkable adaptability, versatility and resilience.

Below: The white rhino, distinguished from the black rhino not by colour but by the shape of the mouth, is exceedingly rare in Kenya. One small herd of these square-lipped browsers in Meru National Park is under constant guard. Poachers almost wiped it out but now a new calf has been born, named Sweet December because she was delivered on 1 December 1980. The gestation period of the species is 15 months and they rarely conceive more than once in four years.

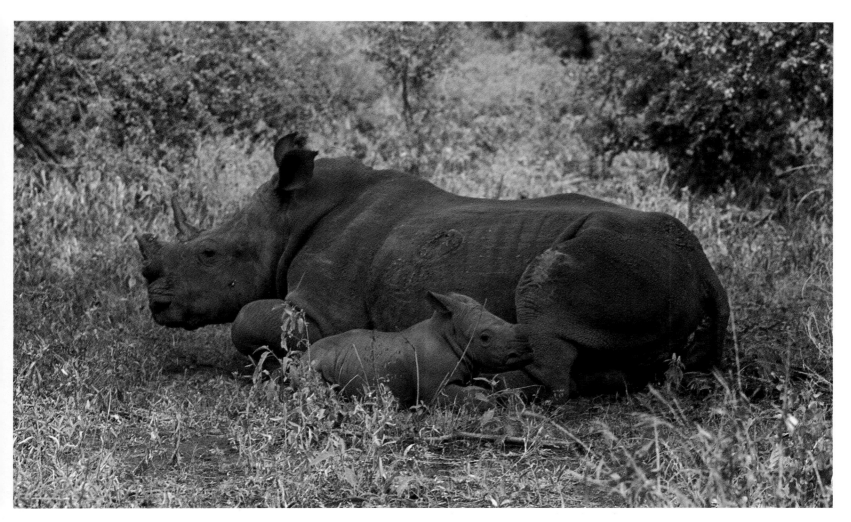

Frontier District was closed territory. Travellers are still required to check out at this post, although the majority are not travelling far—to the Samburu and the Buffalo Springs Game Reserves 40 kilometres beyond.

Two lodges, set on the banks of the wide Ewaso Ngiro river, offer luxurious surroundings from which to watch the passing wildlife. The river, which merges with the Ewaso Narok after it has launched itself over Thomson's Falls, is a river without an outlet. It vanishes into the Lorian Swamp, near Habaswein, several hundred kilometres beyond Samburu. Under the shade of the forest on a bend in the river, visitors sip ice-cold drinks as they watch elephant herds watering only a few metres from basking crocodile while chattering monkeys dart through the branches above. The shy gerenuk, which stands on its hind legs in search of the sparest of dry twigs, is one of the remarkable creatures common to the Samburu Reserve. It has adapted so well to its desert environment that it absorbs all its moisture requirements from its fodder.

A hill which can be seen from one lodge has inspired a series of cartoons displayed on the notice board. A distinct scar from the top of the slope is depicted as an elephant slide. The Samburu jumbos launch

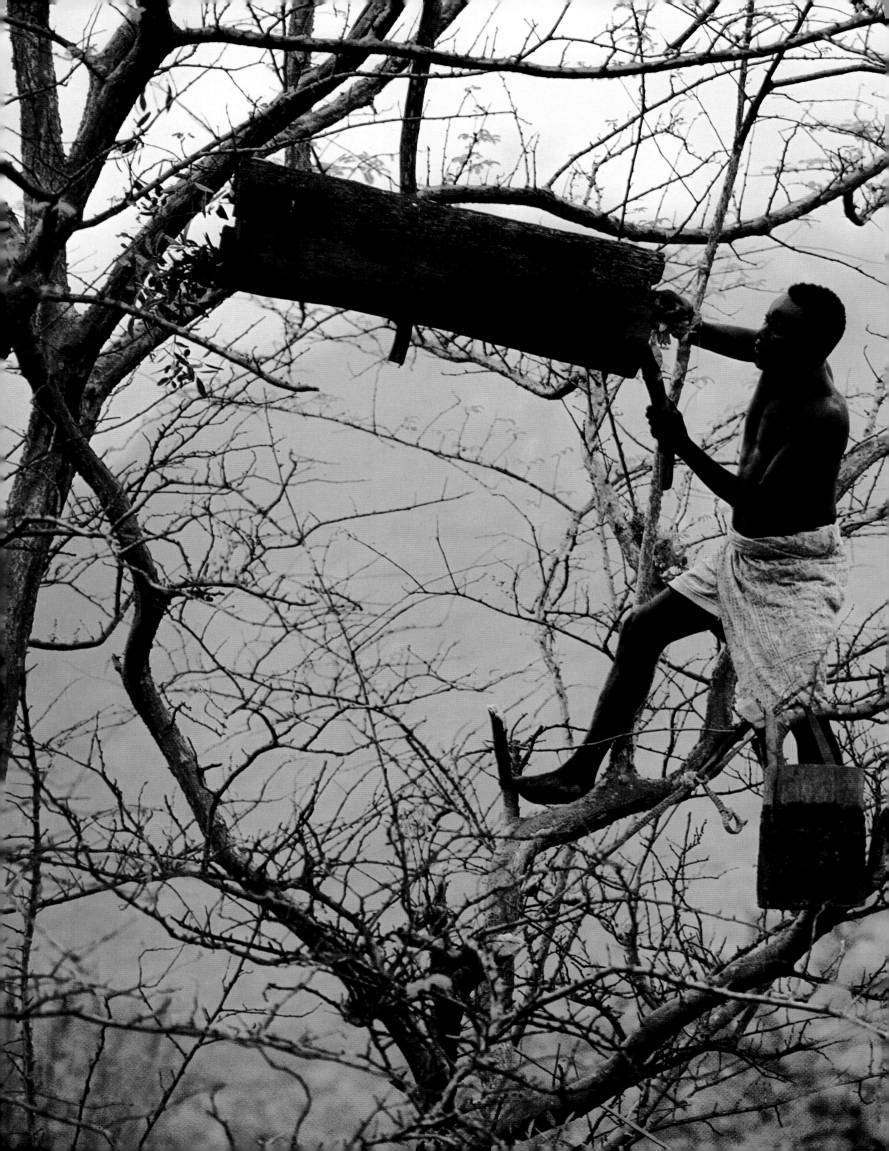

Opposite: Honey-gathering member of the Tharaka tribe tending a bee-hive. Their home territory lies along the banks of the Tana River, Kenya's longest river which courses for a considerable part of its length through semi-arid land. This is the region in which the Tharaka, renowned and feared for the power of their witchcraft, have settled.

Right: Tharaka woman storing grain in hand-woven basket granary.

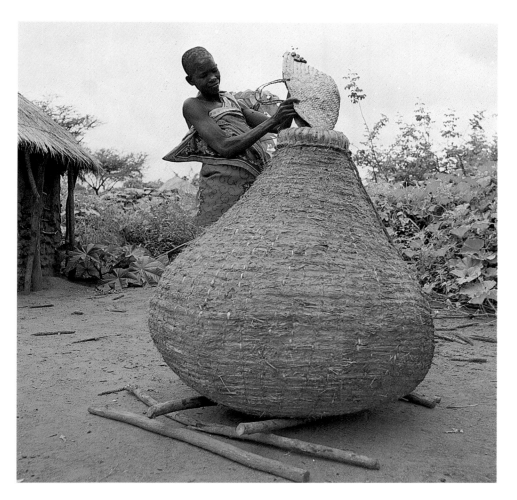

themselves down this on their haunches, dry-skiing pachyderms on a curious slalom run in the tropics.

To the east of Samburu, under the lee of the Nyambeni Hills, is Shaba National Reserve, a 328-square-kilometre desert sanctuary of thorn scrub and riverine palm. It was in Shaba in 1980 that the writer Joy Adamson, the author of *Born Free, Living Free, The Spotted Sphinx, The Peoples of Kenya* and *The Living Spirit*, was murdered in mysterious circumstances. Her body was found a few metres from the camp where she was preparing Penny, a domesticated leopard, for her return to the wilds.

Beyond the Nyambeni Hills, their profile lovely in the fading sun, lies Meru National Park, which has close links with Joy and her husband George Adamson. This was where they rehabilitated the lioness Elsa, heroine of *Born Free*, and released her back into her wild habitat. Even when the area was created an 870-square-kilometre National Park in the 1960s they continued their work.

The Spotted Sphinx tells the story of the cheetah Pippah who is commemorated by a small stone cairn under a leafy acacia in an otherwise unmarked spot near one of the Park's small rivers. Most of these debouch into Kenya's largest river, the Tana, which forms one of the Park's natural boundaries and along which the Adamsons are also commemorated. A stretch of white water at the eastern end of the Park,

Left: Traditional granary of the Mbere tribe. It is raised on stilts to prevent raiding rodents from stealing the stored harvest. The tribe lives in the Embu region of Kenya and cultivates gourds, like those below the granary, for use to store and carry water.

haunted by crocodile and other river creatures, is named Adamsons' Falls.

The Tana is a vital artery for Kenya, its people and its wildlife. Before entering Meru National Park, which is the home of a herd of white rhino imported from South Africa, the Tana pours into a large man-made lake at what was once the 440-foot-deep Kindaruma Falls, where now the Seven Forks hydro-electric project generates much of Kenya's domestic electricity. The lake, which attracts a variety of wildlife species, is reached through Embu, on the south of Mount Kenya. The road continues to Meru, a thriving manufacturing and farming town. An industrious people, closely related to the Kikuyu, the Meru treasure their mountainside scenery which includes waterfalls, caves, forests and a number of small lakes including one sacred to the tribe, Nkunga, high up on the mountain.

Beyond the National Park the Tana meanders through a large flood plain for several hundred kilometres before entering the Indian Ocean south of Lamu. A gash of green marks its course, in vivid contrast to the scorched countryside. Between Meru National Park and the more recently established Kora Game Reserve the river is a frothing series of cataracts and white water, but from Kora it becomes malleable, a thing of living, gracious dimensions. Outstanding in its beauty, its banks attract the plains game which come down to drink, always nervously,

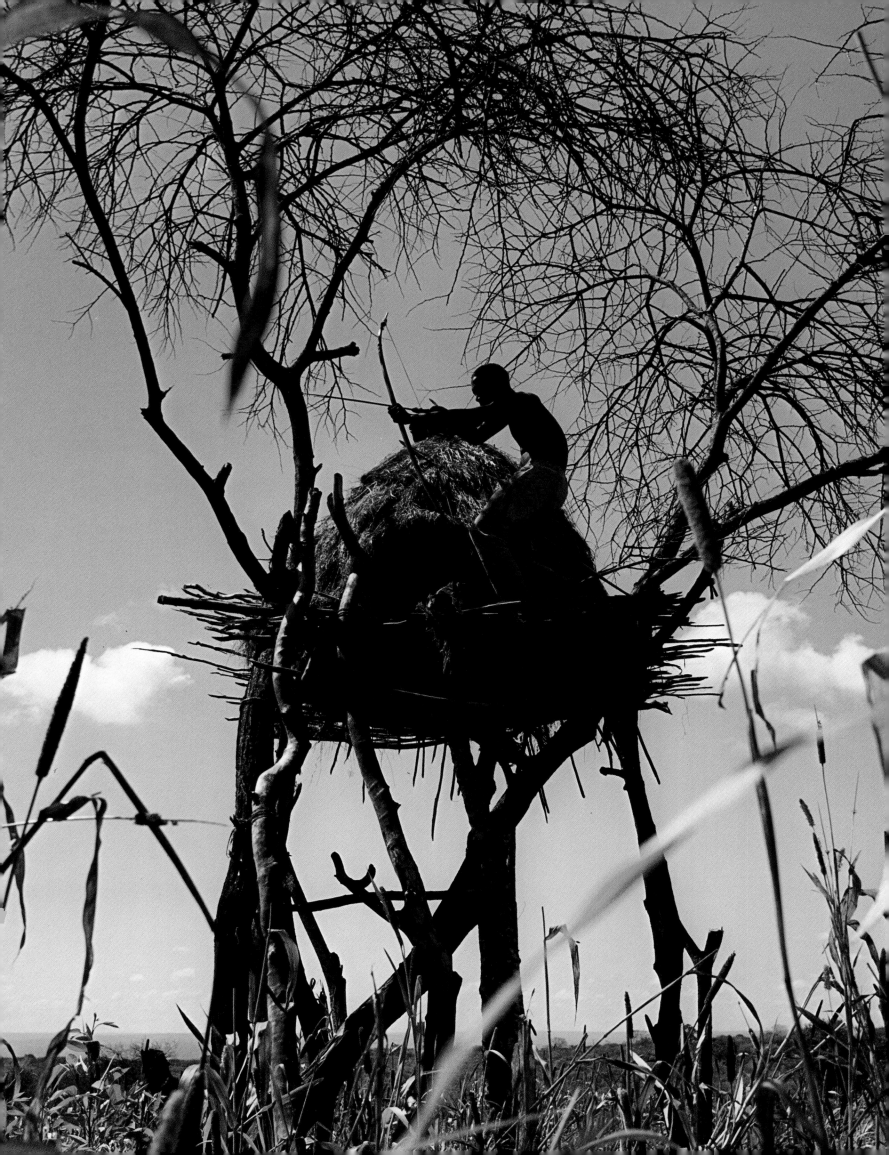

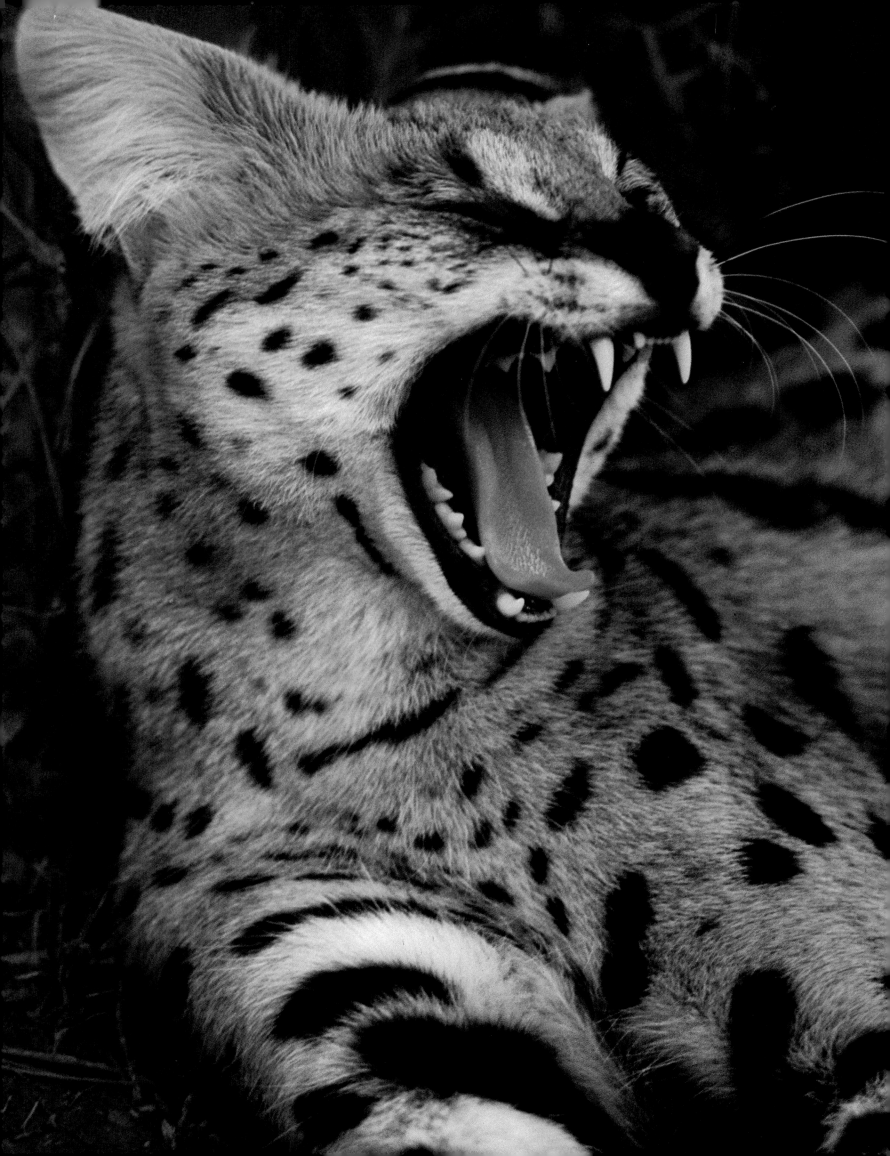

Opposite: Standing up to 2 feet high, the serval is similar in many ways to a domesticated cat, though its ears and legs are proportionately longer. Denizens of marshy land, serval never stray far from permanent water and live mostly on a diet of small mammals and birds.

heads lifting every four or five seconds, tails twitching. Kora is where George Adamson has moved to continue his lifetime study of lions in the lonely, withdrawn isolation in which this leonine, diffident man prefers to work.

Two more game reserves mark the river's lower reaches—Arawale, established principally to protect the only Kenya habitat of the rare Hunter's antelope, an unusual hartebeest with lyre horns; and the Tana River National Primate Reserve. This latter sanctuary emphasizes Kenya's approach to wildlife conservation. Unique in East Africa, the Reserve is a 60-kilometre-long relic of the gallery forests which, elsewhere, can now only be found in Kakamega, the Congo Basin and West Africa. It holds East Africa's only remaining colonies of red colobus and crested mangabey monkeys, species with a predominant West African distribution. The complex forests on which these primates depend are delicate, and both species are sensitive to their environment. The slightest change triggers reaction. Mangabey, for example, are versatile feeders. They will eat the fruit off the trees or, alternatively, when circumstances dictate, the insects on the ground. But whichever option is imposed, the pack varies its intricate social structure accordingly.

The Tana has a curious history in the story of Kenya's relationships with the European missionaries, carpet-baggers and administrators who flocked to its shores in the late nineteenth century. Many of these such as Charles New, Karl Peters, and the Denhardt Brothers, believed they could sail upstream to the fertile highlands. Their old-fashioned steam launches travelled as far as Garissa only to founder or be thwarted on the white water beyond. A more recent relic was visible for many years at the mouth of the river at Kipini. It was the dilapidated wreck of the District Commissioner's launch, *Pelican*, on which in the later days of imperial pomp the administration's representative used to show the flag as far as Garissa.

Overleaf: Elephants in Amboseli with Mount Kilimanjaro in background. A full-grown male weighs more than 5 tons. The heart alone averages 20 kilogrammes and beats 30 times a minute. Voracious eaters, these mighty beasts can each consume 150 kilogrammes of fodder in a single day. In times of drought thousands die for lack of sufficient food. These beasts have no known enemies except man. Their young thrive on constant contact and handling by adult elephants.

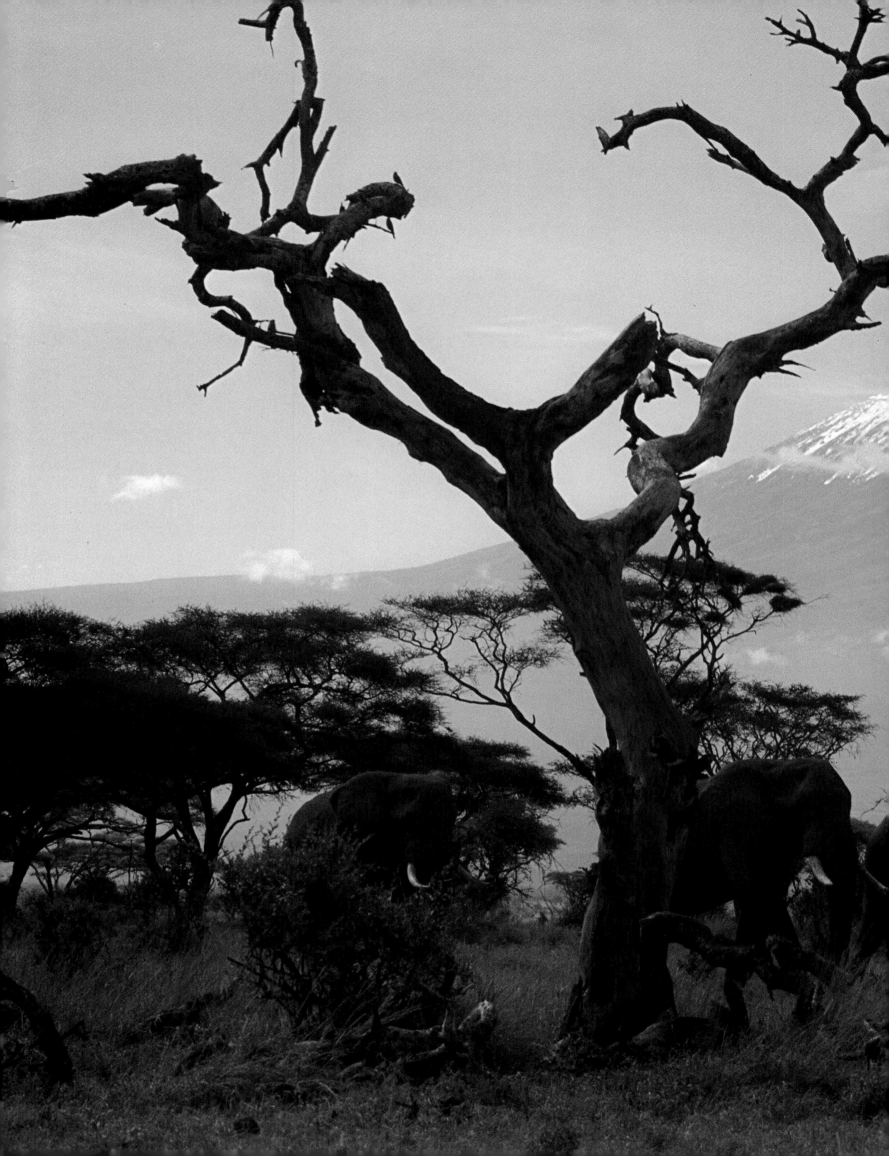

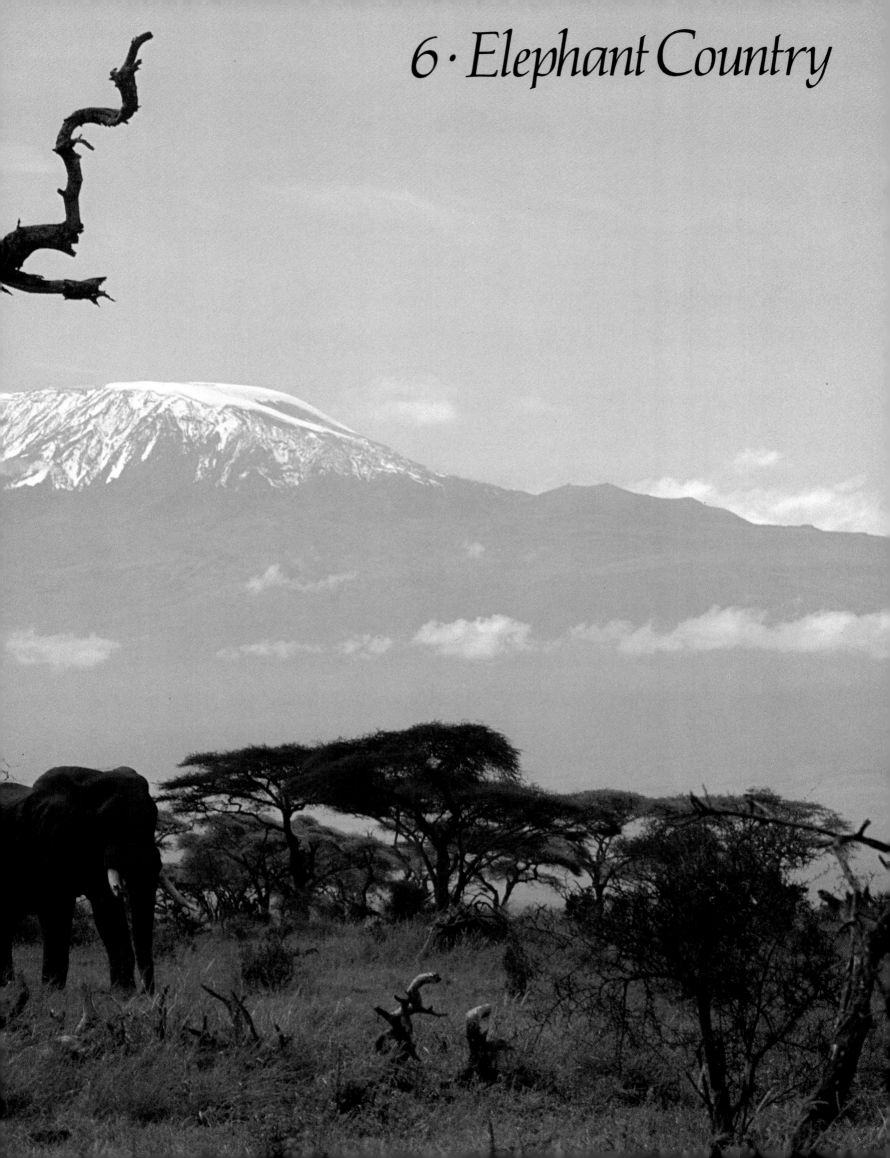

Morning, with a cup of fine arabica coffee, is the best time of day in Kenya. An indefinable promise hangs in the crisp air over the capital. The sun is climbing in the east. Nairobi Park is ten minutes' drive away. But varied and interesting though it is, the Park's great virtue is the escape it provides from the claustrophobia of the city—and the adventure which lies beyond its east boundary at Athi River.

There it joins the main road to Namanga, the border town which is the nearest entrance to Amboseli, the most popular of Kenya's National Parks—too popular, in fact, for the number of visitors is taking toll of the fragile ecology. Where there used to be stands of grazing grass are now only eroded dust pans. Amboseli Park is 380 square kilometres of once pristine Africa set within the larger mass of the 3,248-square-kilometre Amboseli Game Reserve. The Reserve's southern boundary is drawn where the foothills of 19,340-foot Mount Kilimanjaro rise out of the plains.

Africa's highest mountain was once part of Kenya. But when the German Kaiser was married his British relative Queen Victoria thought Kilimanjaro an ideal gift and transferred the entire mountain to the other side of the border to stand within what is now Tanzania. Kilimanjaro inspired the Ernest Hemingway novel *The Snows of Kilimanjaro*. Amboseli was used as the location for the film version, and also for many other Hollywood epics.

Lions are perhaps the Park's main attraction, more easily seen there than anywhere else in Kenya. Amboseli's elephants, subject of intensive zoological research and at least one book, make an ideal snapshot, of course, framed against Kilimanjaro's snowclad Uhuru peak, formerly Kibo.

A dirt link-road joins Amboseli and Tsavo West National Park. Off this road lies the Maasai market town of Oloitokitok, cool and refreshing after the heat of the plains. It is 8,000 feet up on the slopes of Kilimanjaro and is a border post with Tanzania. To the north the road crosses a spectacular lava flow, Shetani, which spilled down the southern slopes of the scenic 7,248-foot Chyulu Hills in the last three centuries. The melted rock, like a subsided tarmac road, tangled and tortured, is evidence of nature's power. Now the wooded crests of the Chyulu Hills, beneath which lie one of the biggest cave systems in the world, abound with wildlife, including rhino and buffalo, but remain one of Kenya's least known attractions. From the top, the 220-kilometre-long spine of the Yatta Plateau, one of the world's longest lava flows, stands out far away in the east. It is ancient and covered in vegetation, unlike the primal virgin rock of the smaller Shetani flow.

The Chyulu Range forms the eastern edge of Kenya's Maasailand. The tribe roams as far as Nakuru in the north, and the Soit Ololol Escarpment, the boundary of Maasai Mara, in the west. To the south the tribe extends well into Tanzania. The Maasai population in Kenya numbered 240,000 in 1979. Famous from the day they confronted the first European visitors, there is a belief among some ethnographers that the Spartan warriors might possibly belong to the legendary 'Lost Tribe of Israel' or, even more remotely, to the famous 'Lost Legions of Anthony'. They feed on milk and meat, sometimes enriching the milk

Opposite: The lappet-faced vulture takes flight from its perch in an acacia tree.

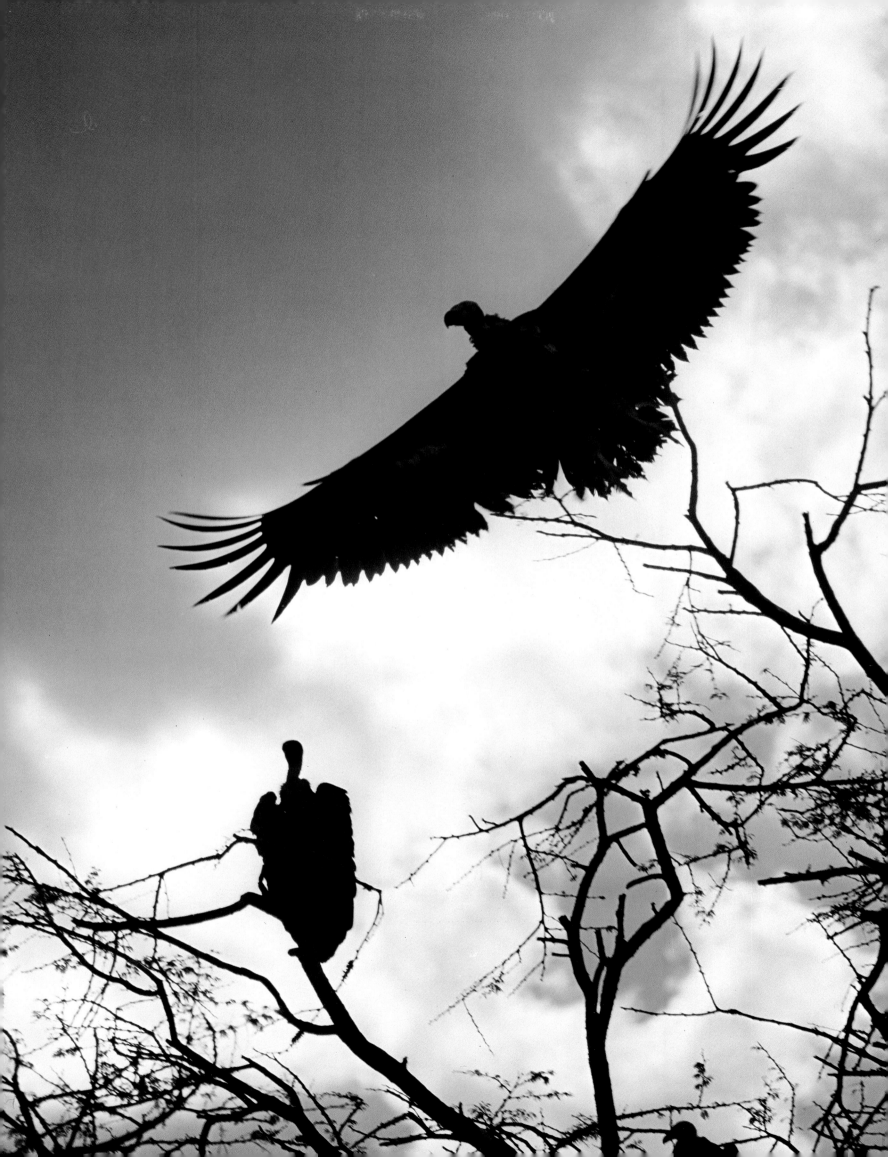

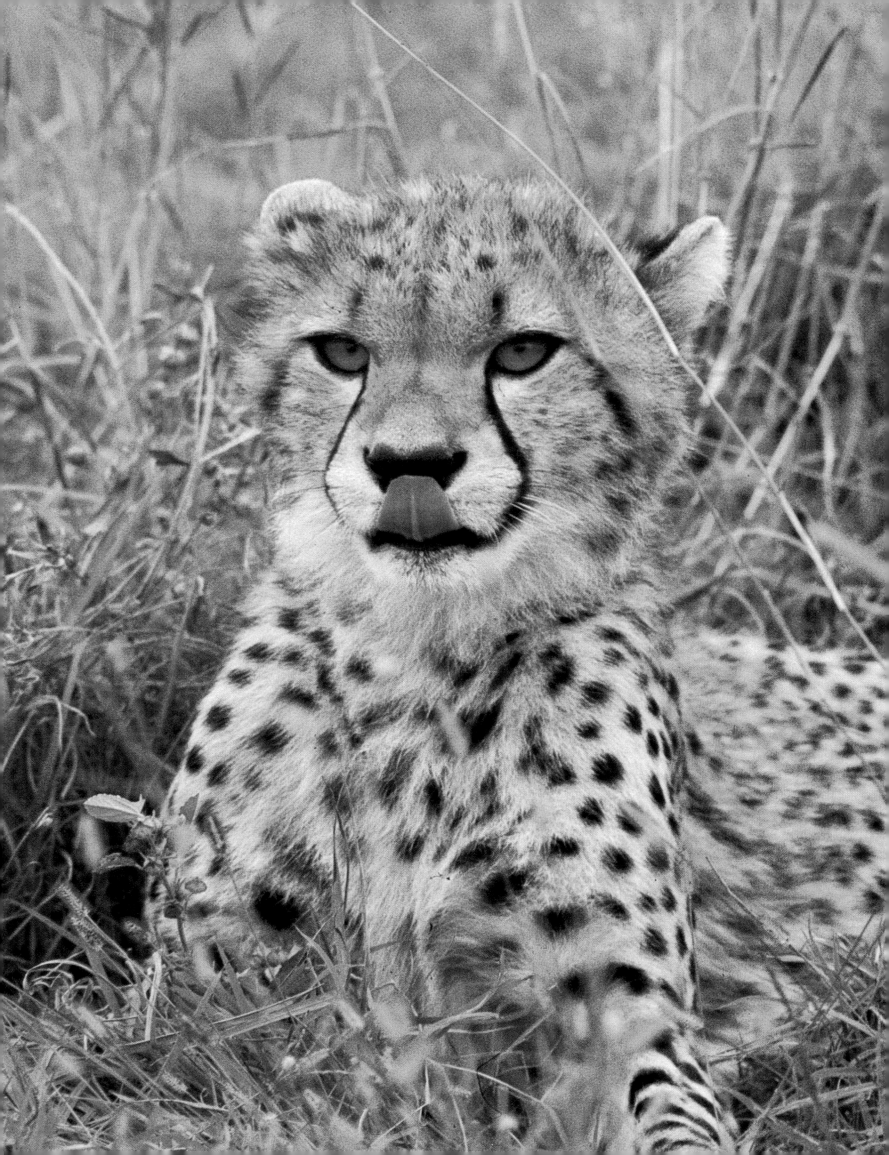

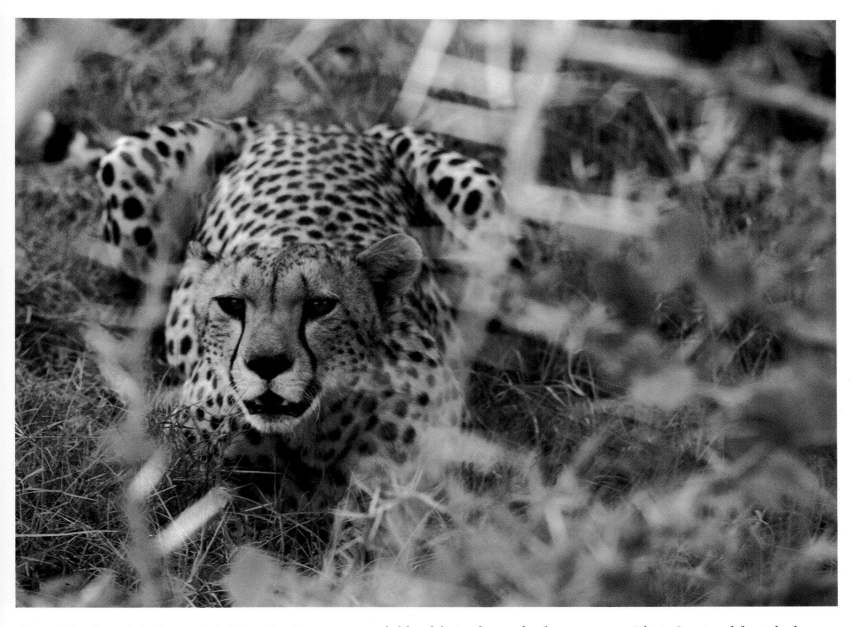

Above: The cheetah is the world's fastest land animal. Touching speeds up to 72 kilometres an hour, the feline uses this impressive power in short bursts to catch prey.

with blood from the neck of a cow or ox. Their Spartan life-style does justice to the old ideals of Roman nobility and hardiness. The tribe has preserved many traditions including that of the warrior ranks which means that the young men are segregated and undergo strict discipline before they attain the status of elder.

The south end of the Chyulu Hills also has a more prosaic function: an unmanned gate at its foot marks the entry into Tsavo West's 7,700 square kilometres. Together Tsavo West and Tsavo East cover an area of almost 21,000 square kilometres—larger than the islands of Corsica and Cyprus put together and larger than Wales, by 28 square kilometres. The whole adds up to more than 3.5 per cent of Kenya's total land area. By comparison, all the National Parks of the United States of America equal little more than 1 per cent of the USA's land area.

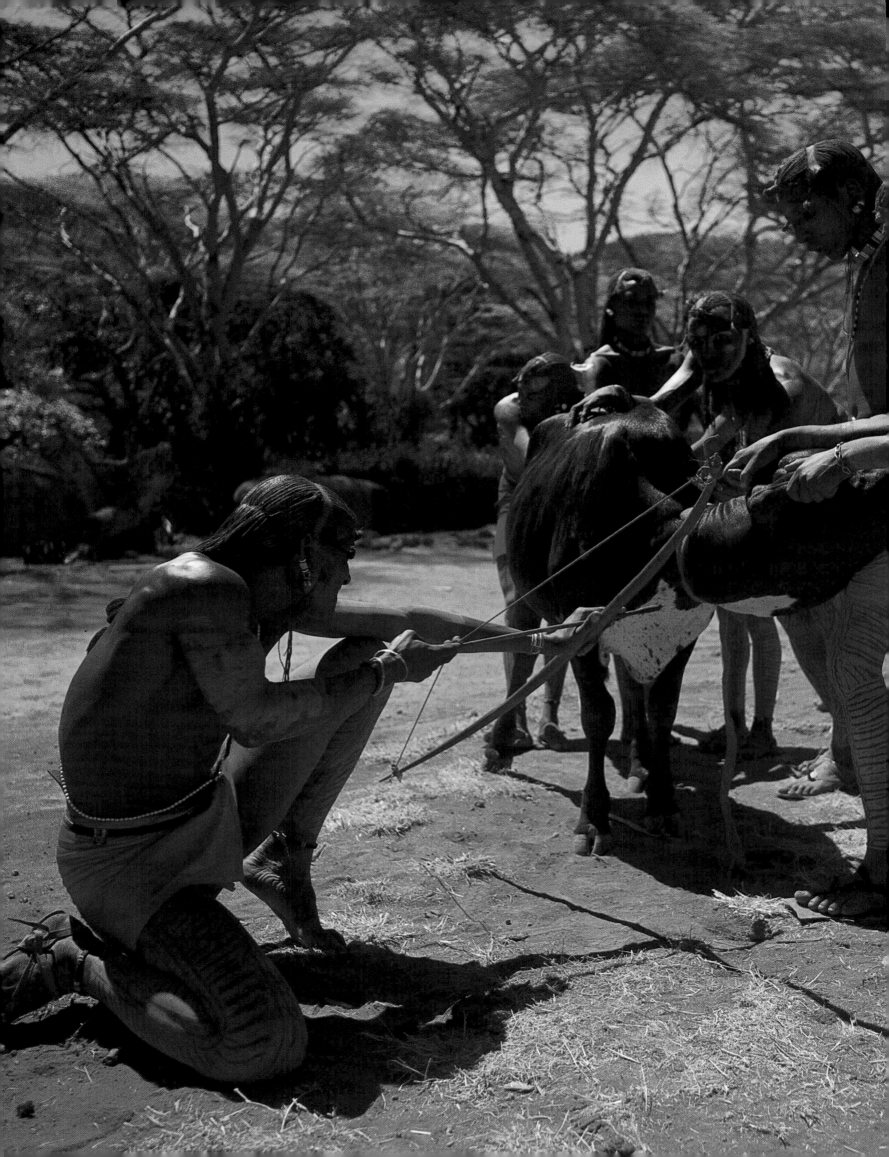

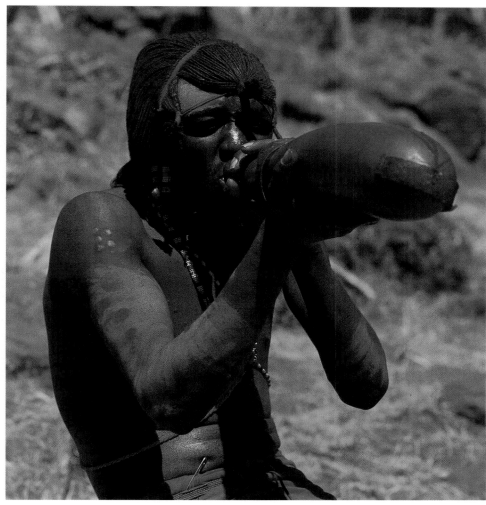

Left: Maasai warriors hold down an ox as their bond brother prepares to fire an arrow into the beast's jugular to draw blood. The Maasai, who once lived almost exclusively on a diet of milk and cow's blood, have few recorded instances of heart disease and often drink (above) the cattle's blood straight from the gourd. Renowned throughout the world, their ages-old ways are disappearing quickly. The cherished institution of warrior, however, is still an opportunity, no matter how brief, for the new generation to salute both vanity and incomparable past.

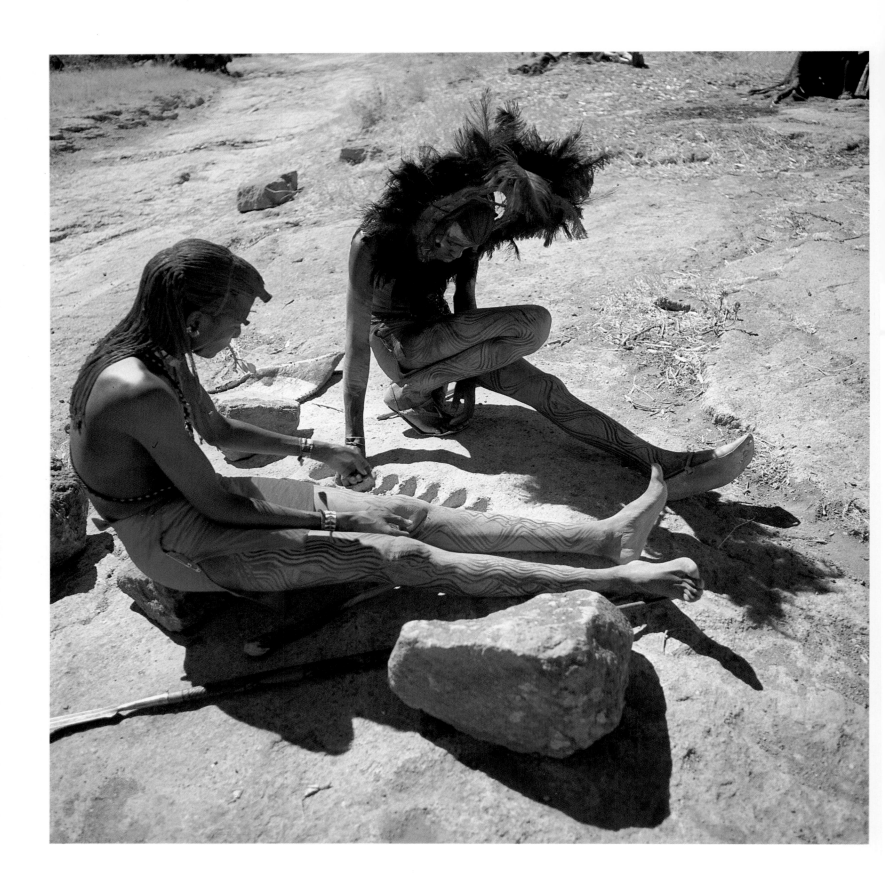

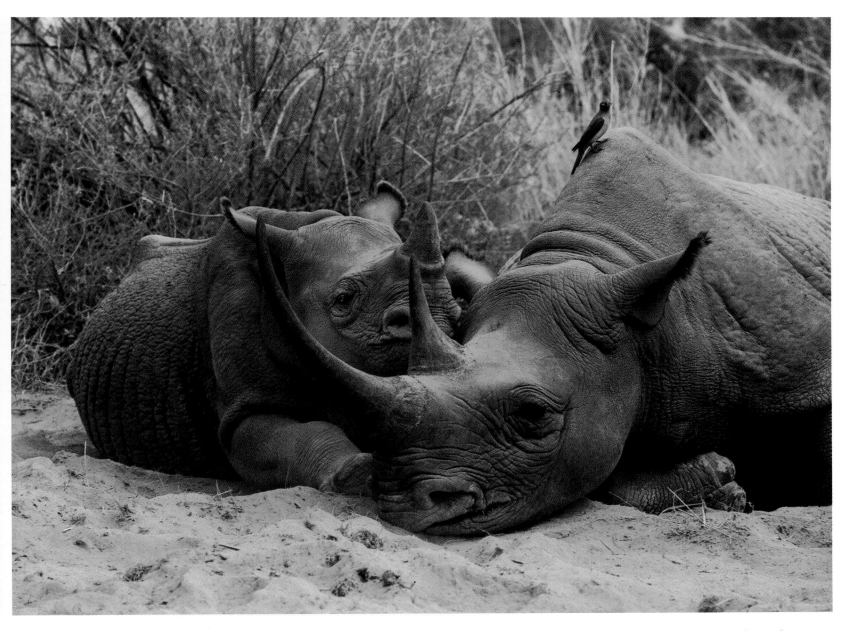

Above: The black, hook-lipped rhinoceros—a grazer as opposed to browser—is now one of the most endangered species in the world. Kenya game authorities have been drugging those found outside sanctuaries to translocate them within National Park boundaries. Rhino horn is said to have medicinal properties by many millions in the Middle and Far East and is also popular for dagger handles in the Yemen. In fact, it has no chemical properties whatsoever. It is keratin—compressed hair. Nevertheless, it fetches many thousands of dollars and, within a single decade, Kenya's rhino population was virtually wiped out—from 20,000 in 1970 to fewer than 1,000 in 1980.

Tsavo contains 30 airfields and 5,500 kilometres of roads and receives a quarter of a million visitors a year. Income from gate fees alone averages more than £200,000 a year. Other income is derived from royalties for bandas (Swahili for houses), camp sites and, in the case of Tsavo West, income from the country's first lodge in a game park, Kilaguni, which is owned by the National Parks. Kilaguni was opened in 1962 by the Duke of Gloucester and within its walls there is a shady garden, manicured and cool in contrast to the unkempt, overhot plains outside.

But it is on these plains, directly in front of the lodge's lofty verandah, where the visitor can sit and sip iced drinks in comfort, that Tsavo's

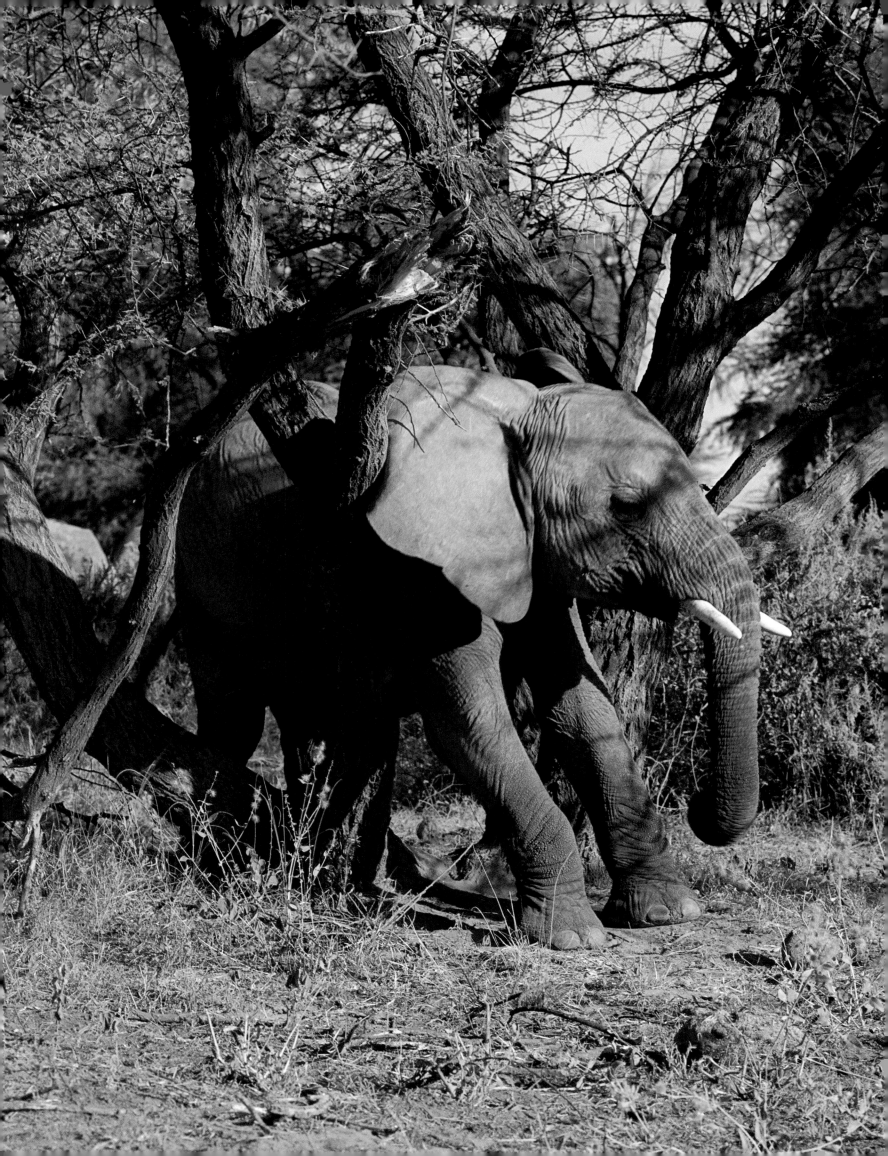

Opposite: Elephant scratching its back on a thorn tree.

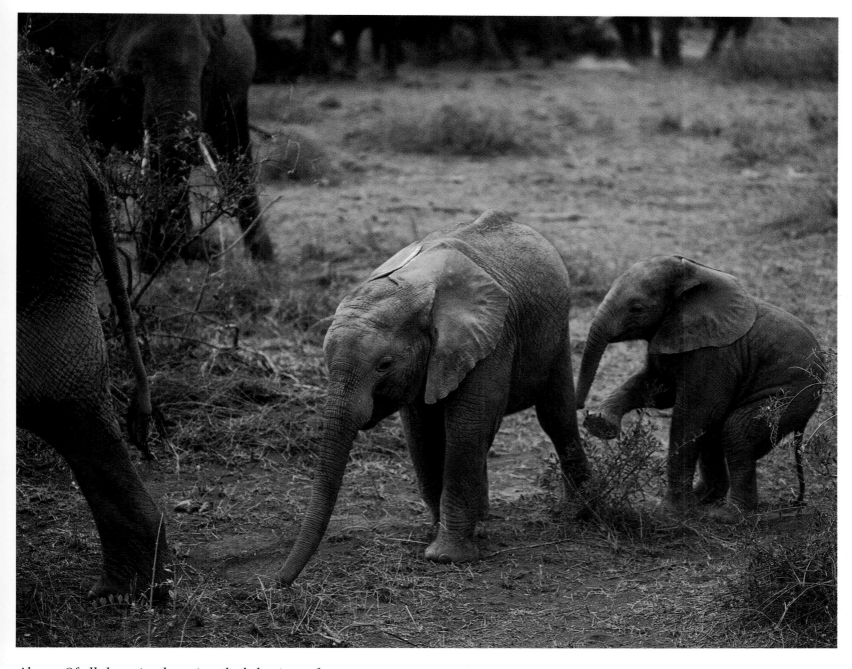

Above: Of all the animal species, the behaviour of elephants comes closest to that of mankind. They live communally and are extremely fond of their young who crave constant tactile contact with their parents and big brothers and sisters. The elephant is the only species apart from mankind known to destroy the habitat on which they depend. They imitate us in another way, too: they often bury their dead, covering the bodies with leaves, branches or dirt.

Opposite: Hippo in the crystal clear waters of Mzima Springs, in Tsavo West National Park. The Springs produce 10 million litres of water an hour filtered down from the volcanic Chyulu Hills and Mount Kilimanjaro. The name hippopotamus derives from the Greek and means 'river horse'. They can submerge for up to six minutes at a time. Mzima Springs is host to crocodile too, as well as many fish. An underwater glass observation room allows visitors an eyeball-to-eyeball meeting with many of them.

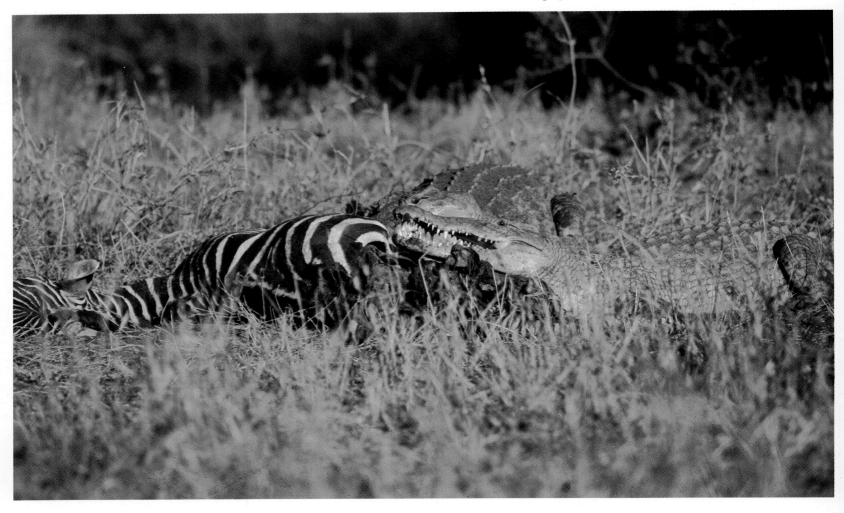

animals, big and small, parade themselves day and night while myriad semi-tame hyrax, birds, dwarf mongoose, and other species scamper among the feet of the guests searching and, sometimes, even begging for scraps of food. Marabou storks strut around the water hole, grotesque thoraxes bobbing coral pink, obscene gullets which, from a distance, have the aspect of funeral shrouds. The marabou stork's poxed face and scabby beak, and the bright scarlet bubble at the back of its neck, are like a warning from a leper—keep away, diseased. The birds have the hunched shoulders of the undertaker and walk with the shuffling sycophancy of the money-lender.

Tsavo, once savannah, later woodland, endured immense change in its first thirty years and yet, by late November 1980, after good rains, with new flushes of growth, it had regenerated itself to the semi-dry grassland which marked its beginning—although its elephant population had thinned down to slender proportions by comparison with the herds that had unimpeded access to these lands in the 1940s. A tsetse fly region, there was no outcry when Tsavo was earmarked for wildlife. There was no profit in it for the farmer.

Looking south-west, Kilimanjaro is framed between two breast-like hills to the south and the Chyulu Range to the north. It is on the

Above: Nile crocodile with zebra kill. Kenya is the last remaining stronghold of this diminishing crocodile species, with at least 12,000 of them in a stable breeding colony in Lake Turkana. Savage predators, crocodiles reach up to five metres in length. The young make a chirping noise just before hatching out of the eggs which the mother has buried a few centimetres below the sand.

Overleaf: Africa's highest mountain, Kilimanjaro, which rises 19,340 feet above the Kenya-Tanzania border, silhouetted against the fading sun from this water hole in Tsavo West National Park.

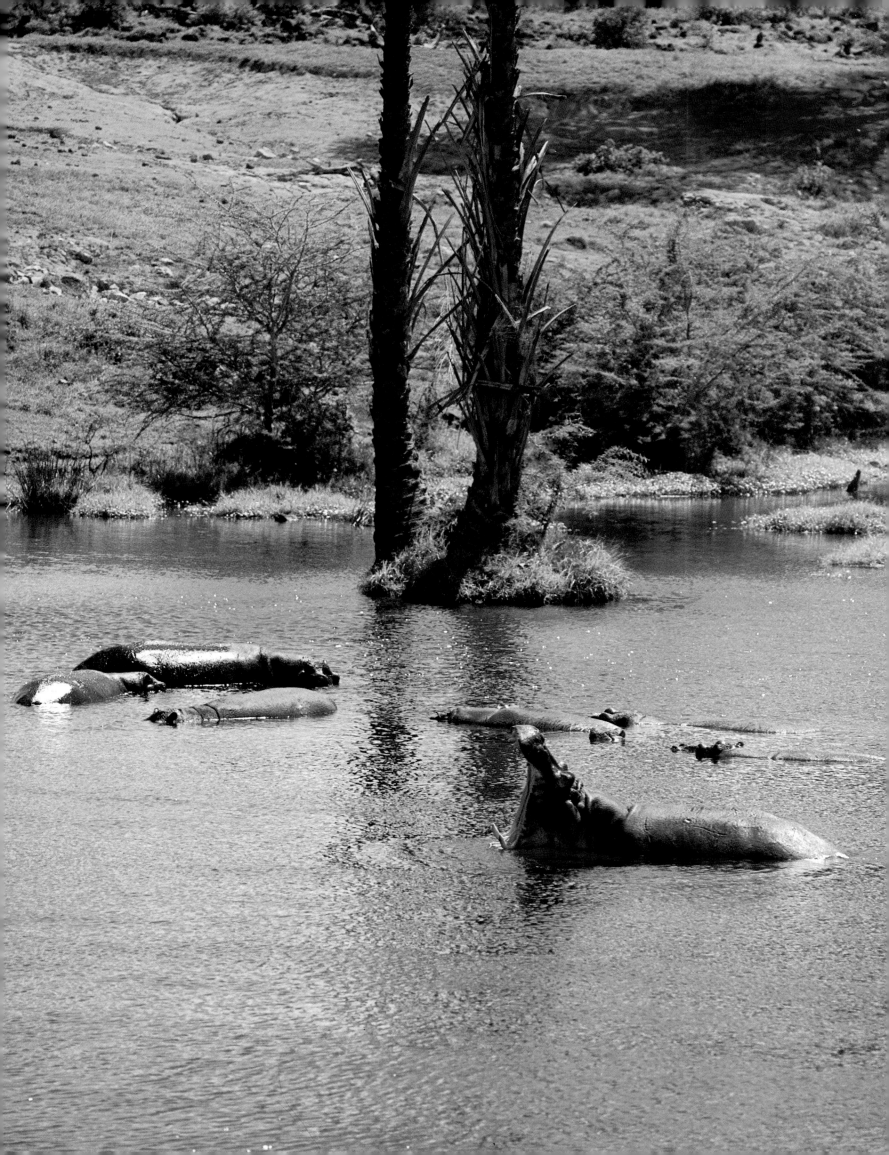

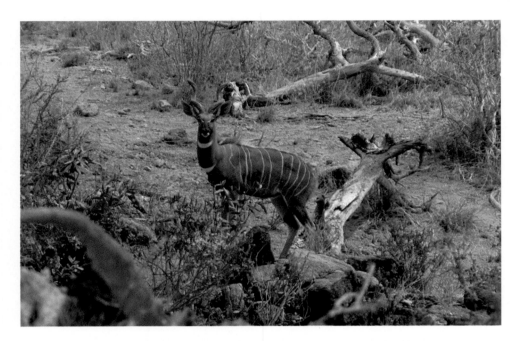

Left: The attractive lesser kudu, one of the rarer species of antelope found in Kenya.

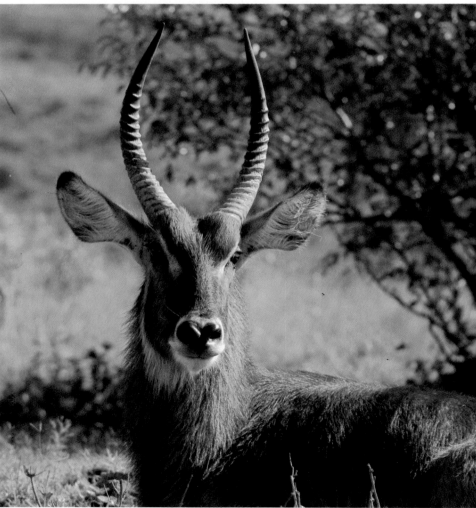

Left: The gentle and timid waterbuck is a creature of grace. There are two species but they are virtually indistinguishable.

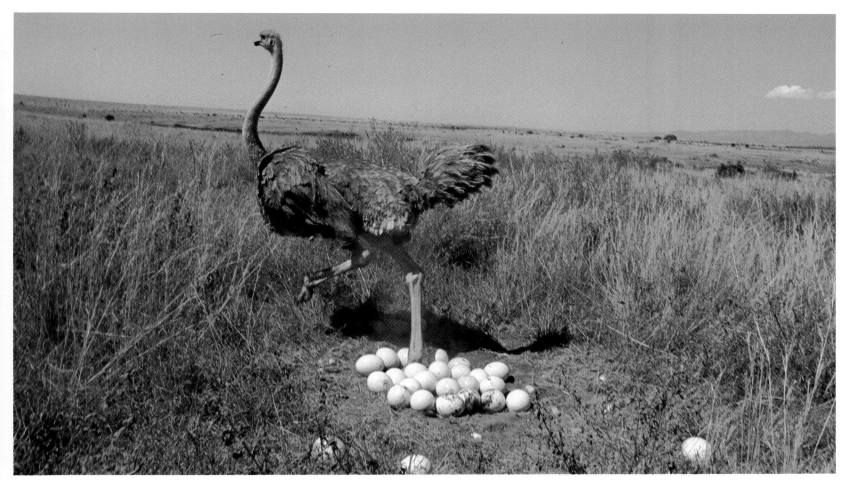

Above: An ostrich hen struts away from her nest. The shell of her eggs is as thick as a china cup—so tough it can only be opened with an instrument like a saw or hammer. An average egg weighs almost 2 kilogrammes and takes forty-two days to hatch. A mature bird can run at up to 70 kilometres an hour and bounds almost two metres with each stride. The kick is devastating. When asleep the ostrich rests its head and neck on the ground—the source, no doubt, of the myth that it buries its head in the sand.

Chyulu Hills, and from the slopes of Mount Kilimanjaro, that the source of the Mzima Springs is found. Kilimanjaro's melting snows flow underground to join a subterranean river beneath the Chyulu Range and then emerge, crystal-clear, as a timeless, self-sustaining oasis. Ten million litres an hour spurt out—enough, years ago, to provide an abundant supply for Mombasa and its satellites, though not now. An underwater observation room at the Springs allows visitors to watch the slow motion antics of the ponderous hippo and also provides an occasional view of the scaly back of a predatory crocodile.

Beyond Mzima rises another spectacle, the Ngulia Hills with a magnificent escarpment which falls 1,000 feet to the plains below. The ribbon of the Tsavo River winds away to the east where it joins the Galana River in Tsavo East National Park.

Tsavo is the Kamba word for slaughter. The river became a temporary railhead during the building of the Uganda Railway while work progressed on the bridge needed to carry the rails across it. The supervising engineer estimated that this would take about four months. However he reckoned without Kenya's wildlife. Two lions created so much terror that they were mentioned in the British Prime Minister's Parliamentary address, and their deaths established the heroic image of Col. J. H. Patterson. The lions killed, and ate, at least twenty-eight Indian labourers and untold numbers of Africans during their raids,

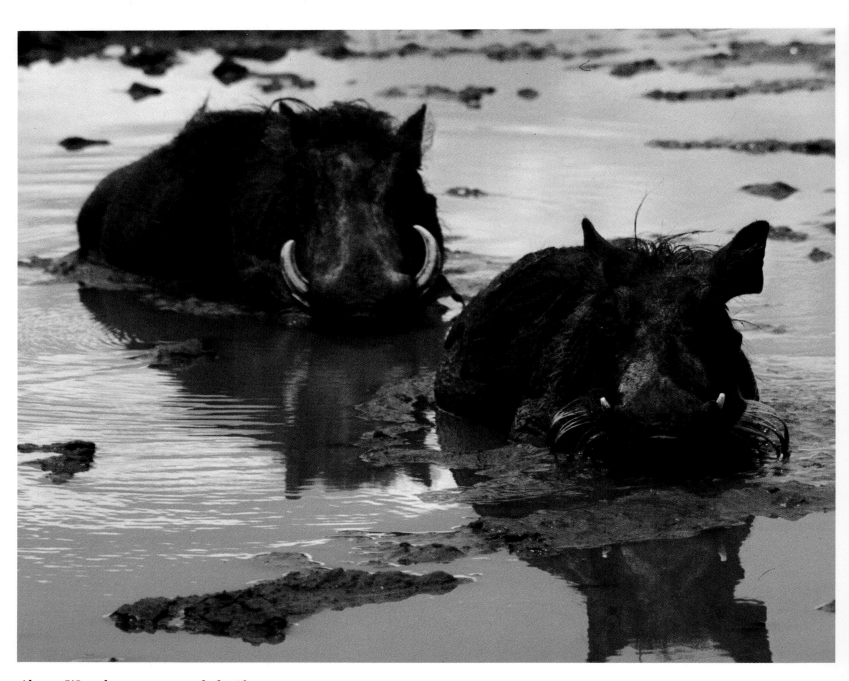

Above: Wart-hogs at a water hole. The species derives its name from the four wart-like protuberances which project from each side of its face.

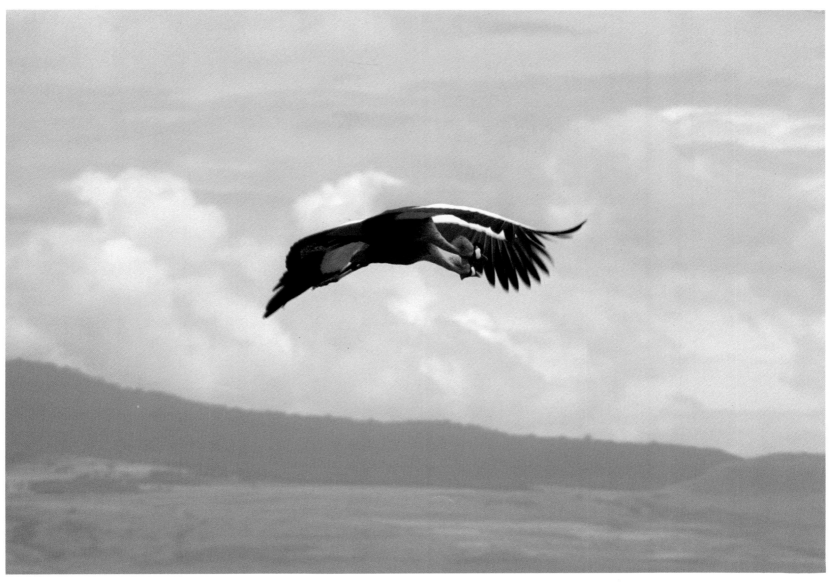

Above: Crested or crowned crane, common throughout Kenya and East Africa, is the national emblem of Uganda.

Left: Nature's clever camouflage is well demonstrated by the way this Kenya owl, one of many species of nocturnal bird raptors common in Kenya, blends perfectly with the parched grey limbs of the thorn tree on which it is perched.

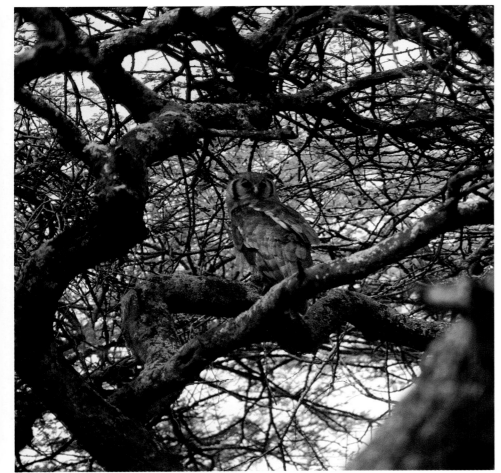

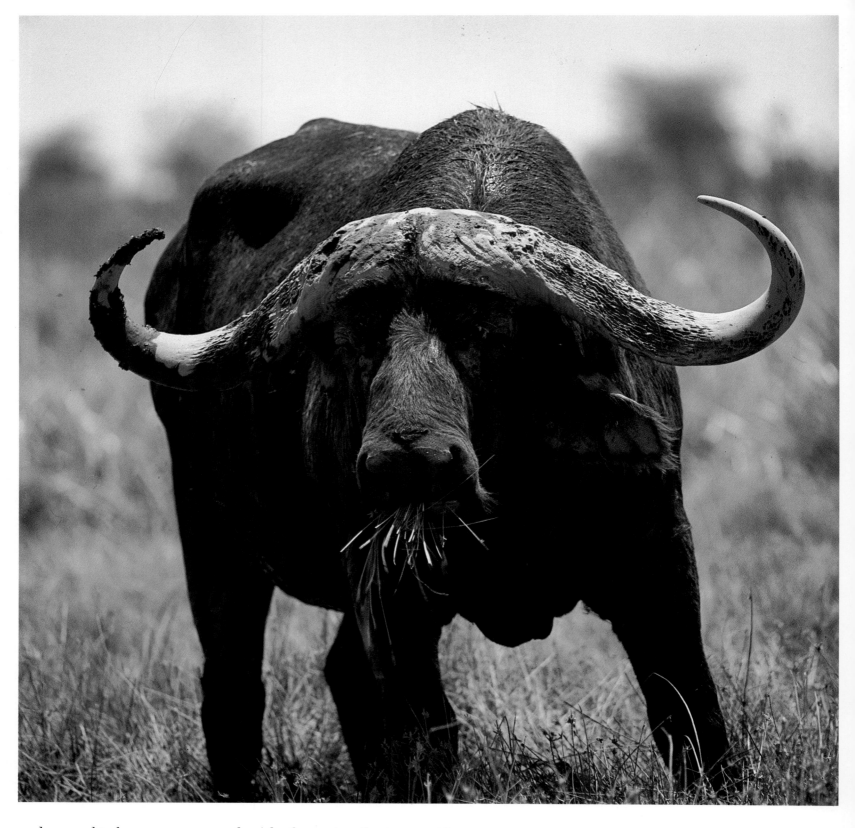

and seemed to have an uncanny knack of escaping the traps set for them. Patterson, who finally shot them both, was a military martinet but capable of such a melodramatic account of the affair that it has become a classic of African adventure.

A half-finished motel, imaginatively planned as a circle of vintage railway wagons, circa 1897–98, now indicates the spot on the main Mombasa-Nairobi road where the railhead camp was pitched. The tormented ghosts of the construction workers who were eaten are still said to walk at night. However, the moaning noise which can be heard more probably comes from the thousands of baboons which haunt this spot.

The southernmost road leaves Tsavo West near Chala on the eastern foothills of Kilimanjaro. Cloud sometimes rings the sister peak of Uhuru,

Above: Cape buffalo, one of the celebrated Big Five which, unlike the other four—elephant, rhino, lion and leopard—is in no danger of extinction. A full grown bull measures up to five feet tall and weighs almost 1,000 kilogrammes. They are often truculent, especially when grazing is short in times of drought.

Right: Baboon have a patriarchal social order and the young are frequently chastised by their elders. Extremely gregarious, these primates move in large packs.

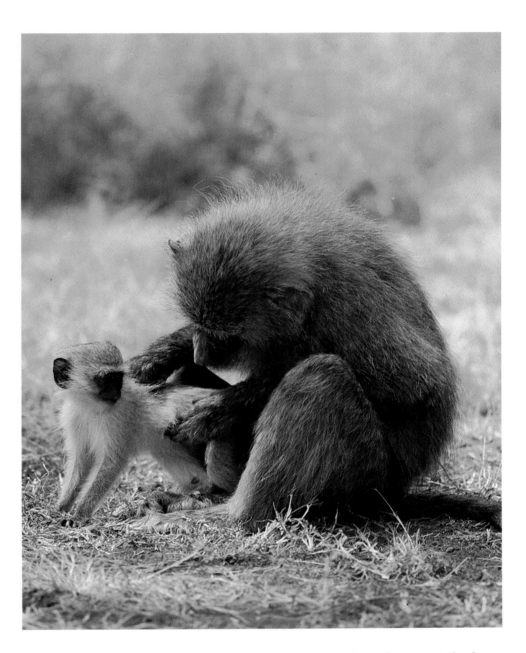

the 16,900-foot Mawenzi, visible from Chala on clear days. Rarely does it detract from the wonder the visitor feels when he climbs a rough track to come out on the rim of what is arguably East Africa's loveliest crater lake—Chala, a sparkling green-blue jewel set in the throat of Kilimanjaro. Some 350 feet below the rim two canoes float on its serene surface. The fishermen live in caves at the base of an almost unclimbable, precipitous and eroded track. An iron jetty is evidence of the efforts of a British naval survey team to chart the lake some years ago. The border with Tanzania bisects the lake exactly at its centre but the fishermen live on the Kenya side.

Halfway between Chala and Lake Jipe in the east, the border of Tanzania and Kenya jinks inward in the direction of Moshi, one of two odd squiggles in an otherwise straight line which were caused by the transfer of the mountain to the Kaiser. The last stop on the Kenya side is

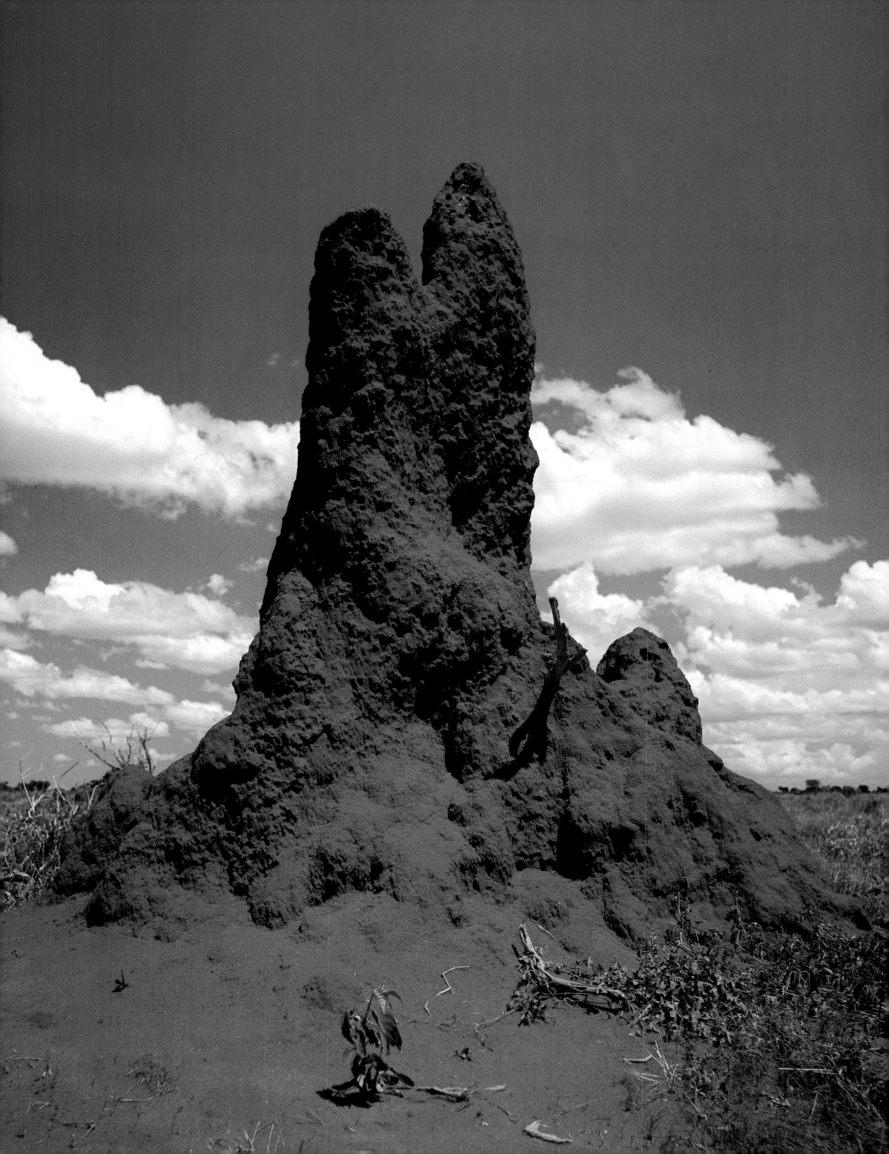

Opposite: Termite hill, of the macrotermes *species, in Kenya's Tsavo West National Park, rising more than 12 feet high. Elaborate and intricate examples of insect architecture, the hills are sophisticated community centres with many central passages and effective air-conditioning systems.*

the pleasant farm and railhead town of Taveta where the now defunct East African Railways track used to cross into Tanzania. The North Pare Mountains rise 6,928 feet in the east and provide Taveta with an idyllic setting. The range dangles its feet in the waters of Lake Jipe where the border once again makes an exact dissection down the centre of the lake. Lake Jipe is fringed with reed and papyrus swamp. The Park's staff run a motor-powered punt from their base, which is also served by a landing strip.

Euphoria induced by an hour's cruise on the ruffled waters amid the most varied avifauna in East Africa becomes stronger on the long drive through the Tsavo Plains to the Taita Hills. The blur of termite hills, the hammering of the road, charge the blood with African fever. It is an almost hallucinatory need to be moving on, ever on, through an endless plain of thorn and grass while in the distance ahead, on every horizon, another range of misty mountains beckons the soul forward. The fever is incurable. Frequent stops in cities are the only known relief.

The contrast between the semi-desert plains of Tsavo, wearing their first mantle of late rains grass, and the Taita Hills is one of the most pronounced in Kenya: perhaps, more than any other, it captures the sense of surprise, the sudden change of both climate and scenery which can confront the traveller during a journey through this diverse country.

The mind recalls the blurred images of three weeks of travel through almost 5,000 kilometres of Kenya—and remembers the moment when, just 7 kilometres from the Kenyatta Conference Centre in Nairobi, two rhino stopped to sniff the air for danger.

The dirt road to Wundanyi climbs some 3,000 feet in the space of a few kilometres of hairpin bends, and at each level the verdant Taita Hills take on new perspectives. From a height of 4,000 feet neat terraced smallholdings step down the steep slopes—vineyards of vegetables and fruit which look as if they have been removed from the southern slopes of the Italian Alps and put down in Africa. Below, pimpled by lava and hills, the Tsavo Plains stretch into infinity. Another 1,500 feet higher and the air is champagne. The hills are crowded with the industrious, friendly Taita people who, long ago, extended an unsuspecting welcome to the first slave caravans.

The Taita Hills were the area around which a small German force, led by Colonel Paul von Lettow-Vorbeck, managed to taunt and tease an overwhelming British army of 250,000 under General Jan Smuts during the First World War. Von Lettow-Vorbeck, whose handful of African commandos has been fictionally immortalized in Wilbur Smith's *Shout at the Devil*, struck often and effectively at British defences, threatening to destroy the bridge which Colonel Patterson had flung across the Tsavo. On the plains below the Taita Hills they constantly harassed the British and the conflict is now perpetuated by an imaginative, if forbidding looking, lodge built in the baroque style of a Teutonic fort, from cemented sandbags. Vorbeck's motto was: 'Harass, kill, but do not get caught.'

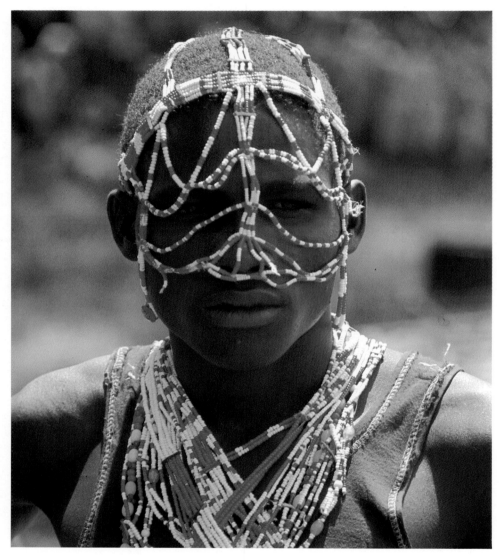

Left: Kamba warrior: the tribe, numbering more than 1.5 million, speak a language similar to the Kikuyu and make first-class hunters, trackers and military recruits.

Near to the Taita Hills is Voi, which used to be a mandatory stop on the rail journey from Mombasa to Nairobi while dinner was served in railside bungalows. Now even the main road which bisects the two Tsavo Parks bypasses it. The road, built more than half a century after the railway, was not so much as a twinkle in the administration's eye when L. Galton Fenzi made an epic pathfinding expedition from Nairobi to the Kenya coast via Arusha in a car in 1926. It took him more than two weeks. The road remained a hazardous means of travel and, even as late as the early 1960s, it was a good two-day adventure to reach Mombasa, broken by the joys of Mac's Inn at Mtito Andei, almost exactly halfway. In the early 1970s, however, a new highway joined the railway dividing the two game parks and was followed in close succession by an overhead power line, a chain of micro-wave radio relay stations and, finally, the Mombasa to Nairobi oil pipeline. These left the largest half of the park on the east side.

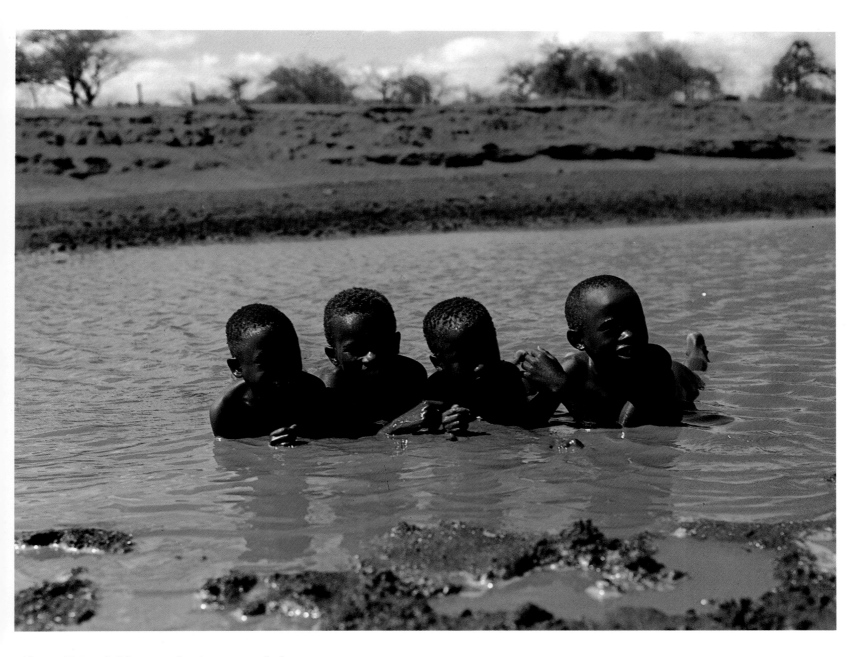

Above: Taita children at play in a water hole near Voi.

Its north-west boundary begins south of a small roadside settlement marked by Hunter's Lodge which is named after a game warden, J. A. Hunter. He was a Scotsman employed in the Machakos area for many years. In one legally-sanctioned session of wildlife control after the Second World War he killed almost one thousand rhino, an episode described in his book *Hunter*.

Some 30 kilometres from the lodge is the Sikh temple of Makindu, which means palm trees, where a Sikh sect offer a unique adaptation of the Good Samaritan parable. Weary travellers can pull in and eat their fill of simple, wholesome food. There is no charge, but a contribution to the temple's upkeep is welcome. When building the railway, Makindu became a railhead town and the relief station for the provision of food for the Kamba, who were almost wiped out by famine in 1899.

The tribe, which lives in the hills around Machakos and Kitui, numbers more than 1.5 million. Excellent soldiers, they also have a strong artistic streak. It is Kamba wood carvings which line the streets of Kenya's main towns. A visit to a Kamba wood carvers' co-operative is salutary: thirty to forty craftsmen, each with his whorl of hard or softwood, sit crosslegged whittling with a dexterity so swift it deceives the eye. A lump of ebony becomes a stampeding elephant within twenty minutes; a log of Elgon olive, a rheumy old village elder, with gnarled and pain-twisted fingers, inside fifteen minutes. It is art on a scale which merits the description mass-production.

Beyond Makindu is Kibwezi, which used to be a malaria-infested black swamp and is now a minor town serving Msongaleni, a large flower farm on the periphery of the national park which once supplied thousands of cut flowers daily to winter Europe but is now a research farm.

Kibwezi lies on the south side of the Yatta Plateau, at the foot of which runs the Athi River to merge, at the east end, with the Tsavo and become the Galana. It widens out some kilometres downstream to tumble through Lugard's Falls in one of Kenya's rare displays of white water. The Falls are named after Frederick Lugard, Britain's first pro-consul in East Africa. Crocodiles drowse on the sandspits downstream.

North of the Galana, Tsavo East is virtually a private sanctuary. The dangers of the desert and the marauding *shifta* bandits and poachers, together with the ideal of an undisturbed animal kingdom, prohibit the general public from visiting these remote regions. The roads are permanently closed and, in spate, the Galana itself is a considerable obstacle to cross. Tsavo East's only other river meets a man-made dam at Aruba, little more than 30 kilometres from the Voi Gate.

The eastern end of the park is bleak and touches on the Taru Desert which was feared by all the early travellers for its lack of water.

Right: One of the high peaks of the picturesque and fertile Taita Hills which rise out of the Tsavo Plains.

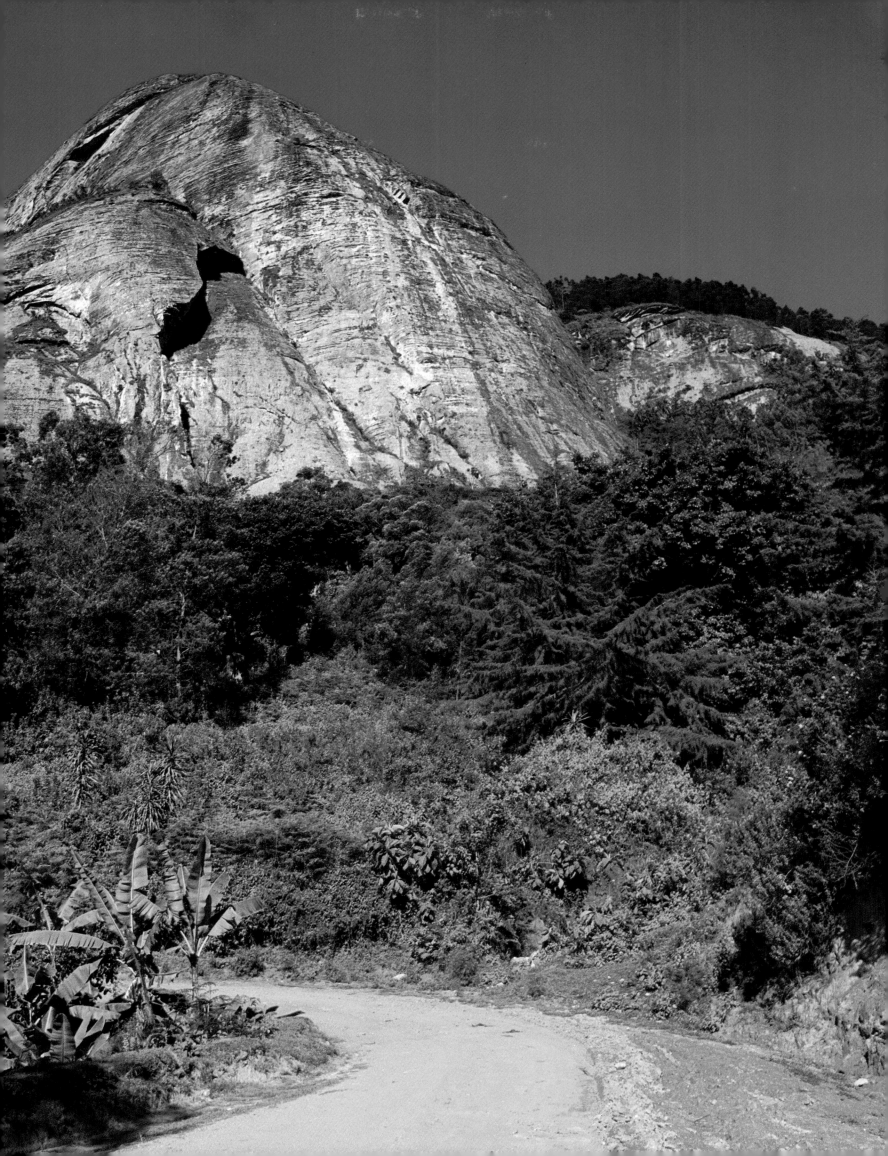

Opposite: Weaver-birds nest in a Tsavo Park baobab tree. The curious appearance of the baobab has given rise to many legends. Its inner trunk is often hollow and one legend of the coastal Swahili people is that its branches are its roots—after it was uprooted by the Devil in a rage and turned upside down.

Occasionally water was available at Buchuma Wells; otherwise the only permanent source was at the waterhole on 1,200-foot-high Mount Maungu. The Buchuma Gate of Tsavo East is near this spot and also near the dusty one-street town of Mackinnon Road which derives its name from the British ship-owner Sir William Mackinnon who planned to build the Uganda Railway as a private enterprise. Recognizing the desert as a major obstacle he brought in steam rollers and put a road across the Taru to conquer the badlands. Mackinnon Road started life as the main work camp for this project.

The desert was the great barrier. For centuries it held back all but the Swahili caravans which ventured to cross it in search of wealth in the form of slaves and ivory. For the rest, the sultry heat of the Coast was enough. Enervating, the sea-level humidity prohibited almost any heavy physical effort. But it was infinitely preferable to death by thirst in the Taru.

Ironically, while Kenya's early tourists came to cross the Taru and marvel at the wonders of the interior, fashions had changed markedly by the beginning of the 1970s. Today there is only one destination in the minds of most—the delights of the 480-kilometre-long coral coast. No longer the 'white man's grave' of legend it is, in reality, one of the world's most idyllic holiday playgrounds.

Overleaf: Fort Siyu on Pate Island, north of Lamu, is a well-preserved monument of a more recent era.

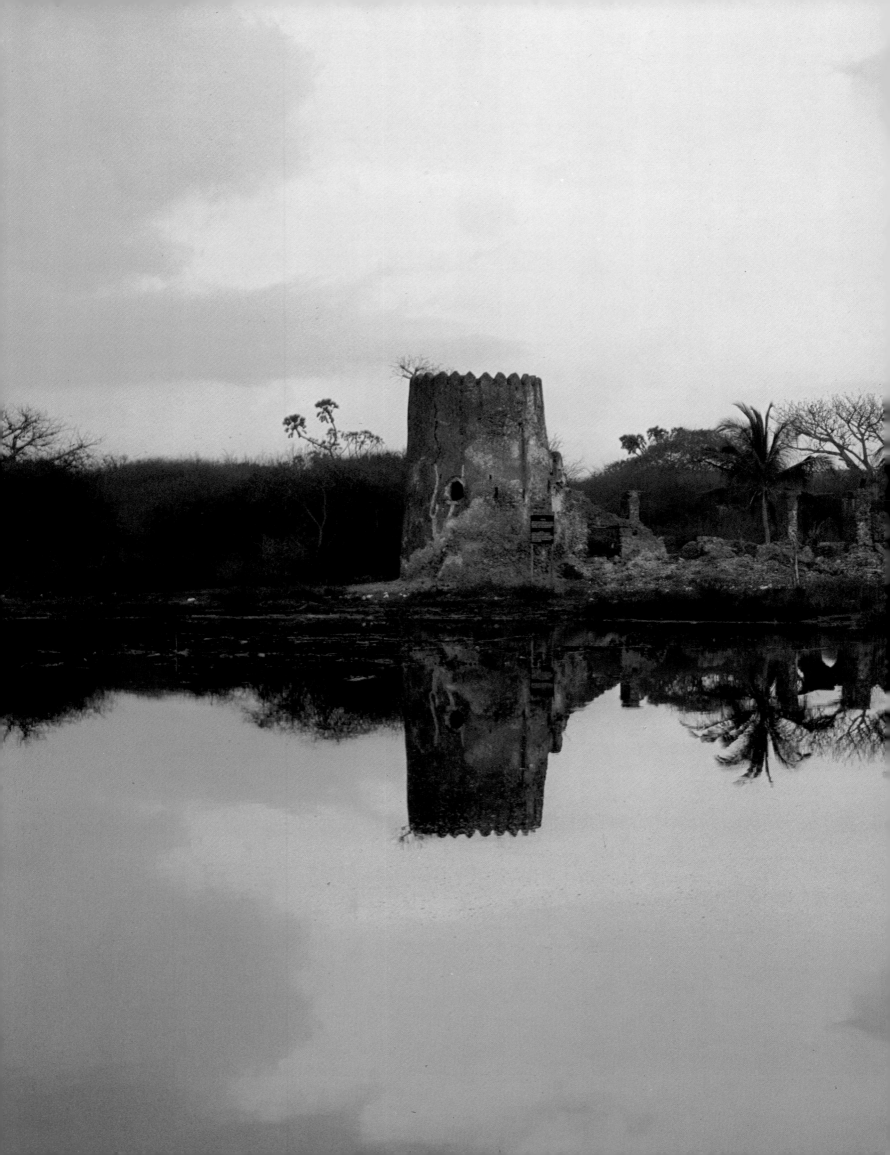

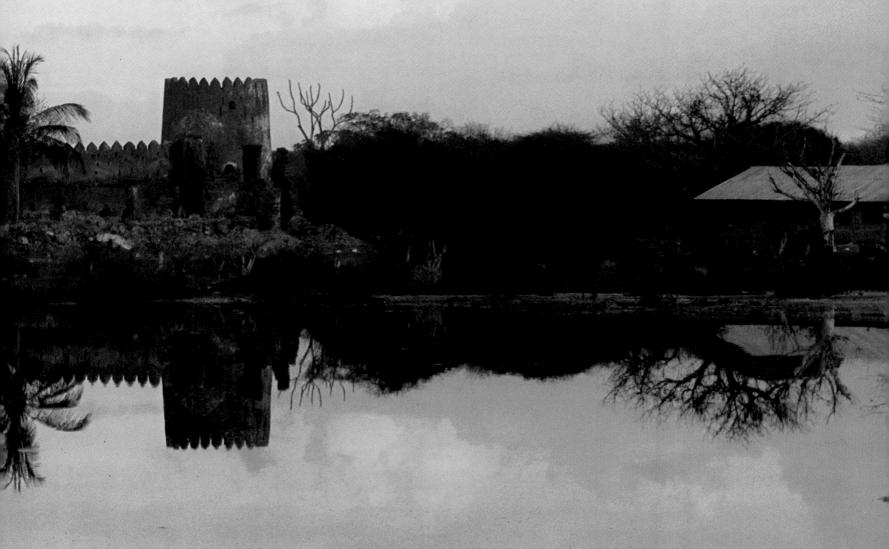

Some say they can smell the hibiscus and the frangipani, the poinsettia and the oleanders, the casuarinas and the gardenias long before they reach Mariakani, 750 feet above Kenya's coast. Named after the Kamba arrows used in battles with the Maasai early in the nineteenth century, Mariakani is where the Nairobi-Mombasa road dips to the always unexpected indolence of Mombasa.

Kenya has more than one hundred international-class hotels—five listed in the register of the world's three hundred greatest hotels—ranging from comfortable to extreme luxury. More than fifty of these are beach hotels—and for more than 50 per cent of Kenya's tourists this is where a Kenya safari begins and ends. Even after hours of non-stop driving tiredness vanishes at the sight of the high-pitched makuti roof of the bar and the caress of an evening breeze. The transition from the desert is complete. Luminous night descends, fireflies perform their incandescent dance among the bougainvillaea and succulents, and a pale shaft of silver moonlight strides across the lagoon. The scent in the air is no illusion for the frangipani seem to bloom even in the pale dark night.

The Kenya coast is in lush contrast to the deserts, plateaux and mountains upcountry; a world removed from the primordial wildlife which roams the diminishing inlands. Under the tall palms, effort of any kind is an exhausting exercise. Islam dominates and from the minarets in the still-dark morning the echoing calls of the muezzins summon the faithful to prayer in a scene unchanged since Arab traders first came centuries ago to seek profit and stayed to settle, intermarrying with the indigenous peoples. This was the locale for Sindbad's tales of *The Arabian Nights*, the country the Arabs called the 'Land of Zinj' (Blacks). The Greeks knew it as *Azania*, The Dry Country.

Monkeys abound and snakes, both deadly and harmless, proliferate—the shy but lethal black and green mambas vanishing silently into the prolific undergrowth and coral outcrops at the first footfall of an approaching human. Bats wheel dizzily under the trees. Among the sweetness of frangipani, coconut and mango, a family of monkeys bursts out chattering.

Early morning sees the first pink of dawn on the far horizon and sandals of cloud stepping across the sky glow briefly before fading. The incoming tide raps the reef and floods the lagoon. Sail surf-boards are pushed out from the shore and suddenly heel into the breeze, lithe helmsmen tacking by inclination of hip and knee.

Swimming is safe on almost every beach though at low tide it is best to wear some footwear to avoid injury from stonefish, coral and other hazards. The water is always warm, ranging from 27°C to 35°C but never ruffled by storms. Kenya's climate reflects the kindness of its tropic shores. Though the sun shines clear almost every day of the year—even in the rains—the heat is usually tempered by a cooling breeze. Shade temperatures rarely rise above 35°C.

Another long-time coast favourite is water-skiing, though care should be taken over water levels. At low tides hidden coral heads make the sport potentially lethal. In recent years, coast hotels have introduced catamaran vessels and wind-surfing—sails on a surf-board—for more active leisure lovers.

Opposite: Tourists strolling on one of the many sylvan beaches which abound on the 480-kilometre-long coast where sunshine averages 10 hours a day all year round.

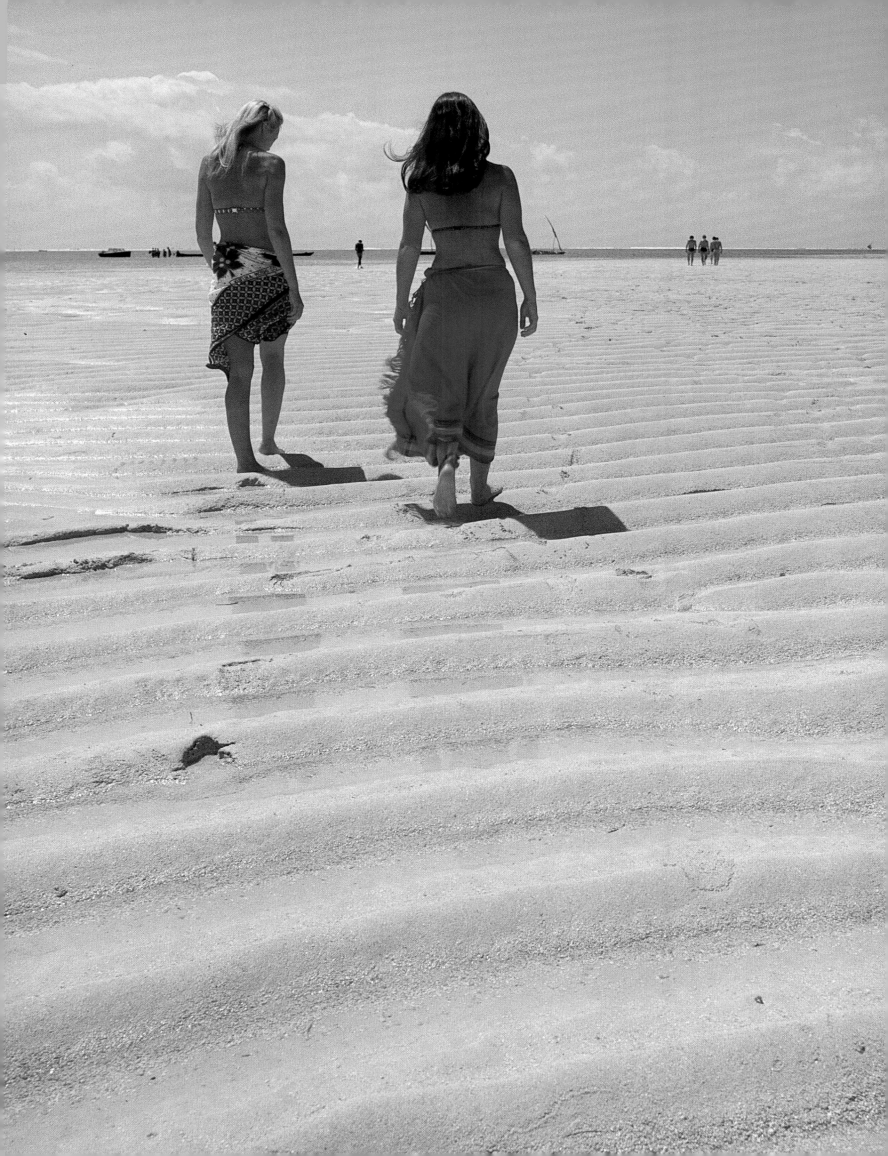

Below: Wind-surfing on the Indian Ocean, the surfer steering with inclination of hip and knee. A frieze of whispering palms by an aquamarine sea, Kenya's sun-kissed coral coast has become the Number One destination for most tourists to Kenya.

Most come simply to enjoy sun, sea and sand but for those inclined to snorkel and scuba dive Kenya's reefs, coral gardens and lagoons are among the most beautiful in the world, filled with more than 200 species of fish. In one day, in one small area no bigger than half a hectare, the selection ranges from tiny, brilliant jewel-fish to huge rock cod weighing upwards of 300 kilogrammes—for all their weight and length, shy harmless creatures of the deep. In this remarkable world of marine wildlife the names are often from another environment—the zebra and parrot fish contend with the scorpion, butterfly and bat fish for familiarity.

Thousands of scuba divers annually make the Kenya coast their resort destination—plunging down 100 feet to marvel at the complexity of marine life which flourishes beneath the surface. The name scuba is an acronym for Self-Contained Underwater Breathing Apparatus. Comparatively weightless in the water, the equipment provides a reliable life-support system inside a mask and rubber suit which helps to reduce the chill produced by prolonged immersion even in Kenya's surface-warm tropical waters. The first experience, slowly

drifting with the current along the wall of one of the main reefs, is euphoric.

Though it is possible to dive in almost any part of Kenya's reef waters, the country's three marine national parks—two in the north, at Malindi and Watamu, and one in the south, at Shimoni—provide safe and certain underwater rewards.

On the bottom, serrated ripples of coral sand change shade as the clouds pass above the surface, and the swaying diver hears only the gurgle of bubbles and, beyond that, the rasp of the parrot fish gnawing the coral. Colours change swiftly from pellucid technicolor to almost monochrome greens and greys and browns as schools of vivid fish, zebra and parrot and other species, swim by heeling in elegant disarray.

Giant turtles emerge ahead of the swimmer in the 100 feet or so of horizontal vision and in a coral overhang lurks a barracuda with malevolent eye and killer teeth. Moray eels perform a slow motion dance of aggression. A poisonous stone fish, obscene and hideous, is almost hidden on the murky sea bed, its back a sac of venom waiting for the unwary. An octopus scuttles across a coral head, distended with fear, jet black ink staining the aquamarine water as it seeks refuge in an overhang.

Almost before it has begun this strangest and most delightful wildlife safari is at an end. The shadow of the boat lies over the water and the recovery rope drifts away on the current. From this depth the diver climbs the rope, pausing at intervals for proper decompression before his head breaks surface and he clambers back into the boat which he left an hour before.

Out beyond the reef, in the combing white horses of the deep swell of the seasonal monsoon, perched in the swivel seat of a well-rigged power boat, an angler trolls for some of the finest fighting fish in the world. Kenya's waters lie within those latitudes in which Big Game fish thrive.

All along Kenya's 480-kilometre coral coast outside the protection of its idyllic reef lagoons, the giants of the sea—like swordfish, tunny, bonito, falusi, sailfish, barracuda, shark, marlin, kingfish, wahoo and others—offer even the most jaded sportsman the challenge of a lifetime. The pleasures of tackling these swift-moving marine predators have grown in popularity since author Ernest Hemingway first discovered these teeming waters off Malindi fifty years ago.

The biggest catch recorded up to 1981 was a Mako shark that topped 325 kilogrammes. On another occasion three anglers who lost a black marlin after an epic struggle were emphatic it would have tipped the scales at 500 kilogrammes. The broadbill swordfish of these waters is reputed to be the gamest fighter.

The best times for fishing are at the end of the year when the major contests are held. But the season is perennial, despite the monsoons, and the big bill fish run well between August and March. The heaviest barracuda taken in Kenya waters weighed more than 30 kilogrammes. Tackle and boats are available all along the coast but there are six resorts which specialize in serving Big Game anglers—Lamu, Malindi, Watamu, Kilifi, Mombasa and Shimoni.

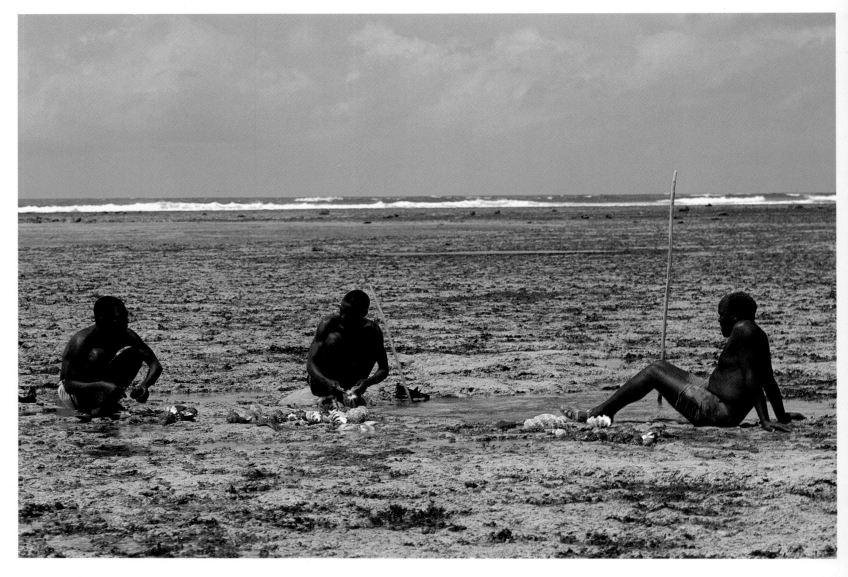

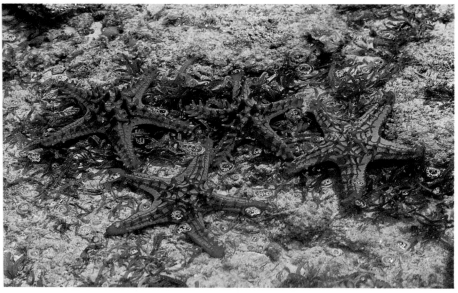

Above: Venomous stone fish, which carries a virulent poison in the sac on its back—waiting for the unwary to settle on it, or tread on it, in the rock pools inside the lagoons along Kenya's Indian Ocean coast which are its favourite habitat.

Top: Coast fishermen with selection of shellfish which are much sought after by tourists. Depredation of Kenya's coral reefs had reached alarming proportions by the beginning of the 1980s, with fears that much of the coral and, in turn, much of Kenya's marine life, would be destroyed by the end of the century.

Above: Sea star, common in rock pools and on reefs in Kenya waters.

Opposite: Bajun fisherman in the Lamu archipelago in the Indian Ocean working on repairs to a sail on his outrigger, the dug-out inshore craft favoured by the Kenya coast fishermen.

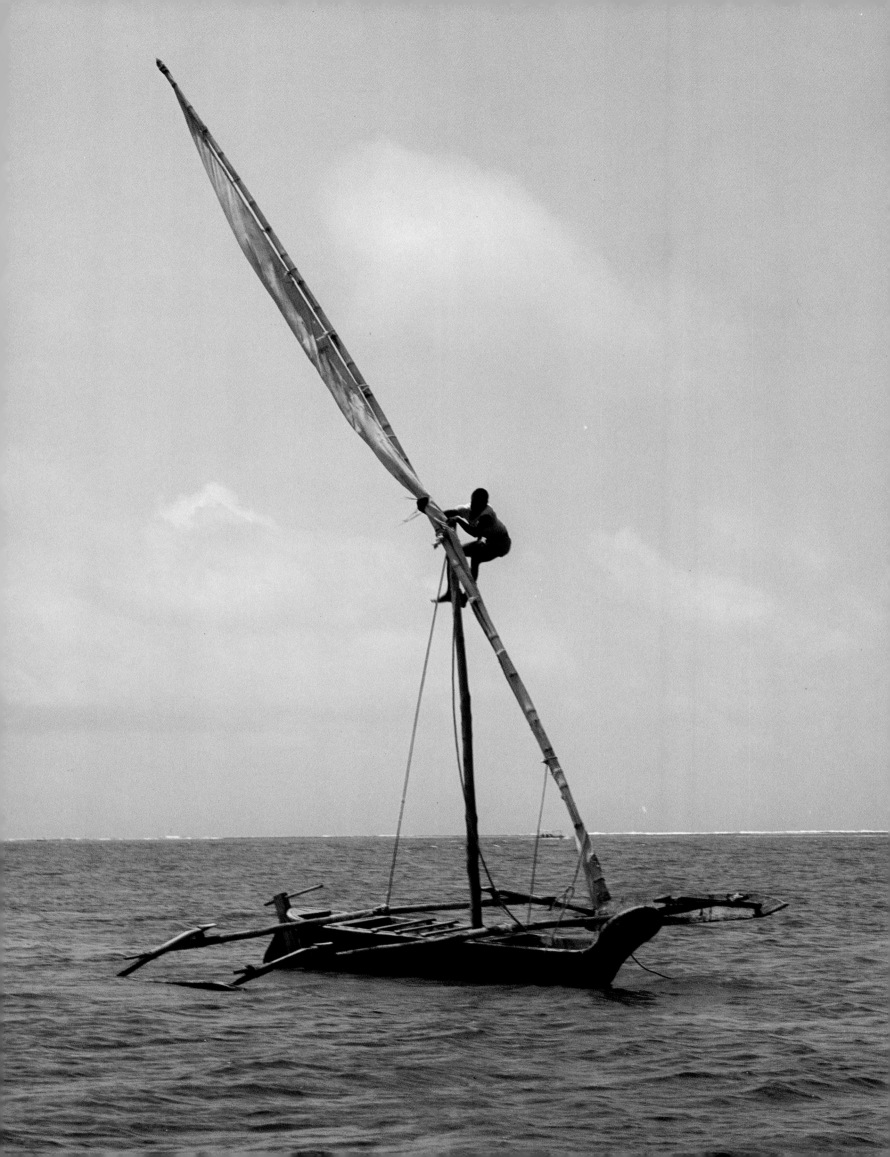

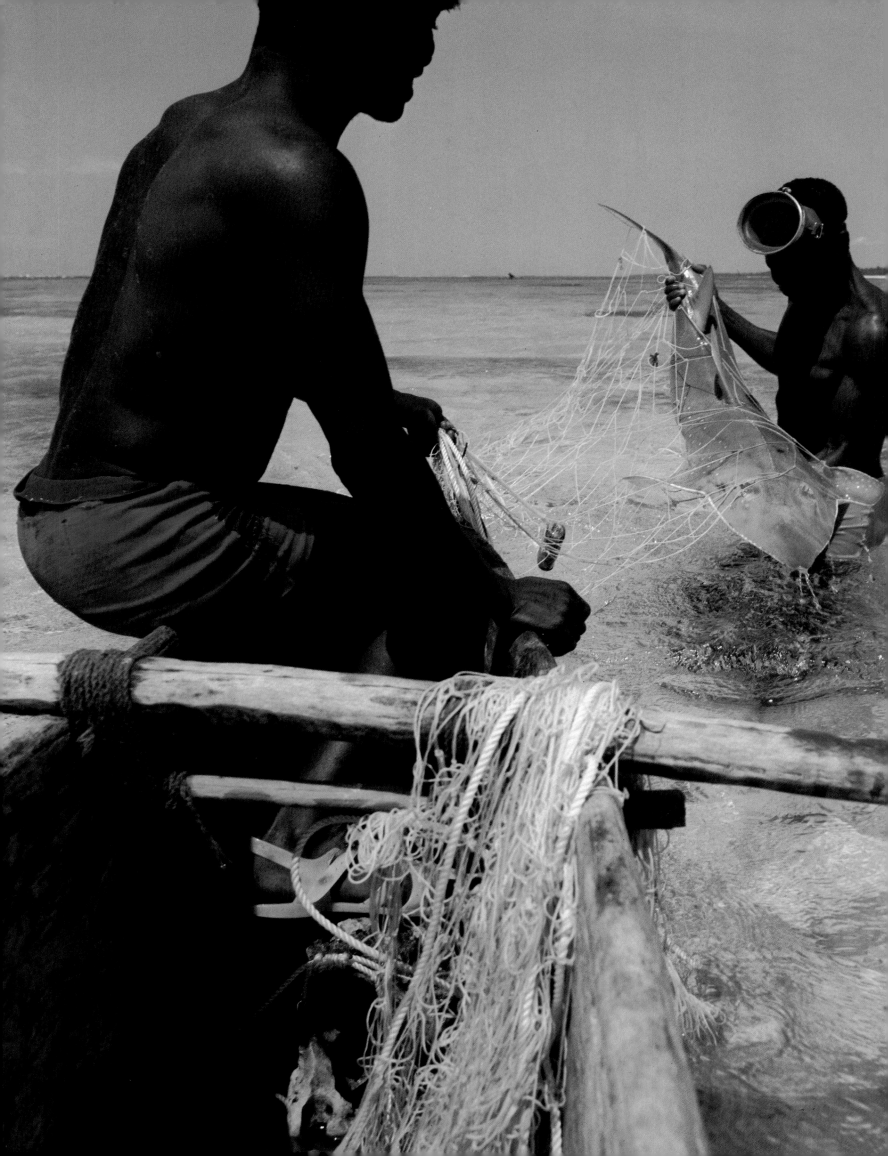

Opposite: Fishermen on Kenya's coral coast untangle sand shark, a ray of the rhynchobatus *species, from their net.*

Right: Well in a Mijikenda village some miles inland on a high plateau overlooking the Kenya coast. The tribe's name, translated, means nine villages, and they do indeed consist of nine groups, including the better-known Giriama and the Digo.

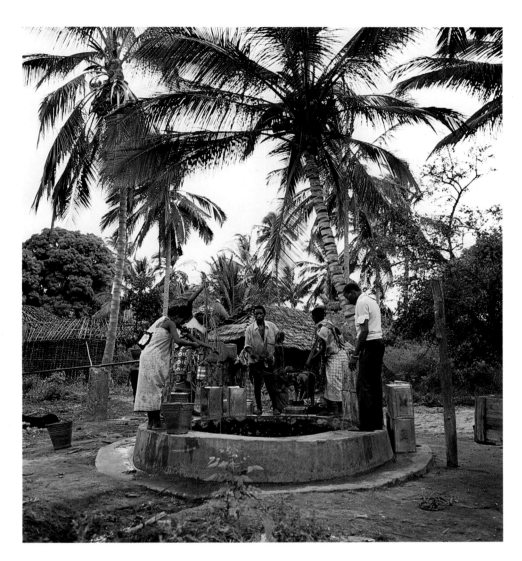

Shimoni, perhaps the most popular Big Game fishing centre on the Kenya Coast, is close to Tanzania. The fishing club provides decent accommodation and offers a sea trip for lunch on Wasini Island, 4 kilometres offshore, beyond which are a series of coral gardens proclaimed the Kisite-Mpunguti Marine National Park in 1973.

The four islets of coral—Kisite is the farthest from Shimoni—were used for target practice by the First World War German cruiser *Konigsberg*, which was destroyed by the British Navy, when she hid up the Rufiji delta in Tanzania. The *Konigsberg's* 40-centimetre shells are sometimes visible on the reef near Kisite. The difference between this park and the two in the north is marked by the soft corals of Kisite-Mpunguti. Among the rare fish found in these waters is the whale shark.

The main resort on Kenya's South Coast, however, lies further north at Diani Beach. In between are some interesting, scenic off-the-road detours: Konondo fishing village; a nineteenth-century sheikh's palace at Gazi; and an old stone ruin, possibly a slave pen, at Msambweni. Diani's silver beach remains unspoilt, an idyllic spot and Kenya's finest stretch of sand, with bathing at all tides.

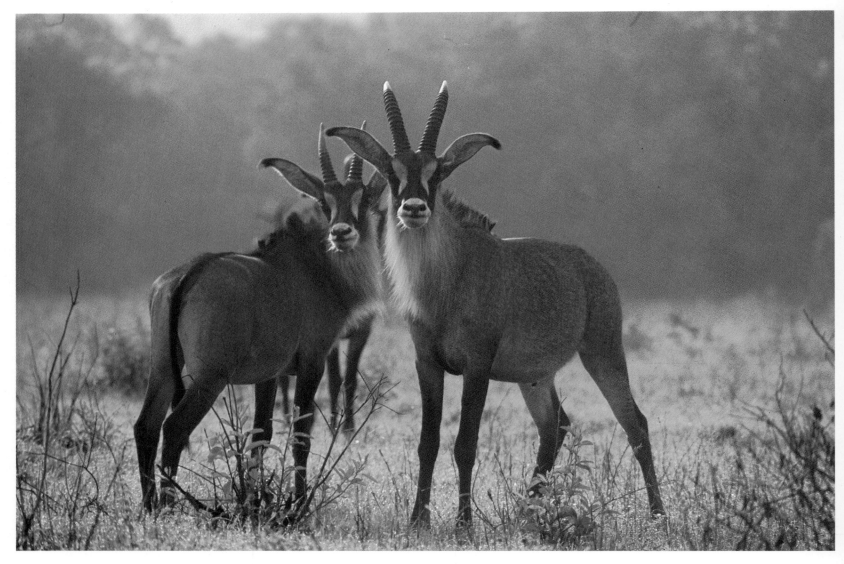

Tiwi, relaxed and casual, without a formal hotel, is the south coast's next major beach resort, redolent with the atmosphere of settler Kenya. A cottage-style lodge with restaurant and bar evokes the easy-going informality which marked Kenya holidays before the outer world discovered this paradise.

Coral cliffs at Waa are interesting for bat caves which can be entered at low tide—and, close to Mombasa Island, is Shelley Beach, on the south side of the Likoni headland, which was established as a resort by Sir Ali bin Salim, once Liwali (Governor) of Mombasa. The ferry which links the south coast with Mombasa adds to its charm. The teeming town is not so easy of access, however, as to tempt the sojourner from the shade of his palm beach.

Mombasa is Kenya's oldest settlement, first mentioned historically in *Periplus of the Erythraean Sea*. Ptolemy marked it on the maps in his *Geography* but only the most ignorant navigator would ignore the invitation of its natural harbours which today form the largest, most developed and most efficient port in East Africa. Ptolemy, who was 78 when he died in AD 168, was an Egyptian astronomer and geographer from Alexandria. He compiled a treatise on map-making and projections, accompanied by latitude and longitude for some 8,000 localities, including Mombasa. It was he who first spoke of mountains of snow on the Equator and of the great inland lakes.

Islam is the culture and faith which has shaped Mombasa society from the first missionary spread of faith around the tenth century. The Swahili language has developed from spoken Bantu and Arabic, but it is a phonetic language and has also borrowed heavily from other languages including English. In Kenya's lingua franca the word 'commissioner', for instance, is *komishona*.

Above: Dawn breaks over the 1,500-foot-high Shimba Hills National Reserve, a sanctuary of pristine, primal African forests little changed in centuries, with two rare roan antelopes. Close cousin of the rarer sable antelope, only the eland and greater kudu of all the antelopes reach a larger size.

Swahili people, too, are an *ad hoc* mixture of ethnic groups, cultures and even creeds; some of the tribes on the littoral have turned to Christianity, though they are in a minority. But this racial and religious mixture has come to be known, like the language which is their common link, as Swahili. They are people of mixed origins, exceptionally cheerful, with an aversion to immodest dress, fully united in their group identity as Swahili. They have given Mombasa a distinctive personality evolved from one thousand years of contact with the East, the Mediterranean and Europe.

North of the Island lies a succession of sylvan beaches, some developed plots with hotels, others as deserted as a Robinson Crusoe island. Two attractive deep-water creeks cut into the coast, far inland, between Nyali Beach and Malindi.

Smartest and most exclusive of the Mombasa suburbs, Nyali Beach boasts a palm-lined beach, a 12-hole golf course and attractive hotels with possibly the finest *à la carte* menus in Kenya. The restaurant, which sits atop a coral bluff overlooking Mombasa's fascinating Old Port—where the last few remaining dhows still clock in on the south monsoon towards year's end—is rated by gourmets as one of the world's finest for sea food and fish. Its prices reflect its quality and its reputation.

After Nyali, there is Shanzu with another stretch of clean, white sand and another cluster of first class hotels. Like Diani, it is possible to swim at Shanzu at any state of the tide. Nearby a bridge crosses Mtwapa Creek, an attractive and extensive deep-water inlet with stylish houses straggling down its cliffs to the water. On the north shore there is an attractive oceanarium including sharks, with beachcomber-style restaurant and bar. Dhow excursions as far as Lamu are offered from this departure point, and the calm, unruffled surface of the creek provides one of the finest water-skiing runs in the world. Years ago, however, tourists took an old dirt road which crossed the creek farther inland by means of a singing ferry. It was a chain and rope affair— hand-hauled across the creek waters to the rhythmic melody of its 'crew'. The song they chanted is said to have inspired at least one pre-war Paul Robeson ballad.

Roughly one kilometre beyond the creek is a national monument, a fifteenth century Arabic settlement, Mtwana. Beyond this is Kikambala, with another cluster of hotels and self-service bungalows and cottages. From all these it is possible to organize 'meet-the-people' excursions to see the life-styles of such ethnic groups as the Giriama, whose women place a great deal of faith in the attraction of enormous buttocks. It is considered *de rigueur* to enhance the rounded portions with old inner tubes, tyres or cushions. They are a Coast people by circumstance only, having been driven off their inland reserves centuries ago by the fierce Galla people, a group of Borana and Somali origin.

Kilifi, half-way between Mombasa and Malindi, is an attractive natural deep-water harbour. Luxury clubs and hotels cling to its high cliffs adding to the charm. Yachts and other vessels rise and fall gently at their moorings. A passage through the reef, an opening known to the Swahili as *Mlango* (Door), provides draught enough at high tide for the largest of these.

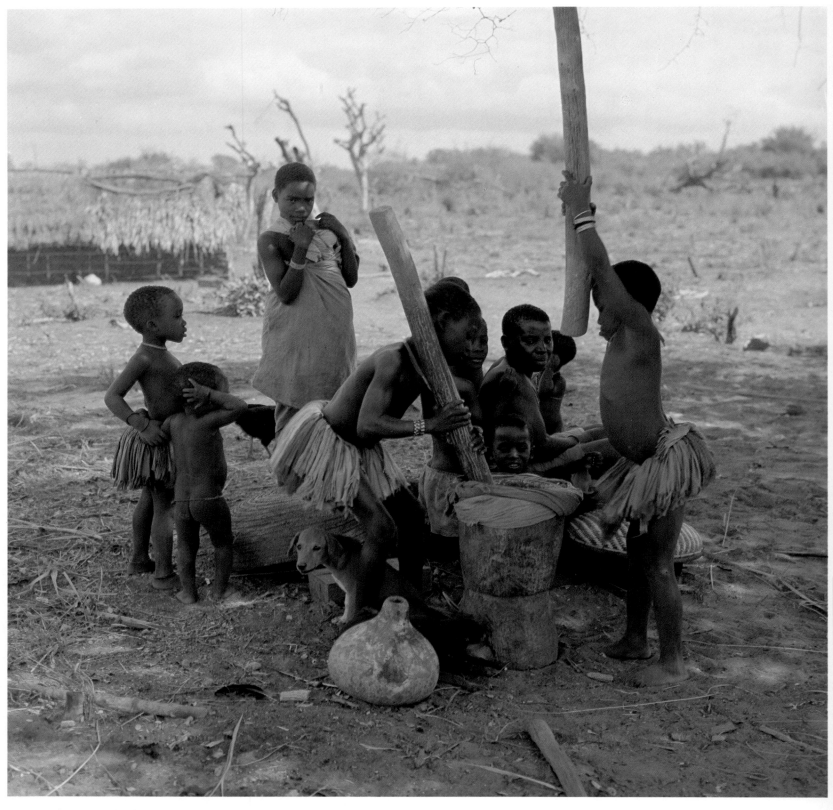

At the inland limit of the creek, which is said to offer some of the best diving in Africa, thousands of resident and migrant birds have turned the mangrove swamps into an ornithologist's delight. Species include the predatory carmine bee-eater.

The creek is crossed by modern ferries and on the other side the road borders the Sokoke Forest, which has an extensive number of natural rubber trees and is Kenya's last remaining tropical timber stand on the north coast.

Some 20 kilometres before Malindi lies Watamu Lagoon, Turtle Bay and the Blue Lagoon. In these three sheltered lagoons swimming is possible all day long, even at low tide. Most of the area lies within Watamu National Park. The Park is an underwater paradise where glass-bottomed boats carry the casual visitor over coral heads alive with colourful fish. More serious marine enthusiasts can turn to deep-sea

Above and opposite: The Giriama are from Kenya's north coast. The group used to live far inland until driven out a few centuries ago by fiercer rivals.

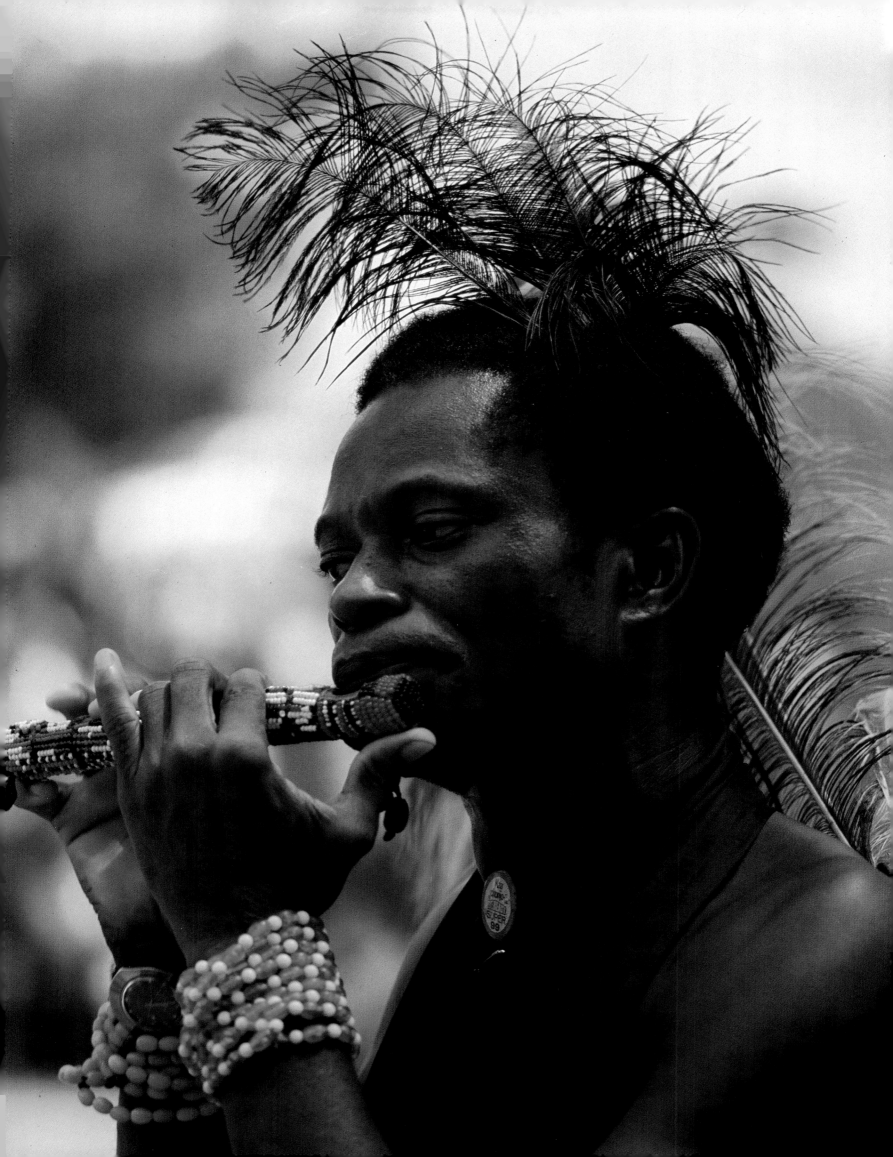

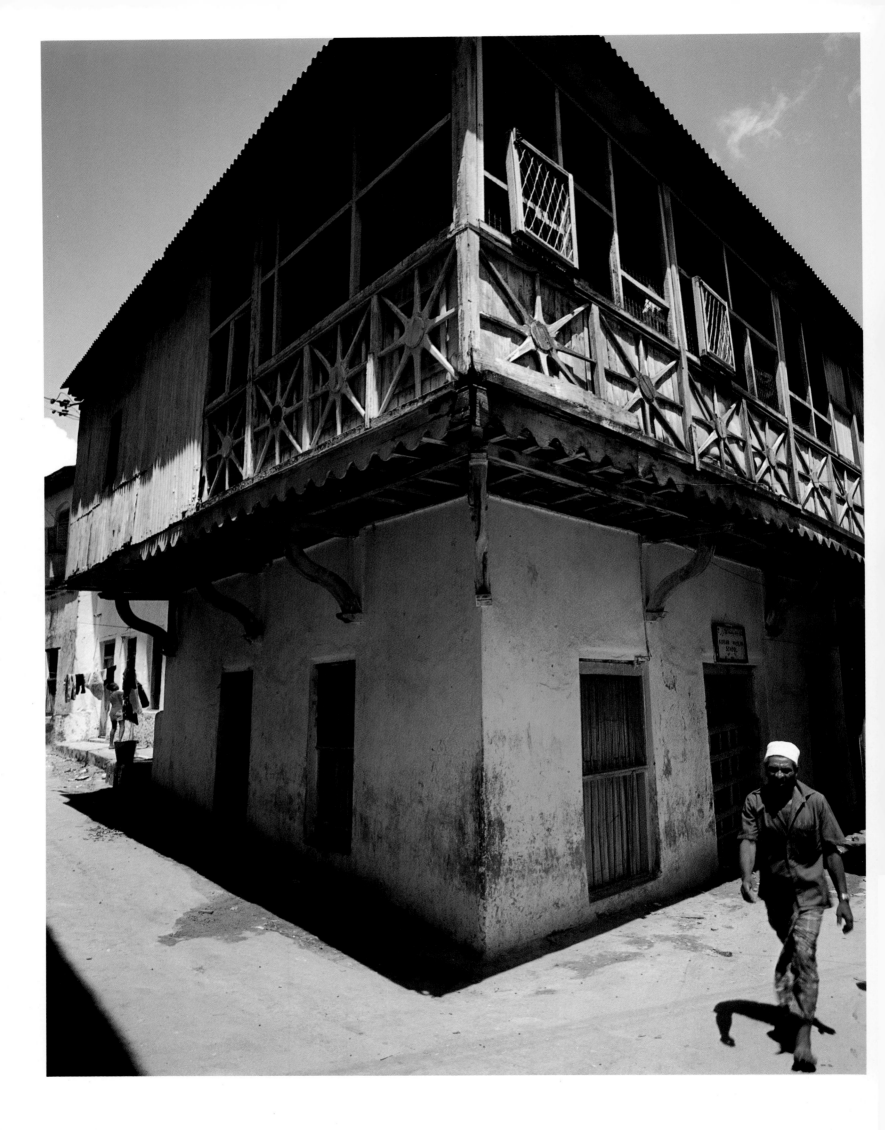

fishing offshore, or water-skiing or scuba diving. Inshore, the coral outcrops and bush are infested with snakes, both harmless and deadly. None the less some visitors join the safaris to see them in their natural setting.

The Gedi ruins, first of the coast's lost, ancient cities to have been uncovered, have been well preserved. They provide fascinating insights into the ways of the sheikhs and potentates who used to run affairs on the coast. Gedi existed for more than two hundred years before it was suddenly abandoned—in circumstances as mysterious as the more recently uncovered lost city of Shanga, farther north in the Lamu archipelago.

Vasco da Gama, the Portuguese navigator who sailed the East African waters in the fifteenth century, was the first European to put his mark on Malindi, a sweep of sandy beach which forms an attractive bay on the south side of the Sabaki River. Tons of silt washed down the river each year have destroyed irreplaceable coral gardens in the Malindi Marine National Park on the other side of Silversands, the south spit of the bay where a pillar commemorating da Gama now stands. He stepped ashore on Easter Sunday in 1498.

The silt has also built up the beach so that it is a long hike from the hotel to the water which used to be but a step away. But Malindi, the 'Melind' of John Milton, is the only frequented surfing beach in Kenya and it is also the coast's major deep-sea fishing base—a state of affairs which exists because of Ernest Hemingway's patronage in the 1930s. It was an idyllic town then and remained so until the 1970s when the Kenya Coast boom destroyed its remote and sleepy atmosphere, turning it into the nearest equivalent of the Costa Brava south of the Equator. Bustling markets and curio sellers have blossomed with the hotels and the tourists and Malindi—in style, if not size—is now similar to metropolitan Mombasa. Some welcome the change but many mourn the old Malindi.

Little less than six hundred years ago the town's Sultan sent a giraffe to China as a gift for one of the Emperors. This was noted in contemporary Chinese drawings and records. Two years after the gift was received the Chinese fleet sailed into Malindi Bay in 1417. It brought reciprocal gifts from the Emperor—and the keeper the Sultan had sent to care for the giraffe.

North of Malindi lies a world reminiscent of Sindbad's *Arabian Nights*, Arabic villages and towns set down by the side of steamy mangrove deltas. Of all the settled areas of Kenya least influenced by the twentieth century, this stretch of coast is linked to ancient glories by the inextricable threads of its Islamic faith. An hour's flight from Malindi to Pate Island follows a straight line across Formosa Bay over the Lamu archipelago. Below the plane lie faded towns which at their peak gave rise to accounts of wars so ritualized with splendour and chivalry that the actual act of combat was well down the list of heroic virtues.

By car it is a rough, bruising five to eight hour journey ameliorated by incursions into life-styles which were typical of the whole East African coast before the coming of the Europeans.

Not far along the road out of Malindi the town of Mambrui

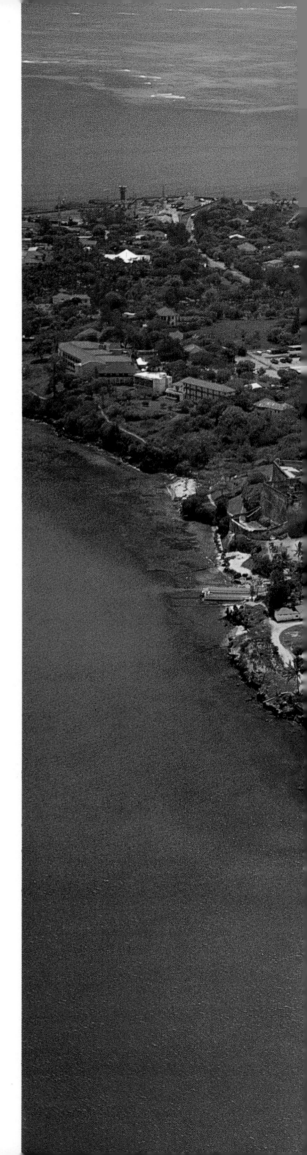

Right: Mombasa Island showing the Old Harbour, Fort Jesus, the sixteenth-century Portuguese-built fortress, and the main commercial areas. In the far background is the deep-water entrance to Kilindini Docks.

immediately evokes the Muslim influence; its fine mosque and pillared tomb are graceful echoes of Arabian architecture. From here to the mouth of the Tana, Kenya's longest river, at Kipini, the shores of Formosa Bay are backed by a stretch of sand dunes.

Centuries of silt from the flooded river have destroyed any reef that used to exist—and the curl of the Indian Ocean breakers makes a comb of fine surf on the broad sweep of the 80-kilometre-wide bay. On occasion an old tusker ambles through the dunes to browse on the salt-tolerant grasses which grow on the slopes, and to wade into the pounding surf.

Just outside Mambrui is the village of Ngomeni. It lies on the Ras Ngomeni sand-spit where the great spread of dunes begins behind a wide expanse of beach, sheltered from the silt debris of either the Sabaki or the Tana. Ngomeni has inspired an interesting juxtaposition of two worlds: ancient Islam and modern technology. The San Marco launch pad of the Italian Space Administration stands some kilometres offshore. Rocket launches seem inappropriate for such an idyllic setting and at night the belching flames leave an enduring image of space-age pyrotechnics. Beyond Mambrui the road cuts inland towards Garsen, passing through Gongoni, which has an extensive salt pan system for collecting salt from the monthly spring tides.

Studded with tidal creeks and mangrove swamps, indolent in the midday sun, the Tana meanders gently along. Perhaps once in every decade it comes into full spate, in a torrent 10 kilometres wide over the flood plains which stretch for hundreds of kilometres along its lower reaches.

These floods often precipitate a new course or mouth. At some time in the past the river used to debouch itself at the south of Formosa Bay at a spot called Mto Tana. On either side of the river, small villages mark its course inland towards Garsen, a trading town almost precisely halfway along the 225-kilometre road to Lamu. One of these villages is Golbani, the site of a Methodist mission established by the evangelist Thomas Wakefield in 1885. Only a year later the Maasai raided it, killing two missionaries and twelve other people. Eight years later rival Lutherans from Germany moved into the nearby village of Ngao. For decades the two Christian sects were in active competition for the souls of the resident Pokomo villagers. The Germans were forced out during the last war when one of the missionaries was discovered working as a spy, sending radio messages containing military secrets to the Italians in nearby Somalia.

About 5 kilometres before Garsen the road tops a rise revealing an extensive view of the lower Tana basin—north-west the savannah is broken by the meandering green belt which follows the Tana's course until it vanishes into a shimmering horizon. Gabbra, Orma and Pokomo people have made Garsen their main centre and meeting place, and the market is alive with the swirl of colourful cottons and clothes and the bustle of movement and conversation. In the region's rare rains—perhaps two or three months of the year—Garsen often serves as an impromptu long-term stopover *en route* to Lamu. The Tana is navigated by a hand-hauled ferry but 8 kilometres of wheel-bogging black cotton soil on the far bank create a wet season barrier before opening out on to

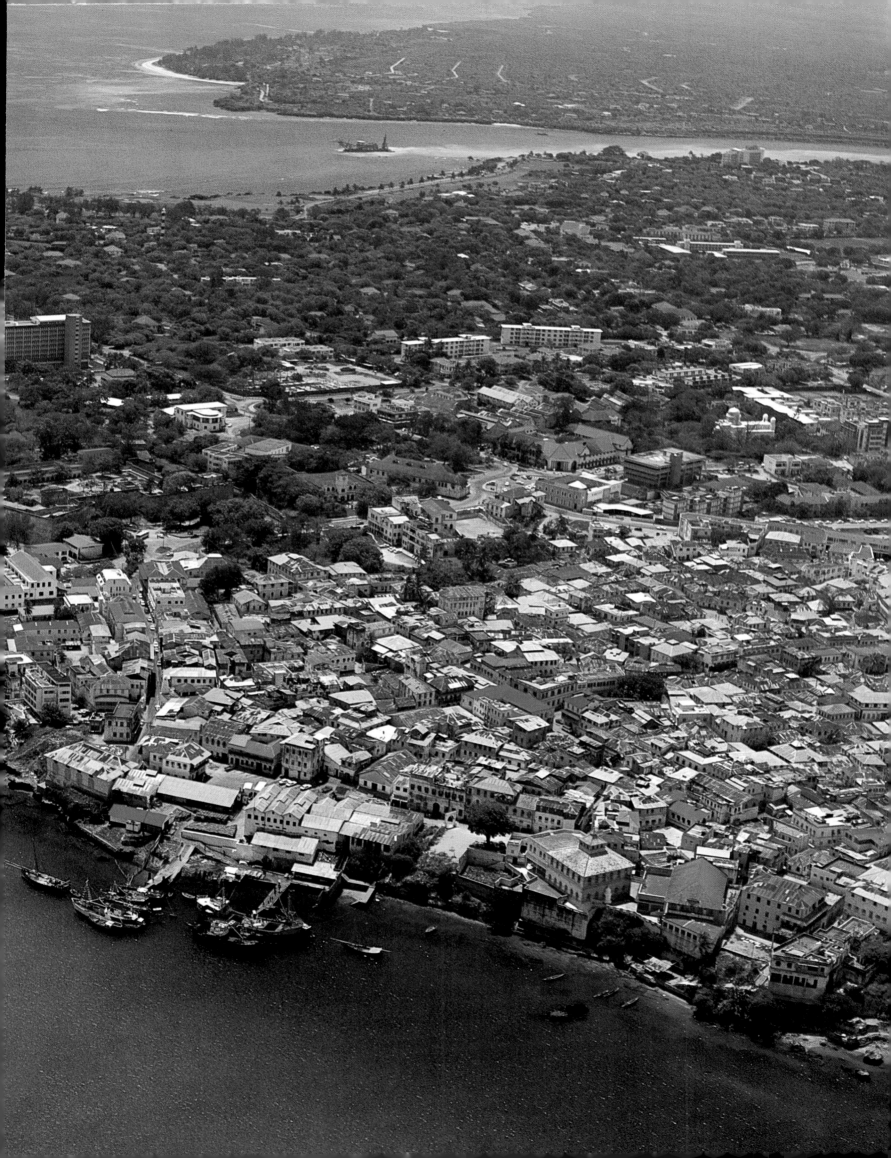

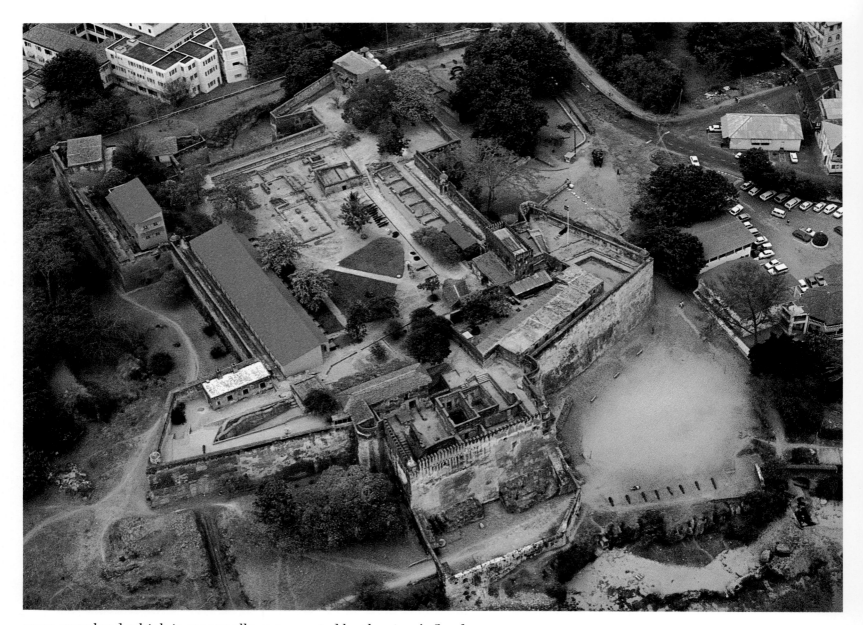

open grassland which is seasonally regenerated by the river's floods. The area is alive with water birds and at least one species of antelope, the topi.

Beyond is Witu, capital for a brief time of one of the Coast's petty fiefdoms, Swahililand. Driven from Pate in 1862 by the Sultan of Zanzibar's troops after a quarrel with the Sultan, the Zanzibari representative, known as Simba, decided to set himself up in business. The air echoed with his ringing proclamation that he was now the Sultan of Witu and that the new territory would be called Swahililand. But in 1888 he accepted the protection of two Germans which brought his territory under the Treaty of Berlin signed two years later in 1890. Under this, the British became administrators of the whole of Kenya. At Witu, the message clearly was not received. The Sultan's son was incensed at the plan of a nine-man German consortium to open a sawmill and said as much. Herr Kuntzel, one of the Germans, shot one

of the Sultan's guards. In turn, he was shot and when the gunsmoke had dispersed and the swords had been set back in their sheaths more Germans lay dead. But Sultan Simba flatly refused to discuss the matter with the new British envoy and, as a consequence, Admiral Freemantle led a punitive expedition of 950 British troops which razed Witu and its peripheral plantations.

Twenty years later the estates were back in business under the administration of two British eccentrics, Charles 'Coconut Charlie' Winton and Percy Petley, who has left his name behind on the Inn he used to run in Lamu. For many years this was the only hostelry which relieved the monastic sobriety of the Islamic coast.

Extensive settlement sponsored by the Kenya Government has taken place recently in this area, predominantly around Lake Kenyatta, and Witu is now a thriving centre of trade.

It was the Sultan who designed and supervised the construction of the canal which cut from Mto Tana on the south side of Formosa Bay to a small stream called the Ozi which entered the sea at Kipini in the north. Extensive flooding early in the 1890s resulted in the Tana changing course dramatically and adopting Kipini as its new mouth. Known as the Belazoni Canal, the cut provided the water for a large and diversified estate which included rubber plantations, at one time managed by Petley. The estate went out of business during the depression of the 1930s.

Mokowe, the roadhead for Lamu, lies at the end of the journey—sleepy and unspoiled on the mainland banks of the island's backwater. A ferry crossing serves as an introduction to the old waterfront town and its array of sailing vessels among which, for many months of the year, are the last of the ocean-going dhow fleets.

Sole survivor of a thousand-year-old cultural epoch, Lamu's attraction as a holiday destination has increased in almost exact proportion to the reduction in the number of unspoilt and remote holiday destinations elsewhere in the world.

Lamu is believed to have been first settled—in common with the entire archipelago, mentioned by Ptolemy—around the ninth or tenth century. Two other settlements, which have since vanished in the sand dunes around Shela, were Lamu's predecessors as the archipelago's principal town. Shela, with a mosque looking out over the channel which divides Lamu from Manda Island, is now the main tourist resort because of its beach and the attractive hotel set there 11 kilometres from the town.

The island has more than twenty-nine mosques; the oldest of these is the fourteenth-century Pwani mosque. Two centuries after it was built Lamu surrendered to the first European navigators to linger on these shores, men of Vasco da Gama's Portuguese fleet. The next three centuries became sagas of squabbling between the Island and the Sultanates of Pate Island, to the north, and Mombasa and Zanzibar to the south. Trade with the Yemen, Arabia and the Gulf capitals continued to flourish, however, and the island's ambergris, mangrove poles, turtle shells, ivory, rhino horn and slaves were eagerly sought abroad. More trouble followed when the fierce Galla came raiding from

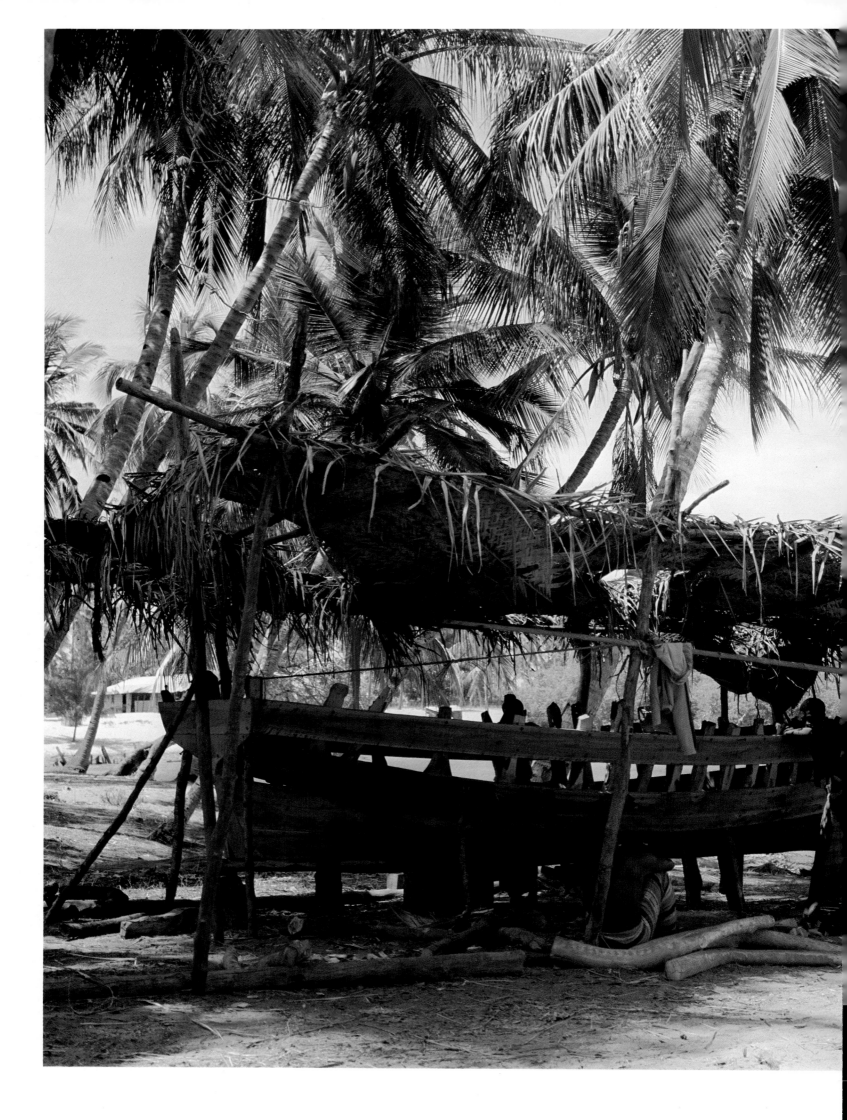

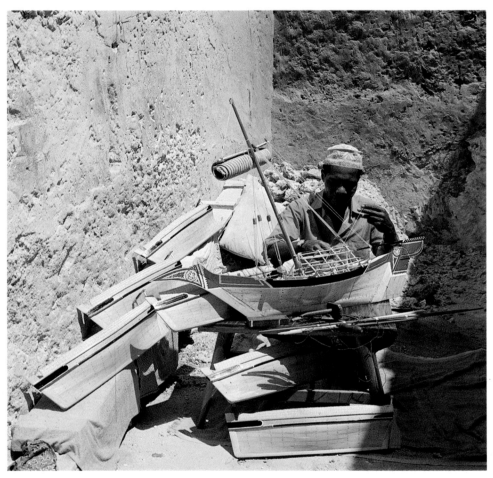

Left: Ship-builders constructing a coastal dhow, a mashua. *The great days of the dhow trade are almost at an end. The ocean-going vessels which have plied the waters between the Gulf and Kenya for more than two thousand years are now only built in Arabia.*

Below: A Bajun craftsman on Lamu Island, off Kenya's north coast, working on the model of a dhow.

the north; but, although most of the mainland settlements were razed, Lamu and the islands remained untouched.

Lamu's main trade competitor was Pate, a larger isle 30 kilometres to the north. For thirty years from the end of the eighteenth century into the second decade of the nineteenth century the competition became so fierce it resulted in actual conflict. Then the Lamu forces routed the Nabhani's army at Shela in 1813 and entered a period of unprecedented prosperity which lasted sixty years until the Royal Navy's ships hove to offshore to blockade slave shipments. Not long after this, the reporter and adventurer Henry Morton Stanley visited the town.

Lamu has remained in virtual suspended animation ever since the 1873 confrontation with Britain's anti-slave squadrons. The sense of torpor still exists endowing the town with its unique charm, a living antique becalmed in an ocean of nostalgia.

Narrow streets and sloe-eyed women clad in bui-buis, the black veil which is the universal fashion of Islamic womanhood, the shuttered windows and the motes of sun filtering through the gloom as a carved door opens and closes to reveal a tantalizing glimpse of a patio garden, add to the mellow atmosphere of the old Muslim town.

Donkeys trudge by the grandeur of the castellated and verandahed walls of the main houses down to the doors of Lamu Prison, a Foreign

Opposite: Ivory Siwa on Lamu Island is an outstanding piece of Islamic craftsmanship, an historic trumpet very similar to those which impressed Portuguese invaders led by Vasco da Gama in 1498. Obscurity exists about the origins of the craftsman who made these fascinating instruments using either ivory or brass. A more recent tradition was the use of the horn by Lamu's élite to announce weddings and other important family functions.

Left: Ornate niches in coral ruins of the lost city of Shanga speak eloquently of the sophisticated civilizations which flourished along the Kenya coast during the dark ages of Europe.

Legion remnant built in 1821, and beyond to a rise topped with a tapestry of mud and wattle and makuti-roofed Swahili houses.

Here the past is alive as nowhere else in Kenya. The feeling is tangible, almost a reality, and why not? For north from Lamu there exists a treasure trove of lost Islamic civilizations—ports, villages, and mosques that were once an animated and integral part of this remote civilization. They flourished and rose to glory when Europe was shrouded in its dark age.

These ruins have been excavated as part of Kenya's own heritage. Lamu is an ideal base for boat safaris to neighbouring islands where these 'lost cities' abound. On Pate Island, Shanga is a 7-hectare relic believed to be East Africa's oldest Islamic settlement; in fact, its tenth-century houses of mud and wattle predated the arrival of Islam, experts believe. The site was discovered in the 1950s but the first major excavation and survey did not follow until thirty years later. The original settlement was built upon several times, lifting the level of the town by some 30 feet on a rise overlooking Pate Bay. Behind is a dried-up creek which long ago was the anchorage where the dhows used to moor in calm, sheltered waters.

Shanga was suddenly abandoned after six hundred years of occupation—like so many of these coastal settlements—and the reason remains a mystery. Some conjecture that the settlements were attacked

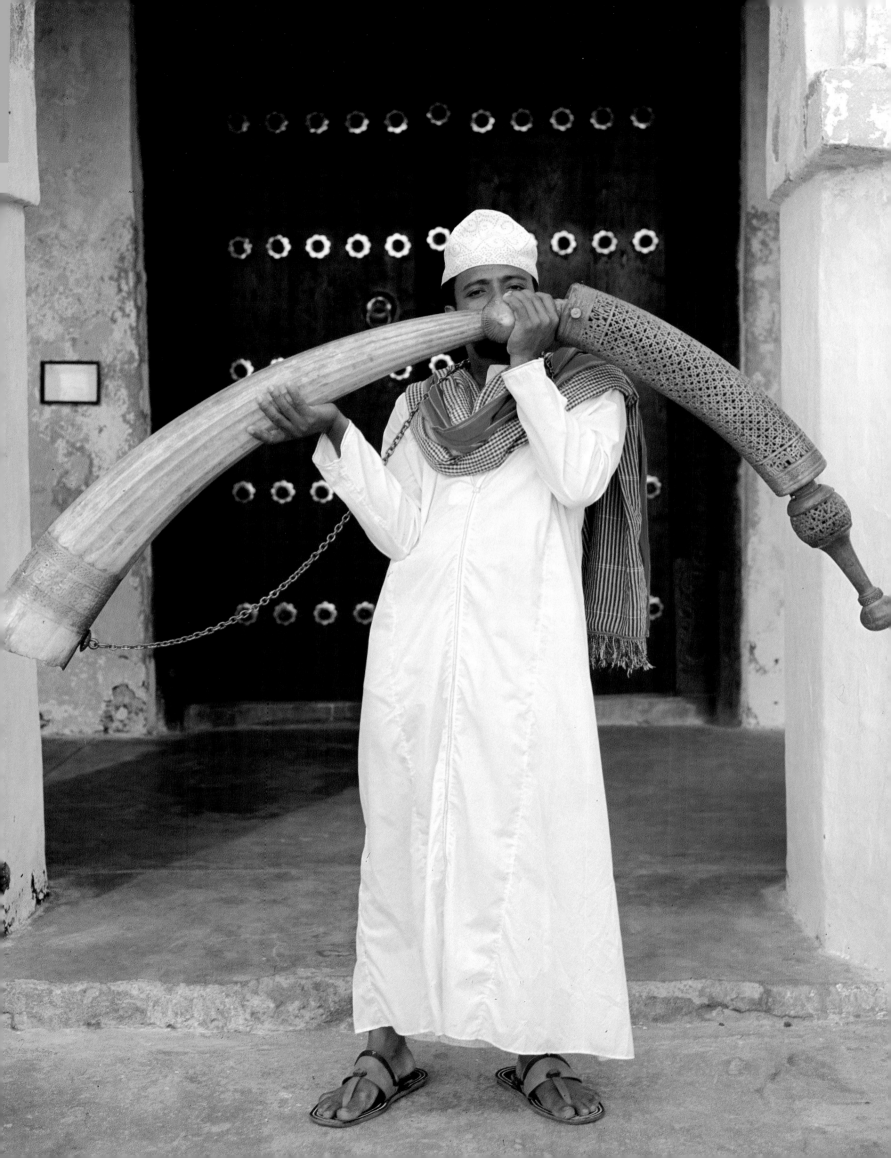

Left: The lost city of Shanga on Pate Island in the Lamu archipelago.

by other Islamic states; others say they were just abandoned because of the silting up of the harbours; and yet others argue the probability of attack by people from the interior.

Pate is an island particularly rich in ruins. They include Faza and Siyu, with its fairly recent but extremely well-preserved fort. And on Manda Island there is a relic of the sixteenth-century village, Takwa, which is very similar to the Gedi ruins at Malindi. Visitors to this island occasionally come across the sight of a large elephant or small herd of buffalo—these lords of the plains sometimes swim across from the mainland.

Few people venture farther north than Pate. As a result 100 kilometres of coastline remains Kenya's untouched pleasure ground; and inland stand two unspoilt national reserves, Boni and Dodori. Capital of this wilderness delight is Kiunga, a Bajun village whose lotus-eating charms are marked by a colonial-style District Officer's house atop a coral headland. The village is a good centre from which to explore the coast in either direction.

To the north is the forbidding, unmarked border with Somalia at Shakana with its 400-year-old tombs and a 1970s shipwreck. South, however, for 40 kilometres, runs a strip of wild, overgrown coral islands, some of them more than 5 kilometres long. Undercut by the waves, it seems impossible for anyone to land on them, and those who do have to tip-toe through a jungle of thorns and succulents growing on knife-edge coral platforms. They make virtually inaccessible, and therefore safe, breeding grounds for seabirds. But the curious may sometimes wonder how, on the larger islands, vervet monkeys gambol among porcupines, and how bush pigs and bushbucks seem to live comfortably. Kenya's great ornithologist and naturalist, the late Leslie Brown, recalled his astonishment at the sight of a bushbuck galloping along a coral clifftop wet with spray from the raging surf.

At the far end of this chain is a wide and deserted bay with silver sands facing Kiwaiyu Island. It is reached from the village of Oseni after travelling through the ruined villages of Omwe and Ashuwel.

And Kiwaiyu Bay, most remote and untouched of Kenya's beaches, is a perfect place to camp and contemplate the wonder of a 5,000-kilometre safari through Kenya.

In misty memories of nights under the pin-cushion canopy of the southern sky, the smell of damp earth and warm camp fires evokes its own sense of adventure. The words of *Paradise Lost*, by John Milton, the English poet of the seventeenth century who knew of the Kenya coast, echo through the mind:

'The world was all before them, where to choose
Their place of rest, and Providence their guide;
They hand in hand with wandering steps and slow
Through Eden took their solitary way.'

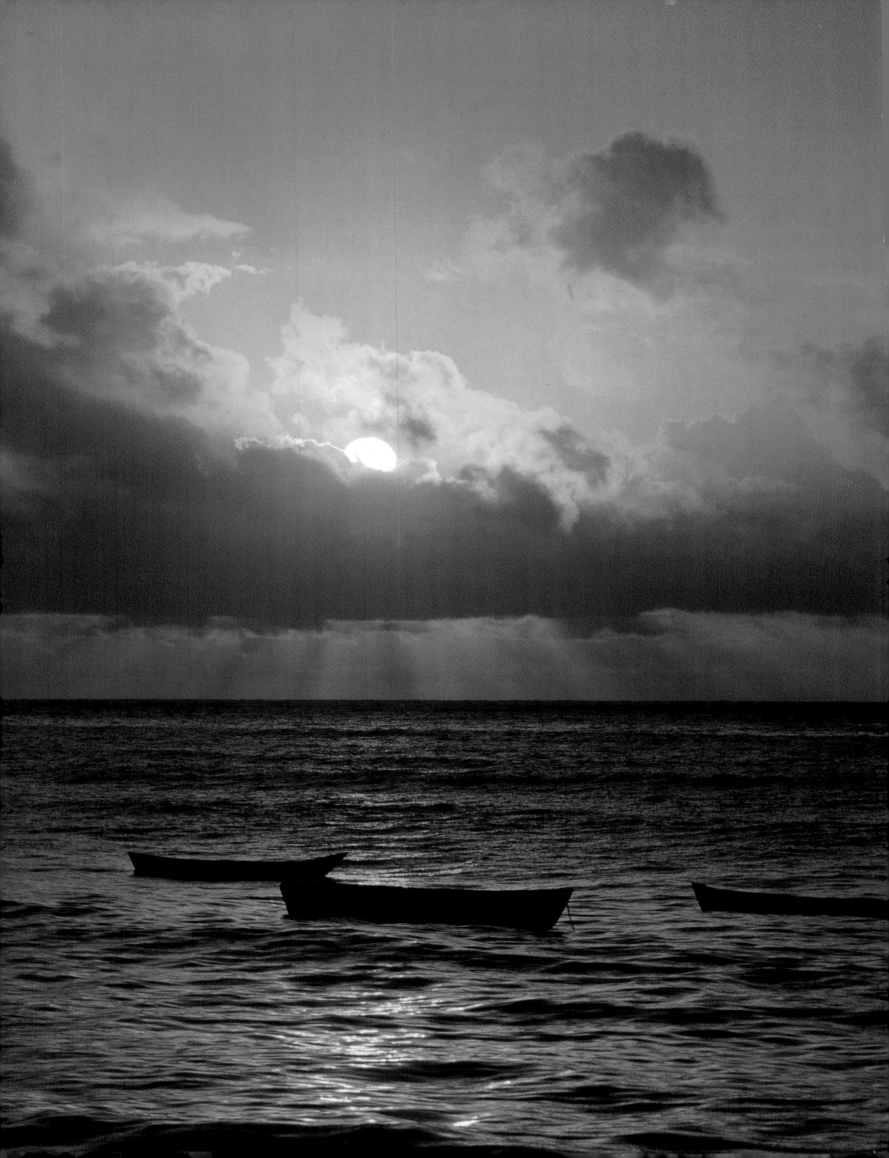

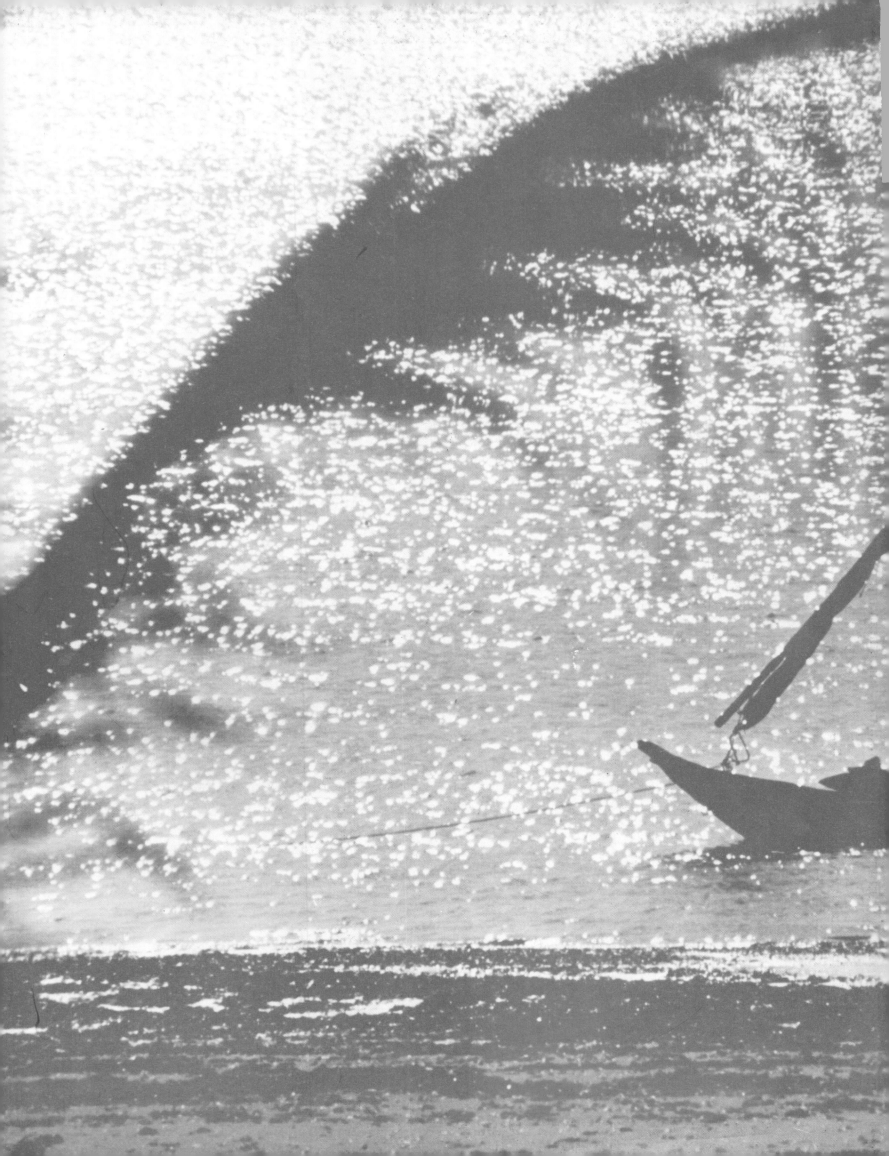